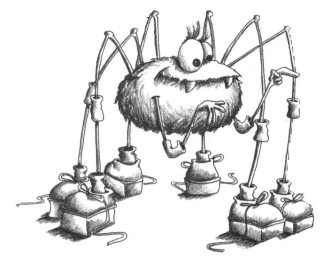

Drawing in 3-D with Mark Kistler

From Amazing Androids to Zesty Zephyrs
333 Neat Things to Draw in 3-D

Mark Kistler

A Fireside Book
Published by Simon & Schuster

W9-BRC-437

FIRESIDE
Rockefeller Center
1230 Avenue of the Americas
New York, NY 10020

Manufactured in the United States of America
10 9 8 7 6
Library of Congress Cataloging-in-Publication Data
Kistler, Mark.
 Drawing in 3-D with Mark Kistler : from amazing androids to zesty
zephyrs : 333 neat things to draw in 3-D / Mark Kistler.
 p. cm.
 "A Fireside Book"
 1. Drawing—Technique. 2. Composition (Art) 3. Optical
illusions. 4. Perspective. I. Title.
NC740.K57 1998
741.2—dc21 98–18363 CIP
ISBN 0-684-83372-7

What's Where

Foreword

Wow! Look at me! I'm writing the foreword to Mark Kistler's latest drawing book! Cool! And you're reading it! Amazing! Imagine if one of your heroes, say, Sally Ride the astronaut, said, "Hey, you like outer space, why don't you come along on the Space Shuttle!" That's what it feels like to me, to contribute to a book by Mark Kistler, my number one art hero!

I didn't learn how to draw in 3-D until I was a grown-up, working in New York and riding the train three hours a day. I spent the commute learning to draw. I didn't like most of the books I found in the bookstore—I wanted to draw realistic things, but I wanted to have fun, too. Mark's books taught me good basic skills, but I learned them while drawing cool stuff like pencil ships and planets, not plain cones and spheres.

Drawing has helped me a lot on the job (I write books about computers). I've made logos, flyers, and brochures; designed T-shirts; created Web sites; and illustrated my documents. In fact, it was the pictures I did for a computer book that first caught Mark's eye and resulted in our working together on television and Internet projects.

What goes around, comes around. If Mark hadn't taught me to draw in 3-D through his books, I would never have had the confidence to create the drawings, I wouldn't have met him, and I wouldn't have been able to help get the word out to other people that drawing is fun and easy.

You never know what's going to happen when you share what you know with other people. You can touch many other lives and cause a lot of good things to happen with a single act of generosity.

The best part of working with Mark is getting to meet all of the people who surround him. Mark is a magnet for the most intelligent, funny, creative, successful, friendly, and generous people I've ever met. People like you!

It's the coolest thing in the world that I got to write this, and it's cool that you took the time to read it. But now, let's do some drawing!

—Webmaster Dennis Dawson

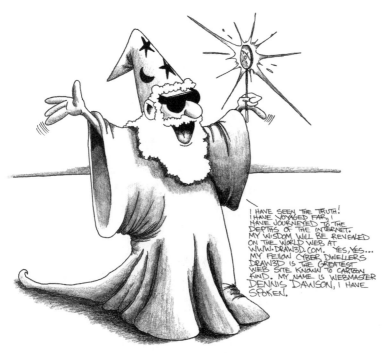

I HAVE SEEN THE TRUTH! I HAVE VOYAGED FAR, I HAVE JOURNEYED TO THE DEPTHS OF THE INTERNET. MY WISDOM WILL BE REVEALED ON THE WORLD WEB, AT WWW.DRAW3D.COM. YES, YES... MY FELLOW CYBER DWELLERS DRAW3D IS THE GREATEST WEB SITE KNOWN TO CARTOON KIND. MY NAME IS WEBMASTER DENNIS DAWSON, I HAVE SPOKEN.

Yippee!

I've always wanted to create a giant how-to-draw in 3-D book. A book packed full of hundreds of drawings in 3-D adventure lessons organized in an alphabetical encyclopedia format. A book that kids all over the world could use as an "idea bank" for any kind of drawing on any subject at any time. After two years at the drawing board I have created for you an *A* to *Z* "idea encyclopedia."

I loved using the alphabet as my drawing guide. Starting with the letter *A*, I created 3-D drawing lessons. Most lessons include an "amazingly awesome alliteration" or a "powerfully peculiar poem" or even a "super story starter" all the way to Z. An alliteration is a sentence that contains words that start with the same sound.

You can use this book to learn how to draw exotic animals, plants, trees, buildings, cities, space colonies, planets, birds, fish, insects, people, and, yes, even the hard-to-draw human hand!

I've received thousands of letters requesting a special book on how to draw lettering in 3-D. So I decided to include five 3-D lettering lessons for each letter of the alphabet. That's 130 3-D lettering adventures. With over three hundred 3-D drawing adventures, this book is going to keep you very, very busy for many months to come.

The only materials you will need to use this book are a pencil, paper, and a glass of cold milk (to cool your brilliant creative brain while you are drawing!). You may want to purchase the companion *Mark Kistler's Drawing in 3-D Wacky Workbook*. This sketchbook contains nearly two hundred pencil-power practice pages emphasizing important lessons in this book. If you already have the *Drawing in 3-D Wacky Workbook*, turn to the first sketch page and let's get busy. If you don't have the sketchbook, just go grab a handful of scratch paper from the drawer next to your parents' desk, or from the trash can next to the computer printer. Now you are ready to begin.

With book in hand, sit down at the kitchen table with your paper, sharpened pencil, glass of milk within easy reach, perhaps a banana, too (in case you need a potassium and natural sugar brain-cell thinking booster). Read the Diligent Drawing Declaration on the next page, think about what it says, and sign your name to the bottom of it. Buckle your imagination-exploration seat belt; you're in for the biggest, most exciting drawing adventure of your life!

Dream it! Draw it! Do it!

MARK KiSTLER

P.S. Oh, yeah! I almost forgot to tell you to visit me on the World Wide Web at www.draw3d.com and E-mail me your drawings, letters, and powerful poems!

Diligent Drawing Declaration

The "Less Television, More Drawing" Legally Binding Contract

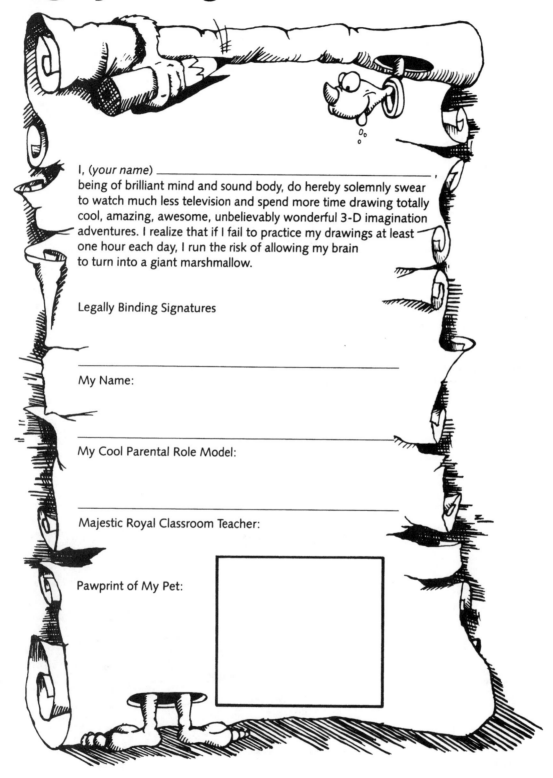

I, (your name) _____,
being of brilliant mind and sound body, do hereby solemnly swear
to watch much less television and spend more time drawing totally
cool, amazing, awesome, unbelievably wonderful 3-D imagination
adventures. I realize that if I fail to practice my drawings at least
one hour each day, I run the risk of allowing my brain
to turn into a giant marshmallow.

Legally Binding Signatures

My Name:

My Cool Parental Role Model:

Majestic Royal Classroom Teacher:

Pawprint of My Pet:

Come with Me! Let's Draw in 3-D

The Goal

My goal with this book is to teach you how to draw in 3-D with great skill and confidence. You'll have the power to draw anything, at any time, from your imagination or from what you see with your eyes in the world around you.

Drawing in 3-D is my favorite thing to do! Since you are holding this book in your hands, I'm going to assume you love to draw as much as I do, and that you are looking for someone to teach you how to make your drawings look more "alive" and action packed, as if they really "exist" on the piece of paper. The good news is that drawing in 3-D is an easy-to-learn skill that *you* too can learn. You will become the paper dominator, the imagination master. You will become the great pencil-power wizard of planet Earth. How? When? Is this really possible? Of course it's true. Let's start now; just follow the directions below.

How to Use This Book

There are many ways to use this book. One way is to turn to the Dynamic Drawing Directory on page 27. Scan down the illustrated columns of the hundreds of lesson choices, find one that catches your eye, turn to that page, and draw like a wild Ninja artist.

Another way to use this book is as an idea resource dictionary, an "idea encyclopedia." When you want to draw something in particular for a school report, such as an ancient Egyptian pyramid or an African gorilla, turn to the Dynamic Drawing Directory and find the appropriate theme. Follow the illustrated lesson to draw the object in 3-D.

The best way to use this book is to follow it beginning to end. The beginning lessons will teach you several very important Renaissance drawing words and art terms and will help you understand the more difficult lessons later in the book. I also have added helpful pencil tips on blocking, sketching, and finishing. Along the way you will be learning several detailed shading techniques to make your drawing appear to pop off the paper in 3-D. After you complete chapters 1 through 4, go wild with your powerful pencil personality. Draw the lessons at random in whatever order you feel like. If at any time you feel your drawings are starting to look a bit tilted, askew, or misproportioned, you can always review chapters 1 through 4. When you go back to review the early chapter find out which Renaissance word you seem to be having difficulty with. Practice a few more of these early lessons once again. You'll fix the peculiar pencil problem promptly and be able to jump back to the more advanced chapters in no time. Relax, have fun, keep your pencil loose and your lines sketchy. You will want to draw each lesson several times before you have a masterpiece suitable for world exhibition on the family refrigerator. So enjoy the slow process! Drawing in 3-D is not just a quick lesson, it's a life adventure!

Once you finish the first lesson on page 46, work your way through each letter *A* drawing lesson. I've written the lessons for the letters *A* and *B* as the main teaching components for you to learn the most important basic drawing in 3-D skills. The lessons for letters *C* through *Z* have minimum text, focusing more on the line-by-line instruction. While you are blasting across the paper, drawing lessons *A* and *B*, be sure to read carefully the text I have written next to the specific steps. These helpful basic concepts will prepare you for the other three hundred-plus drawing adventures to follow. A few of the more advanced lessons in one-point perspective will appear in later chapters. For examples of these more advanced lessons, look at Dirk's Declaration (page 84), Forest of Freedom (page 97), Kazoo Kingdom (page 133), and Question Queue (page 177).

While creating this book, I wanted it to be useful as a viewer's guide to my children's how-to-draw public television series, *Mark Kistler's Imagination Station*. At the beginning of each episode I introduce the thirty-minute lesson with the title of the day. When I say the title, viewers can turn to the Dynamic Drawing Directory, find the appropriate lesson adventure, and turn to that page. Now you can watch me on PBS and follow along with me in the book! Pretty cool, eh? If this children's public television series is not currently broadcasting in your area, you may call the programming director of your local PBS station and suggest they include the series in the broadcast schedule. I donate this children's television series of sixty-five episodes to PBS stations across America. Millions of children are having daily "art attacks" with me from their TVs. You can find the phone number on my Internet Web site at www.draw3d.com, or look in your local phone directory. Your phone calls, letters, and faxes to PBS stations across America have made it possible for me to broadcast these children's television series over the last fourteen years. Thanks for sharing my dream of art TV for kids.

Supplies You Will Need with This Book

Paper and pencil—that's it. Of course, if you want to go absolutely nuts with drawing supplies like I do when I go into an art supply store, you can, but fancy supplies are not necessary to learn how to draw. Just grab a pencil and piece of paper from the drawer next to your refrigerator, and you are set to draw. However, listed below are some "bonus" fancy supplies you can collect for your "genius drawing in 3-D" supply box. Keep this list handy for your parents to refer to before your birthday and holidays. This list is also very cool to give to your "deep-pocket art suppliers" (your parents) when you hand them your exceptionally brilliant straight-A report cards.

Mark Kistler's Drawing in 3-D Wacky Workbook

This is the companion sketchbook to the lessons contained in this *Drawing in 3-D* book. This sketchbook will guide you through specific lessons that will emphasize all of "the twelve Renaissance words" and "the twenty-two augmenting art accents," along with the "dynamic drawing directory." It also contains some super story starters written by my big brother Stephen Kistler, and dozens of awesome alliterations to challenge your poetic propensity. This sketchbook is a fun bonus learning tool to have while you are jammin' through the 3-D lessons in this book.

Paper and Other Sketchbooks

For drawing practice you can use simple scratch paper out of the trash can, the recycling bin next to the copy machine in your parents' office, or even the back of unused junk mail envelopes and flyers. If you want to get a sketchpad of blank paper, go to your local art supply store. Pick a large one for table-top practice and a small one for your back pocket or book backpack. Any pad that reads "for

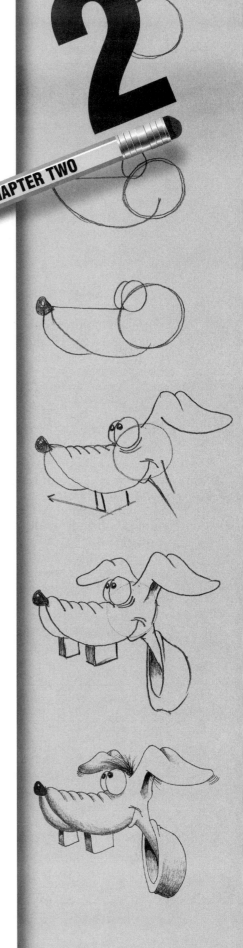

sketching with pencil" will work just fine. Spiral binding on the top or side of the sketchbook helps you open the pad flat to draw. I especially like using pads of newsprint for quick sketching practice sessions. You might want to add a pad of newsprint to your drawing supply box as well.

Pens, Pencils, Erasers, and Paper Stumps

Go through your house and look in all the drawers, closets, and cubbyholes in which old pencils, pens, and crayons may be hiding. Put them all in a shoe box, old coffee can, or a recycled milk jug with the top cut off. This collection is plenty to get started with.

Pencils

I keep a bunch of standard yellow pencils handy. You should have a few of these yellow puppies sharp and ready for action along with a pencil sharpener. Any little plastic pencil sharpener will do. I keep an electric pencil sharpener ($19 version) in my drawing studio. Most of the time though, I use mechanical pencils because they are so easy to keep sharp and the points don't stick you! My favorite mechanical pencil is the Pentel P209 .9mm with an assortment of leads. I have one with a *B* lead, and others with *HB*, *2B*, *4B*, and a *2H*. I like using the softer leads of the *B*s, but you may prefer the harder lines an *H* lead will give you. Again, you need to experiment to determine what you enjoy most. The higher the *B* rating of the lead, the softer and darker the line will be, and also the more messy and likely to smudge and smear. The higher the *H* lead rating the harder and lighter your drawing line will be. The reason I prefer the softer, darker lines from the *B* leads is that I love using "paper stumps" to smudge and blend the shading in my pictures. A paper stump is a small, short, stubby stick of compressed paper. You use this stubby stick to smooth shading from dark areas to light areas. This creates a nice blended professional look to your 3-D object. If you have never used a paper stump before, you simply *have* to go buy one and experiment with it! They are very cool and cost around $.75 each. You can get a similar blended effect on your drawing by using your finger to smear the shading from dark to light. However, you'll notice a lot more control with a lot less mess when you use a paper stump.

The black painted pencils I use to teach 3-D drawing on my public television series, *Mark Kistler's Imagination Station*, are standard graphite pencils ranging from *4H* to *6B*. These pencils are available at the art store. They need sharpening constantly but are great for tilting sideways to shade larger areas quickly. Graphite art sticks are also wonderful for shading large surface areas quickly. These sticks are basically pencil lead in a thick, squared stick without any wooded covering. Very fun to use, but extremely messy. Have a damp towel handy to wipe your soon-to-be-blackened fingers.

Erasers

When you sketch in pencil, you are probably going to want to erase a lot. Try to resist this, because the more you erase the more tense you will be

when drawing rough sketches. Try to train yourself to use your eraser only to clean up your finished pictures of extra lines and finger smudges. The two types of erasers I use the most are the block "gummy" erasers and the "kneaded" gray erasers.

Gummy erasers crumble as you use them, making a really cool mess all over your drawing desk. I use a drafting dusting brush to wipe the crumbled mess away. The drafting brush costs around $4 and makes me feel very important and professional every time I use it. Sometimes, when I know people are walking by my drawing studio, I'll start brushing my drawing for no reason other than to look like a busy professional.

The "kneaded" erasers are smaller, gray, soft, malleable putty erasers. They come in a plastic wrapper and sell for around $2 each. I like to mold a nice pointed tip out of the kneaded eraser to clean up delicate areas in a detailed pencil drawing. I used this type of eraser often in each of the final inked panels of this book, especially after I added the B pencil shading to the inked illustration.

There is a nifty eraser product called a "bag" eraser. It's available in mechanical drafting stores for around $5. This bag eraser is a small, white bag filled tightly with crumpled gummy eraser bits. It is sewn at both ends and fits in the palm of your hand. These are used for a final cleanup of inked illustrations that have light pencil lines that need to be removed over larger areas. These are also great for getting rid of finger smudge marks. After you use your bag gummy eraser it gives you yet another good opportunity to look supercool while you sweep the crumbly mess away.

Ink pens

As far as the type of ink pens I use, any ballpoint can be used for a great practice drawing session. Pens build confidence. Why? Because you are much less likely to worry about the need to erase every little misplaced line and squiggle. Start with a light quickly sketched "blocking" of your object. Then you can add layers of darker detail and shading. Keep a few ballpoints in your drawing supply box; any color will work. I use a lot of blue-ink ballpoints.

I also enjoy using the Sharpie ultra fine-point red and black ink pens by Sanford. These are nontoxic and great ink lines. You will need thicker paper to sketch with these because they soak through lighter-weight paper. Always put a piece of cardboard or sketchpad under the paper you are inking; this will keep the ink from staining your table.

Another great pen I enjoy is the Pigma micron black ink pen by Sakura. This wonderful pen is available in tip sizes of 005, 01, 02, 03, 05 and 08. These micron pens replaced the sets of Rapidograph drafting fine ink pens that I have loyally used for years. Micron pens cost around $2.50 each, last a few weeks of daily use, and are disposable. Rapidograph pens cost around $20, with interchangeable tips ranging from 005 to 08 at around $6 a tip, and are completely refillable. So in the long run, Rapidographs are more economical and infinitely better for the environment. My problem with Rapidographs have been the messy refilling, unclogging, and cleaning processes. I must admit that in junior and senior high, I prided myself on how fast and efficiently I could change tips on my extensive Rapidograph collection. I felt like an artistic scientist conducting laboratory experiments, with towels and rags spread over the bathroom sink counter, pen tips in varying stages of assembly, ink cartridges and refilling jars scattered around, and hollow-body pen containers lined up in an orderly row waiting for my reassembly process to commence. This is an experience I heartily recommend for all budding cartoonists and illustrators. It's kind of like learning the behind-the-scenes mechanics of a Broadway play set construction or a television show production. Rapidograph pens are fun.

When you use micron or Rapidograph pens you will want to use a smooth-surface paper that is made for ink lines. A heavy, smooth-surface illustration board is ideal for creating a large pen-and-ink mural poster. You can start with a pencil sketch using a light, harder lead 4H pencil, then spend countless hours of inking intricate details. I included an example of this type of thick, smooth illustration board with Rapidograph ink line on page 76. I created this pen-and-ink castle poster when I was a high school sophomore (seventeen years ago, whew!), on a 24 X 36-inch white illustration board. These boards cost around $4 each.

When you are planning to create a nice pen-and-ink picture, starting from pencil roughs, you will need to use appropriate paper. For the illustrations in this book I used Canson 116 bond, sixteen-pound layout paper and Canson pro-layout marker eighteen-pound paper. These styles have wonderful smooth surfaces that are resistant to your ink line bleeding out everywhere. The best paper for a guaranteed no-bleeding ink line is a drafting vellum (seventeen-pound rag), or a thicker slicker (more expensive drafting film). Wait until you experiment with a nice piece of vellum or sheet of film with a great flowing micron or Rapidograph pen! It is sheer indescribable cartooning bliss! What a line, what a sharp edge—a perfect black-and-white image! The problem with vellum and drafting film is that I like to add pencil shading over my ink lines, and this type of paper doesn't handle pencil well.

There are many other drawing tools I haven't mentioned, such as the clear plastic ruler to create one- and two-point perspective drawings (see pages 64 and 76). I want you to discover more exciting drawing tools as you work your way through *Drawing in 3-D with Mark Kistler*. Keep all your supplies organized in one box, bag, or drawer. This way you will always be able to find them.

You should also have an instant "travel" drawing kit prepared. Your travel drawing kit should have a small pad of blank paper and a plastic Ziploc bag to hold your pencils, pens, and equipment. Have this always handy to grab anytime you go out the door to school, the store, the mall, the movies, etc. You know when you go to the movies and you always have to wait twenty minutes for the film to begin? A perfect opportunity for a spontaneous practice session! I always have a pocket sketchpad handy to practice sketching interesting faces around me. There is always lots of time during the day that you sit waiting for something. Turn this time into practice time with your travel kit. My nephew Ian has a copy of the *Drawing in 3-D Wacky Workbook*. He takes the workbook, this lesson book, and a large plastic Ziploc bag filled with his drawing tools. He puts the books and pencil pouch in a special "art attack backpack," and off he goes on errands with his parents. What kind of travel drawing kit will you create?

The Twelve Renaissance Words of Drawing in 3-D

Below you will find the handy-dandy reference chart, The Twelve Renaissance Words of Drawing in 3-D. These words have been used for over five hundred years by artists all over the world. These terms help create the illusion of the third dimension, depth, in paintings and drawings. Each time one of these twelve Renaissance words is used in the drawing lessons, I point it out for you to learn and use. You may make copies of this chart for use as a quick-peek reference guide. Pin this chart to the wall behind your drawing desk or in your school classroom. This chart is also handy to carry in your pocket for instant access during any unexpected drawing in 3-D urge that may strike.

Be a paper dominator! Use these words to really make your drawings pop off the paper in 3-D. These twelve Renaissance words build tremendous 3-D pencil power!

The Twelve Renaissance Words of Drawing in 3-D

1. Foreshortening

Squishing a shape to make one part look closer to your eye.

2. Placement

Placing an object lower on the surface of the paper will make it appear closer.

3. Size

Draw objects larger to make them appear closer. Draw objects smaller to make them appear farther away.

4. Overlapping

Draw an object behind another object to make it look deeper in your picture.

5. Shading

Add darkness to the side of an object that faces away from your imaginary light source.

6. Shadow

Add darkness to the ground next to the shaded side of an object, opposite the imaginary light source.

7. Contour

On round surfaces, draw lines curving around the object to give it shape, volume, and depth.

8. Horizon

Draw a line behind the objects in your picture to create a reference background edge.

9. Density

Draw objects very light and less distinct to make them look far away in the background of your picture.

10. Bonus

Add billions of cool, nifty "extra ideas" to each of your drawings! Bonus ideas are brilliant!

11. Practice

Apply these twelve Renaissance words to your drawings each and every day! Draw at least one 3-D drawing adventure each day! Nineteen hours a day is all I ask.

12. Attitude

Your brilliant super-positive mental attitude is very important when you are learning a new skill in life, especially drawing in 3-D!

Dream It! Draw It! Do It!

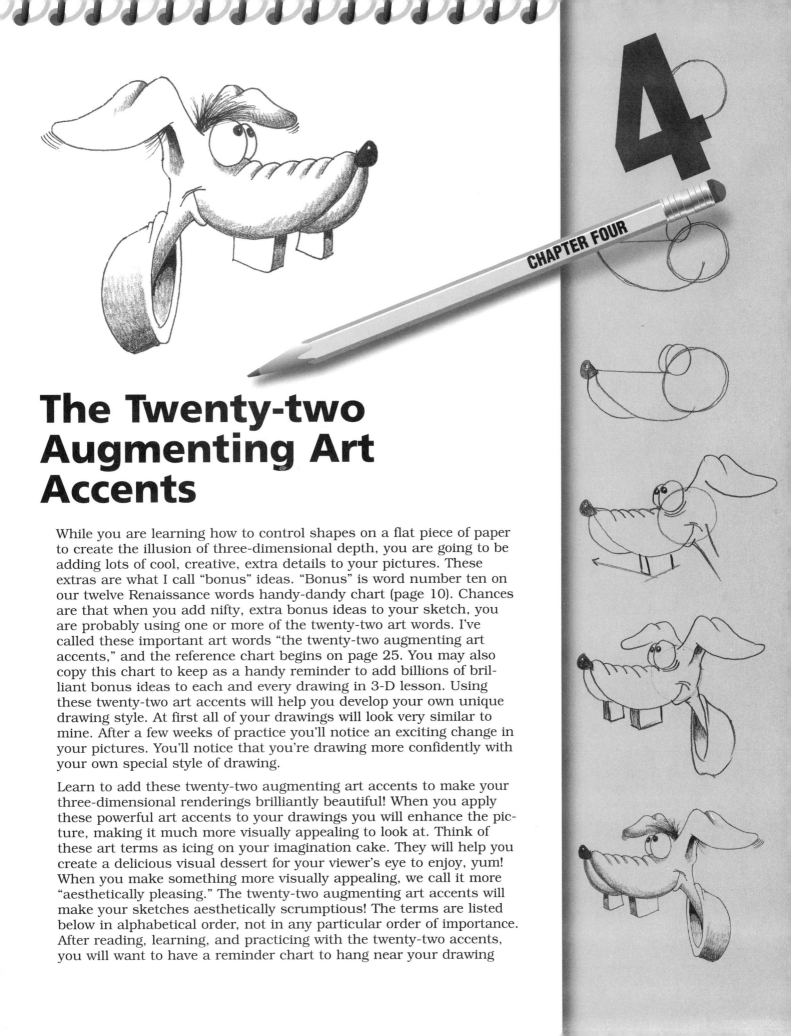

The Twenty-two Augmenting Art Accents

While you are learning how to control shapes on a flat piece of paper to create the illusion of three-dimensional depth, you are going to be adding lots of cool, creative, extra details to your pictures. These extras are what I call "bonus" ideas. "Bonus" is word number ten on our twelve Renaissance words handy-dandy chart (page 10). Chances are that when you add nifty, extra bonus ideas to your sketch, you are probably using one or more of the twenty-two art words. I've called these important art words "the twenty-two augmenting art accents," and the reference chart begins on page 25. You may also copy this chart to keep as a handy reminder to add billions of brilliant bonus ideas to each and every drawing in 3-D lesson. Using these twenty-two art accents will help you develop your own unique drawing style. At first all of your drawings will look very similar to mine. After a few weeks of practice you'll notice an exciting change in your pictures. You'll notice that you're drawing more confidently with your own special style of drawing.

Learn to add these twenty-two augmenting art accents to make your three-dimensional renderings brilliantly beautiful! When you apply these powerful art accents to your drawings you will enhance the picture, making it much more visually appealing to look at. Think of these art terms as icing on your imagination cake. They will help you create a delicious visual dessert for your viewer's eye to enjoy, yum! When you make something more visually appealing, we call it more "aesthetically pleasing." The twenty-two augmenting art accents will make your sketches aesthetically scrumptious! The terms are listed below in alphabetical order, not in any particular order of importance. After reading, learning, and practicing with the twenty-two accents, you will want to have a reminder chart to hang near your drawing

table. You can duplicate the twenty-two augmenting art accents chart following these definitions (pages 25-26). This way you will always be prepared to add delicious aesthetically pleasing elements to your three-dimensional masterpieces!

Tip: Hang the augmenting art accents chart next to the twelve Renaissance words chart on your wall or in your drawing folder.

1. Balance

Drawing not only brings wonderful balance to your busy brilliant life, but it also brings a very dynamic force to your sketchpad! When you draw objects on either side of the page to create a stable composition you are using the art augmenting term "balance." For example, if you draw a giant castle on the left side of the page, you might consider drawing something on the right side of the page to balance it out. A large mountain, or even a puffy cloud, on the right side would work to keep the viewer's eye recirculating in your picture instead of falling out of the frame. Look at the Fearless Floating Frogs drawing lesson on page 95. Notice how the group of cattail plants on the left side of the picture could very easily unbalance the drawing, weighing it down on the left. I added the text cartoon balloon to the right side of the drawing to balance it out. I could have drawn a tree stump or an alligator's tail instead, anything to bring that sense of balance to the picture, capturing your viewer's eye in the drawing. An unbalanced drawing will often dump the viewer's eye off the picture and onto something else. Look for more use of balance in Early Egyptian (page 88), Kazoo Kingdom (page 133), and Launch Lever (page 140).

2. Color

"Color" is a fantastic augmenting art accent to work with. Color does so many things to enhance your drawing. It sets objects apart from the background and apart from other objects in your picture. Color also helps you identify objects. If you decide to draw a three-dimensional banana man, coloring him yellow would help you identify him as a boisterous banana. Use crayons, color pencils, watercolors, ink markers, or even airbrushes to enhance your drawings with color. Next time you are at the library or in a bookstore look at the colored illustrations by the authors Steven Kellogg, Graeme Base, and Dr. Seuss. Their illustrations will inspire you to add color everywhere! A little bit of color goes a long way. Draw the Enthusiastic Environmentalist lesson on page 92. Instead of using your pencil to shade, use an orange crayon on the boxes. Now shade the funnels with a light-green crayon. A little bit of color in this picture has helped us identify the shaded sides, separate the funnels from the boxes, and even "pop" the contraption off the page in 3-D. A little bit of color goes a long way!

3. Grouping

Next time you are outside walking near a park, forest, or the ocean, take notice of how many "groups" of things you see. Nature tends to gather most things into nice happy groups. You'll notice a scattering of groups of clouds, rather than a lot of individual puffs, and groups of trees in a forest, rather than single trees spread out by themselves. Even waves come to shore in groups called "sets," with spaces between the groups called "lulls." It's fun to learn from your observations of nature and the world around you and apply this new knowledge to your drawing. Next time you draw a moonscape, try grouping different areas of craters around your drawing. See if you can find where I used grouping in the following pictures: Wonderful Whale (page 219), Yelling Yahtzee! (page 230), and Gnome's Home (page 107).

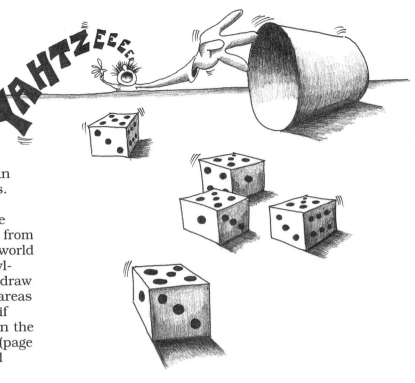

4. Natural Design

Another thing to notice during your stroll through a forest, park, or on the beach is the textures of the objects you see in nature. The trees have wonderful patterns of bark; seashells have extraordinary patterns of intricate design; birds' feathers and fish scales all have specific, beautiful "natural designs." Nature is the best teacher of adding unique texture designs to the objects in your picture. Try different natural designs when you draw rocks, trees, clouds, and animals. I used natural design to make the feathers on my Enchanted Eagle look more realistic (page 91). I also used the natural texture of Swiss cheese to make the Yummmm drawing (page 232) look more fun and full of character.

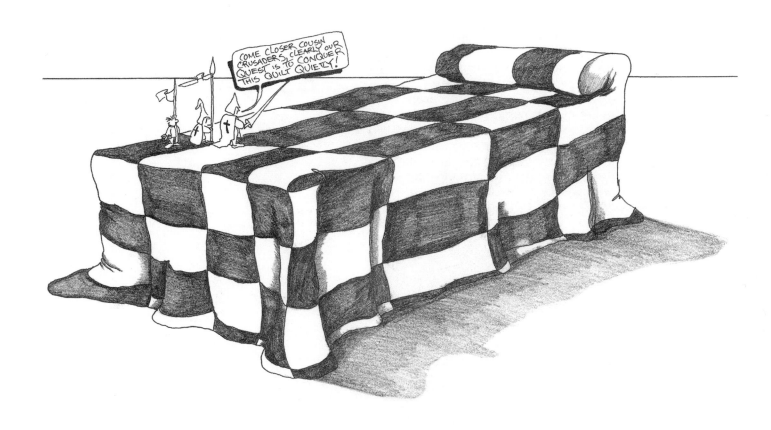

5. Plaid and Checkers

Sometimes I will look at a drawing I am working on and notice an object that looks a bit bland. It looks as if it needs something extra to give it more character in the overall picture. Often what this object will need is some kind of "texture," some kind of surface treatment to make it more interesting. I've found adding "plaid or checker" patterns to some object surfaces really adds personality to the drawing. Try adding plaid or checker augmenting art accents to your next sketch. I used plaid and checkers to add a nice pattern to the surface texture of my drawing Huge Hand (page 117), Daring Driving Dogs (page 83), and Quilt Quest (page 178).

6. Proportion

This is a very interesting augmenting art accent. When you draw a jumbo jet, how do you make the plane look "jumbo"? One way is to draw disproportionately small windows—lots of them. The tiny windows make the plane look enormous. To make skyscrapers look gigantic in a cityscape, draw the windows and streets disproportionately tiny. To make a monster dragon look huge, draw a small character riding its back. "Proportion" helps establish the size relationships of objects in your sketch. Experiment with the augmenting art accent "proportion" by drawing a group of people. Draw them all the same size, but experiment with the proportion of the details. Draw one with tiny eyes and tiny ears, another with large eyes and ears. Draw one with tiny feet and hands, and another with big feet and hands. Try this with a cityscape like the Billions of Blocks exercise on page 64. Draw the picture with small windows; now redraw the picture using giant windows. Notice how the giant metropolis now looks like a hamster hotel complex, just by changing the proportion of the windows. Find where I've used proportion in the following sketches: Quilt Quest (page 178), Zesty Zephyr (page 237), Near NASA (page 153), and Drooling Dragon (page 86).

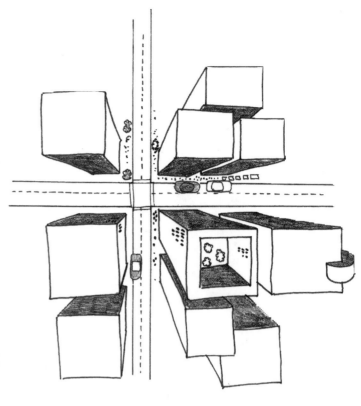

7. Repetition

What is the first thing that pops into your mind when I say "Greek architecture"? I always immediately picture lots of columns in a row. The repeating pattern of pillars is very pleasing to the eye. The early Greek artists who designed buildings for their cities understood that by repeating patterns of arches, doorways, windows, and pillars they would create aesthetically pleasing structures. "Repetition" will help you in your effort to draw the most aesthetically pleasing three-dimensional rendering on planet Earth. Try repeating a row of flying craft in your next space scene, or repeat a cool pattern with the fur on the side of a mythical monster. Take a peek at how I have used repetition to create a very pleasing effect for your viewing eye in my drawings of the Xeroxing Xylophone (page 223), and the Royal Ribbons (page 184). The repeated foreshortened circles used in drawing the chain in the drawing lesson Long Links (page 142), and the repeated pattern of folds in the lasagna noodles in the lesson Leering Lasagna (page 141), both create good examples of repetition for you to enjoy.

8. S Curve

Graceful "S curves" flow through-
out nature all around you. Since
we have learned that nature is
our best teacher of how and
when to use these augmenting
art accents in our pictures, let's
look around our environment
and see how S curves really make
objects flow beautifully. You'll see S
curves in cat's tails, fish fins, tree
limbs, flower stems, creeping vines,
and even the back of your ear. Find the
S curves I've used to make my drawings
flow more aesthetically in the following
pictures in this book. Peaceful Pelican (page
166), Crawling Cobra (page 80), Drooling
Dragon (page 86), Eccentric Elephants (page
89), and the Jiggling Jellyfish (page 127).

9. Silhouette

Just as color helps set objects apart from one another, "silhouette"
helps spotlight objects more dominant in your picture. For example,
when you draw a flock of three-dimensional birds soaring overhead, by
drawing some of them in silhouette, you will spotlight your viewer's
attention to the more detailed birds. Silhouette works really well with
the Renaissance words "size" and "overlapping." Try this experiment:
Draw a herd of twenty-three Eccentric Elephants from page 89. Pick
four of the elephants you have drawn that are smaller in the back-
ground and completely darken them in to create silhouette elephants.
What do you notice happening to your drawing as you darken in the
back elephants?

YUM! IT'S SNACK TIME!

HEY WAIT! WHAT'S
GOING ON! HELP!
HELP! THIS IS
DISGUSTING

10. Skewed Curve

A skewed curve will give the object you
are drawing a flowing line and a lot of
character. Look at the lizard's belly;
notice how the line is curved more at
one end than the other. Skewed curves
help your drawing come to life by adding
wonderful style to your lines. Look for
more skewed curves in the following
drawing lessons: Nine Nostrils, top of his
nose (page 156); Noisy Nest, the edge of
each leaf (page 157); Walter's Wig, his
hair and his belly (page 216); and even
the fuselage on the Funky Flying
Faucets (page 100). Skewed curves are
very cool and add a nice graceful look to
your lines. Skewed curves show your
confidence with pencil power.

11. Spiral

"Spirals" are yet another fantas-
tic design derived from looking
at nature to use in your draw-
ings. Spirals are everywhere—
in seashells, snail shells, snake
coils, flower petals, and even in
the cloud formations. Spirals
in nature inspire us to delicate-
ly spice up our drawings with
augmenting art details. I think the
niftiest spiral I've ever seen in a
piece of artwork is in the wrought iron
fence design around Stephen King's house
in Maine. Stephen King is one of my literary
heroes, and one of the most prolific authors on
the planet. While I was visiting elementary
schools in Maine last fall I drove by his house. The
iron fence surrounding his home is sculptured with all kinds of
ghoulish characters woven into the work. I saw spiders and gar-
goyles throughout the spiraling iron design. I did not stop my
car, nor did I take photographs; I consider this to be very rude,
obnoxious behavior in a residential neighborhood. I did see sev-
eral carloads stopping. If you are ever in Maine and you want to
see this fence, have your parents drive by slowly and carefully
but be polite; don't stop and gawk. Pictures that use spiral for a
beautiful effect are the Romantic Rose (page 184) and Vertical
Vine (page 210).

CAPTAIN, I HAVE
A VERY BAD FEELING
ABOUT THIS!

RELAX MR. SPOT
HAVEN'T YOU EVER
BEEN WHITE WATER
RIVER RAFTING, THIS
IS GOING TO BE FUN!

12. Splash

This is probably one of my favorite art words. "Splash" is so full of action with built-in humor. Obviously when you draw water falling over a canyon it will splash into a waterfall. When you draw a dinosaur jumping into a purple jelly lagoon, it will make a very big colorful splash. The action splash lines will usually radiate out from a central area, like the bottom edge of a waterfall. There are a lot of instances where you will be using the augmenting art accent "splash" without any hint of water in your picture. For example, tufts of grass growing along the base of tree roots, or hair puffing out on top of an elephant's head. Pictures to look at that use splash are Positive Poetry, the grass at the edge of the shoe (page 170); Viking Voyage, the water at the bow of the ship (page 211); I.Q. Icon, the hair on Einstein (page 123); and Fearless Floating Frogs, the leaves of the cattail plants in the water (page 95).

13. Spots

I draw "spots" on the surface of many objects and creatures to create a more interesting texture. Spots are fun to use, especially when you combine them with the other art accent grouping. Look how I put a small group of spots on the back of my Drooling Dragon (page 86). In nature you can see spots on leopards, giraffes, cats, Dalmatians, even freckles on your face! Spots are wonderful. I use groups of spots in many drawings. Take a look at the Tremendous Toad (page 198) and the Pirouetting Pandas (page 168). You'll notice the spots on the pandas are some of the most famous in nature, along with the spots on the Kissing Killers (page 134).

14. Stripes

At the dinner table tonight look around the room and see how many surfaces have stripes on them. Perhaps the glasses, dishes, napkins, or even your sister's shirt, your papa's tie, or the placemat under your dish. Stripes are a very popular texture artists use to create an aesthetically pleasing repeating pattern for your eye. Nature is an expert on striped zebras, seashells, birds, and fish. Check out where I have used this handy design art accent in my drawings of the Buzzing Beehive (page 69), Viking Voyage (page 211), eXpensive Xmas (page 224), Enthusiastic Environmentalist (page 92), and the Lunging Lizard (page 143). A single stripe is often handy to create a curving "contour" to a round object while adding a nice element of design. I used a single contour stripe in the drawing lesson Funky Flying Faucets (page 100), Maniac Mouse (page 147), Tube Tag (page 199), and Bat Bean (page 62).

Don't pin yourself down with negative thoughts.

15. Sunburst

The sunflower is a perfect example of the art accent "sunburst" at work in nature. When you draw an object radiating out from a single point you are creating a great visual effect to look at, an aesthetically pleasing design. Remember, when you are using these twenty-two augmenting art accents in your drawing, you are making your picture more delicious for your viewer's eye; you are creating a visual dessert to enjoy! Practice using sunbursts in the drawing lessons of the Knocking Knuckles (page 135); Ouch! (page 163); Early Egyptian, the sphinx head ornament (page 88); Woooo! (page 220); eXploding eXpression (page 225); Pencil Power, with the bursting action lines all lined up to one point in the drawing—can you figure out where that spot is? (page 167); and Zapping Zombies, where the foot pounds the pavement (page 236).

16. Symmetry

When you draw an object that has similar detail on either side of an object or picture, you are creating a "symmetrical" image. For example, let's say you have drawn a beautiful snowcapped mountain range. To create a nice symmetrical picture, you decide to draw a clear, cool lake at the base of the mountains. The lake reflects the rugged peaks like a mirror. You have used symmetry to aesthetically enhance your image. Let's try another example. How about you decide to sketch a car racing directly toward your viewer's eye. You will need to draw each side of the automobile identically to ensure symmetry in your drawing. Study how I have used symmetry in the following drawing lessons: The Crater Cave (page 79); the Colossal Castle (page 76); the Kazoo Kingdom (page 133); the Illuminating Idea (page 121); and Throg's Throne (page 197).

17. Taper

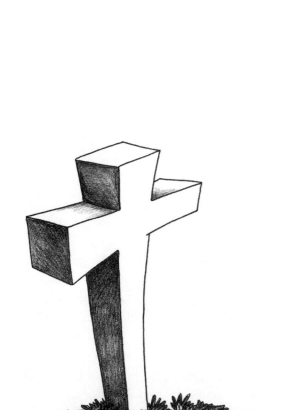

You will find "tapering" to be one of the most useful, fun, and visually pleasing of all the twenty-two augmenting art accents. Nearly every drawing lesson in this book uses tapering to add character, flow, and style to the picture. Look at your arm at the elbow; now look at how your arm gets narrower at your wrist. Your arm tapers from thick at the elbow to smaller at the wrist. The same goes for your leg. Look at your calf; notice how your leg tapers smaller to your ankle. Tapering is everywhere you look. Trees taper from thick trunks to smaller tops; animals' tails taper from thick to thin; even toothbrushes taper! In the picture of the religious symbol I've tapered the cross to use the Renaissance word "size" and tapering together to create an interesting effect. It's fun to mix the twelve Renaissance words together with the twenty-two augmenting art accents. You can really come up with some funky pictures that are aesthetically awesome! I use tapering to enhance the style in the drawing lesson of the Kayak Kid on page 132 (the kayak is tapered on both ends); the Vegetable Virtuoso on page 209 (the carrot is tapered from thick to thin in nature as well!); Banana Boy's body and especially his legs on page 62; and Neptune Ned's eye sockets (combine foreshortened tubes that taper down to the body) on page 154. In the drawing lesson Scary Snarl (page 191), I tapered the dog's ears, neck, teeth, and tongue. The sails in the Sailing Sloop (page 190), are tapered from a wide base to the fine-point top. Here's a quick challenge for you: Find ten more drawings in the book that use a lot of tapering. Find these ten drawings in less than two minutes—go!

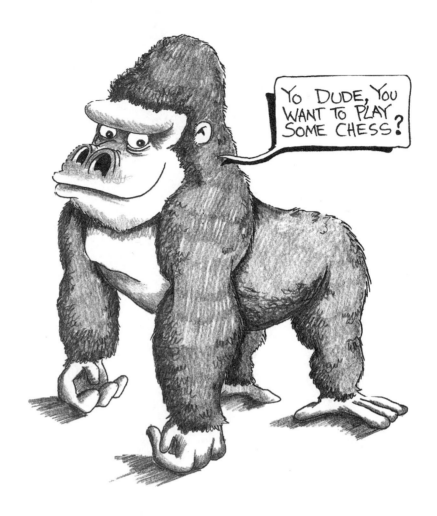

18. Texture

Picture in your mind the reflection of the sky off your front window. If you were to draw this reflection you would be drawing a smooth "texture" to the glass. Now look at the ground where you are sitting. Is the floor carpet, tile, or wood? Think of how you would draw this texture in a picture to help your viewer feel this floor with their eyes. Adding texture to an object is creating a visual sense of what the surface would feel like if you could reach in and touch it. The fur on the gorilla drawing above would feel different than the wooden surface of a chair. It's your job as the artist to express these different surfaces to your viewing audience. You be the judge of how well of a job I did in creating textures to describe the surface "feeling" of the objects in the following drawing lessons. Look at the Gnome's Home (page 107)—does the gnome look like it has fur, tree bark, or scraggly hair? Now check out the cloud in Jumping Jack (page 130)—does the cloud look soft and puffy? How about the cloud rings in Vrooom (page 213)? I really enjoyed the process of adding final texture to the Spectacular Spider on page 192. How would this spider feel if you could pet her? Can you find three different textures in Noisy Nest (page 157)? How about Nice Neanderthal (page 155)? Using texture really rocks! Rocks really use cool texture! You are doing a great job learning these twenty-two augmenting art accents. You've practiced eighteen of these powerful art techniques. Let's learn three more.

19. Tilt

You are sketching a super-peanut-buttered, powered flying saucer turning in orbit around the planet of Pastry, and you want to make it look like it is really jammin' across the galaxy. One very helpful art word to use is "tilt." By tilting the flying saucer you are creating the feeling of movement. Now all you need to add is some bonus action lines and you have an action-packed space scene. There we go again, combining some of the twelve Renaissance words with some of the twenty-two augmenting art accents. Combine these as much as possible in your renderings, and the combinations will have a powerful aesthetically pleasing impact on your eye. Tilt helps create the illusion of movement. Tilt can also add a little element of surprise, a little morsel of curiosity to your picture. For example, if you draw a group of people singing as in Quirky Choir (page 179), you can tilt a few of the people to create a rather odd gathering.

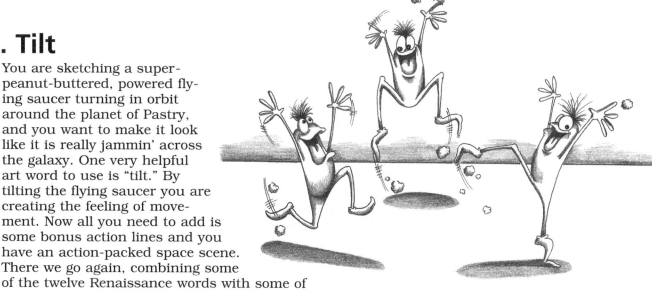

Here is a tilt challenge. Draw the eXpensive Xmas lesson (page 224). Try to tilt the package as much as possible while keeping the drawing in balance. Look at my use of tilt in the lessons Ha! Ha! Ha! (page 113), Jolly Tamales (page 127), and the Unicycling Unibear (page 202).

20. Twist

This is another great augmenting art accent that adds a lot of character and style to your drawings. When you draw the Vertical Vine lesson (page 210), you will want to twist the vine as it grows up your sketchbook page, rather than just draw a straight boring vine line. Twisting things makes them more fun to draw and more interesting to look at. In the drawing lesson Tongue Twister (page 198), I didn't want to draw just a boring normal tongue; I wanted a twisting, drooling, knotted tongue, you see? A much more interesting drawing, eh? Use twist when you draw tree roots and branches, flowing flags, flamboyant flowers, or even five furry ferrets fumbling frozen footballs!

21. Value

Yes, I am well aware that your drawings have a tremendous value of over a million dollars. And yes, I am also aware that you are the most valuable human living in this hemisphere. However, this is a different kind of "value" that I'm talking about here. The augmenting art word "value" refers to the shade or tone of the texture you have drawn on a particular object. If you draw a robot carrying a large box of hot dogs on the surface of Mars, you can use value to help separate those objects from each other. The hot dog box needs to have a lighter or darker value than the robot. The robot needs to be drawn lighter or darker than the surface of Mars to separate the two images. In the drawing lesson Gracious God (page 109), I used a darker value on God's hands than on the planet Earth. By using a different value I helped create the illusion that the hands are separate objects from the planet. In the lesson Vrooom (page 213), I used a darker value to make the jet stream appear inside and separate from the puffy cloud rings. You can also overwork value, which can cause your viewer a bit of visual confusion, such as those three-dimensional computer posters, or my lesson Crater Cave (page 79). It's hard to distinguish the craters from the stalactites because I was having so much fun blending the shading with my paper stump that I created a consistent value for the entire picture, rather than contrasting values to pull the images apart from each other.

22. Variety

Variety is the spice of life. I wonder who first said this famous cliché. It's a wonderfully descriptive mantra to repeat when you are drawing a picture of the city of marshmallows carved into the side of Mount Twinkie. If you ate the same pancake, with the same syrup, on the same plate, with the same fork every single morning for breakfast for an entire year, you would probably be very happy to see a box of Cheerios. The same goes for your drawings. Instead of drawing the same tree over and over again to create a forest, use "variety" to make some trees tall, some trees short, some fat, some tiny, some knarly and twisty, and some spindly. In the drawing lesson Rubbish Reconnaissance (page 186), I've drawn a heap of garbage using variety. I've drawn some square objects, some round objects, some squished objects, and some full objects. I wanted to use various shapes to create a messy-looking pile. Look at how I have used a lot of variety in the Radical Road (page 183), the Spectacular Spider (page 192), and especially the Kooky Keyhole (page 136). You have noticed that many of the definitions of these twenty-two augmenting art accents refer to the same illustrations in the book, over and over again. This is because a successful aesthetically pleasing picture will harness the power of several of these art terms at the same time. If you look even closer at the pictures that I refer you to many times, you will notice that several art accents are combined with several Renaissance words of three-dimensional drawing. By the time you finish this book you will be the supreme expert at combining the twenty-two augmenting art accents with the twelve Renaissance words of drawing!

The Art Chart!

22 Augmenting Art Accents

Use these with the twelve Renaissance words to draw powerful eye-catching 3-D masterpieces.

1. Balance
Equalize your drawing.

2. Color
Enhance, identify, and enlighten your drawing. A little bit of color goes a long way.

3. Grouping
Avoid "clutter," draw objects in "families."

4. Natural Design
Nature is the best design teacher.

5. Plaid and Checkers
Draw patterns on blank surfaces for visual effect.

6. Proportion
Identify the size relationship of objects.

7. Repetition
Repeating patterns are pleasing to the eye.

8. S Curve
Flowing lines add style to your picture.

9. Silhouette
Separate and identify distance of objects with bold dark shapes.

10. Skewed Curve
Curve some lines more at one end than the other.

11. Spiral
Patterns create rhythm in your picture.

12. Splash
Add action and movement lines away from one source.

13. Spots

Surface patterns identify objects while adding more character.

14. Stripes

Vertical, horizontal, or diagonal lines repeating a pattern.

15. Sunburst

Lines, colors, or patterns radiating from a central point.

16. Symmetry

Similar shapes drawn on opposing sides of a picture for balance and effect.

17. Taper

Lines or objects that are wide at one side and narrow at the other.

18. Texture

Patterns creating a visual feeling for the surface of an object.

19. Tilt

Leaning an object to add character and effect.

20. Twist

Bending or knotting an object to add interesting character.

21. Value

Adding different tones of color or shading for contrast.

22. Variety

Creative changes in repeated objects or patterns for a visually pleasing aesthetic effect.

Augmenting art accents equal delicious visual treats for your eyes!

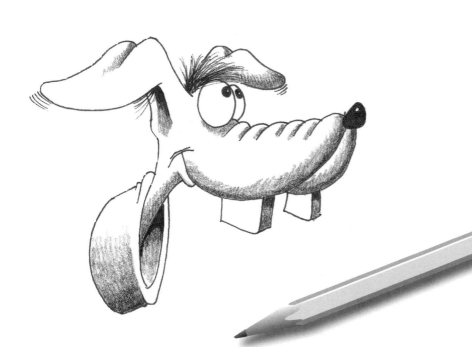

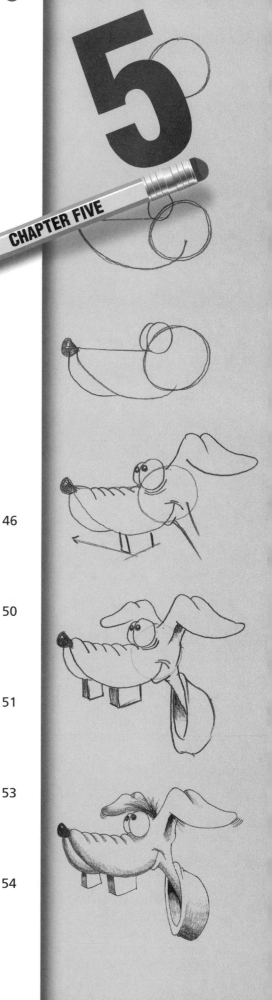

Dynamic Drawing Directory

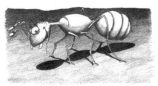

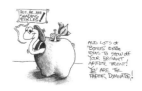

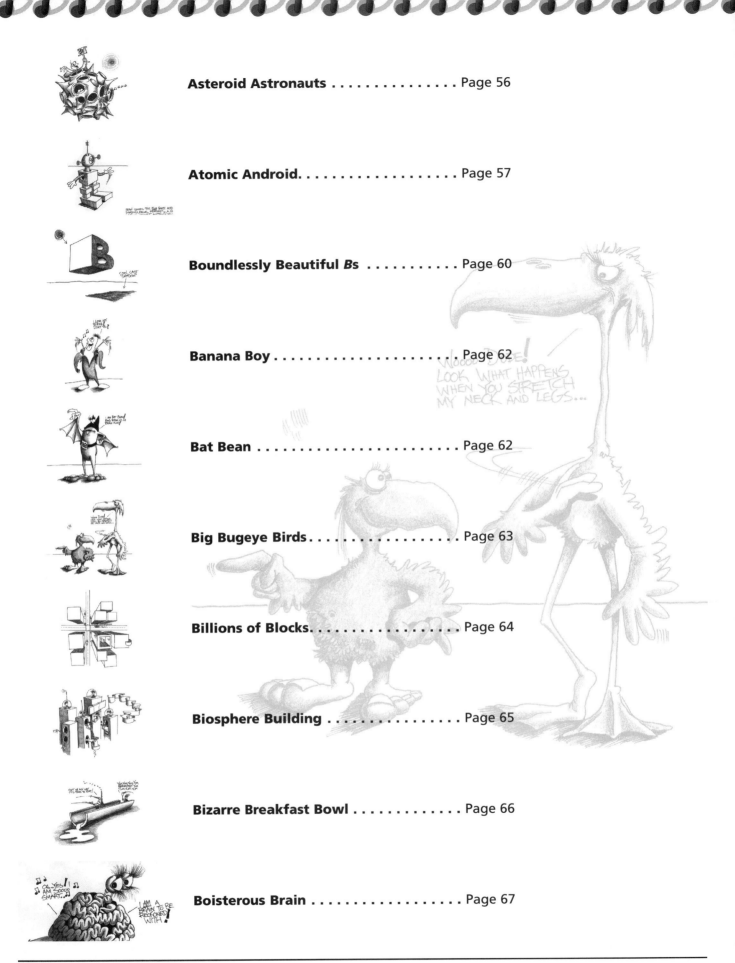

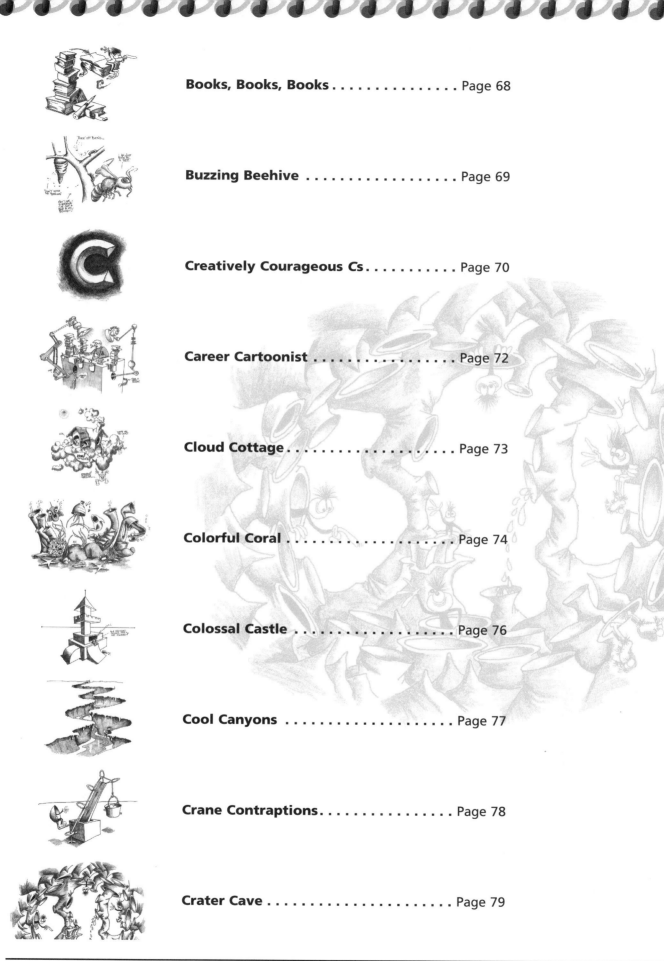

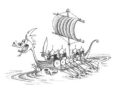
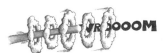

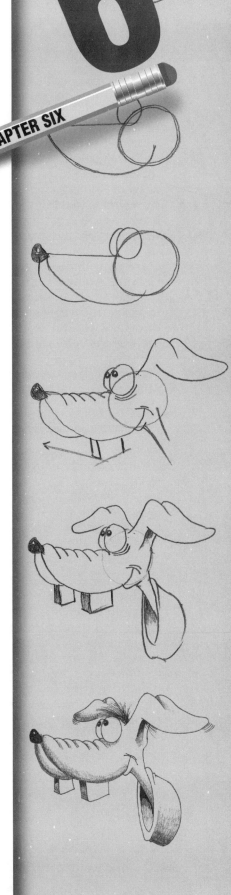

Drawing Lessons *A* to *Z*

Introduction to 3-D Lettering Styles

Drawing letters of the alphabet in three dimensions is a very cool thing to do. You can draw your name on your lunch bag or your friend's name on his book report or even create a title page for the great storybook you are going to be publishing. Let's learn how to draw the alphabet in five different 3-D "style types." Remember, just about all of the important "learning text" is written in these first few drawing lessons of chapters 3 and 4 (pages 9 through 24). Pay close attention to each of the Renaissance words that I introduce and practice drawing in 3-D nineteen hours each day. I will also be introducing several of the twenty-two augmenting art accents with each of these first few drawing lessons. If you haven't read the descriptive chapters about the twelve Renaissance words and the twenty-two augmenting art accents, you need to look at those pages now and learn these very important words. The easy reference charts follow the word descriptions on pages 10 and 25. You can duplicate these charts on a copy machine and tape them to the wall near your drawing desk. With the word charts handy you are now ready to relax like the paper dominator that you are. Let your pencil power pour across your paper, yeeehaw!

Cloud Texture Style

1.– 3. Let's draw a 3-D letter *A*, making it appear to be floating in the sky like a puffy cloud. You could draw a supersonic jet soaring across the sky creating these 3-D puff letters in its wake! How cool, 3-D puffy cloud skywriting! Begin by "blocking" in the letter. Blocking is a very important idea to understand. Blocking in a shape completely before you begin to add dark detail helps you figure out where things will fit into your picture and how to size objects for the correct proportion. Blocking is so important that I almost added it as the thirteenth Renaissance word of 3-D drawing. Artists through the centuries have used blocking as an initial step in their picture creating process. I used blocking with every single drawing in this book. If you block the object in lightly, you won't need to erase your lines during your final picture cleanup. Many illustrators and animators use nonreproducing blue and green pencils or pens to block in their drawings. This way their final drawings will not require any eraser cleanup at all. The initial blocking nonreproducing pencil lines will disappear during the duplicating photo scanning process. I explain nonreproducing blue in more detail on page 245.

4. Great job! You have successfully blocked in the structure of an *A*. Now let's begin to add the puffy texture.

5. Think of puffy cotton balls. Make sure the lines inside the hole curve in. Think of a whole line of fast quick *W*s. For the outside line think of a series of fast quick *M*s. This repeated pattern of curves makes use of the art accent word "repetition." Repetition makes the drawing more visually appealing, more aesthetically pleasing.

6. Use circular scribble lines to add more puffy texture. Concentrate your scribbling on the left side and watch the 3-D shading give your *A* shape and depth. Natural design, a very helpful augmenting art accent, is used in this scribbling process. Figure out how natural design fits into this drawing. Other augmenting art accents to include in your sketchbook while drawing the puffy letter *A* are: symmetry, taper, texture, value, and variety.

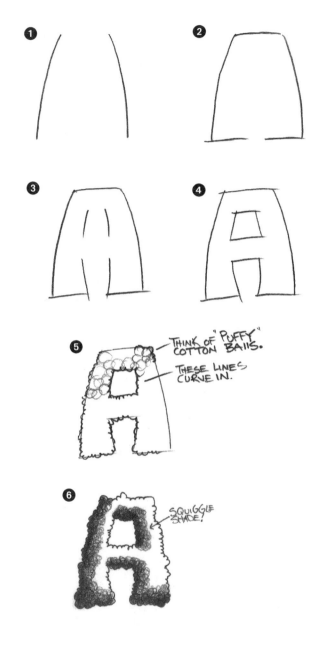

THINK OF "PUFFY" COTTON BALLS.

THESE LINES CURVE IN.

SQUIGGLE SHADE!

Peeling 3-D Shadow Style

This is a really nifty 3-D lettering technique I learned from my master cartooning teacher, Bruce McIntyre. He was a Walt Disney animator in the 1940s and was my art teacher for nearly a decade in the 1970s. Bruce used shadow lettering often during his career at Disney Studios.

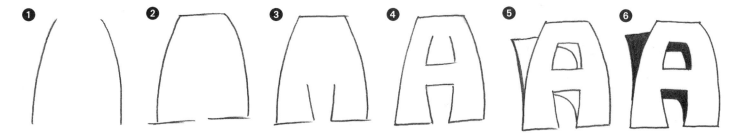

1.– 4. I always begin a drawing by blocking it in.

5. Use the same base structure you created in steps 1 through 5 of the puff cloud texture. This time let's peel a shadow away from the edge. Darken in the shadow to see your neato letter *A* pop off the flat surface of your piece of paper in three dimensions! Once again you have success-fully created the optical illusion that an object is really existing on that flat piece of paper. Good work! Draw the names of your family in this 3-D peeling shadow style on folded pieces of paper. Put these creative name cards around the dinner table tonight. Talking about getting the conversation jump-started at dinner. Surprise your family with your finely tuned drawing in 3-D skill!

Chiseled-Stone Style

This is one of my favorite 3-D lettering techniques because of the black contrast background we tone in. Chiseled letters look great on book covers and reports. Chiseling is easy and it looks so cool when completed.

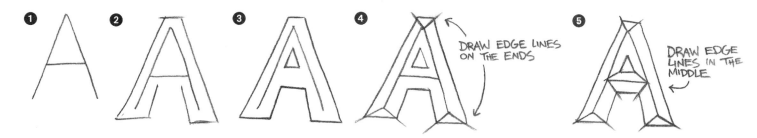

1. Begin blocking your basic wide letter *A*. Use the art accent taper to slant the sides.

2. Outline your letter.

3. Add the hole.

4.– 5. Draw the edge lines shooting off the center *A* to the outside. This creates your sloping surface.

6. Determine where the light source is coming from and shade all the surfaces facing opposite that direction. Use your finger or a paper stump to smooth the shading. This will give the surface of your chiseled letter the look of marble or metal. Creating a surface texture on your chiseled letter *A* helps you learn the art accents natural design, symmetry, and value.

7. Now for the really fun part. Use the art accents value, texture, and balance to add a very dark background to create a ground beneath your chiseled 3-D letter *A*. Your drawing looks very cool, eh? Try this art activity. Draw your aunt's and uncle's names in 3-D chiseled style on an envelope. Write them a fantastic letter filled with your brilliant 3-D illustrations, mail the letter, and feel totally cool that your artwork is now being distributed via the United States mail!

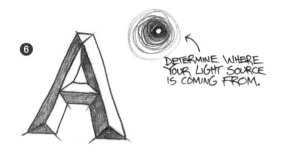

DETERMINE WHERE YOUR LIGHT SOURCE IS COMING FROM.

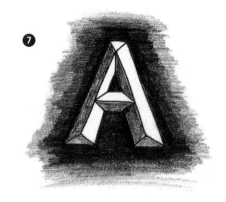

Super 3-D Style

I've always loved the 3-D lettering that Marvel comics used in their *Superman* titles. Let's learn how to draw letters zooming across the sky. First we will learn one letter at a time. Later on we will create words and sentences by using alignment.

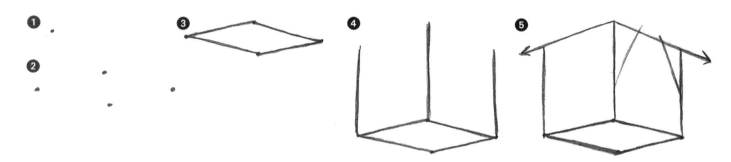

1. We will need a 3-D box to begin. This box must be foreshortened and drawn from a point of view from below. This first foreshortened square is very important. Throughout your drawing in 3-D journey with me in this book you will be drawing over two thousand of these foreshortened squares.

2. Make certain you draw these two dots close together in the middle.

3. Connect the dots to create a perfect foreshortened square. This is definitely the most important shape for you to learn when you are beginning your drawing lessons. These foreshortened squares are so important in fact, I'm going to stop the lesson for a pencil power practice pause.

Turn to your workbook (page 30). Draw eight foreshortened squares in the space provided. If you don't have a workbook, draw eight foreshortened squares on a blank page in your sketchpad.

4. Draw the middle line longer, using the Renaissance word "size," near edges that are drawn larger to create the illusion that it is closer to your eye.

5. Use the Renaissance word "size" again to connect the top of the box by slanting the sides away; the back edge is smaller than the front corner line. Begin blocking in the letter *A* on the side of your foreshortened cube. Think of this like chiseling with a mallet, small strokes at first . . .

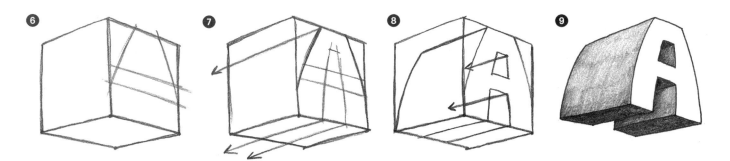

6. . . . bigger hammer strokes now to chip away the excess stone. Use guidelines to help you block in more detail of the letter *A*.

7. You see how much I depend on guidelines to keep my lines angled away in the same direction. Guiding blocking will become second nature to you as you begin practicing your drawing nineteen hours every day.

8. Complete the shape of your floating super 3-D letter *A*. The back line needs to sloop at the same angle as the front. Use lines you have already drawn as guide edges to follow. Guidelines, guidelines, guidelines—are you getting sick of me saying that yet? Just think, this is only the fourth drawing of hundreds, and you are going to hear me say "guidelines" and "alignment" a million more times before the end of the book.

9. Voilà! A wonderful, beautiful, splendid, exquisite, fantastic, floating, super 3-D letter *A*. I added the horizon line and the shadow below the block to create the floating illusion. Let's determine

how many of the twelve Renaissance words we have used in this single drawing lesson: "foreshortening" for the box shape; "size" to make the near edge of the letter look closer; "shading" to push the sides away from our imaginary light source; "horizon" to establish where the surface of the planet is creating a reference point for your eye; and finally "shadow" to give the entire object a "hovering" over the ground appearance. A very good start indeed! Our fourth drawing lesson and we are already mastering nearly half of the twelve Renaissance words. Remember, these twelve words have been around for over five hundred years. These words have lasted through the centuries because they really are powerful for anyone willing to learn them.

Along with these powerful Renaissance words we have also used many of the twenty-two augmenting art accents. Can you pick out these words while drawing the super 3-D letter *A* in your workbook on page 30—taper, value, balance, symmetry, tilt?

Block 3-D Style

This lettering style is probably the most requested type of letter to learn how to draw. Once you learn this letter *A* in block style, you will be able to easily draw the entire alphabet in 3-D block style. Once again, pay close attention to that first foreshortened square. When you draw this foreshortened square you are laying the groundwork for your entire drawing. If this first foreshortened square is crooked, your entire drawing will look like it's falling over.

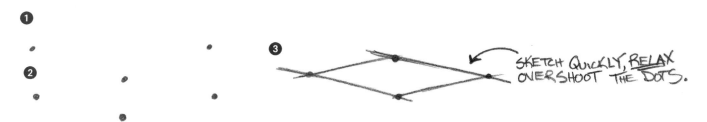

SKETCH QUICKLY, RELAX OVERSHOOT THE DOTS.

1.– 3. Before you draw any further, draw five foreshortened squares in your workbook on page 31. Remember, my goal is to get you to practice at

least two thousand of these before you finish this book.

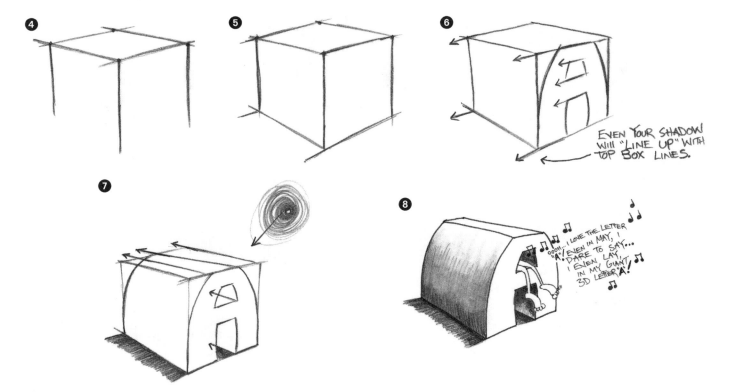

EVEN YOUR SHADOW
WILL "LINE UP" WITH
TOP BOX LINES.

OOOH... I LOVE THE LETTER
"A" EVEN IN MAY, I
DARE TO SAY...
I EVEN LAY,
IN MY GIANT,
3D LETTER "A"!

4.– 6. Guidelines, guidelines, guidelines!

7. Determine which direction you want your imaginary sun to be coming from. Use the bottom lines of the letter *A* to keep your shadow lines lined up. This will make your shadow appear to be cast onto the ground next to the object.

8. My favorite part of the drawing is the bonus stage—adding lots of really nifty little extras to make the drawing look uniquely brilliant. This is where you let your creativity pour out of your pencil-powered imagination! Try this drawing challenge. Sketch your 3-D letter *A* in a zoo of all letter-*A* animals, such as an Aardvark with a block 3-D letter *A* as a house or an alligator with a block 3-D letter *A* between its teeth, or you can even draw the letter on a giant anthill with ants crawling all over it, kind of a New York ant metropolis. Another cool block 3-D lettering challenge is to stack block letters spelling out your name. You can draw just about anything with block 3-D letters! You are a paper dominator!

Amazing Ants

1. Even the most complicated detailed sketches begin with a single shape. Start this cool complex insect with a simple circle.

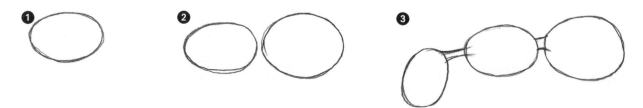

2. – 3. Add some more shaped blocking in the body. The head tilts, the thorax and abdomen are lined up.

4. Overlap the eyes and use size by making the farther eye smaller; this will make it appear deeper in the drawing. Use contour to draw a curving smile; this will give the face some volume. Add more contour lines to the abdomen. Draw a guideline under the ant to block in where the ground shadow will fall.

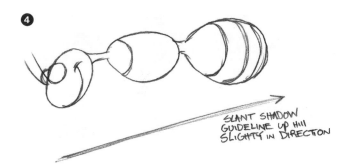

SLANT SHADOW GUIDELINE UP HILL SLIGHTY IN DIRECTION

5. To add expression, draw more contour lines under the eyes. Draw the antennae using size. The near antenna is drawn larger making it appear closer than the smaller one. Size is also used on the mandibles (teeth) and the legs. I want the near legs to look closer, so I draw them larger.

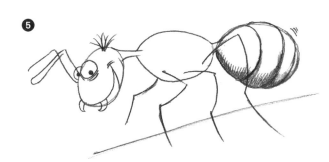

6. Cast shadows are cool to add to the ground underneath your ant. Draw this shadow very dark. The contrast between the dark cast shadow and the lighter foreground will really make your amazing ant pop off the paper in 3-D! After I add the horizon line, I used the side of my 2B pencil (soft lead) to tone the ground behind the ant. This is adding even more contrast to the drawing, more contrast to pop the ant up and out of the page. To blend the background tone I used my favorite shading tool, a paper stump. If you do not have a paper stump yet, you really should go get one; they are very helpful and really fun to use. They cost around $.50 each. Let's take a look at where we have used a few of the twenty-two augmenting art accents to enhance the visual appeal of our 3-D ant sketch. Balance is used to position the ant toward the center of the paper. If you decide to position your ant to the right or the left you might want to add an ant hill to balance the composition. By drawing the hair different lengths on the ant's forelegs we have used variety. Other art accents to look for: value, texture, repetition, proportion, and stripes.

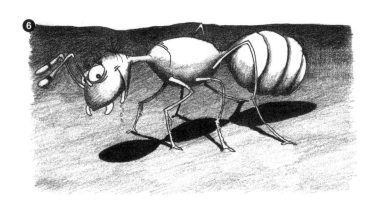

Ant Man

After drawing the complex, more anatomically realistic ant, let's loosen up a bit and draw a cartoonish 3-D ant. Learning to draw objects in different styles will help build your sketching confidence. When I say practice drawing in different styles, I mean cartooning style, realistic style, mechanical style, loose sketchy style, etc. Notice how I've used the twelve Renaissance words of 3-D drawing in this cartoon ant, just as I did in the complex ant drawing. The twelve Renaissance words of 3-D drawing are completely transferable information. No matter what style you decide to draw in or what object you want to draw, you are forced to use a combination of these Renaissance words to make your sketch look three dimensional. There is just no way around these basic words. They are what I call "fundamental elements" of drawing. For example, you can break down a drop of water into smaller, more basic components called "molecules" of H_2O. You can break these molecules down into

even more fundamental components, called "atoms" of hydrogen and oxygen. The twelve Renaissance words are the atoms of drawing. You must combine these to create 3-D molecules of drawing like this very cool cartoon ant man!

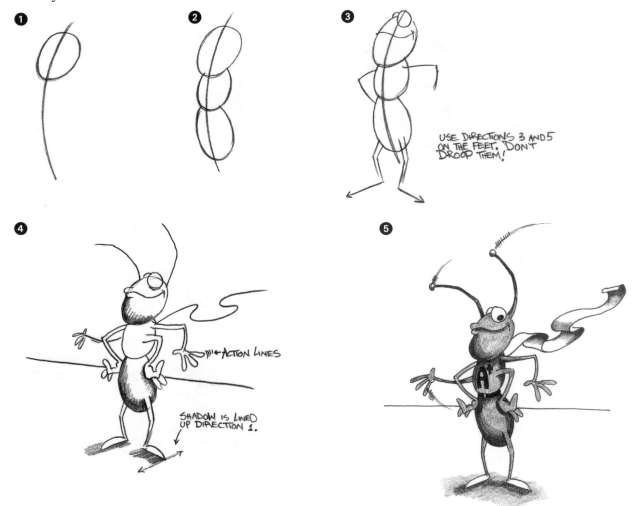

1. Start with a nice swooping guideline.

2. Block in the head, thorax, and abdomen.

3. Blocking is used a lot in all beginning steps of creating a sketch because it helps you figure out where everything is going to fit in a very quick general way. Block in where you want the cartoon ant man's feet, legs, arms, even the smile. Slant the feet slightly downhill; you want to avoid straight-across lines except when drawing horizon lines.

4. Now is a good time to add the horizon line, and to decide which direction you want your imaginary light source to come from. Use contour lines to curve a nice confident grin on ant man's face. Use size to draw the near antenna larger; this will make it appear closer to your eye. When you begin shading your ant, keep the darkness consistently on the opposite side away from your light source. If you shade the belly on the left and the thorax on the right, your ant will look

very peculiar, like it has a flashlight on its belly button. Add the cast shadow on the ground next to the ant foot. Keep this shadow almost horizontal across your paper. Most beginning students want to droop this shadow straight down. Resist this temptation because it will make your ant man look like it's slipping on an ice puddle—ooooops! I broke my antenna!

5. Oh my, oh my! I love this next step; it's time to add bonus ideas. Yeehaw, time to have some fun! Let's transform into paper dominators! I'm going to add a cape flapping in the wind, some action lines on his waving hands, a cool symbol of success on his chest, and even a very fashionable belt suitable for this superhero of the insect population!

How many augmenting art accents did I use in this lesson? Did you notice S curve on the grin line? How about more S curves on the flowing cape? Look for value, symmetry, balance, variety; perhaps you've even decided to add color.

Apple Appetite

I've been called a bookworm my entire life. The only activity I enjoy as much as drawing is reading. Often, my brothers and I will argue over who gets to borrow one another's books first. My entire family loves to read; we treasure books more than money. When I read a good book, it's like having an animated 3-D adventure in my brain. Books are wonderful movies in my imagination! Mind movies that last over a week! Let's all read at least two hours a day, transforming ourselves into paper-dominating, 3-D drawing, book-reading, creative-genius-thinking animals!

START VERY LOOSE AND SKETCHY, RELAX YOUR HAND! LET YOUR ART ATTACK FLOW FORTH FROM YOUR FINGERS...

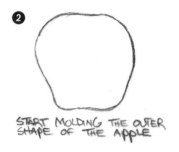

START MOLDING THE OUTER SHAPE OF THE APPLE

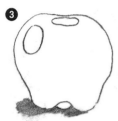

BEGIN THE SHADOW, ADD THE HOLES. THIS IS USING "FORESHORTENING," A VERY IMPORTANT WORD... INDEED!

1. Block in the apple shape.

2. Shape the circle more.

3. Add foreshortened circles and a cast shadow tossed onto the ground next to the apple. I've drawn the shadow off to the left, so which direction is my imaginary light source coming from?

4. Block in the worm's head and body sticking out of the foreshortened circles. I've added thickness to the holes. The thickness on the top hole is on the top; the thickness on the left hole is on the left. Where would the thickness be on a hole if I drew it on the right side?

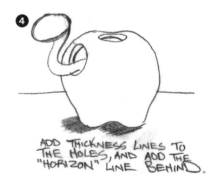

ADD THICKNESS LINES TO THE HOLES, AND ADD THE "HORIZON" LINE BEHIND.

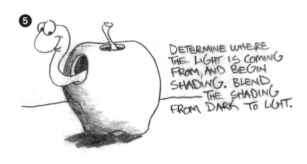

DETERMINE WHERE THE LIGHT IS COMING FROM, AND BEGIN SHADING. BLEND THE SHADING FROM DARK TO LIGHT.

5. Overlap the eyes, making the near eye larger using size. Contour wrinkles below the curving smile add a nice character quality to your cute little adorable worm, ick! Now, use horizon to create the background line. Determine where you want the light source. For this apple let's pretend the light is coming from the top right hand area. We need to blend the shading from very dark on the right side of the apple, to very light as it curves toward our light source. This is a perfect drawing to practice using your paper stump for

creating a perfect blended tone. Practice drawing at least three of these in your companion drawing workbook.

6. It's fun Bonus time! Add a stem, leaves, even a lid on the worm's hole. Add any neat little ideas to make this drawing your own very unique, very brilliant creation. I've added a little cartoon balloon for the worm to speak. What will you make your worm saying? Hey, about adding action lines all around the worm, it's a California worm quake! Why stop there? You can add a tall top

hat on Alfred the worm, or some eyelashes, or perhaps a big door on the right side of the apple with a chimney sticking out the roof! Go crazy with your imagination, show off your brilliant creative artistic talent. I often like to write a story, poem, or even a catchy alliteration to fit with my drawing. My big brother Steve is the king of alliterations in my family. He whipped this alliteration out in about twenty seconds: "Alfred's apple appetite actually amazed Amy!"

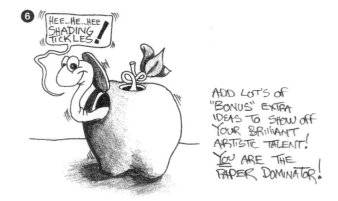

Why don't you try writing your own alliteration in the workbook on page 33. I've used a few augmenting art accents in this picture. Can you point out two of them?

Ascending Achievement

You are an amazing bubble of potential! Every time you pick up your pencil to draw in 3-D you are displaying your genius creativity for all the world to see. Your drawings are a unique way to share your dreams with the planet. At the end of each one of my public television episodes of *Mark Kistler's Imagination Station*, I say, "Dream it, draw it, do it!" The three Ds of a successful life. This drawing lesson is very symbolic of how your life is going to progress from one level of achievement to another. When I think of you sitting there drawing at your kitchen table in your 3-D workbook, I can't help but see you a few years down the line sitting at an enormous engineer's drafting table. I see you busy designing the world's strongest, longest, and most beautiful bridge. I see you drawing the 3-D designs to build NASA's new space station in orbit around Mars. I see you drawing the animated details in a new globally popular CD-ROM game! You are going to live such an exciting life, so full of adventures and challenges. Use your amazing talent to draw your dreams daily in 3-D! Dream it, draw it, do it! Be a dynamic dream dominator determining your delightful destiny! Hey, another clever alliteration . . . now you write one about your dreams on workbook page 33.

1 **2** **3**

1. By now you have practiced drawing over thirty foreshortened squares, correct? In your workbook, follow steps one through three and draw ten more in the practice space on page 33. Foreshortened squares will make or break your 3-D drawing. Let's draw a perfect foreshortened square together. Start with two dots rather far apart.

2. Place your finger in the middle and carefully place a dot above and below your finger so it looks like my drawing step two with dots far apart and two close in the middle.

3. Complete the foreshortened square. Before continuing this lesson, practice ten more in your workbook.

4. We will use the Renaissance words "placement" and "size" in this step. In order to create the illusion of depth with this top step, you need to draw the near line longer to make that corner pull toward your eye. The two shorter side lines will be pushed away from your eye. Pretty cool optical illusion, eh? I told you drawing in 3-D is fun!

5. Now you have to be extremely careful not to let your next step levels "droop" down. Use guidelines matching the lines from your top foreshortened square to line up the next steps. Again and again you will see me using the very first foreshortened square as my blueprint for the guideline angles for the entire drawing lesson to follow.

6. Renaissance word alert! We need placement and size again. Near corners are drawn larger and lower on the paper.

7. Guidelines, guidelines, guidelines, guidelines. . . hmm, Mark must think guidelines are pretty darn important to be pounding them so hard into my subconscious!

8. Here's a tip to help you keep your vertical lines going straight up and down in a complex structure like this one. Each time you draw a vertical line check its angle against the very first one you marked. If the picture is getting so big and detailed that you are a long way away from that first vertical line, check your verticals with the edge of the paper. They should match, going straight up and down. If your vertical lines match the vertical sides of your drawing paper, you have drawn parallel lines.

9. Even the cast shadow on the ground is lined up with guidelines from the bottom of the structure. I continued using the bottom edges as guidelines for the shadows on each step layer.

10. Let your wild artistic animal inside roar! Add bonus ideas galore. Add doors, windows, pipes, tubes, ladders, little character dudes running around, and more! Check out a Martin Hanford book in his *Where's Waldo* series to get inspired by a true bonus master at work. Martin Hanford is the king of bonuses. Here's your creative challenge for today. Study a one-inch square of a Martin Hanford illustration in a *Where's Waldo* book. Copy that one-inch square on a larger scale in your workbook on page 33. Copying master artists to learn drawing skill is a three-thousand-year-old "apprentice" tradition. After you finish this challenge go on to the next drawing lesson. Will you notice any change in your confidence level? You bet you will! You're on fire! Turn the page, sharpen that pencil, let's draw some more, yeah...

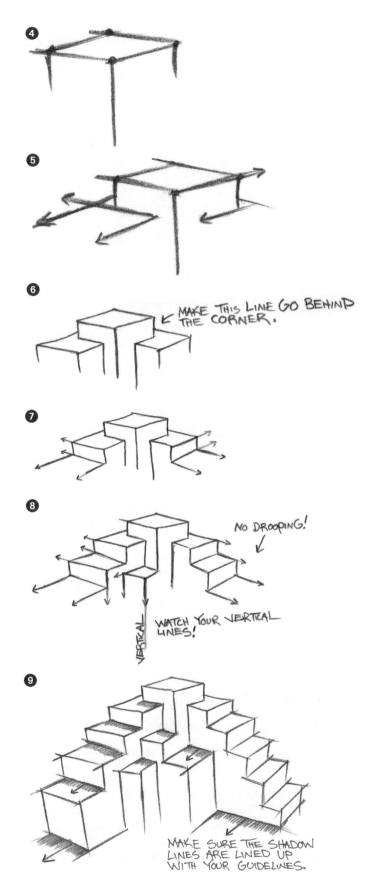

❹

❺

❻ ← MAKE THIS LINE GO BEHIND THE CORNER.

❼

❽ NO DROOPING!
VERTICAL WATCH YOUR VERTICAL LINES!

❾ MAKE SURE THE SHADOW LINES ARE LINED UP WITH YOUR GUIDELINES.

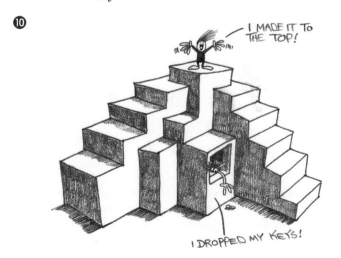

❿ I MADE IT TO THE TOP!
I DROPPED MY KEYS!

Asteroid Astronauts

My favorite theme to draw is space. There is just such a plethora of stuff to draw when you think of space. From stars, planets, moon, ships, asteroids, orbiting stations, green funky slimy cosmic comets, and aliens to clouds in the high stratosphere. Space gets my imagination reeling. What theme really turns your brain into high gear? Perhaps it's an "under the oceans" theme, or maybe it's "jungle jubilee" with monkeys, panthers, trees, and parrots. How about a time-traveling theme to ancient Egypt? With that pencil in your hand you can literally explore any planet, ocean, or time period that your mind can conjure up. Feeling a little brain-locked when you sit down to a blank piece of paper? Experiencing a bit of the "Oh no, blank paper, what should I draw!?" anxiety attack? Believe it or not, I still have days when I suffer an imagination brain-lock. Sometimes it just hits out of nowhere, catching me sitting at my drawing table looking baffled. "I can't think of anything to draw!" If this ever happens to you, I have the cure-all solution. Create a theme index card file. Get a stack of index cards. On the front of one write "space" and on the back list the first five things that come to your mind about space. Now try an index card for "ancient Rome" and on the back write Colosseum, chariots, funny sandals and togas, ivy behind the ear, scrolls, etc... get the idea. Carry these cards with you on trips and add more themes everyday. Waiting at the barbershop for your little brother to finish his haircut, make up a new theme card. You can really go crazy with this and do an "object" card behind the theme card. For example, my theme card for "space" has "asteroid" listed as one of the thirty-four objects scribbled on the back. I've taken another blank index card and written "asteroid" on the front; on the flip side I've listed ideas of neat things to add to the "asteroid," such as craters, mountains, creatures, caves, secret cities, bridges, soap bubbles, etc. Now I have an object card. Once you create a thick file of theme and object index cards you will never experience an imagination brain-lock that lasts more than forty seconds for the rest of your long happy life.

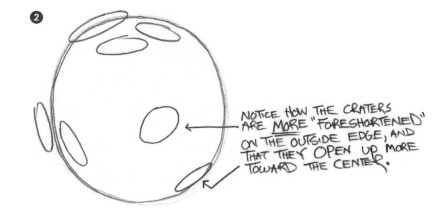

NOTICE HOW THE CRATERS ARE MORE "FORESHORTENED" ON THE OUTSIDE EDGE, AND THAT THEY OPEN UP MORE TOWARD THE CENTER.

1. Relax, loosely grip your pencil and flow a circular shape lightly. Be sketchy, be loose. This is just the blocking stage so don't fret over exact proportions.

2. Notice how the craters are more foreshortened on the outside of the asteroid, and that they open up toward the center. This is because of the positioning. Your point of view allows you to see into the open, round craters in the middle, while the craters on the edge are farther away from your eye; therefore they are more foreshortened. You see? These Renaissance words really do work!

3. You can add as many foreshortened craters as you like.

4. I'm going to completely fill up the asteroid with craters and mountains. If you add a small rim around the foreshortened crater mouth, then slant down the sides, you create a very solid 3-D lip. I've darkened the interior of my craters to give the illusion of a deep cave. Overlapping the mounds will push the craters on the edge back even farther away from your eye, creating more depth. Depth is the third dimension. Do you remember what the other two dimensions are?

5. Pay close attention to how I have rotated the thickness of each crater lip as it rotates around the surface of the asteroid. This is a wonderful drawing exercise to practice thickness. Here's a rule of thumb (Where in the world did "rule of

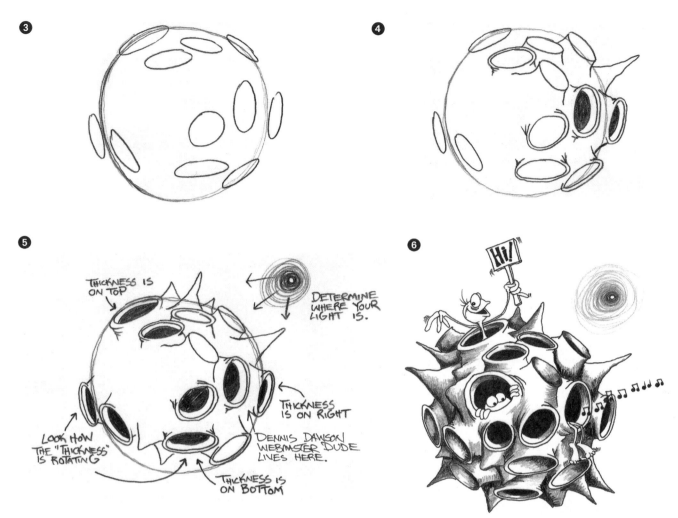

③

④

⑤

THICKNESS IS
ON TOP

DETERMINE
WHERE YOUR
LIGHT IS.

THICKNESS
IS ON RIGHT

DENNIS DAWSON
WEBMASTER DUDE
LIVES HERE.

LOOK HOW
THE "THICKNESS"
IS ROTATING

THICKNESS IS
ON BOTTOM

⑥

Hi!

thumb" come from? When did thumbs rule the world?) I used to remember where to properly place my thickness lines. If your crater is on the top, the thickness is on the top. If your crater is on the right, your thickness is on the right. If your crater (or window, or doorway, or opening) is on the left, your thickness is on the left. If your crater is on the bottom, your thickness line should be drawn on the bottom.

6. Before you go any further you need to decide where your imaginary light source will be placed. For your 3-D illustration to look believable, you need to be consistent with what side you shade throughout the entire picture. (A good creative

challenge for you is listed on page 34 in your *Drawing in 3-D* workbook.) Use foreshortening, overlapping, placement, contour, shading, shadow, bonus, attitude, practice, and size. Try to sharpen up your picture with the augmenting art accents repetition, contrasting values, variety, natural design, spots, grouping, balance, symmetry, silhouette, taper, texture, and tilt. Check this out: In one simple 3-D cartoon of a space asteroid we have used eleven of the twelve Renaissance words, and at least twelve of the augmenting art accents! These words mean power to your pencil! These words mean power for your ability to draw clearly what you picture in your brilliant imagination.

Atomic Android

It's time to practice foreshortened squares again! Since this is the most important Renaissance word you will be learning in this drawing, I want you to turn to page 35 in your workbook and practice sketching fifteen foreshortened squares in the empty space. Follow steps one through three very carefully. After a few more days of drawing, you will be able to whip these foreshortened squares out in your sleep.

1. Place two dots far apart. Sketch your picture larger than mine appears in this book. You have a lot of wonderful space in your sketchbook— let's fill it up!

2. Place your finger in the middle and draw dots above and below. Now you have two dots far apart, and two dots close together in the middle. These first few dots are very important in determining the proper alignment for the entire picture. If these first dots are a bit lopsided, then your entire drawing will appear to be falling over or melting in a microwave oven, yikes! Be careful with the positioning of these first few dots.

3. Connect the dots to complete the foreshortened square. This is one of the most useful shapes of all time. From this simple beginning you can draw huge architectural skyscrapers, a cruise ship navigating the Pacific Ocean, a jumbo space shuttle, or even an Atomic Android!

4. Make sure you draw the middle line longer. Aha!, another Renaissance word. This one is called "placement." Near objects are drawn lower on the paper. To make the box edge look closer to your eye, draw the near line a little longer.

5. Connect the bottom of the box; this creates your Atomic Android's torso. Now extend the near leg, once again making the near line longer. Since we tucked the leg under the torso, we are now using the Renaissance word "overlapping." We also need to use "size"; the near leg is drawn larger, the far leg is drawn smaller. We want to mix all of these Renaissance words together in a clear, detailed 3-D rendering. All the Renaissance words fit together to form objects with depth in your picture. Did you notice how I offset the middle line of the near leg just off the middle line of the torso? This creates a nice "edge" and adds a bit more character.

6. Relax your hand; be loose and sketchy. Add guidelines for the bottom of the legs. These guidelines will also assist your lines for the big boxy feet.

7. Guess what? More guidelines! Use the lines you have drawn above to guide these new lines. Now you can see why that first foreshortened square is so very important. Just about every line after that first foreshortened square is lined up with it, from the Android's head, all the way down to the Android's feet. If the angles you have drawn on that first foreshortened square are too steep, the angles for the entire drawing will be thrown way off. Awkward first angles on that beginning foreshortened square could result in your Atomic Android looking like it is getting sucked into a deep magnetic time warp, aaaaaaagh!

❶ PLACE TWO DOTS FAR APART.

❷ PUT YOUR FINGER IN THE MIDDLE AND DRAW DOTS ABOVE AND BELOW.

❸ CONNECT THE DOTS TO COMPLETE A "FORESHORTENED" SQUARE.

❹ MAKE SURE YOU DRAW THE MIDDLE LINE LONGER USING "PLACEMENT."

❺ CONNECT THE BOTTOM OF YOUR ANDROIDS TORSO, NOW EXTEND THE NEAR LEG. NOTE THE USE OF "OVERLAPPING AND "PLACEMENT" TO MAKE THIS NEAR LEG LOOK CLOSER TO YOUR EYE.

❻ RELAX YOUR HAND, BE LOOSE AND SKETCHY. ADD GUIDELINES FOR THE BOTTOM OF THE LEGS.

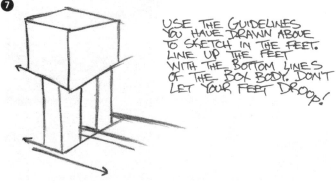

❼ USE THE GUIDELINES YOU HAVE DRAWN ABOVE TO SKETCH IN THE FEET. LINE UP THE FEET WITH THE BOTTOM LINES OF THE BOX BODY. DON'T LET YOUR FEET DROOP!

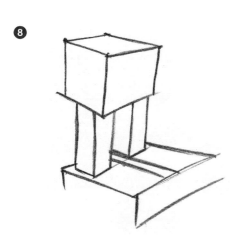

8

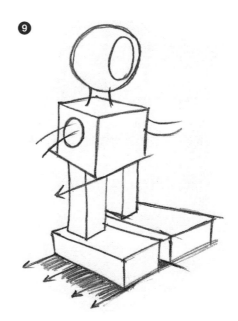

9

8. Add to the feet using more "alignment" guidelines.

9. Finish up the feet. Notice how even the shadow cast on the ground follows the guidelines from the bottom of the box. Let's block in where the head will go and add the foreshortened arm sockets. The arms will overlap out of the sockets with contour lines giving them volume and shape. Another foreshortened circle will place the face plate. Foreshortened circles are just as important as foreshortened squares. I want you to turn to page xx in your drawing in 3-D workbook and practice fifteen foreshortened circles in the empty space. Here's a tip: Start the foreshortened circles by first drawing two dots far apart. Now connect the dots with a skinny hot dog shape. Keep the foreshortened circles squished very thin. Like the foreshortened squares, if you draw the foreshortened circles with a wide open fat circle, it will change the alignment of the entire drawing.

10. Now comes the fun part. Add the Renaissance word shading. Draw in facial features, a cool helmet, some wild antenna-type thingamajigs, and waving hands. Hey, what do you know, this Atomic Android looks just like my little brother Karl in a space suit.

Here's a creative challenge for you: Write up a nifty poem about your Atomic Android. Computer scan your drawing and your poem and E-mail them to me. Perhaps I'll be able to use your brilliant 3-D drawing on my Web site at www.drawwithmark.com. Better yet, write a full-length feature novel that you can sell as an animated movie script for $18 billion. You are just so very creatively cool, a true artistic

genius! How about another creative challenge? Try to write an Atomic Android alliteration using at least seven words. Here's one my big brother Steve wrote using eleven, whew! "Atomic Androids always announce anxious astronaut audiences at all alien activities."

10

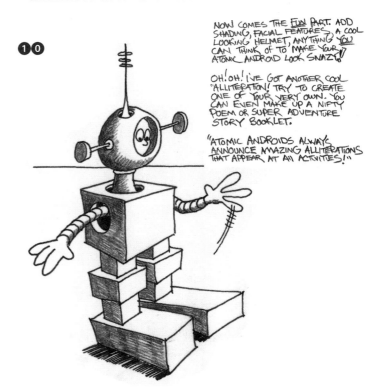

NOW COMES THE FUN PART. ADD SHADING, FACIAL FEATURES, A COOL LOOKING HELMET, ANYTHING YOU CAN THINK OF TO MAKE YOUR ATOMIC ANDROID LOOK SNAZZY!

OH! OH! I'VE GOT ANOTHER COOL "ALLITERATION! TRY TO CREATE ONE OF YOUR VERY OWN. YOU CAN EVEN MAKE UP A NIFTY POEM OR SUPER ADVENTURE STORY BOOKLET.

"ATOMIC ANDROIDS ALWAYS ANNOUNCE AMAZING ALLITERATIONS THAT APPEAR AT ALL ACTIVITIES!"

Introduction to the Five 3-D Letter *B* Styles

Just like the five lessons of drawing the letter *A* styles, each of these lessons follows nearly identical steps to create the 3-D effect. You can pick one style and practice each letter of the alphabet with that specific style. For example, if you want to write your name "Poindexter" in the super 3-D style, simply turn to the super 3-D letter lesson for each letter in order, from *P*, *O*, *I*, *N*, etc. Experiment with different styles and find out which one you enjoy the most. I personally prefer the sharp look of the chiseled stone but tend to use the peeling shadow a lot more because it's much faster and cleaner for big lettering projects. That is precisely why learning to draw in 3-D is so much fun. It's a special time for you to explore new ideas, styles, techniques, and mediums. Go ahead, have a dynamic drawing adventure of diligent discovery!

"B" Block 3-D

"B" Super 3-D

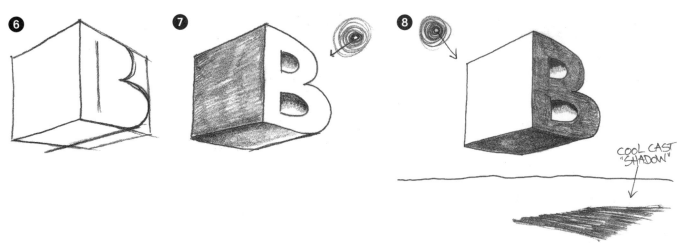

COOL CAST "SHADOW"

"B" Chiseled Stone

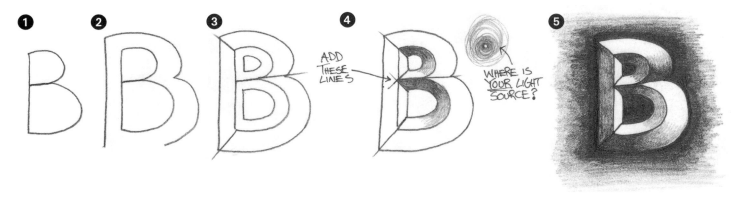

ADD THESE LINES

WHERE IS YOUR LIGHT SOURCE?

"B" Puff Cloud

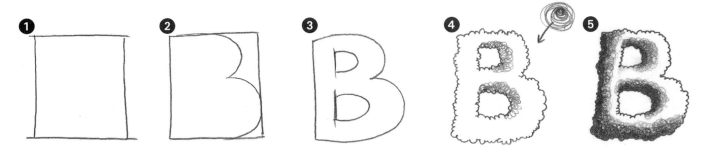

"B" Peeling Shadow

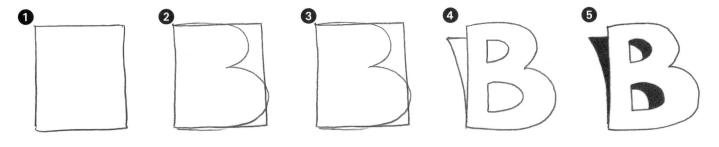

Banana Boy

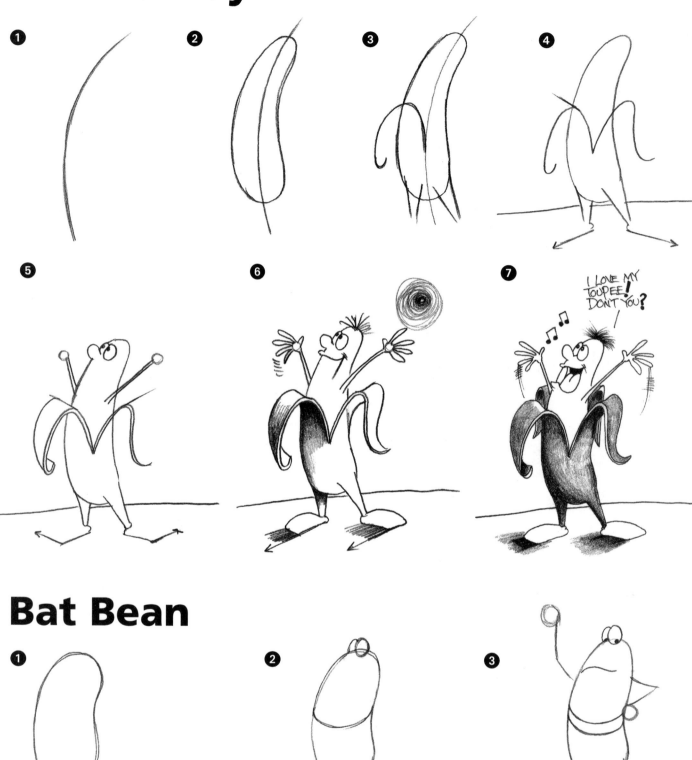

Bat Bean

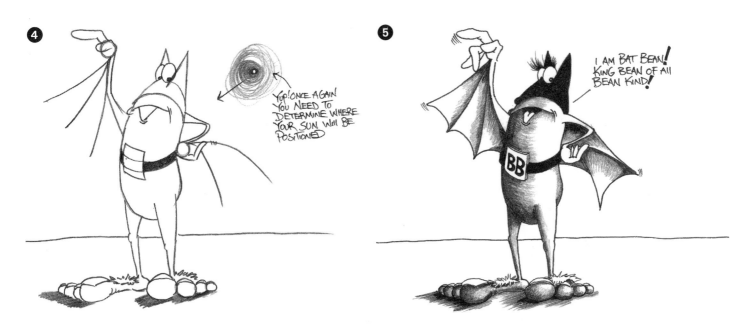

Big Bugeye Birds

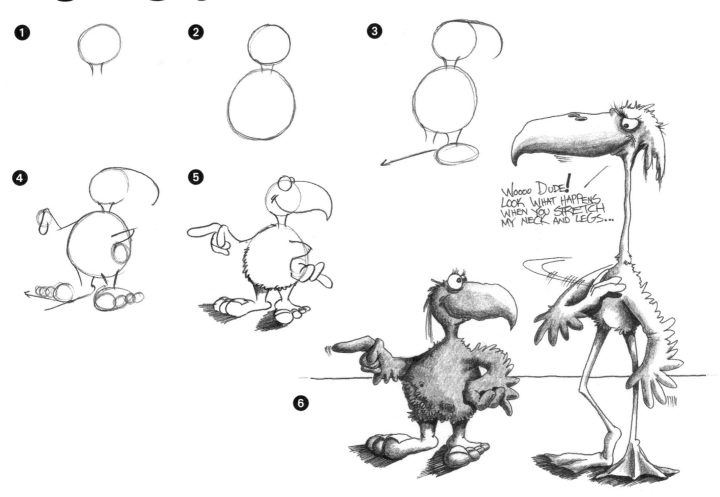

Billions of Blocks

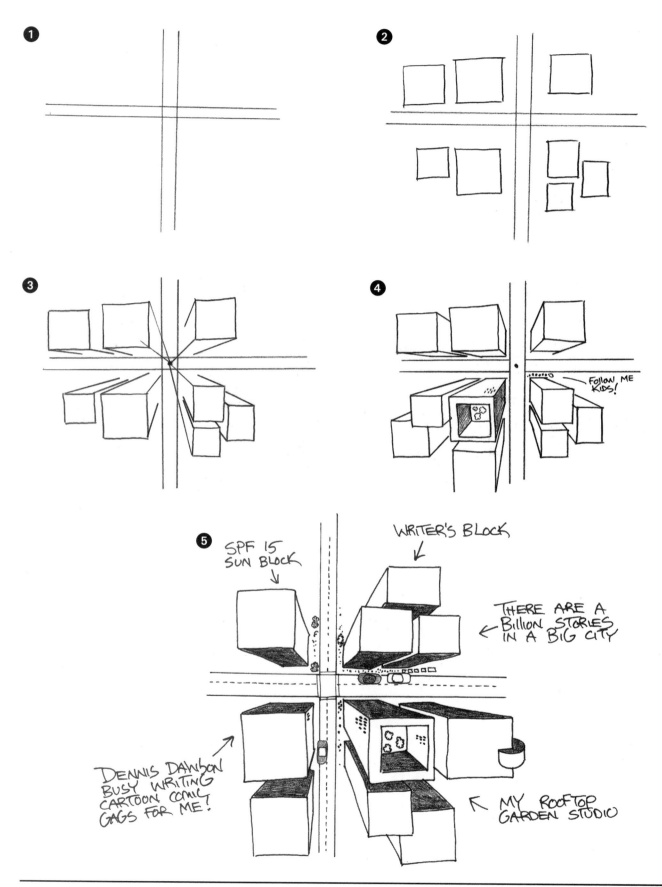

①

②

③

④

⑤

SPF 15 SUN BLOCK ↓

WRITER'S BLOCK ↓

THERE ARE A BILLION STORIES IN A BIG CITY ←

FOLLOW ME KIDS!

DENNIS DAWSON BUSY WRITING CARTOON COMIC GAGS FOR ME! ↗

← MY ROOFTOP GARDEN STUDIO

Biosphere Building

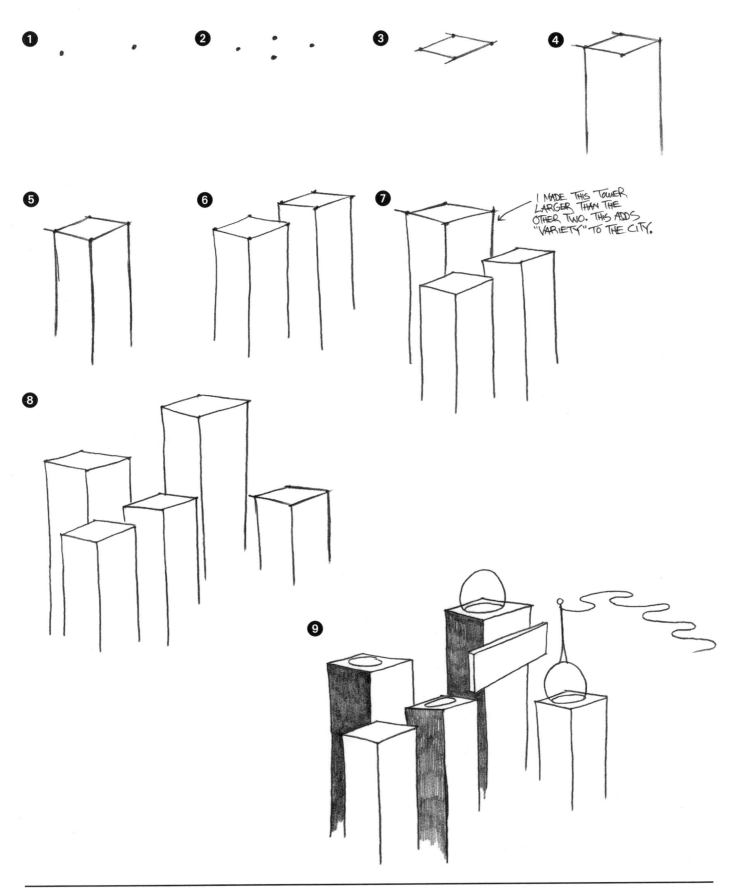

I MADE THIS TOWER LARGER THAN THE OTHER TWO. THIS ADDS "VARIETY" TO THE CITY.

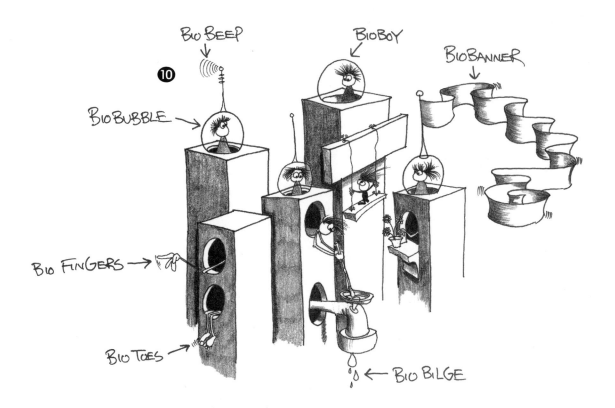

BIO BEEP

BIO BOY

BIO BANNER

⑩

BIO BUBBLE →

BIO FINGERS →

BIO TOES →

BIO BILGE

Bizarre Breakfast Bowl

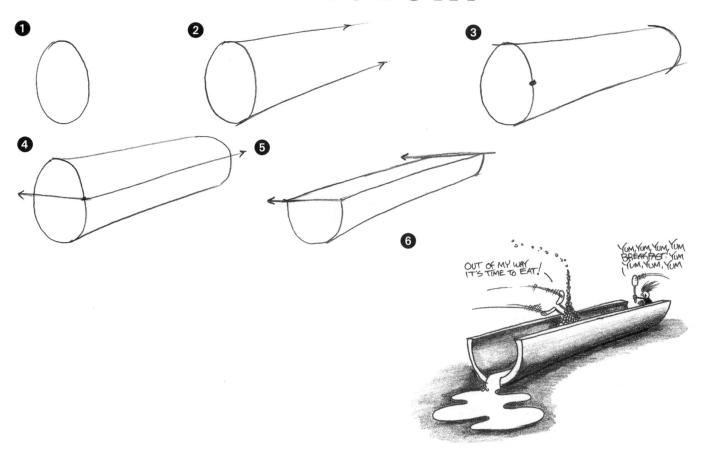

❶ ❷ ❸

❹ ❺

❻

OUT OF MY WAY
IT'S TIME TO EAT!

YUM, YUM, YUM, YUM
BREAKFAST! YUM
YUM, YUM, YUM

Boisterous Brain

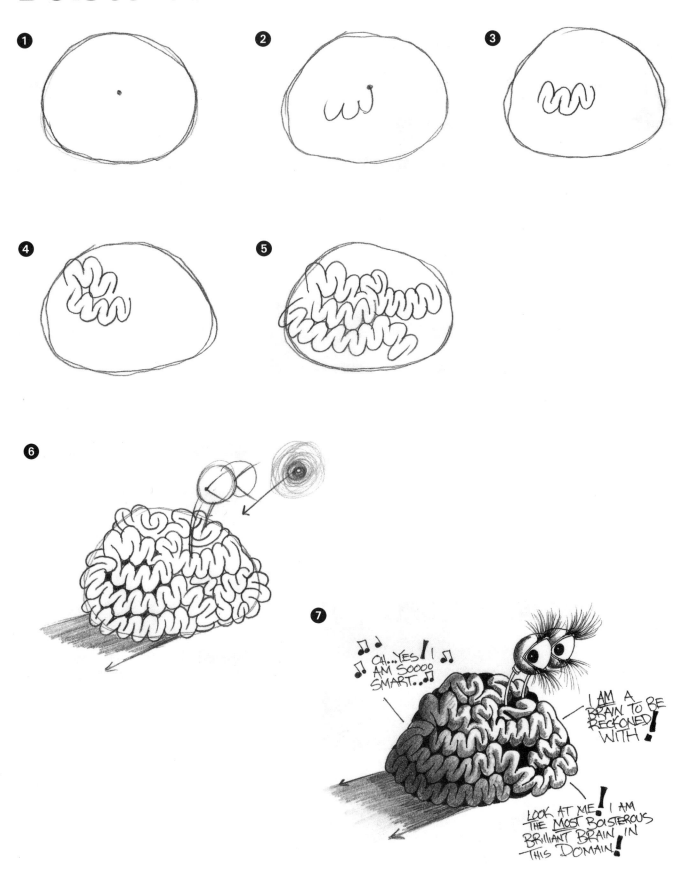

Books, Books, Books!

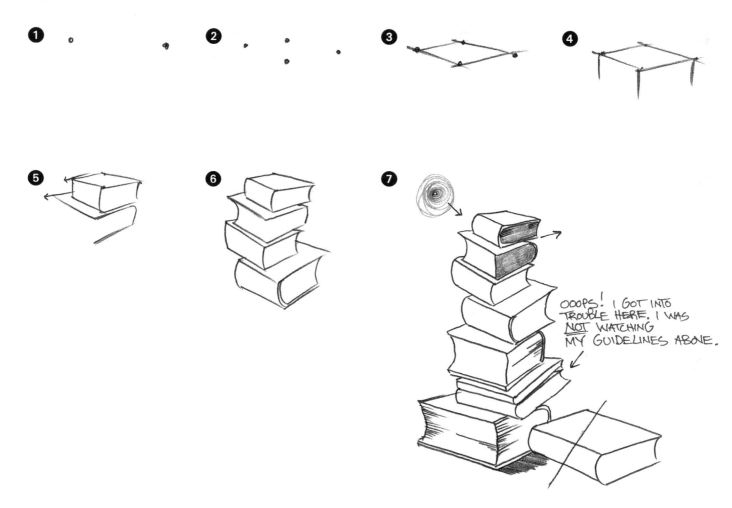

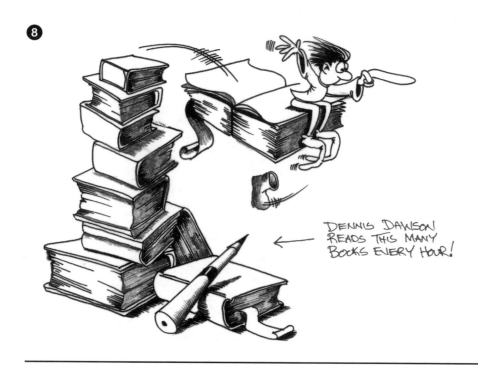

OOOPS! I GOT INTO TROUBLE HERE. I WAS **NOT** WATCHING MY GUIDELINES ABOVE.

DENNIS DAWSON READS THIS MANY BOOKS EVERY HOUR!

Buzzing Beehive

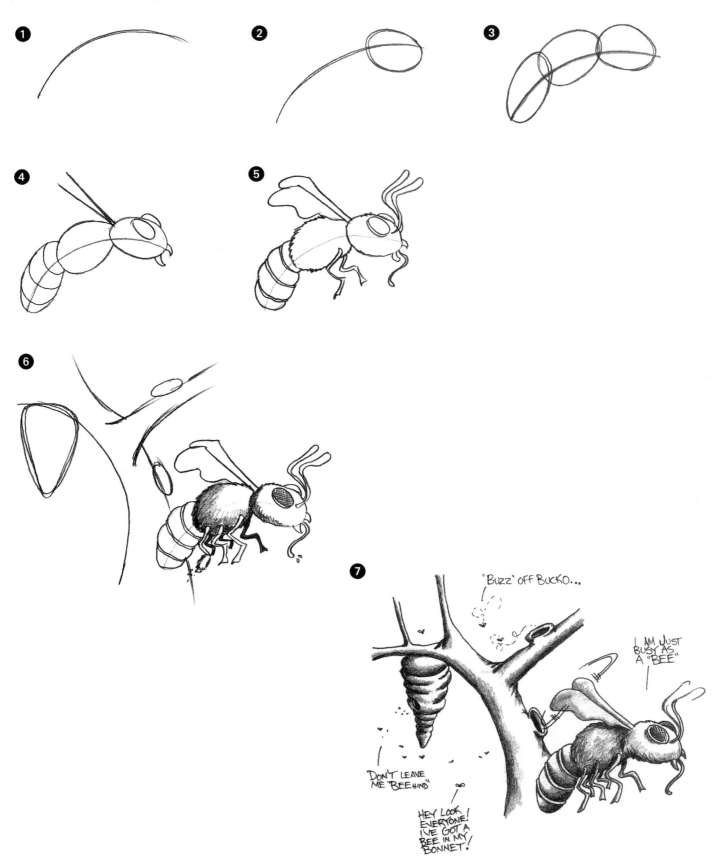

"C" Puff Cloud

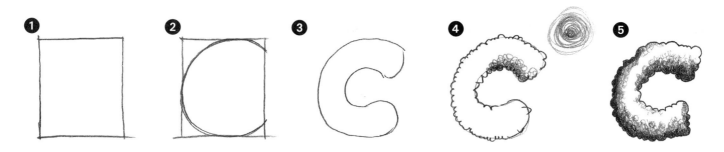

"C" Peeling Shadow

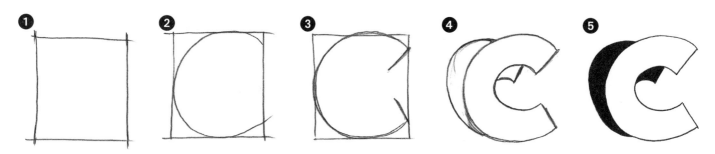

"C" Chiseled Stone

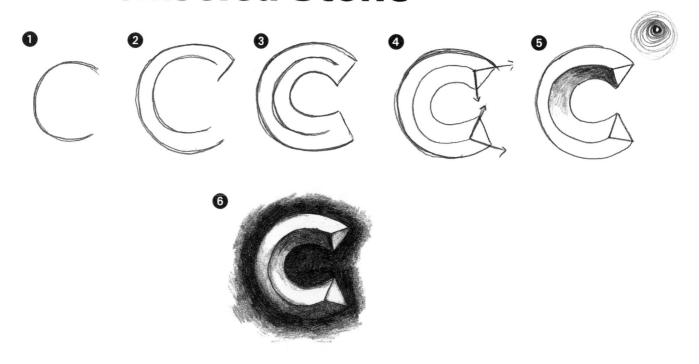

"C" Super 3-D

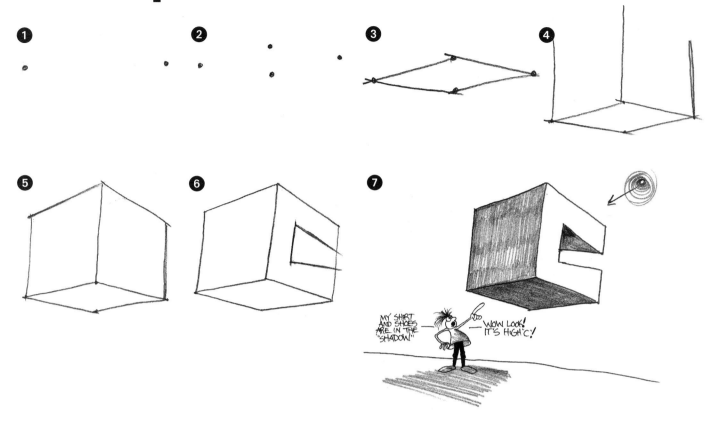

"C" Block 3-D

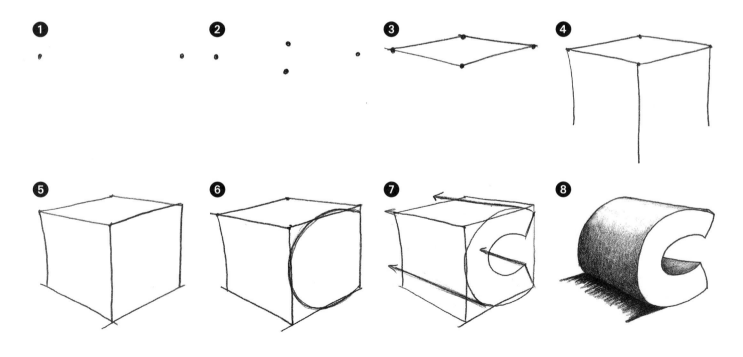

Career Cartoonist

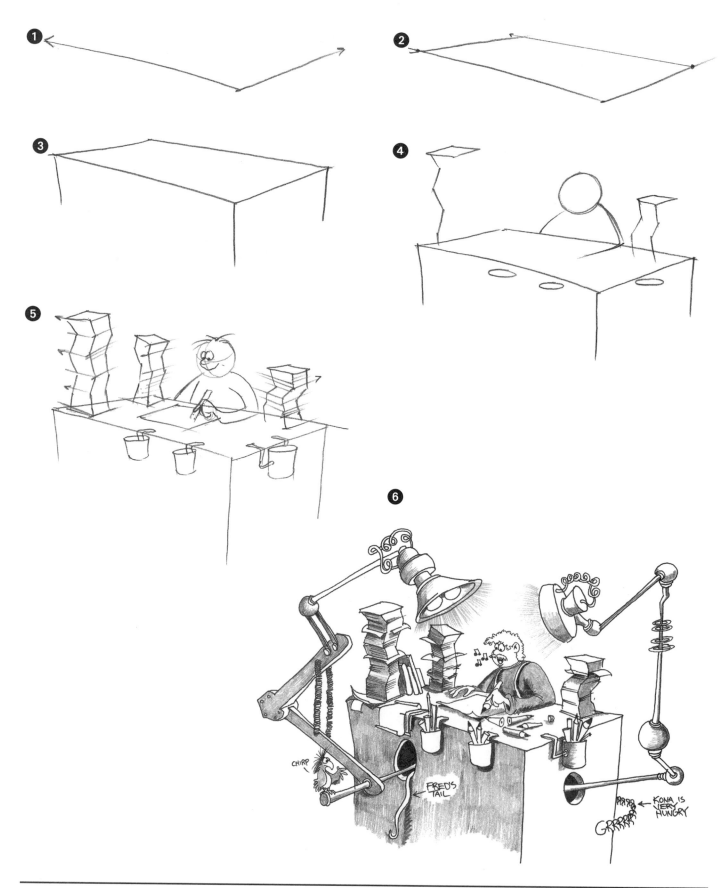

Cloud Cottage

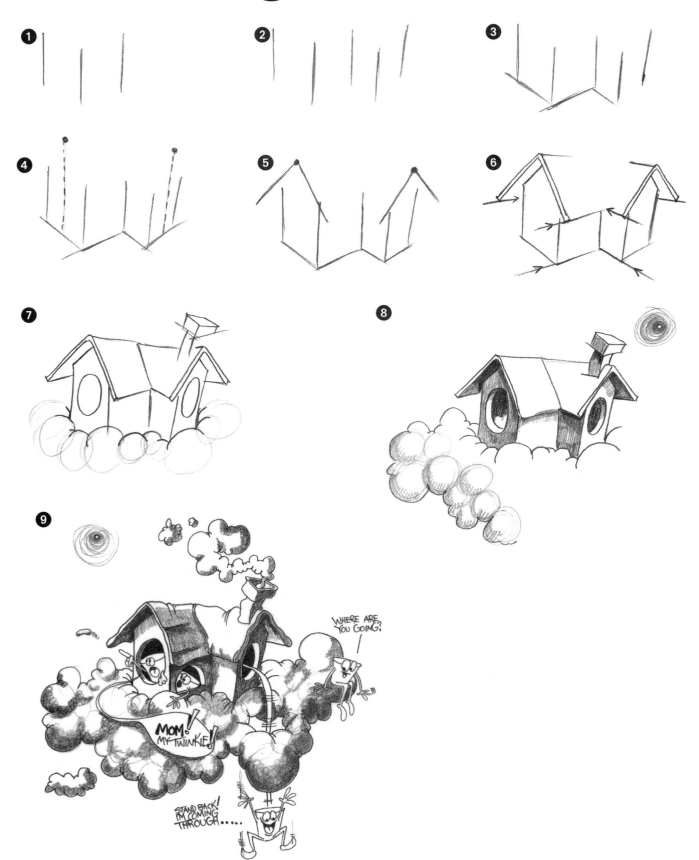

Colorful Coral

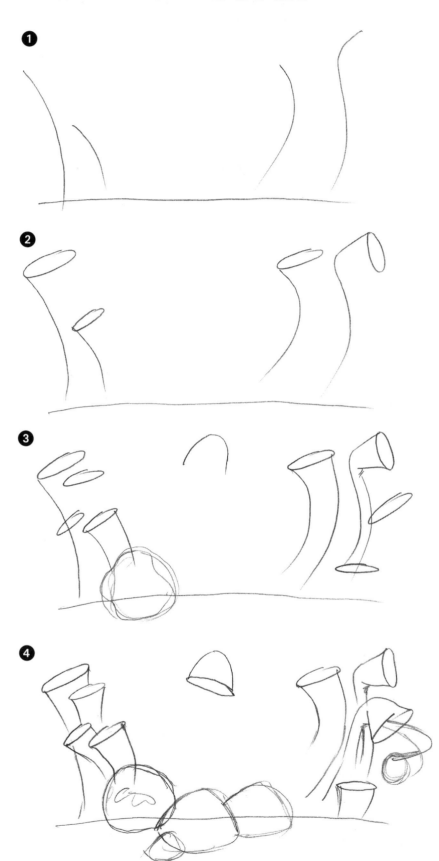

1

2

3

4

⑤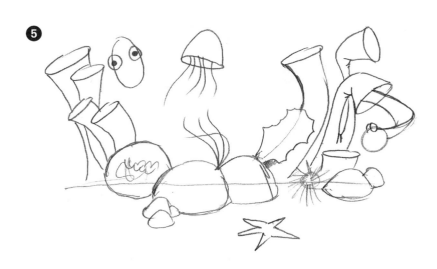

⑥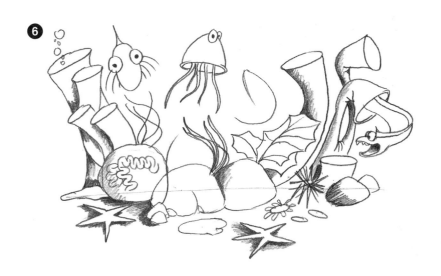

⑦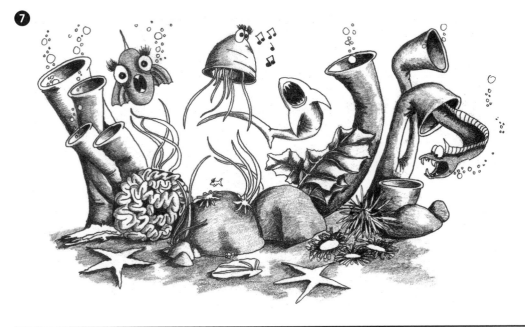

Colossal Castle

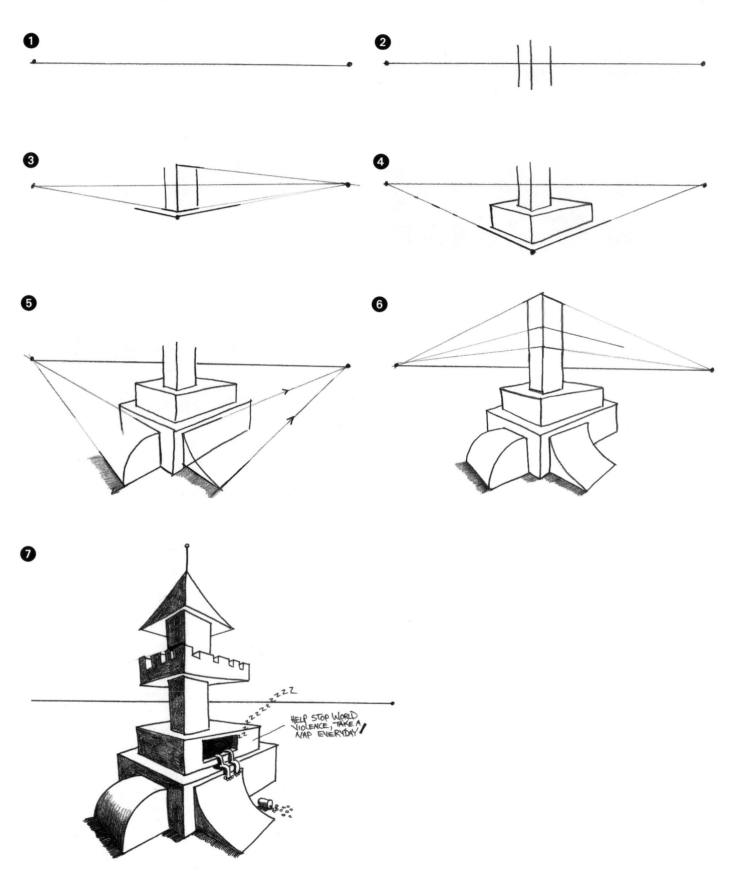

1

2

3

4

5

6

7

HELP STOP WORLD
VIOLENCE, TAKE A
NAP EVERYDAY!

Cool Canyons

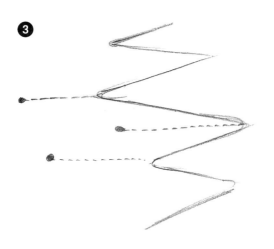

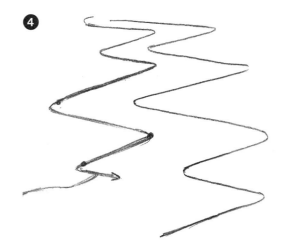

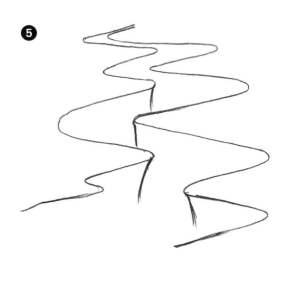

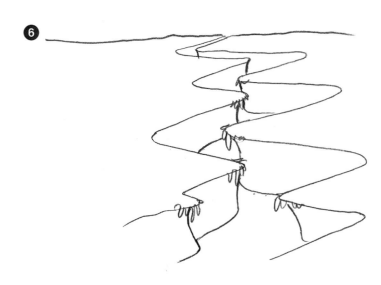

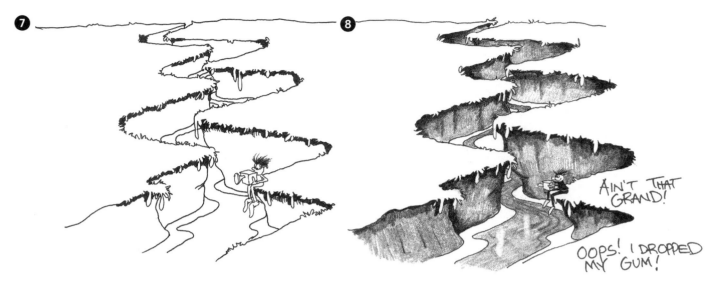

7 **8**

AIN'T THAT GRAND!

OOPS! I DROPPED MY GUM!

Crane Contraptions

1 **2** **3** **4**

5 **6** **7**

8

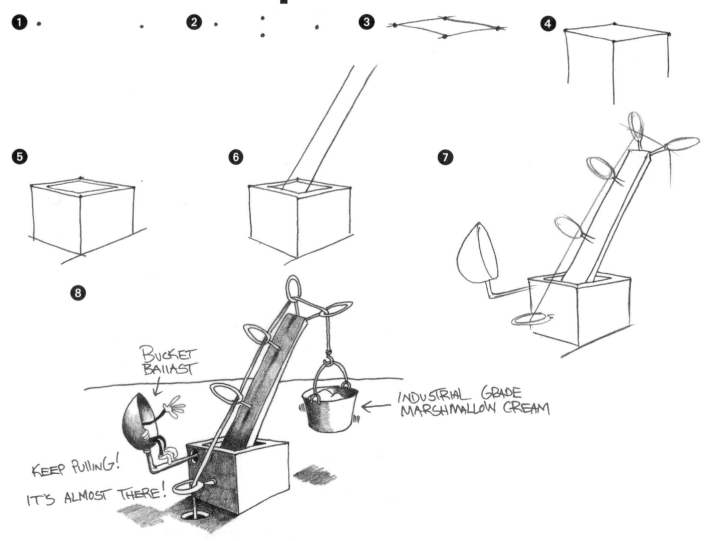

BUCKET BALLAST

INDUSTRIAL GRADE MARSHMALLOW CREAM

KEEP PULLING!

IT'S ALMOST THERE!

Crater Cave

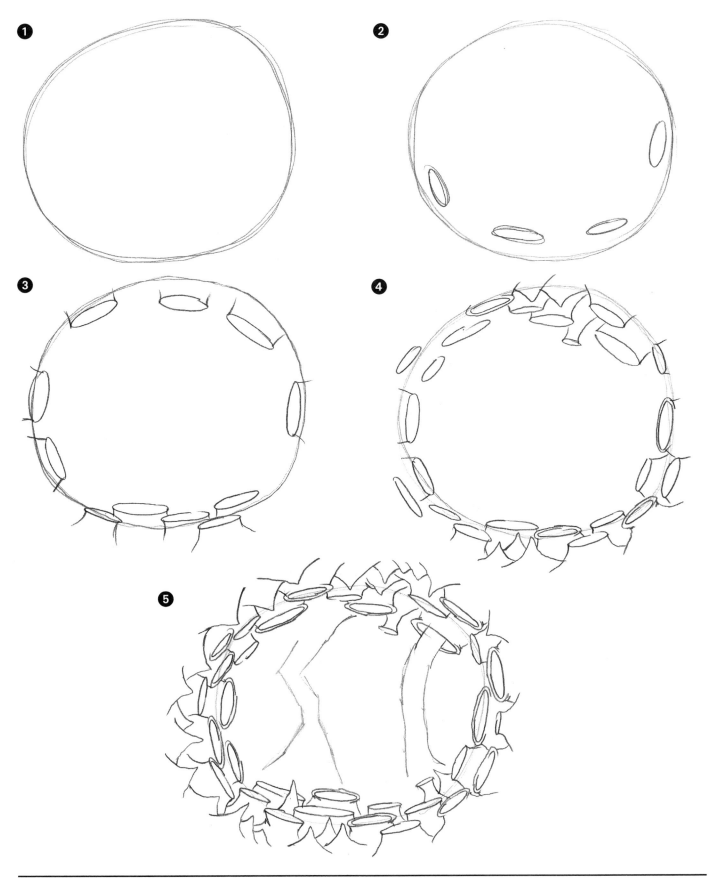

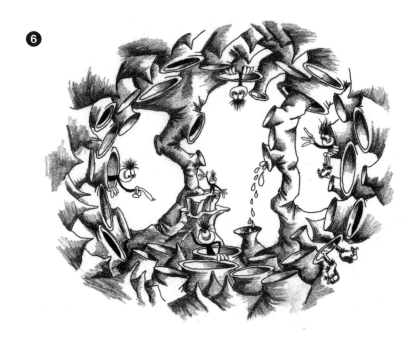

6

Crawling Cobra

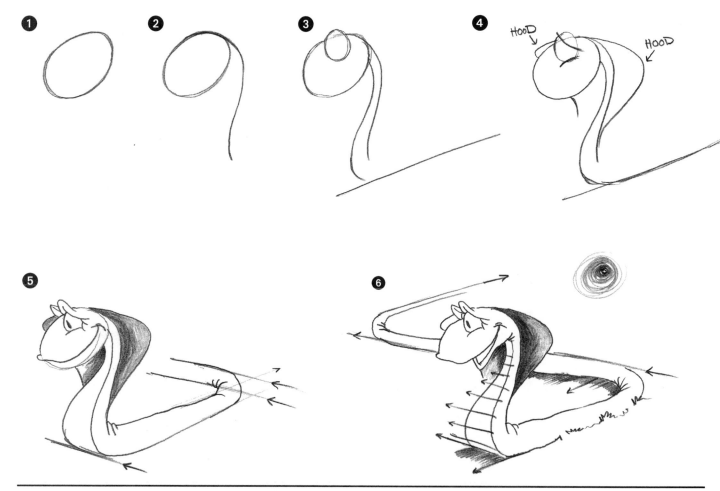

1 **2** **3** **4** HOOD HOOD

5 **6**

"D" Puff Cloud

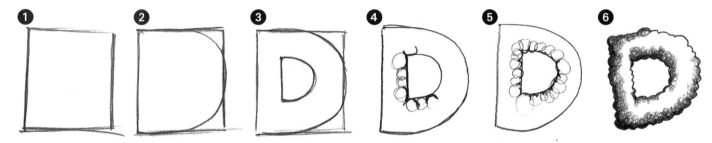

"D" Peeling Shadow

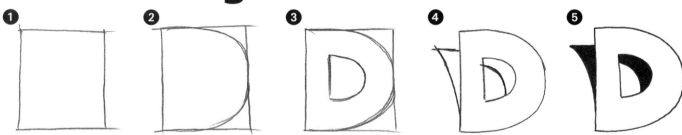

"D" Chiseled Stone

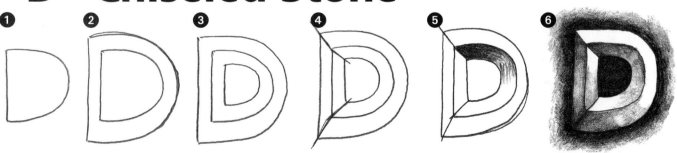

"D" Super 3-D

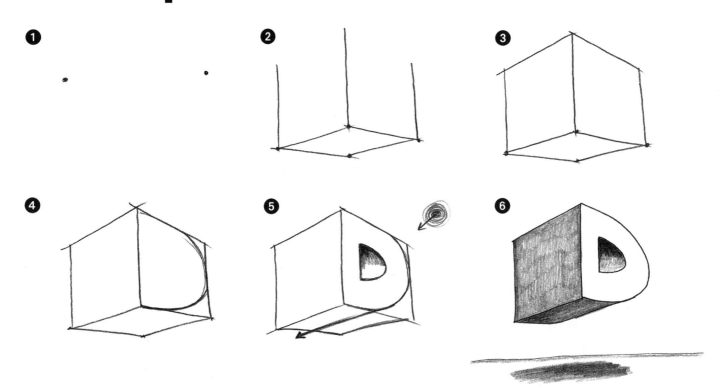

"D" Block 3-D

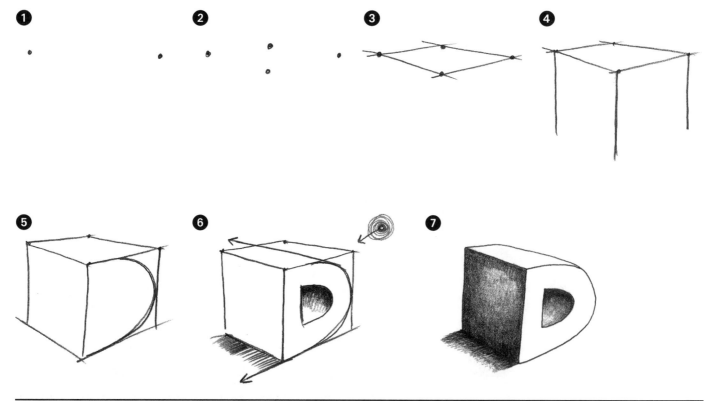

Daring Driving Dogs

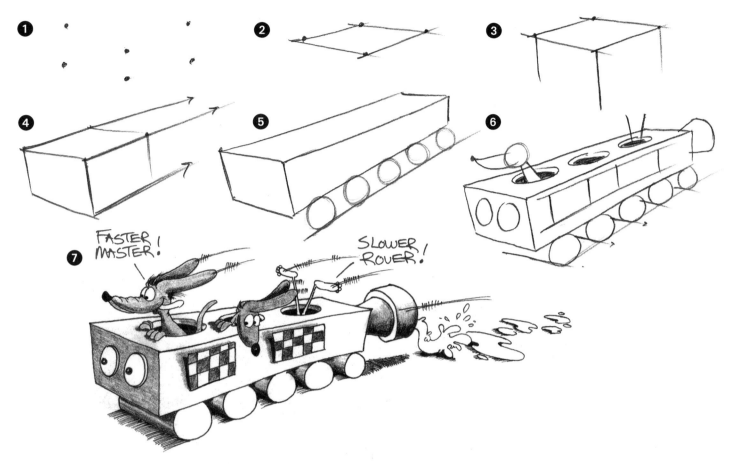

7 FASTER MASTER!

SLOWER ROVER!

Deep Space Droid

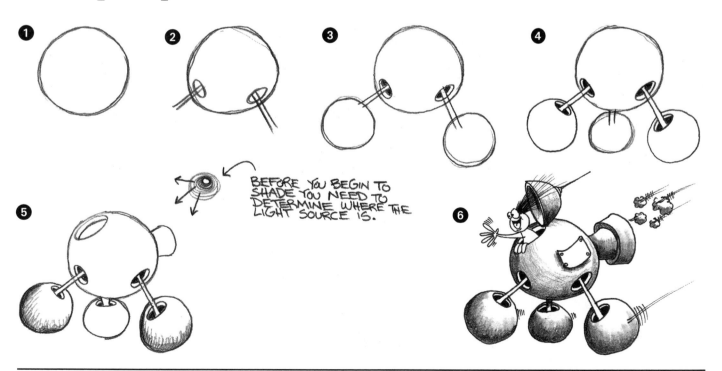

BEFORE YOU BEGIN TO SHADE YOU NEED TO DETERMINE WHERE THE LIGHT SOURCE IS.

Dirk's Declaration

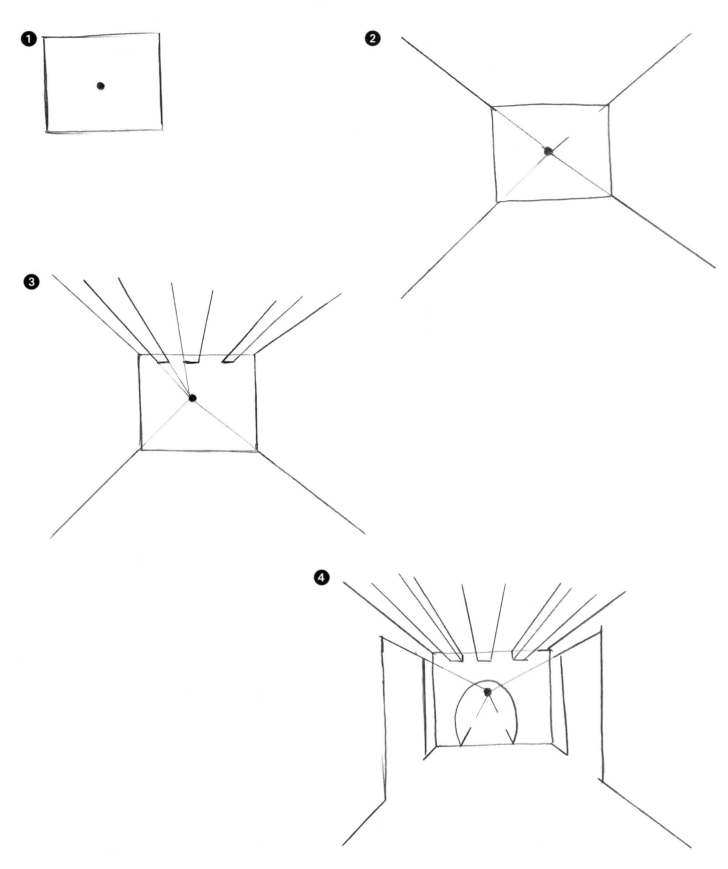

⑤

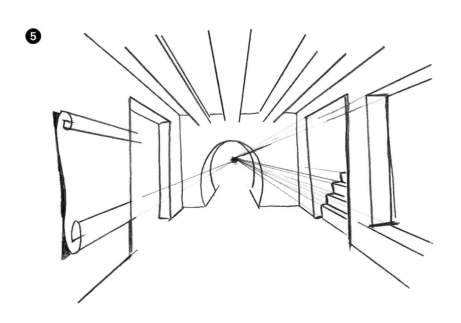

⑥

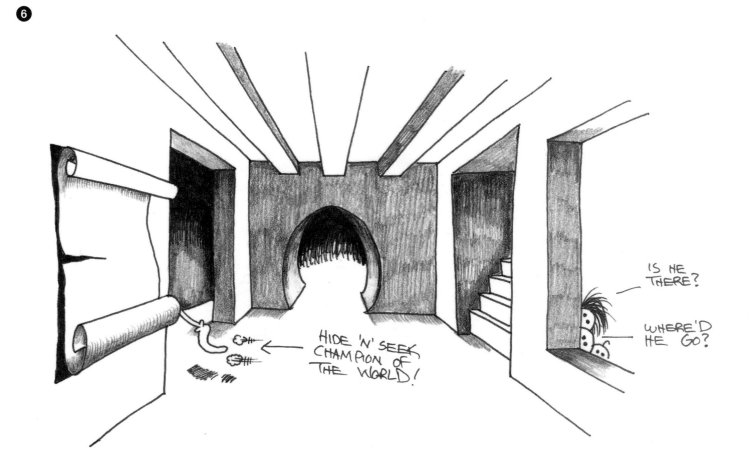

IS HE THERE?

WHERE'D HE GO?

HIDE 'N' SEEK CHAMPION OF THE WORLD!

Dog Dude

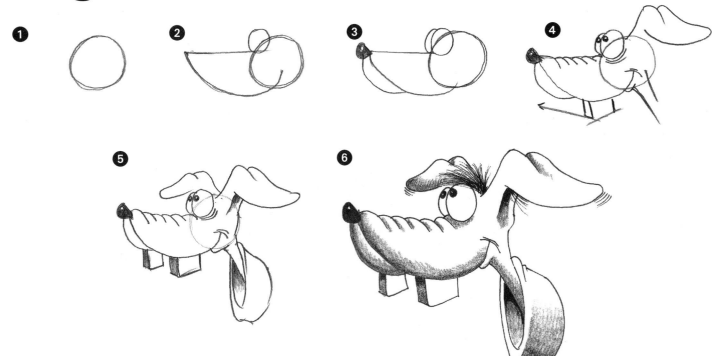

Drooling Dragon

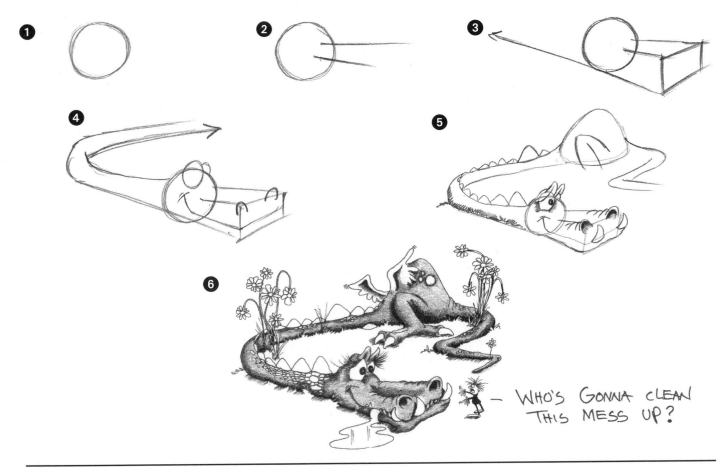

— WHO'S GONNA CLEAN THIS MESS UP?

"E" Puff Cloud

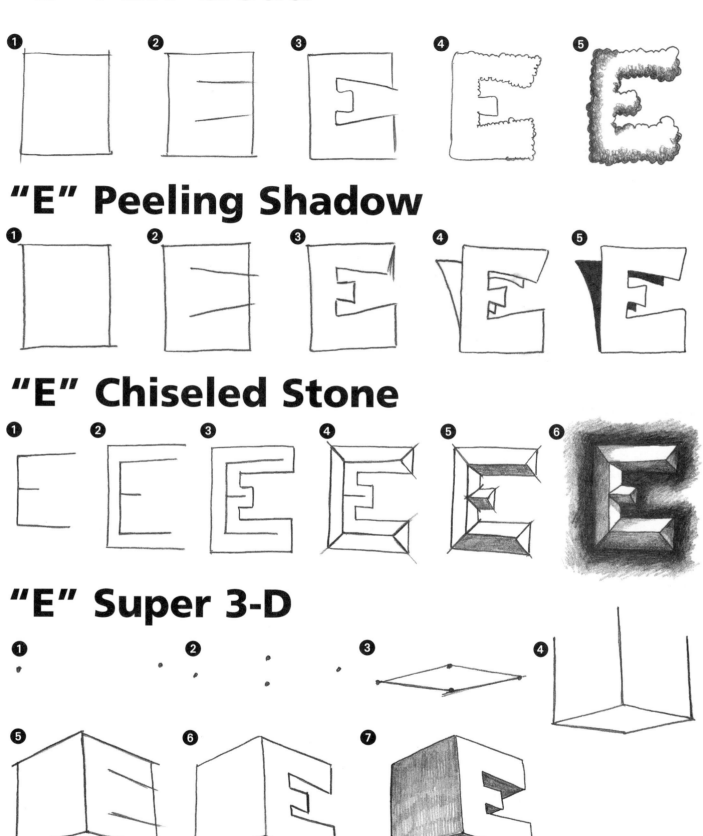

"E" Peeling Shadow

"E" Chiseled Stone

"E" Super 3-D

"E" Block 3-D

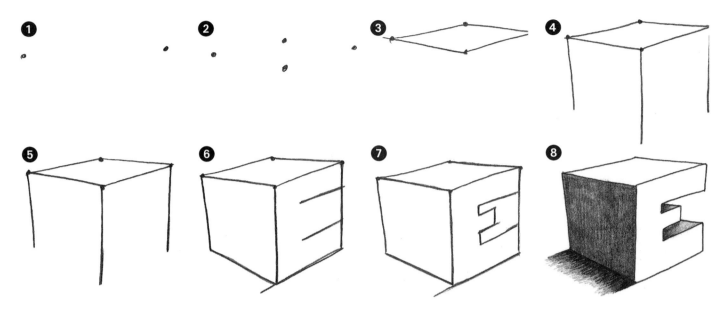

Early Egyptian

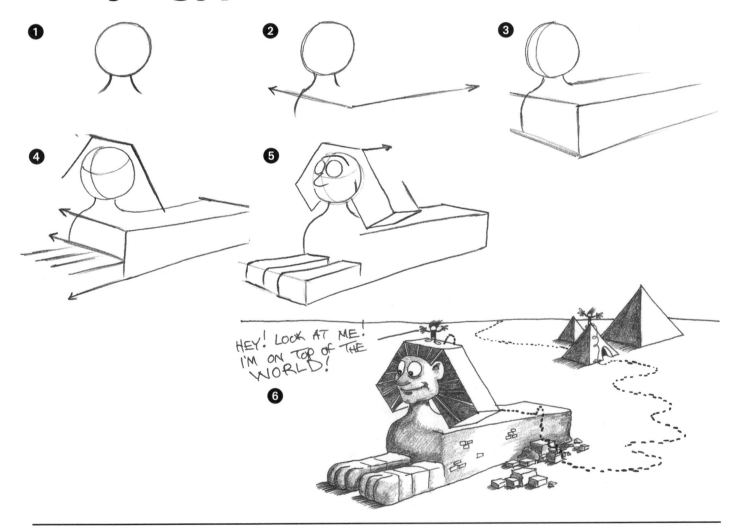

HEY! LOOK AT ME! I'M ON TOP OF THE WORLD!

Eccentric Elephants

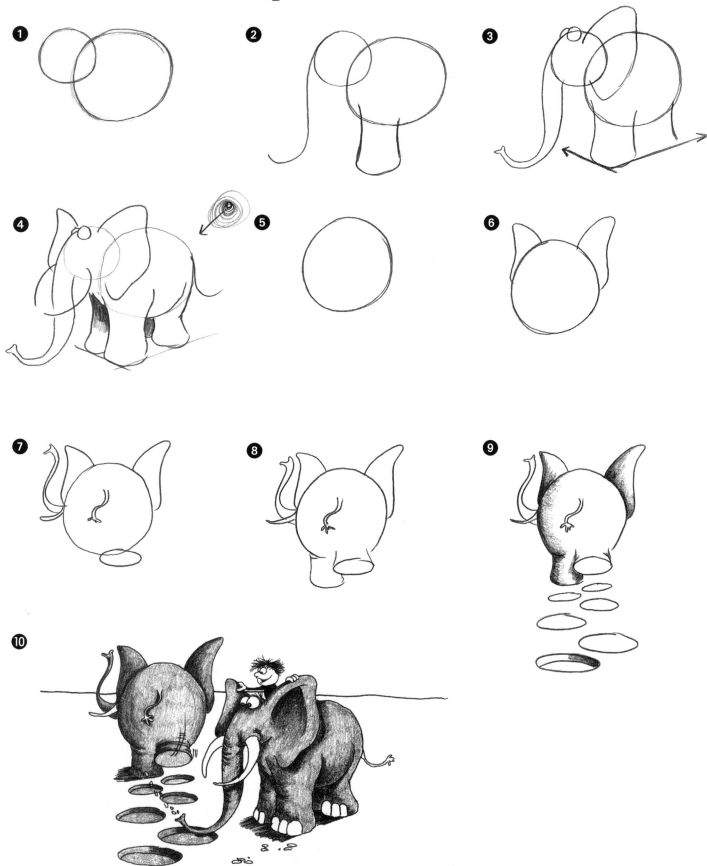

Eeek Squeaks

1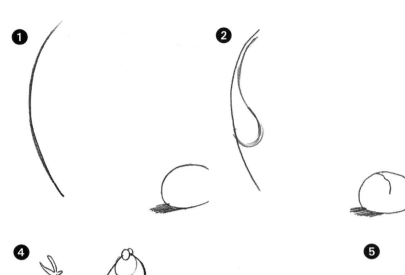

2

3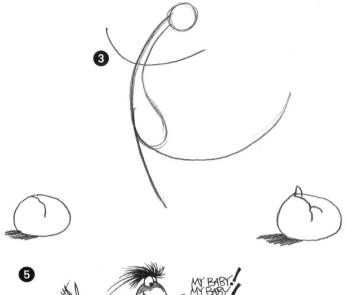

4

5

MY BABY!
MY BABY!

CHIRP!

Elevated Earth Equalizer

1 · · · ·

2 · · ·

3

4

5

6

7

8

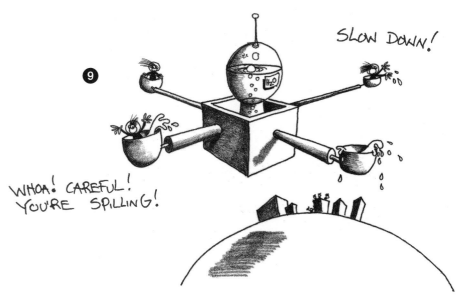

SLOW DOWN!

WHOA! CAREFUL! YOU'RE SPILLING!

⑨

Elf's Ear

 ① ② ③ ④ ⑤

Emotional Eyeball

 ① ② ③ ④ 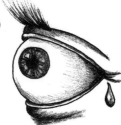 ⑤

Enchanted Eagle

① ②

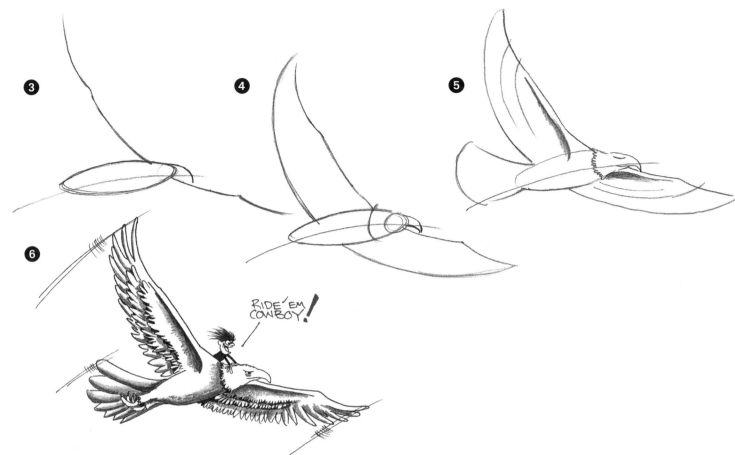

Enthusiastic Environmentalist

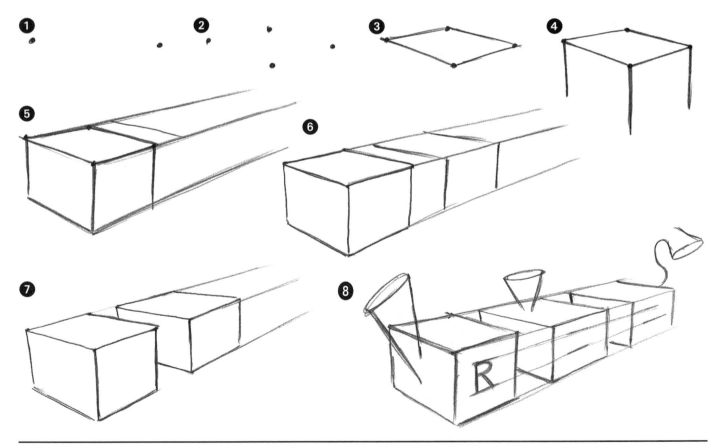

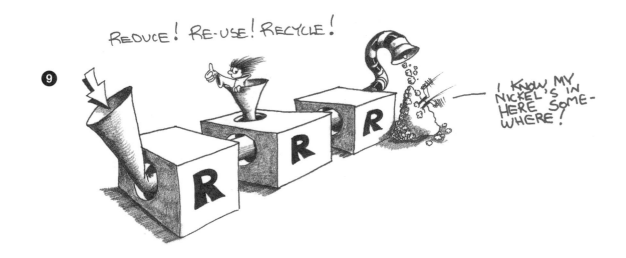

REDUCE! RE-USE! RECYCLE!

I KNOW MY NICKEL'S IN HERE SOME-WHERE!

"F" Puff Cloud

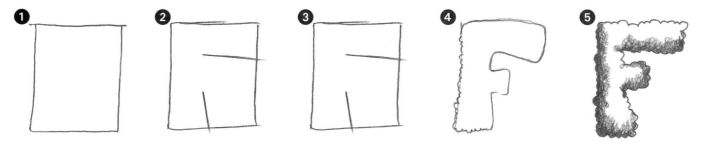

"F" Peeling Shadow

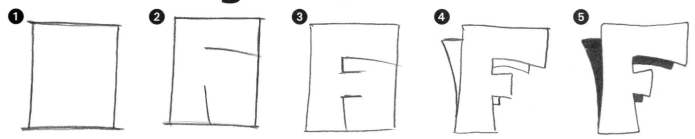

"F" Chiseled Stone

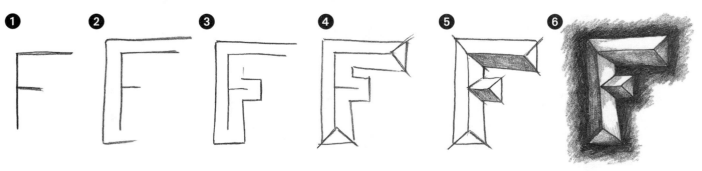

"F" Super 3-D

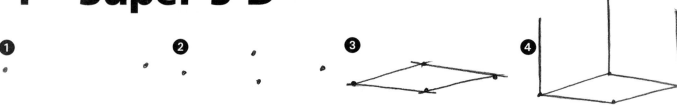

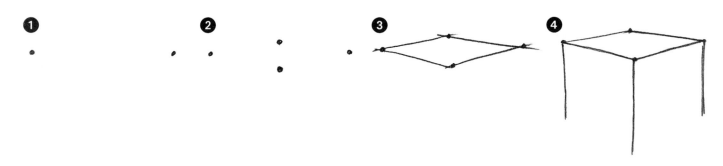

"F" Block 3-D

Fearless Floating Frogs

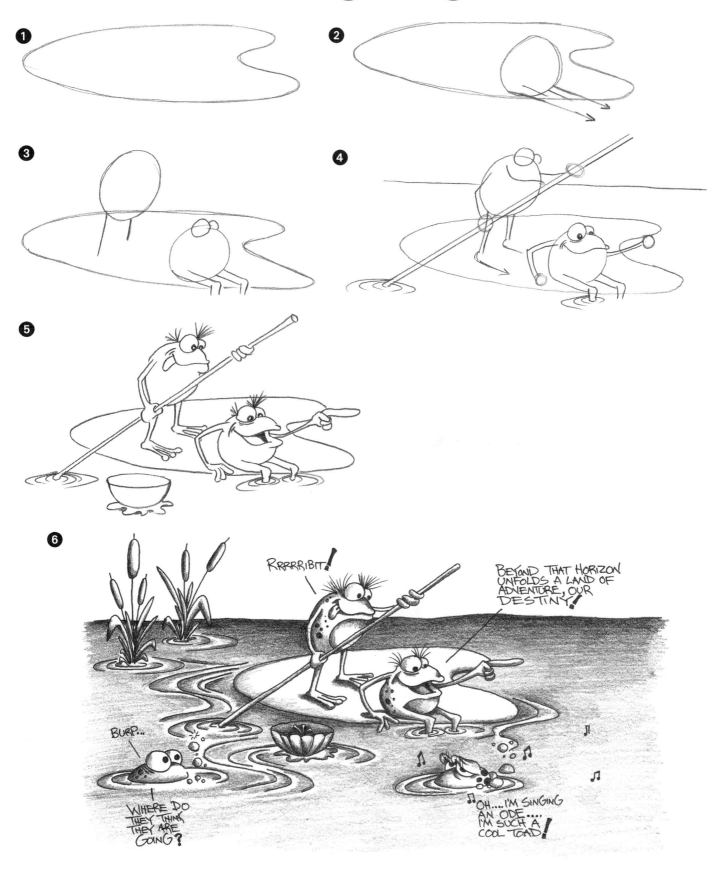

Finicky Fanged Fish

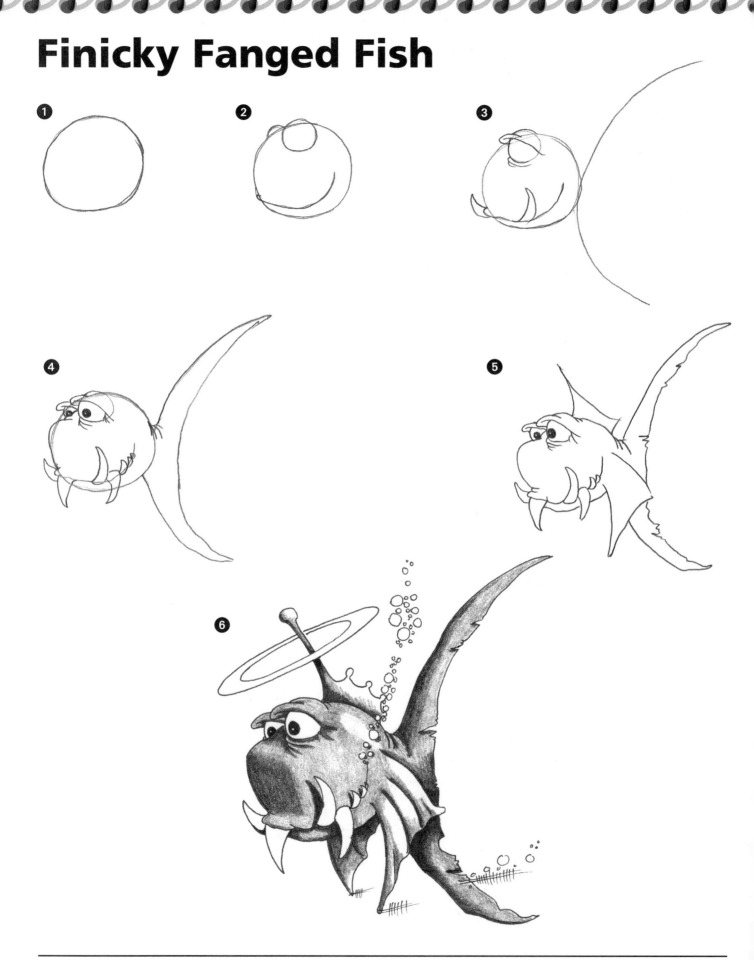

Forest of Freedom

❶ •

❷

❸

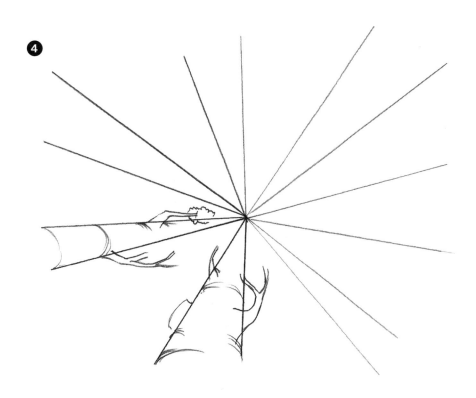

❹

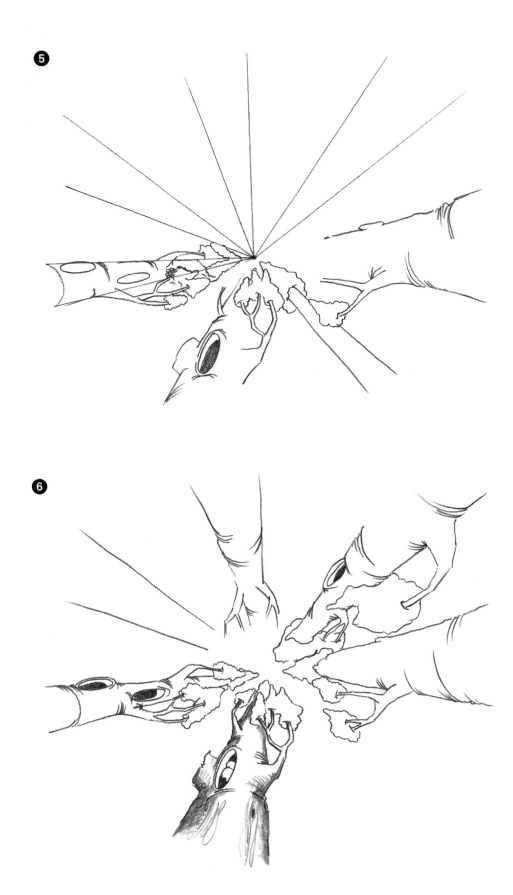

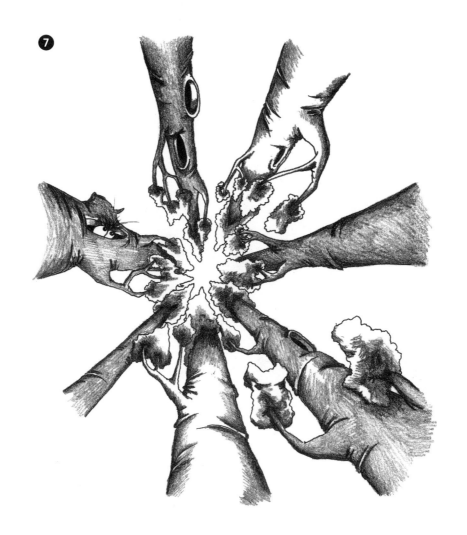

7

Fred's Foot

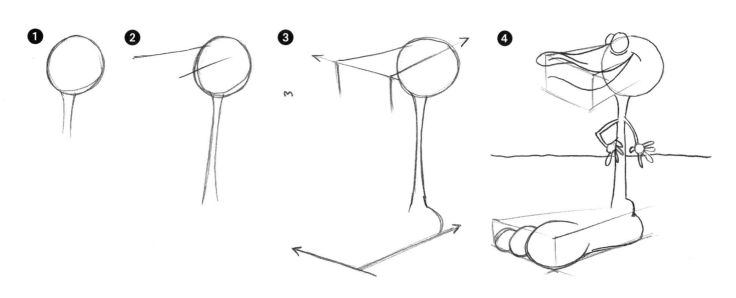

1 **2** **3** **4**

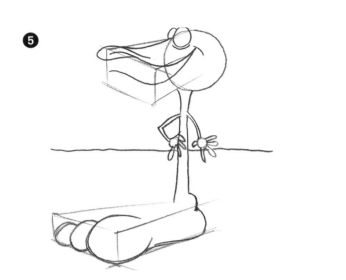

⑤

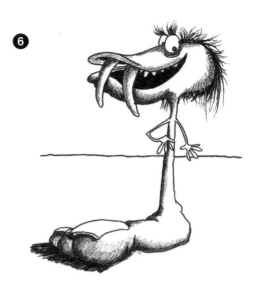

⑥

Funky Flying Faucets

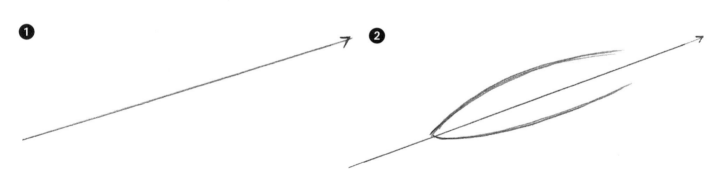

①

②

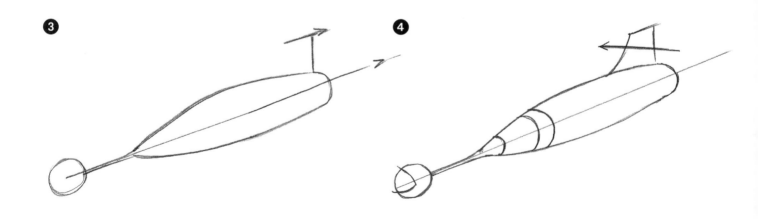

③

④

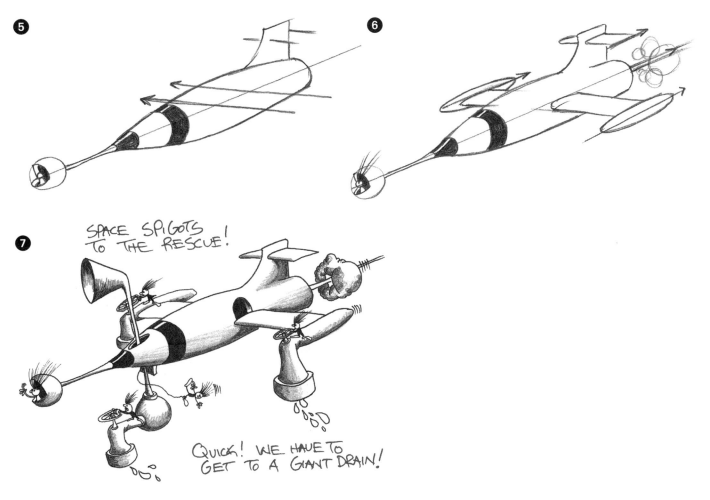

Furry Franco from France

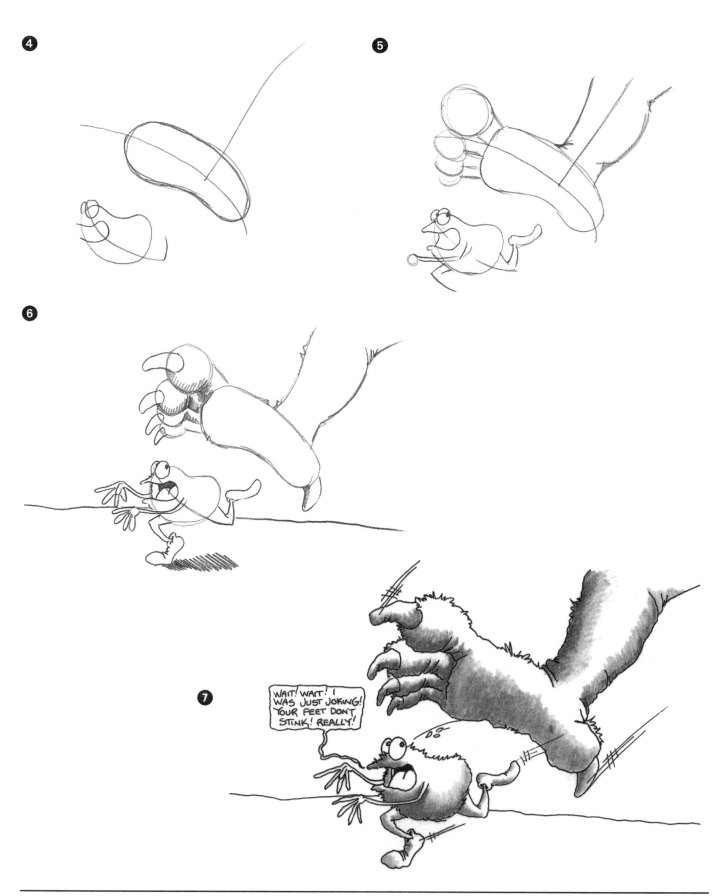

"G" Puff Cloud

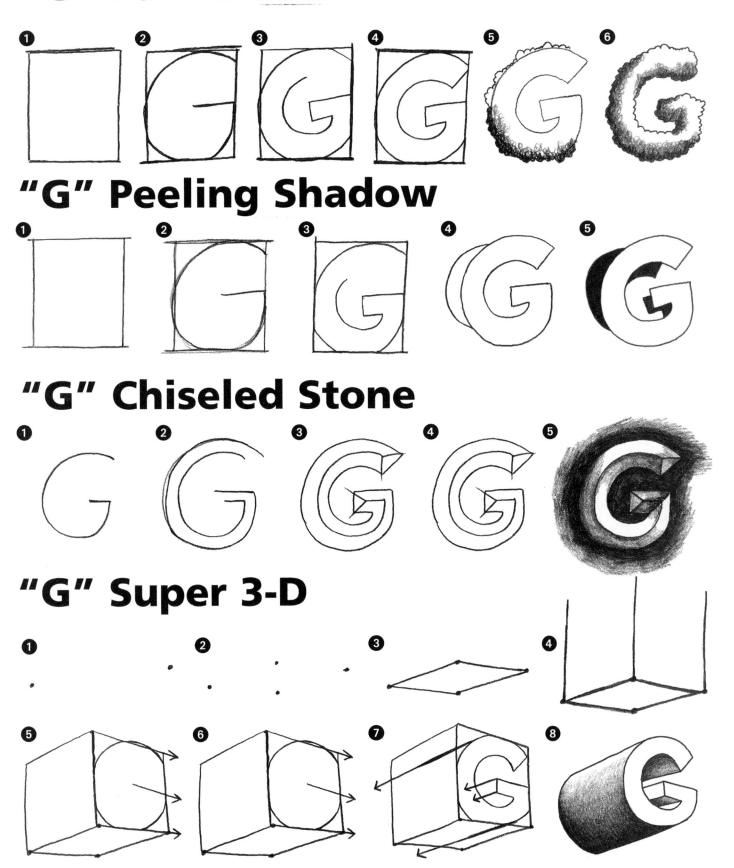

"G" Peeling Shadow

"G" Chiseled Stone

"G" Super 3-D

"G" Block 3-D

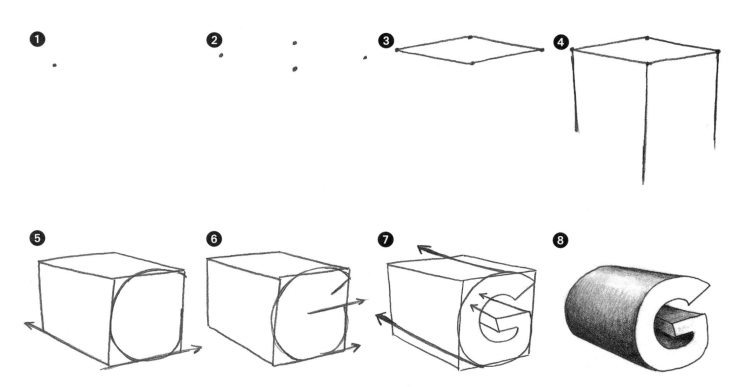

Giant Giraffe

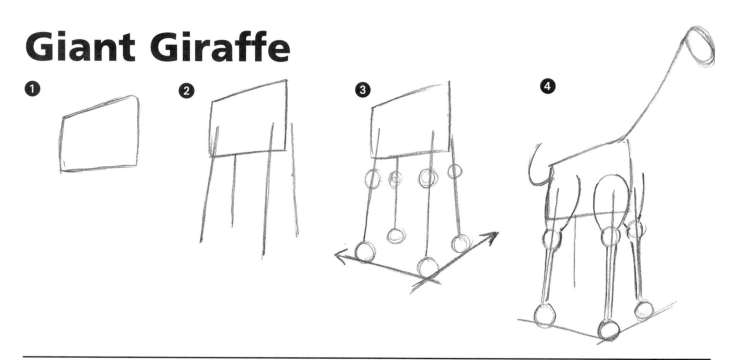

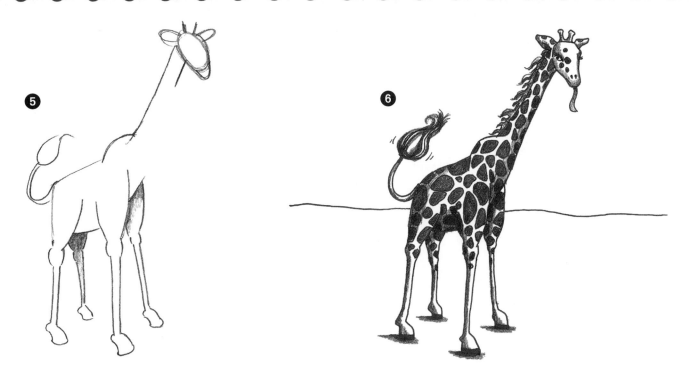

Ginger George

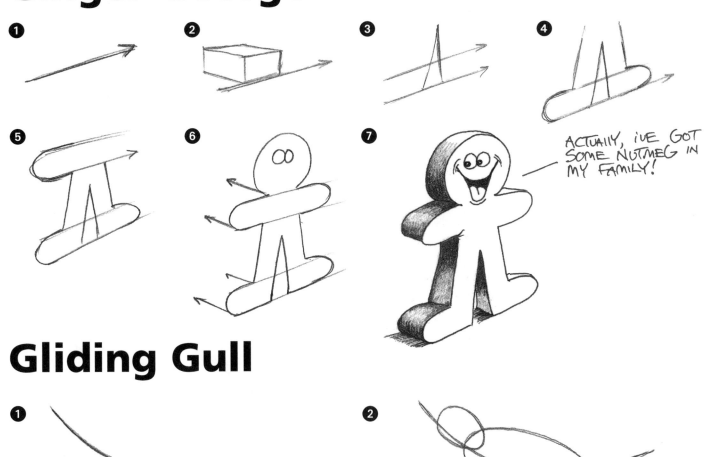

① **②** **③** **④**

⑤ **⑥** **⑦**

ACTUALLY, I'VE GOT SOME NUTMEG IN MY FAMILY!

Gliding Gull

① **②**

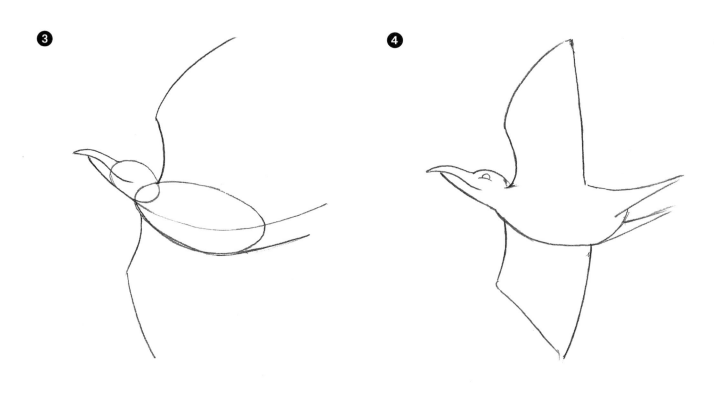

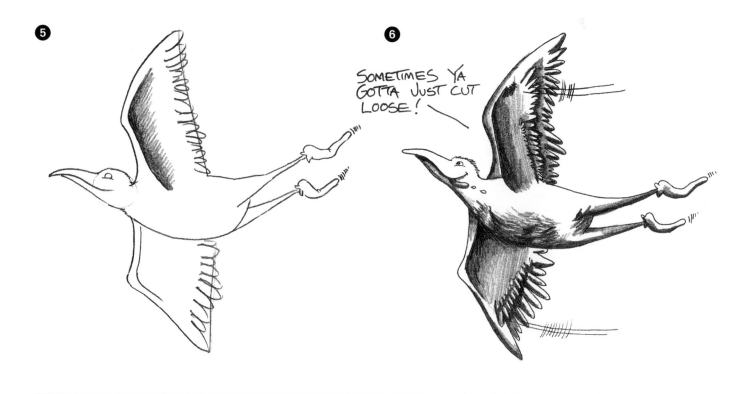

SOMETIMES YA
GOTTA JUST CUT
LOOSE!

Gnome's Home

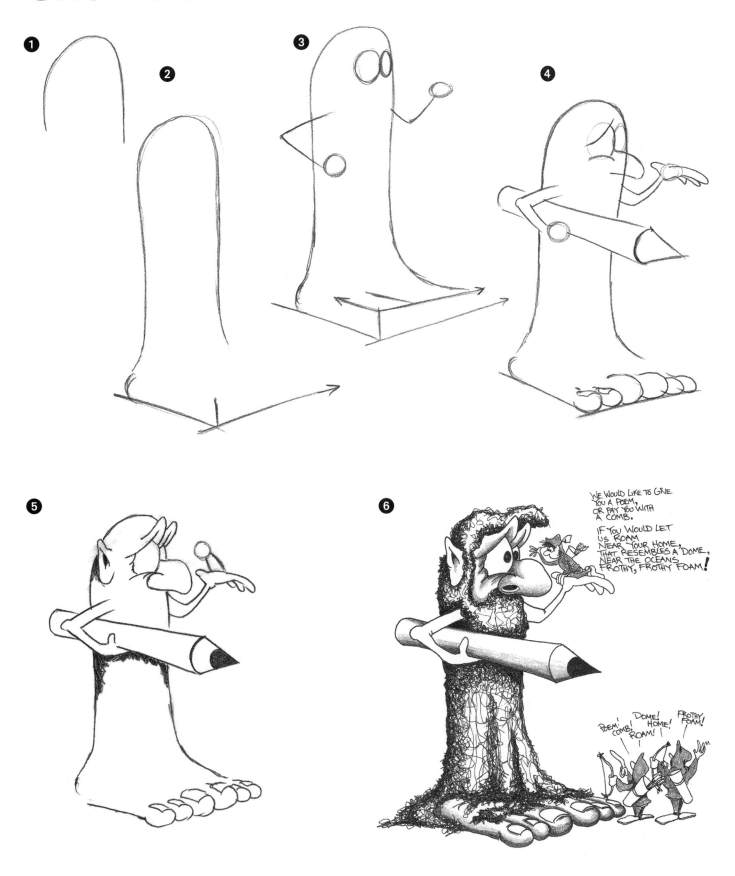

We would like to give you a poem, or pay you with a comb.

If you would let us roam near your home, that resembles a dome, near the oceans frothy, frothy foam!

POEM! COMB! DOME! HOME! ROAM! FROTHY FOAM!

Good Grade

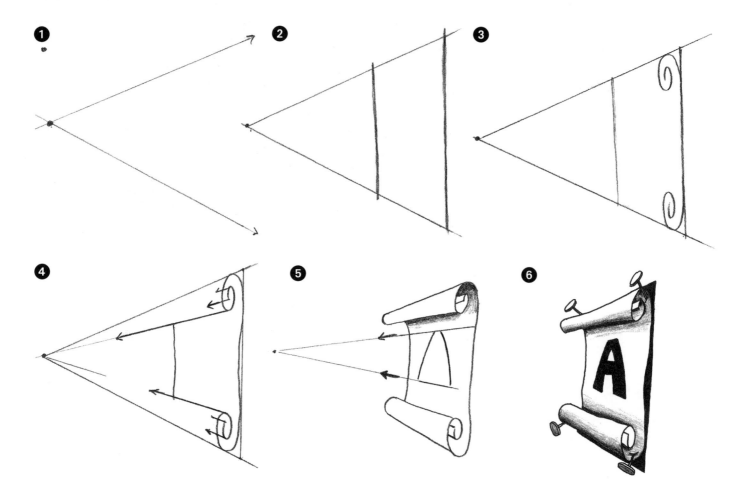

Gorilla Games

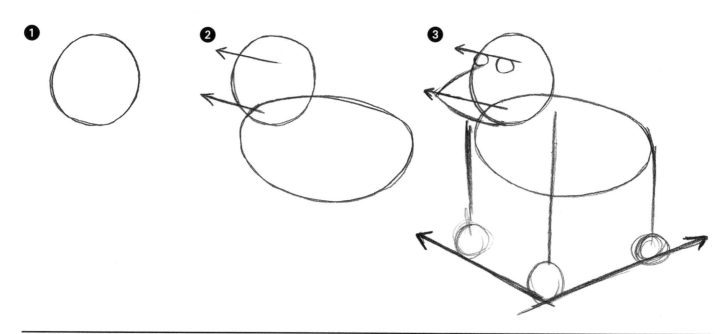

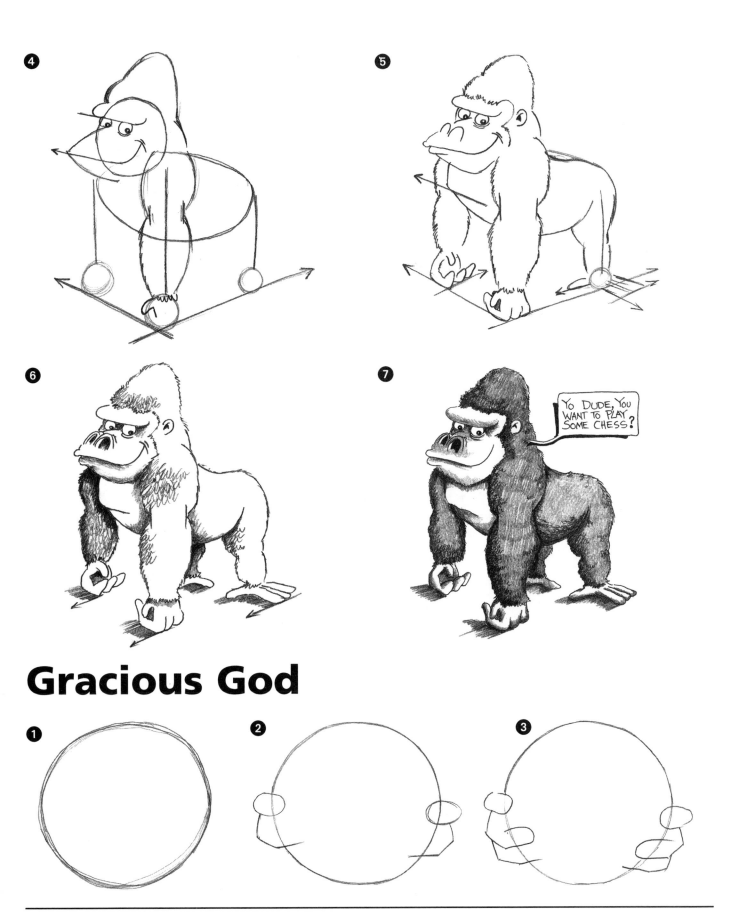

Gracious God

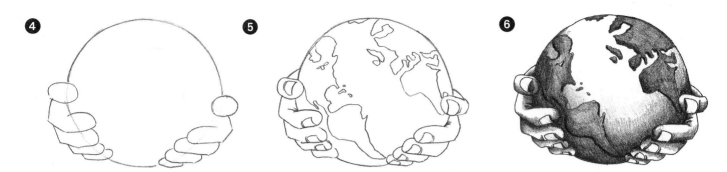

Grandiose Grin

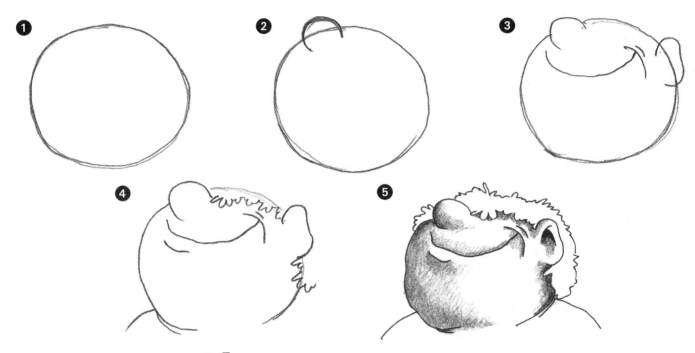

Grumpy Ghost

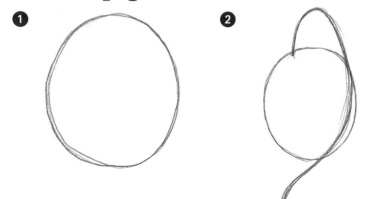
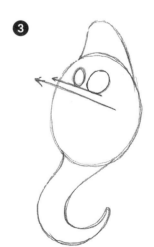

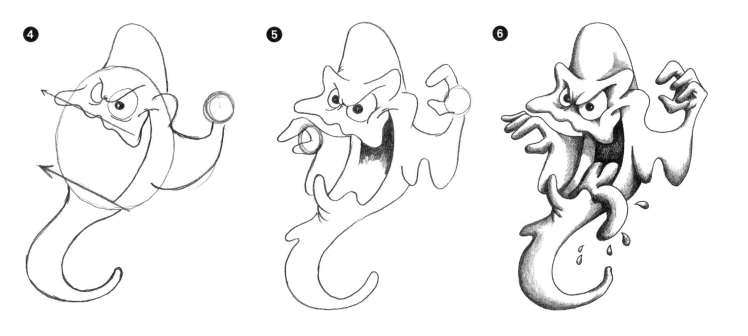

"H" Puff Cloud

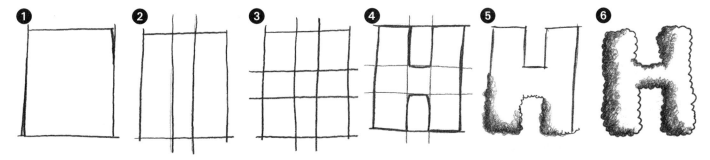

"H" Peeling Shadow

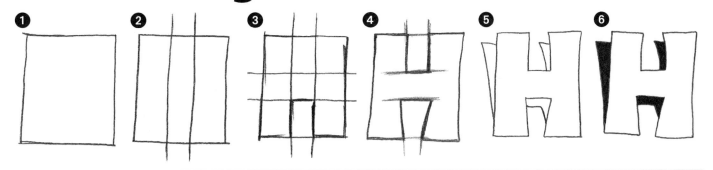

"H" Chiseled Stone

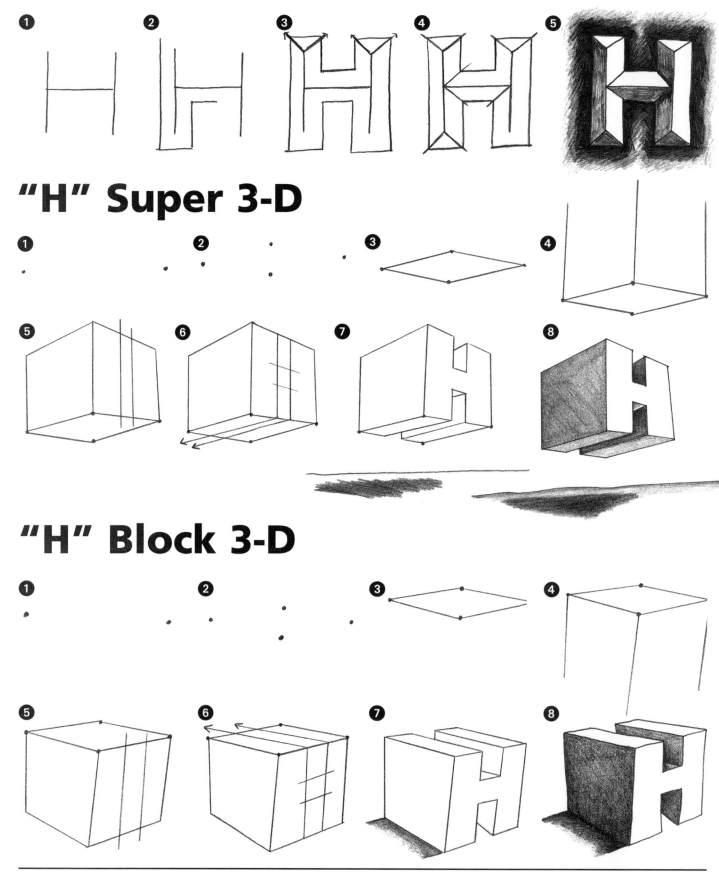

"H" Super 3-D

"H" Block 3-D

Ha! Ha! Ha!

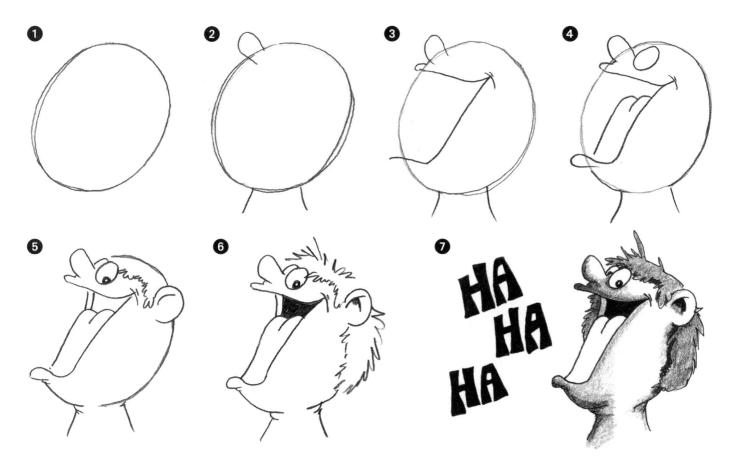

Heavy Helmet

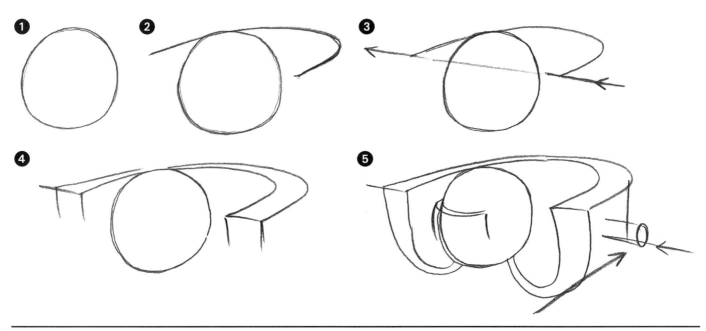

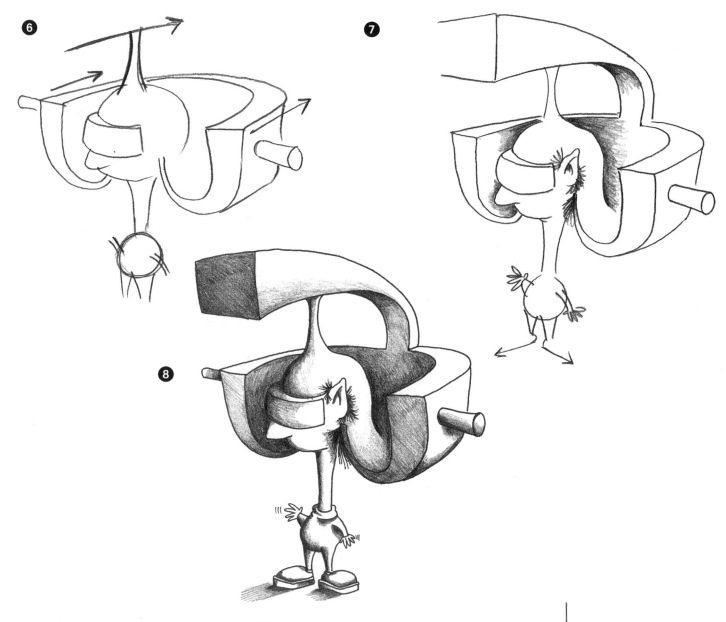

Hiccup Headquarters

①

②

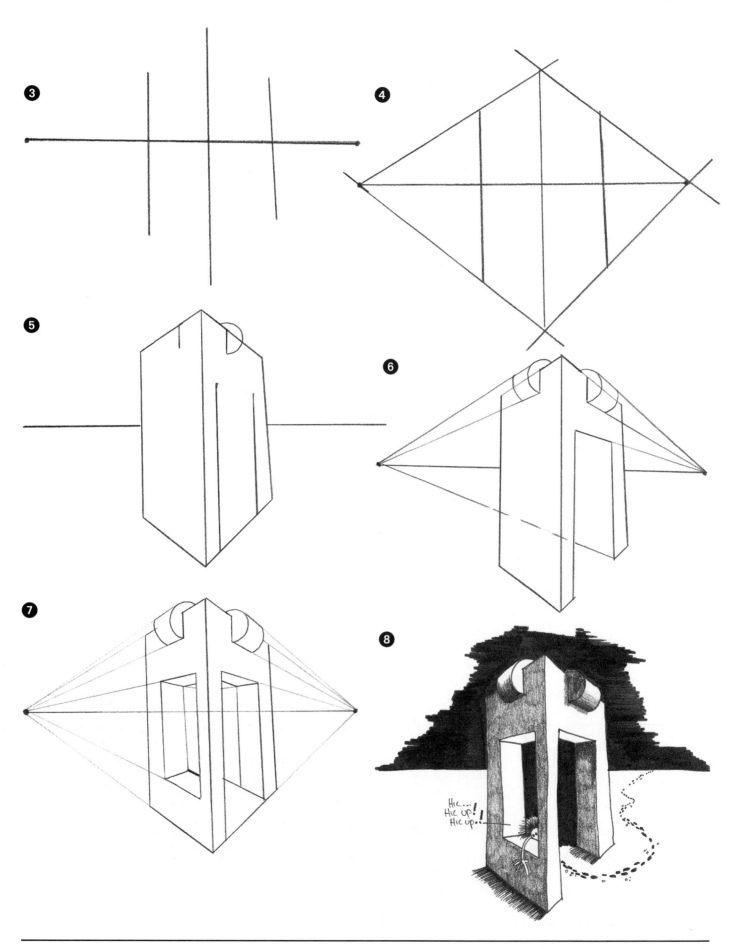

Hiding Henry

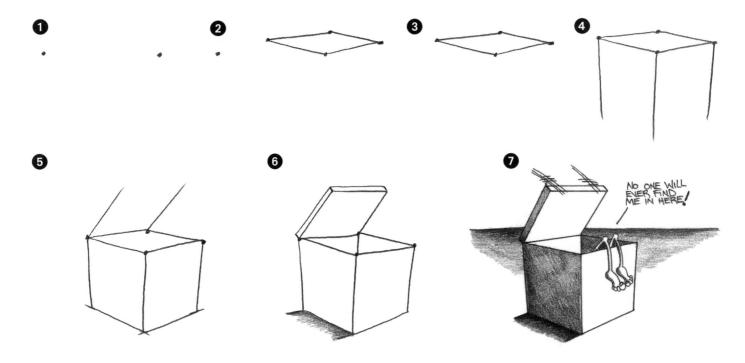

① ② ③ ④ ⑤ ⑥ ⑦

NO ONE WILL EVER FIND ME IN HERE!

House for a Mouse

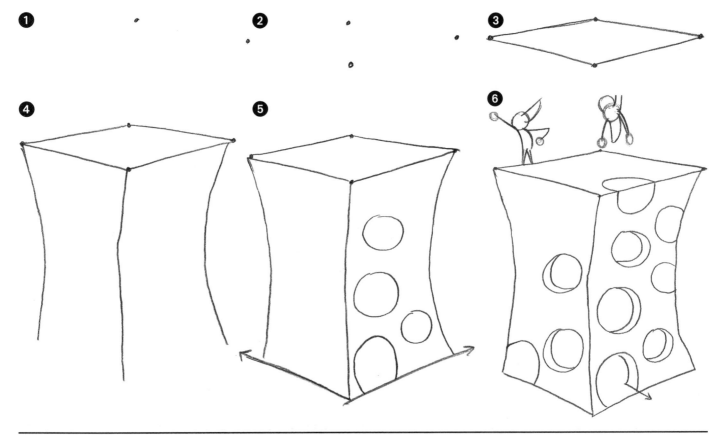

① ② ③ ④ ⑤ ⑥

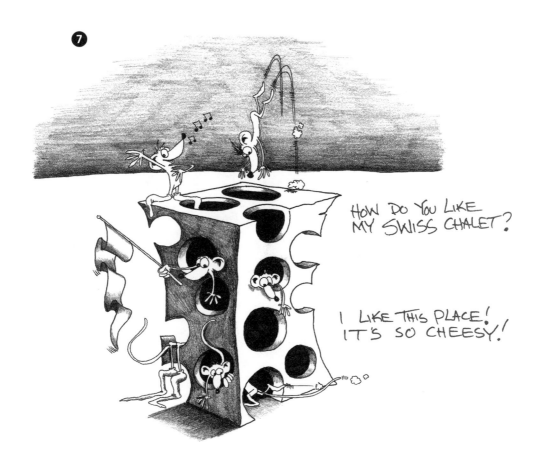

HOW DO YOU LIKE
MY SWISS CHALET?

I LIKE THIS PLACE!
IT'S SO CHEESY!

Huge Hand

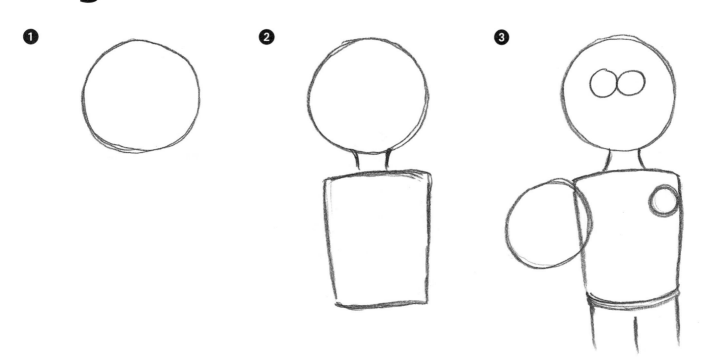

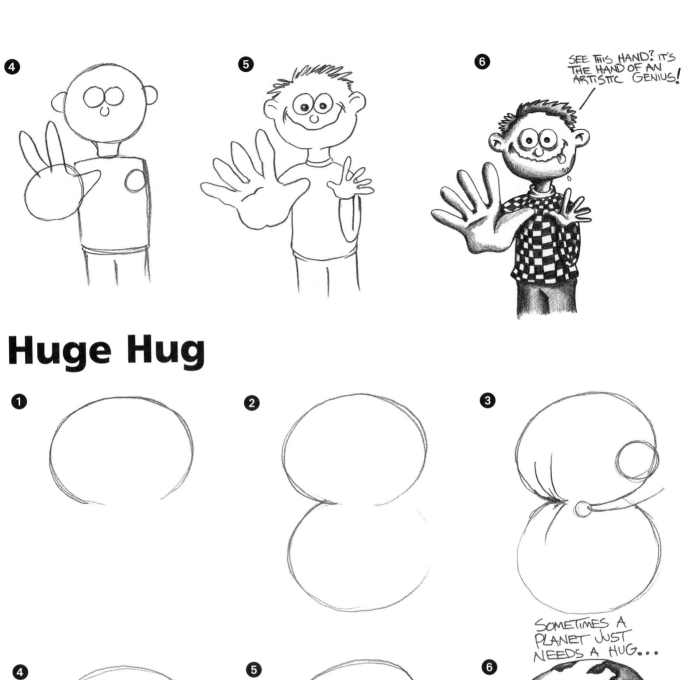

Huge Hug

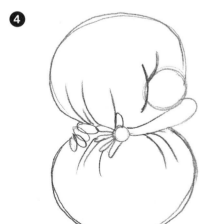

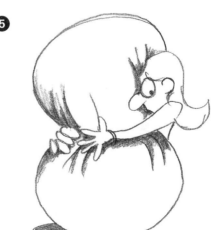

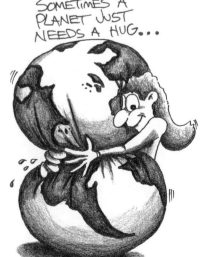

"I" Puff Cloud

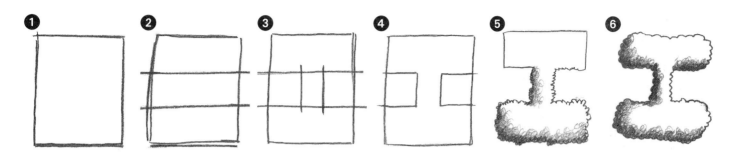

"I" Peeling Shadow

LOOK ME IN
THE "I"...

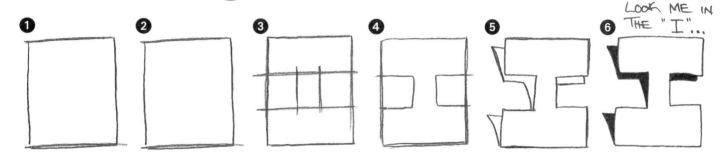

"I" Chiseled Stone

DON'T I
LOOK COOL?

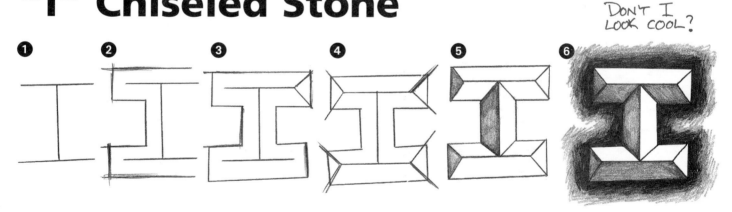

"I" Super 3-D

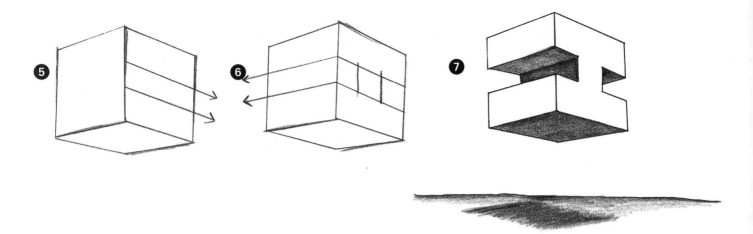

"I" Block 3-D

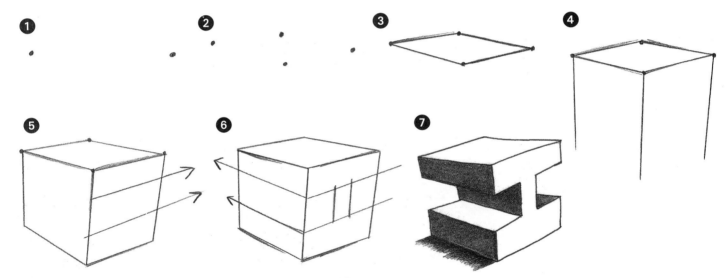

Idea Encyclopedia

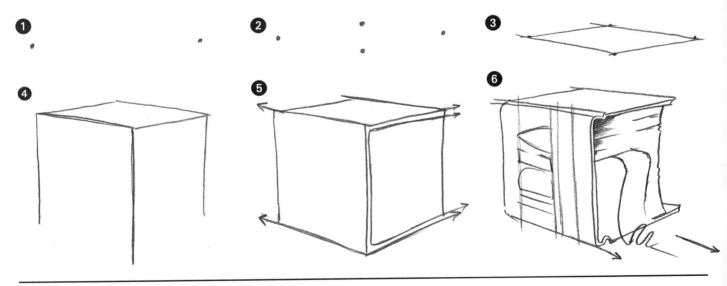

⑦

I BOOKMARKED "I" FOR "IMPLEMENT IDEAS IN IMAGES!"

Illuminating Idea

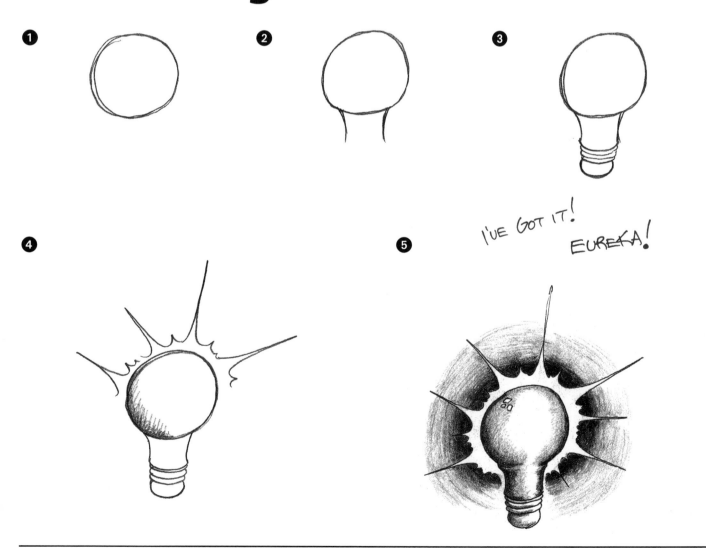

① ② ③

④ ⑤

I'VE GOT IT!

EUREKA!

Intellectual Insect

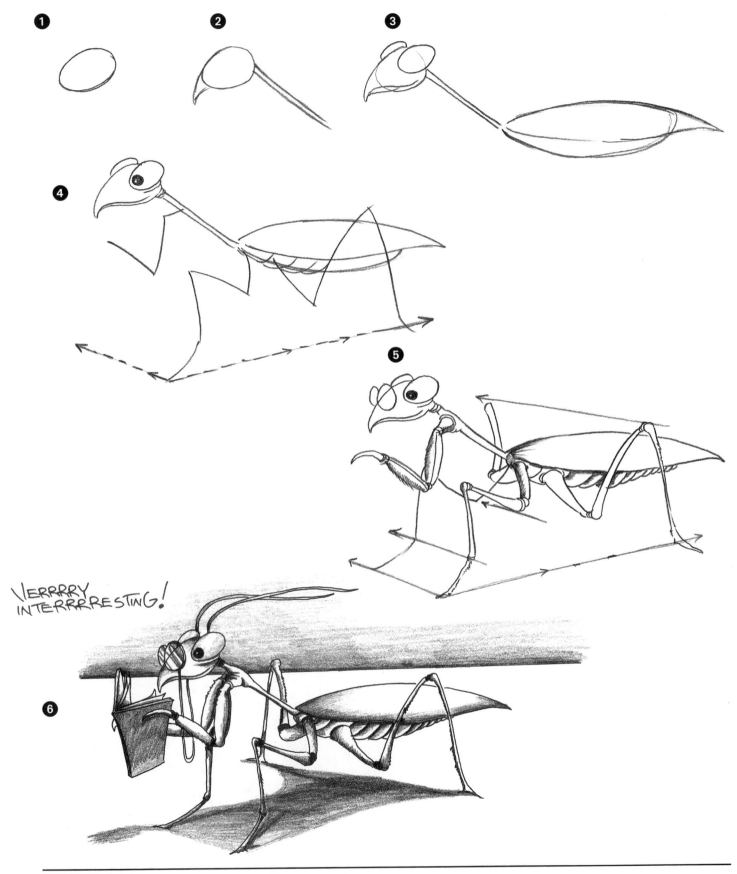

VERRRRY INTERRRRESTING!

I. Q. Icon

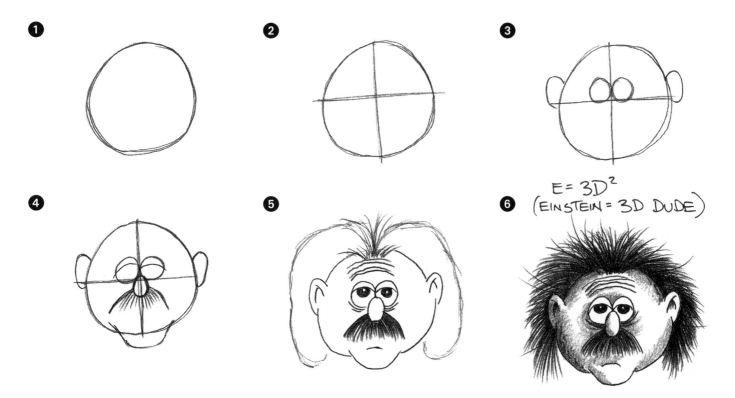

① ② ③

④ ⑤ ⑥

$$E = 3D^2$$
(EINSTEIN = 3D DUDE)

Island Inhabitant

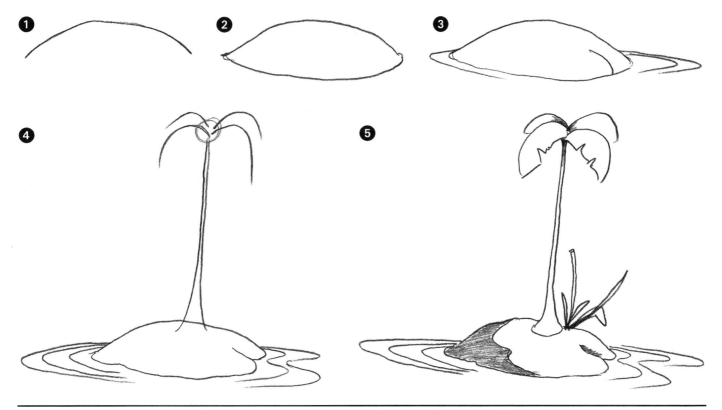

① ② ③

④ ⑤

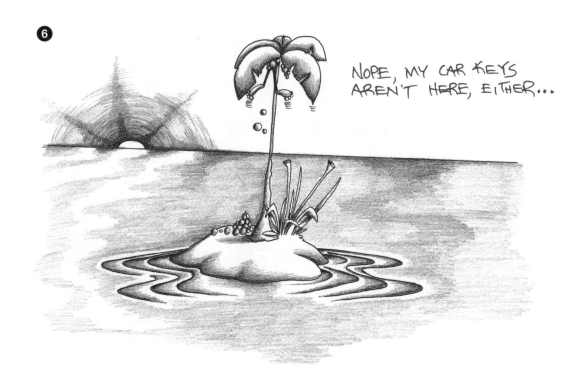

NOPE, MY CAR KEYS AREN'T HERE, EITHER...

"J" Puff Cloud

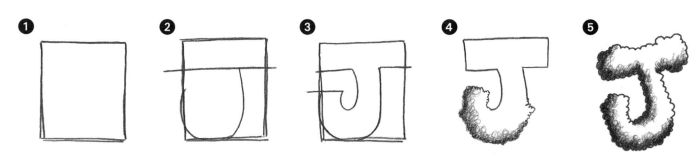

"J" Peeling Shadow

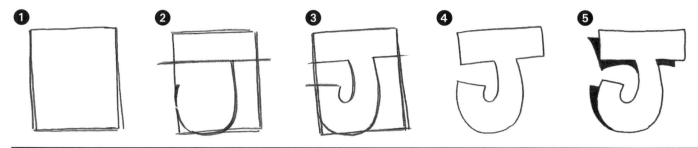

"J" Chiseled

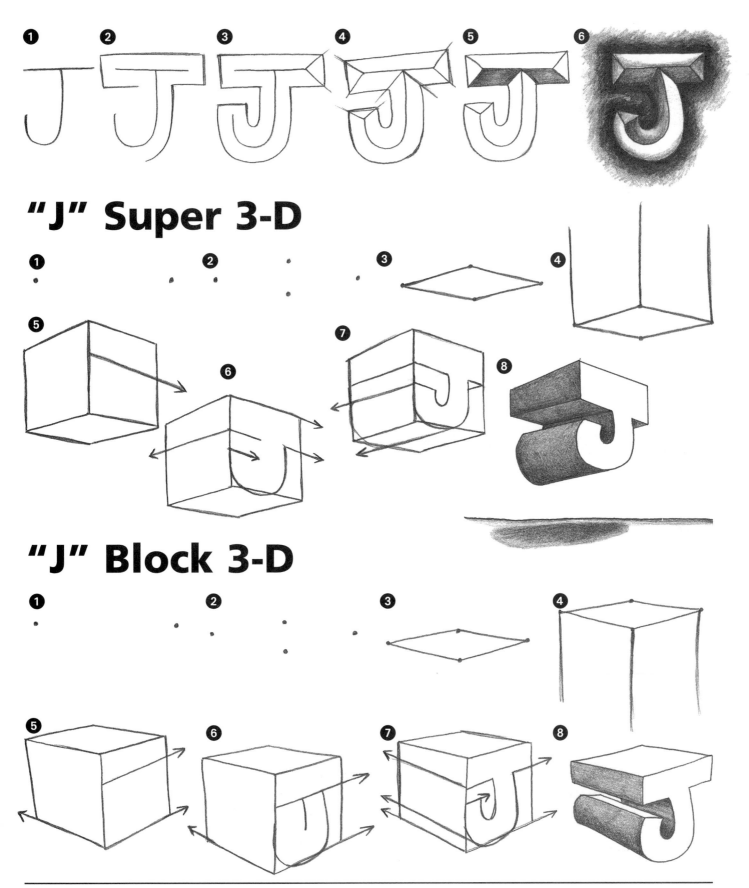

"J" Super 3-D

"J" Block 3-D

Jesus

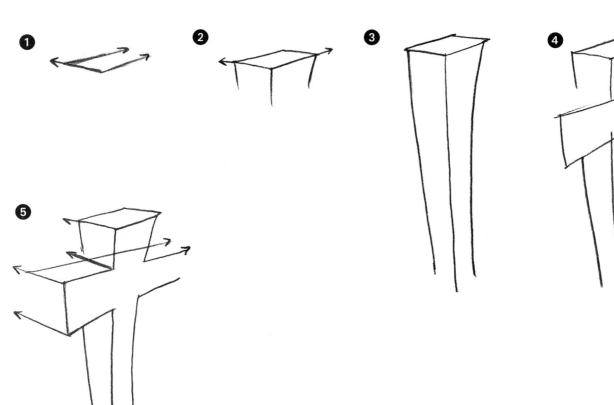

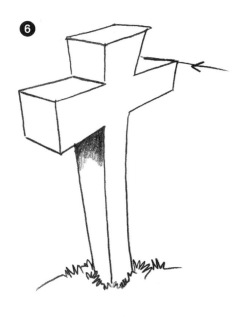

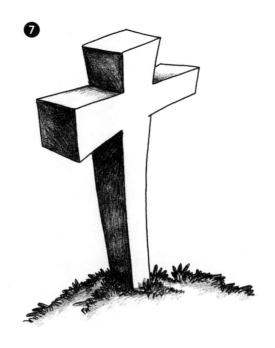

Jiggling Jellyfish

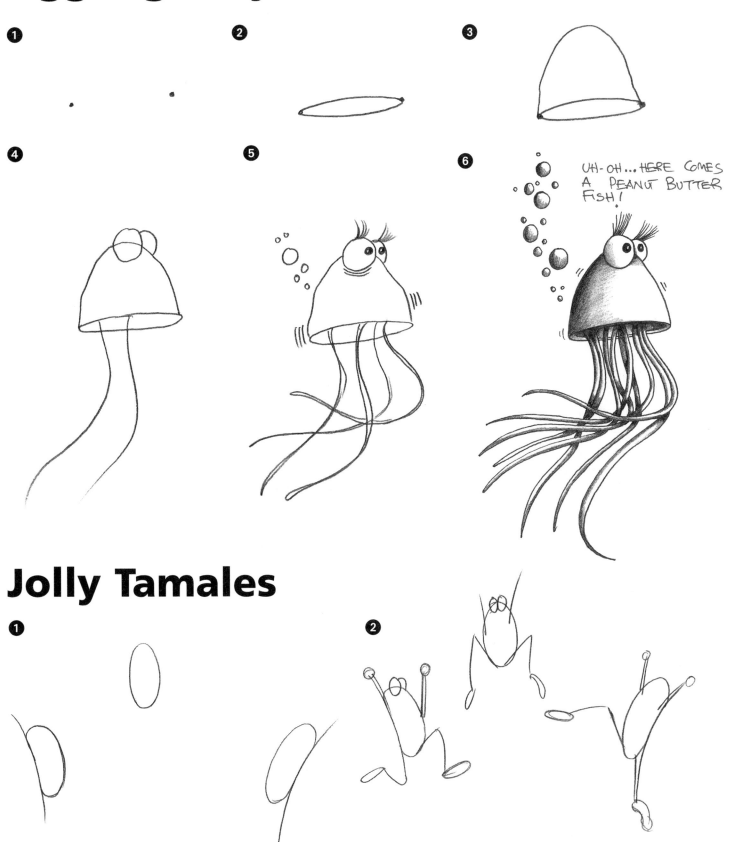

① ② ③

④ ⑤ ⑥

UH-OH...HERE COMES A PEANUT BUTTER FISH!

Jolly Tamales

① ②

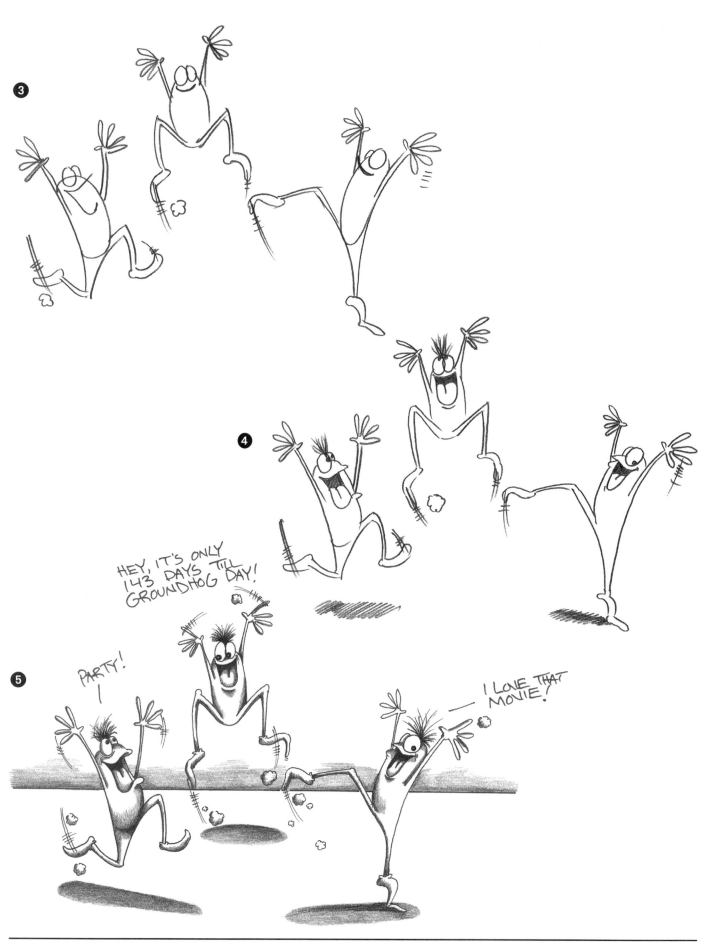

Jumbo Jogger

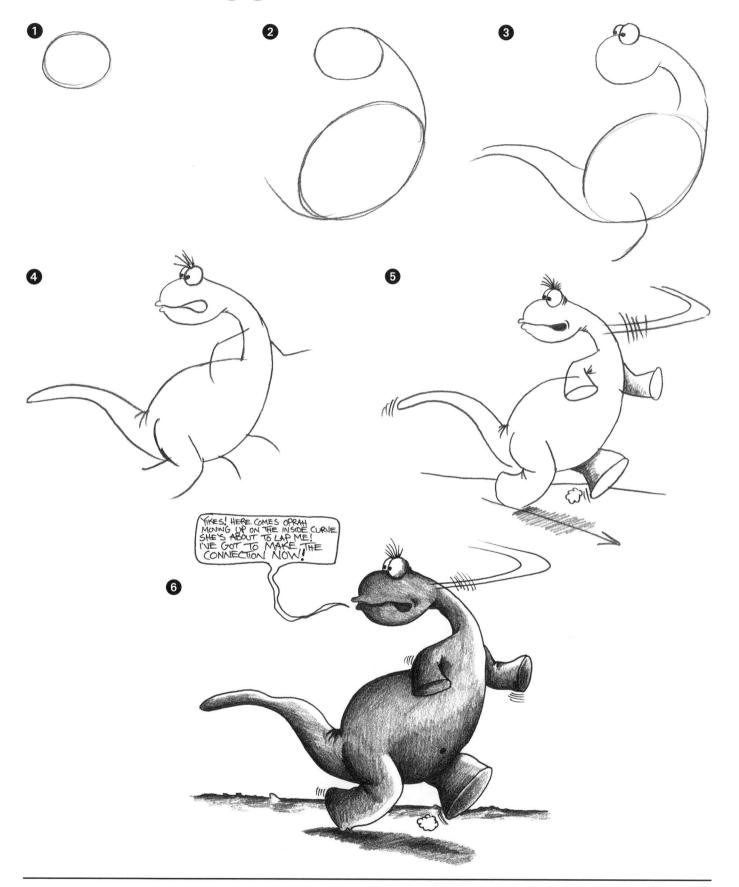

Jumping Jack

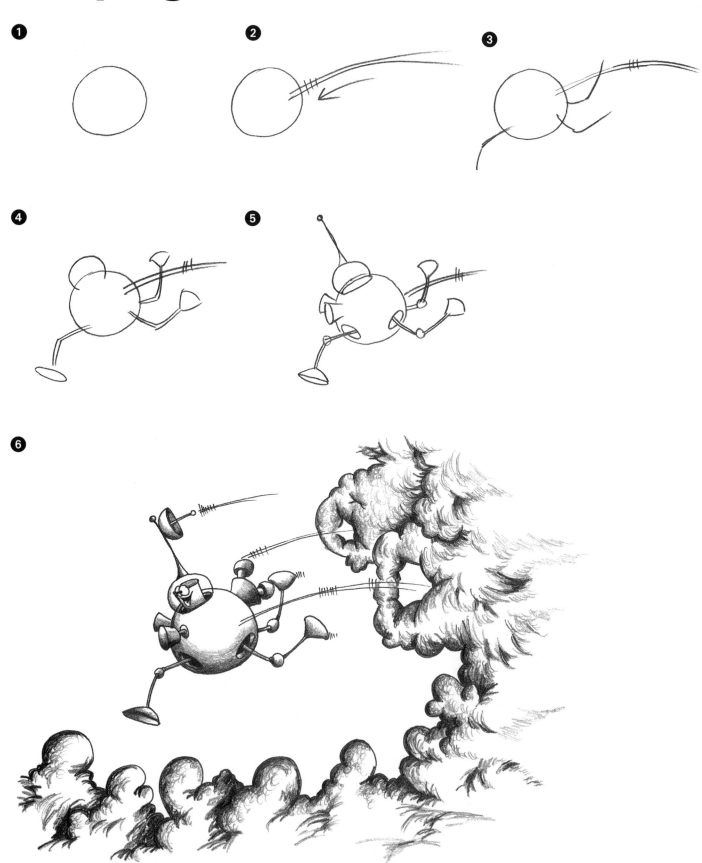

1

2

3

4

5

6

"K" Puff Cloud

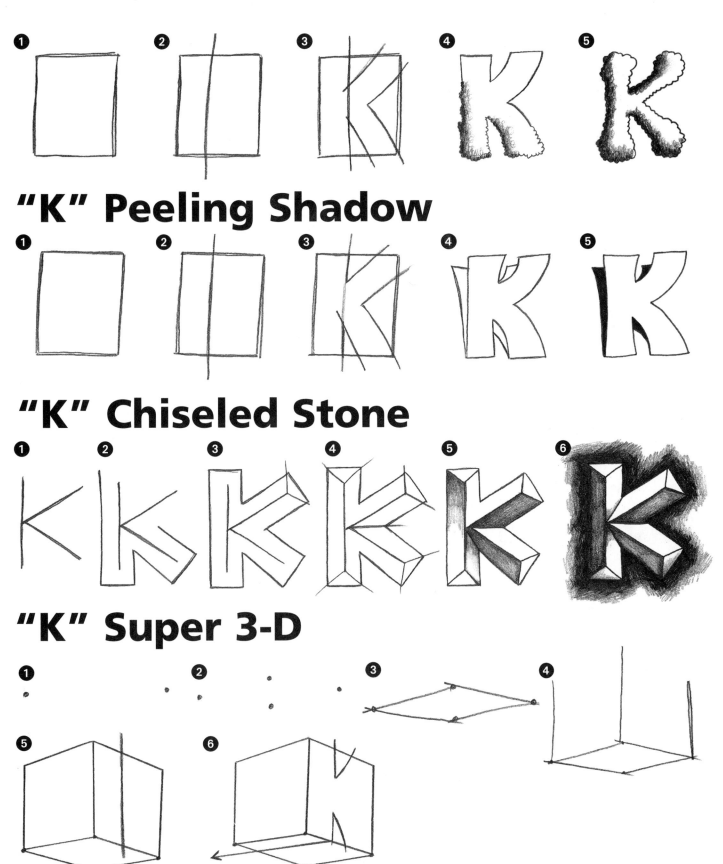

"K" Peeling Shadow

"K" Chiseled Stone

"K" Super 3-D

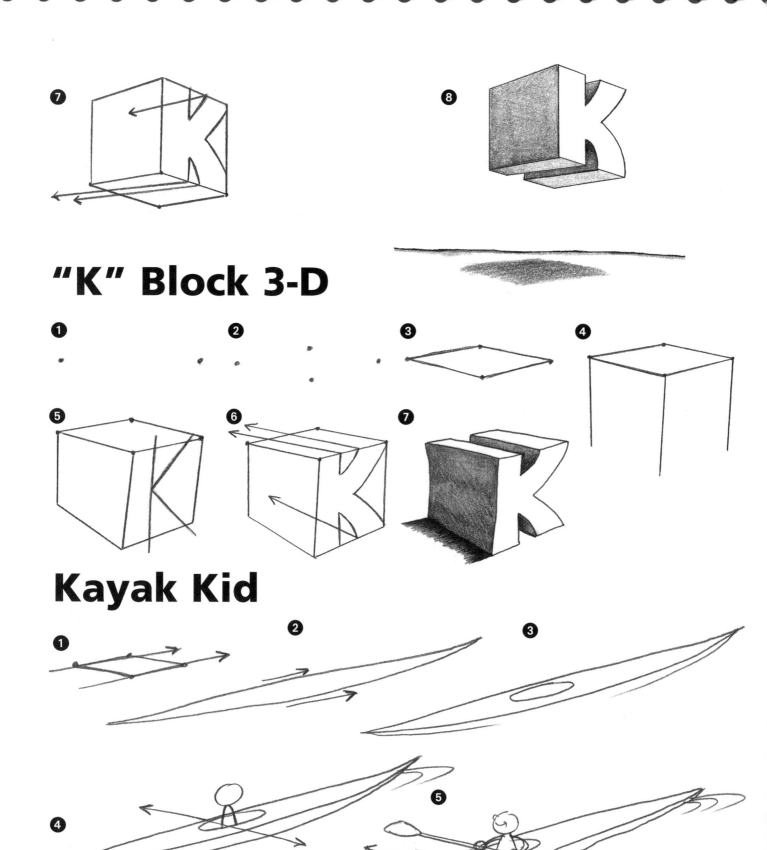

"K" Block 3-D

Kayak Kid

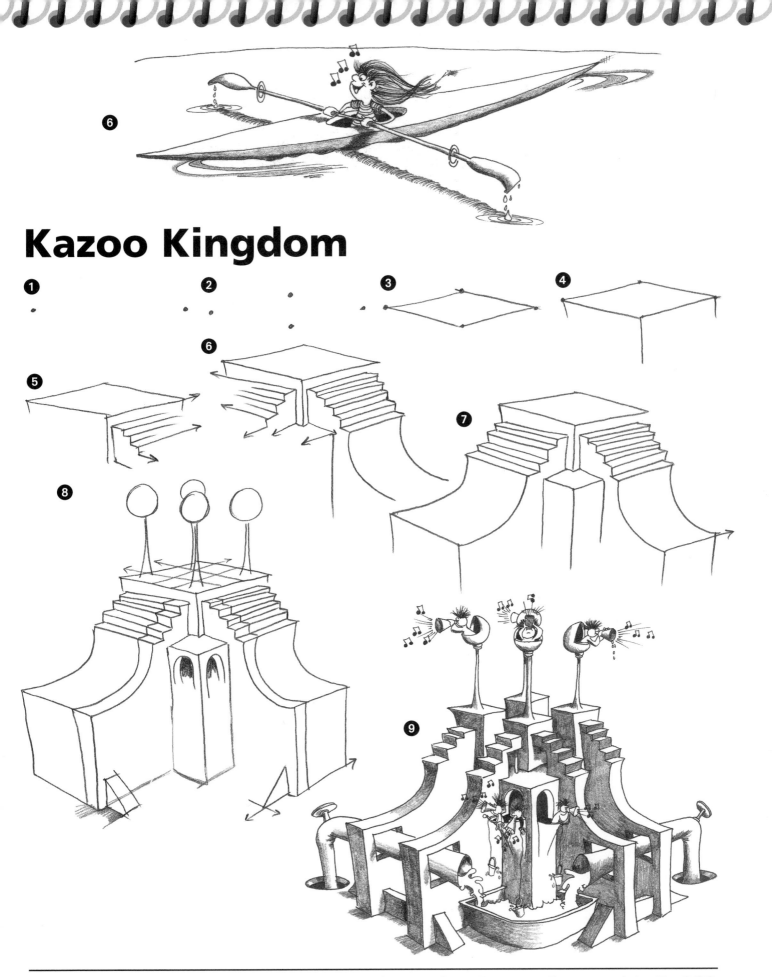

Kazoo Kingdom

Kissing Killers

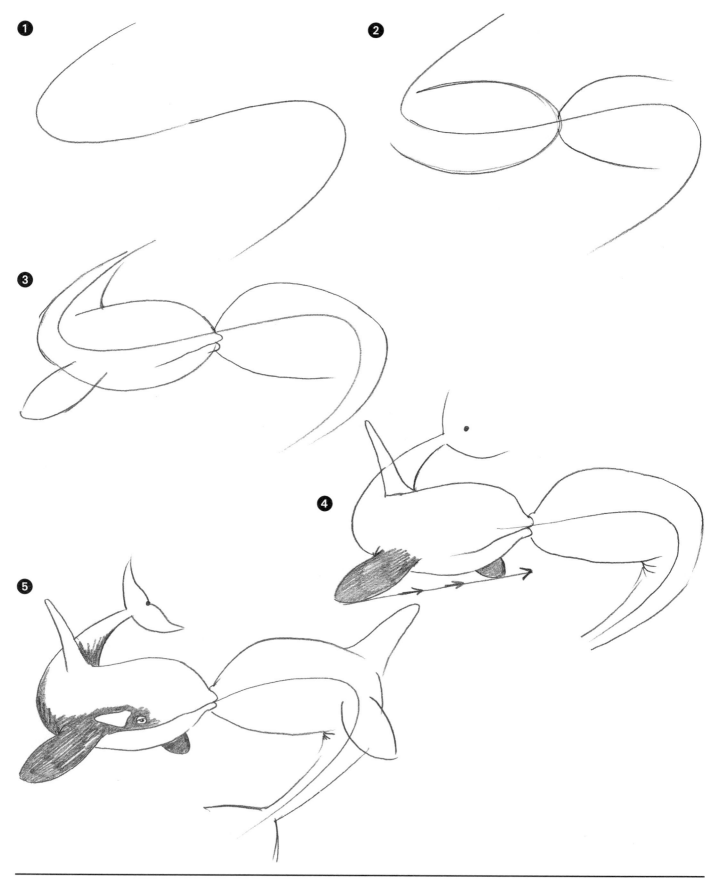

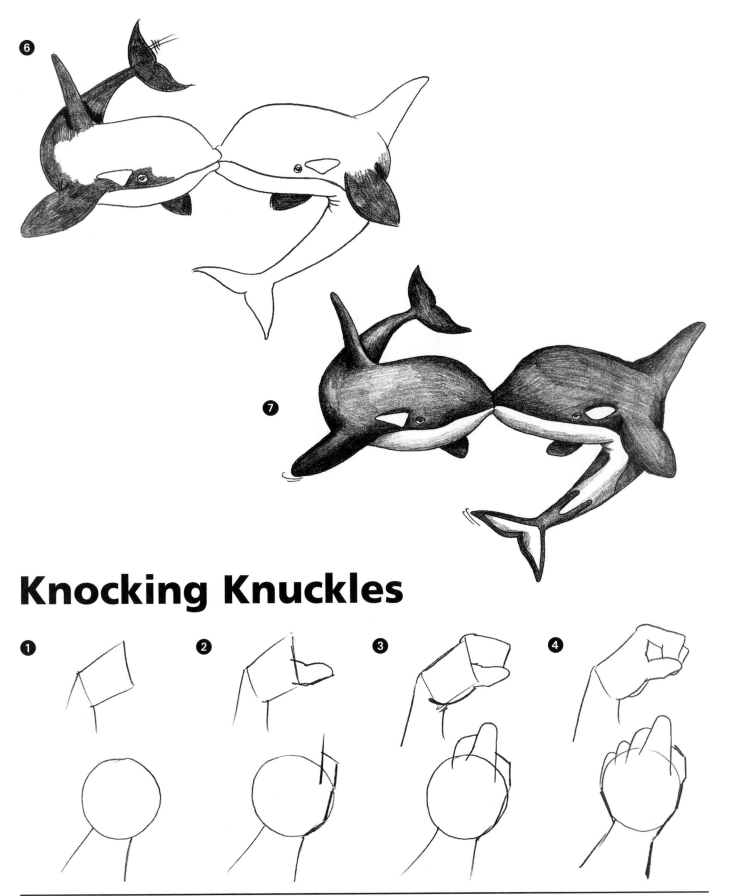

Knocking Knuckles

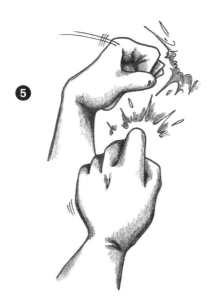

Kooky Keyhole

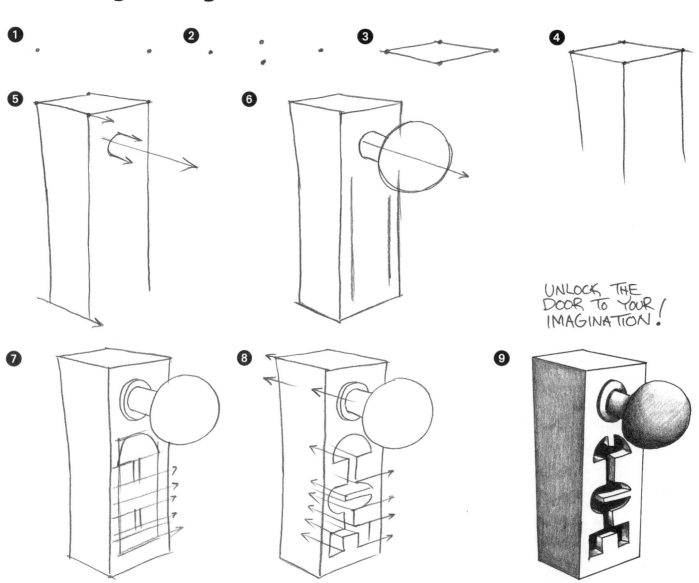

UNLOCK THE
DOOR TO YOUR
IMAGINATION!

"L" Puff Cloud

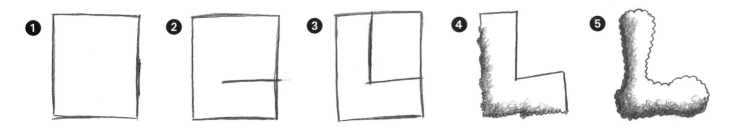

"L" Peeling Shadow

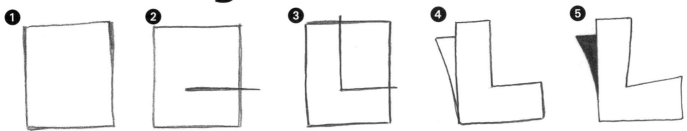

"L" Chiseled Stone

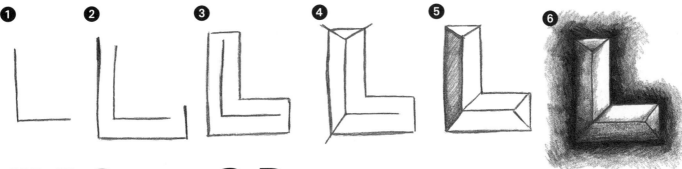

"L" Super 3-D

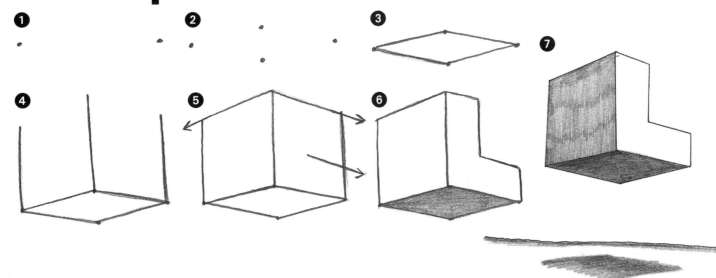

"L" Block 3-D

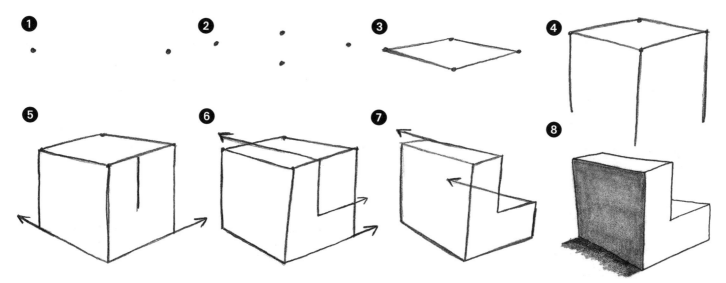

Large Labyrinth

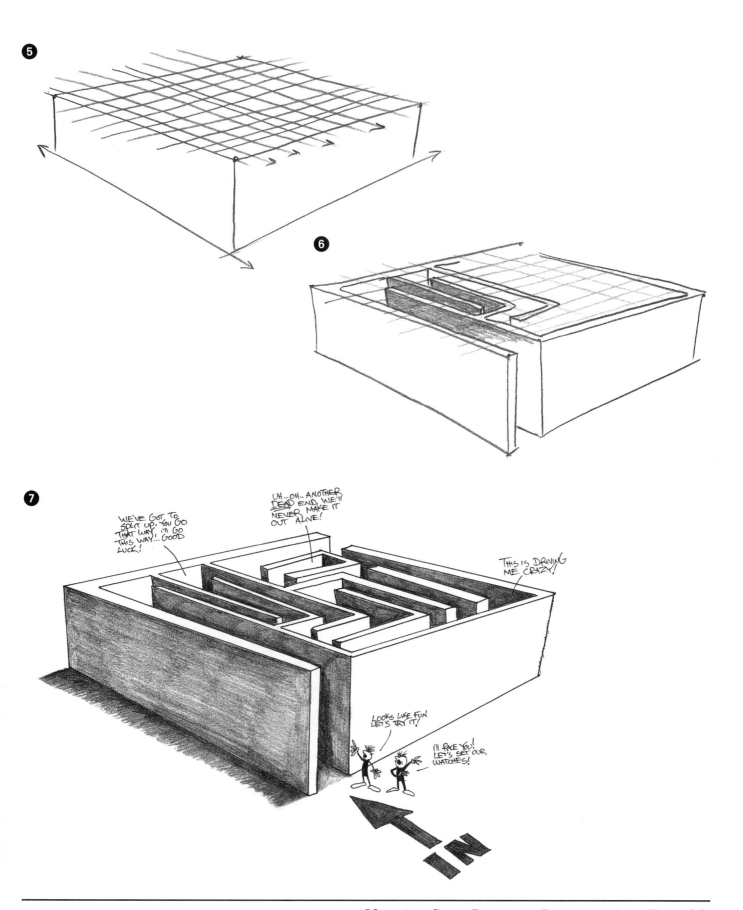

Launch Lever

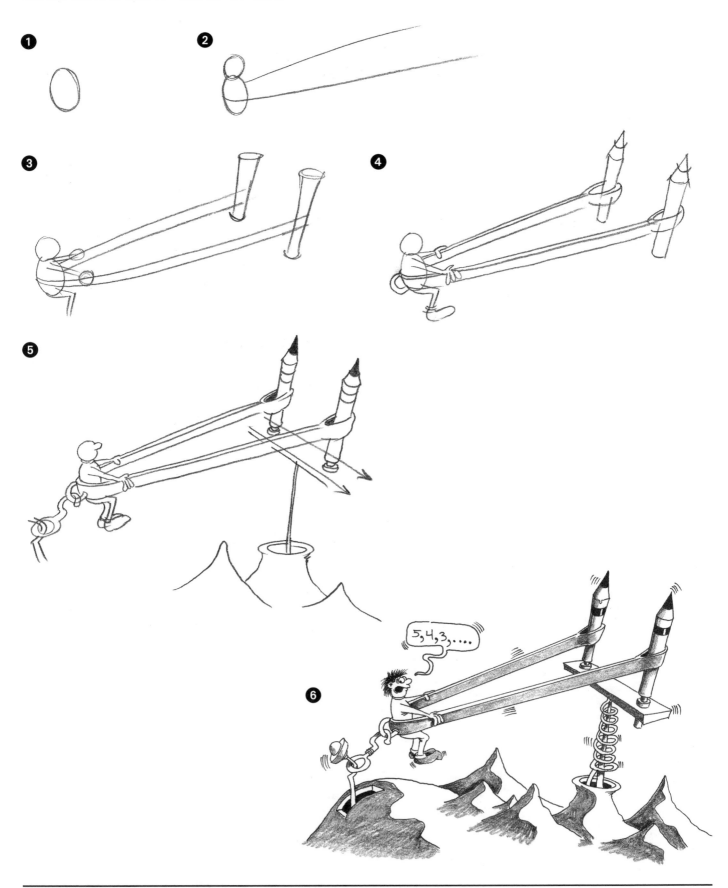

Leering Lasagna

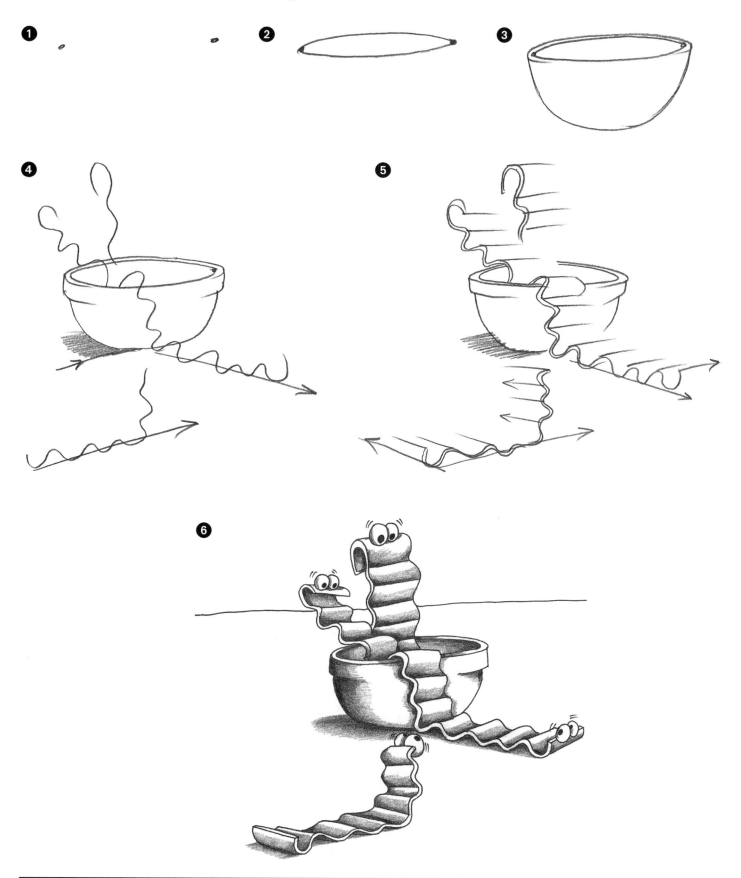

Long Links

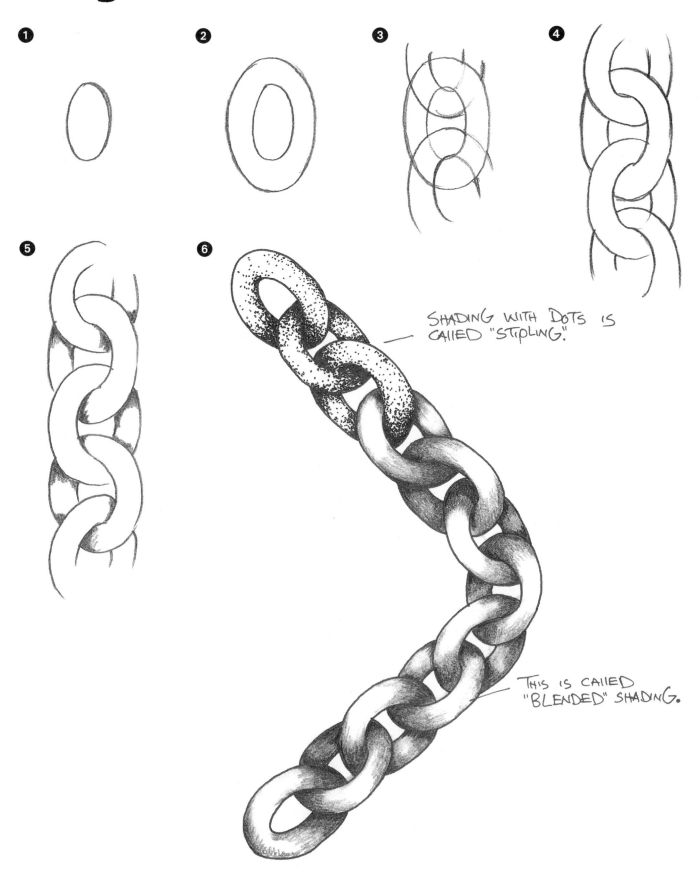

① ② ③ ④

⑤ ⑥

SHADING WITH DOTS IS
CALLED "STIPLING."

THIS IS CALLED
"BLENDED" SHADING.

Lunging Lizard

1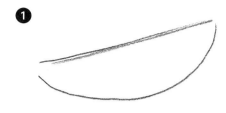

2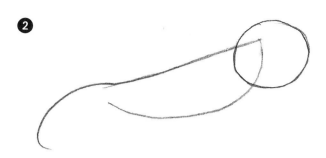

3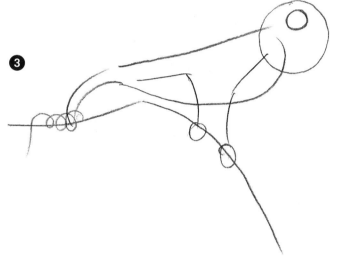

4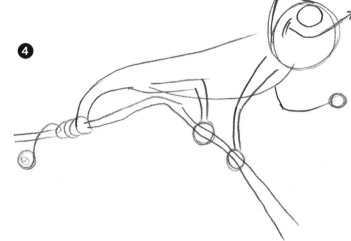

5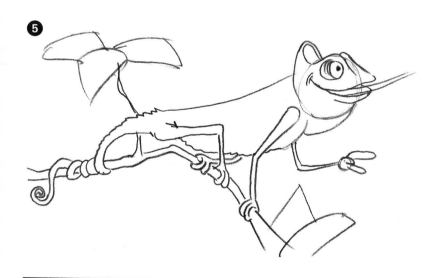

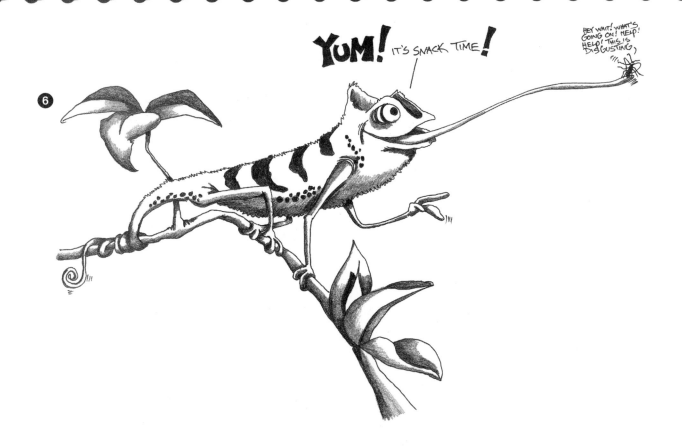

"M" Puff Cloud

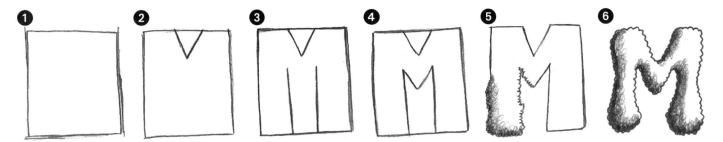

"M" Peeling Shadow

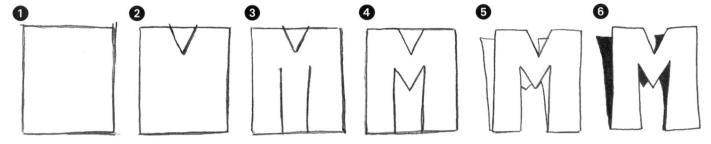

"M" Chiseled Stone

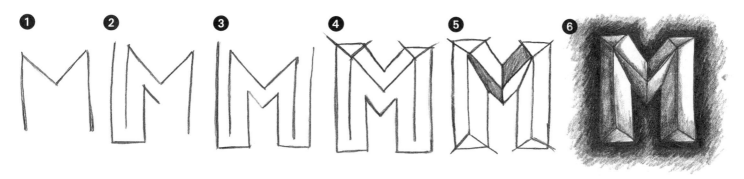

"M" Super 3-D

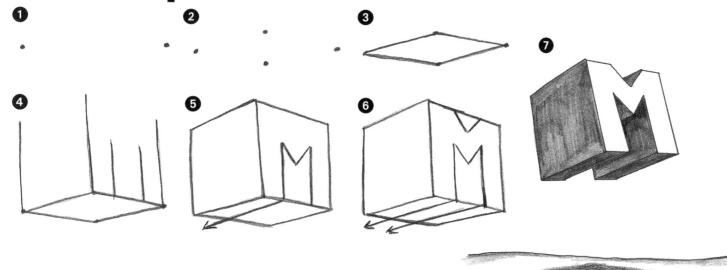

"M" Block 3-D

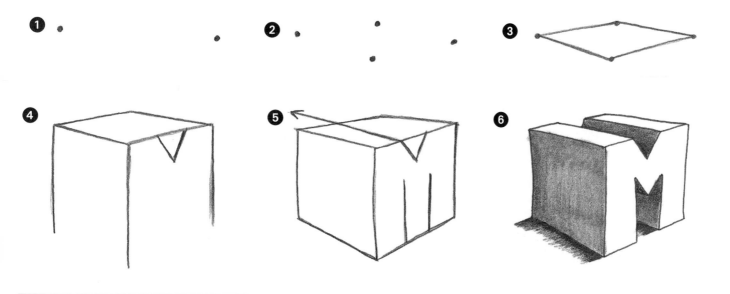

Magnificent Macaroni

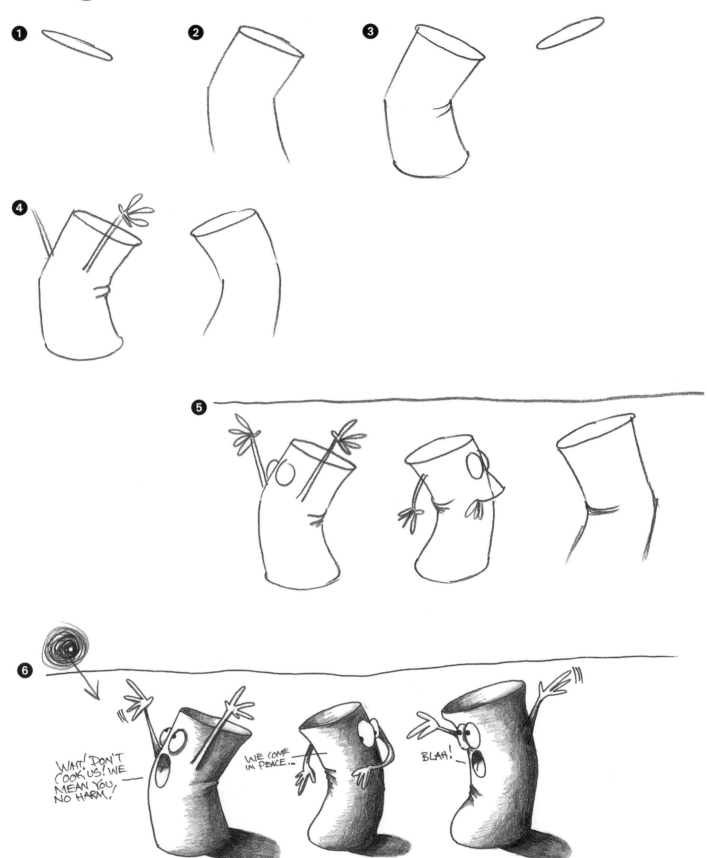

Maniac Mouse

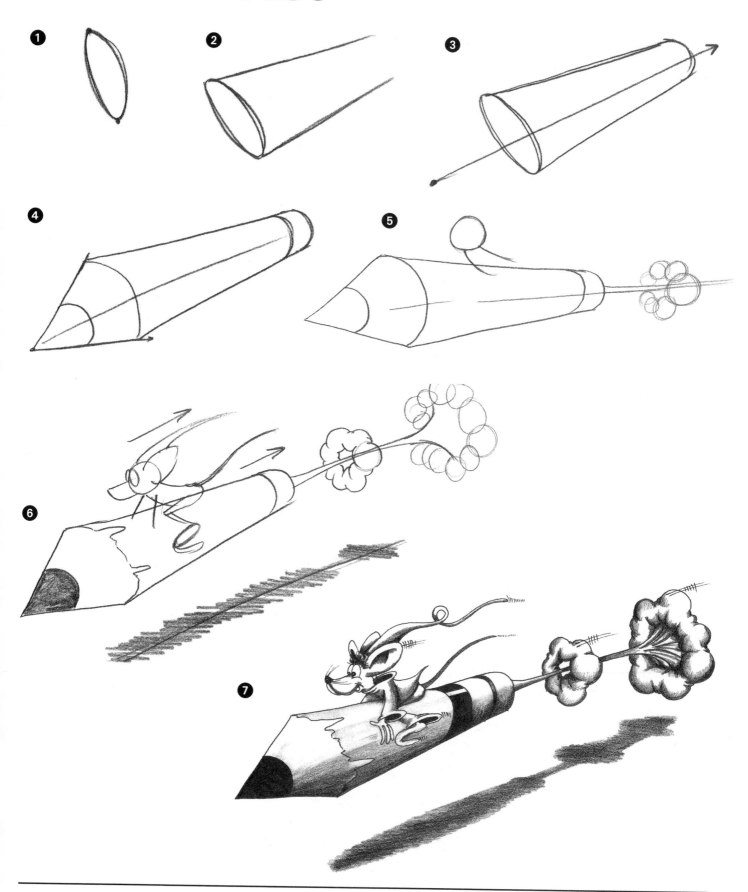

Meandering Manatee

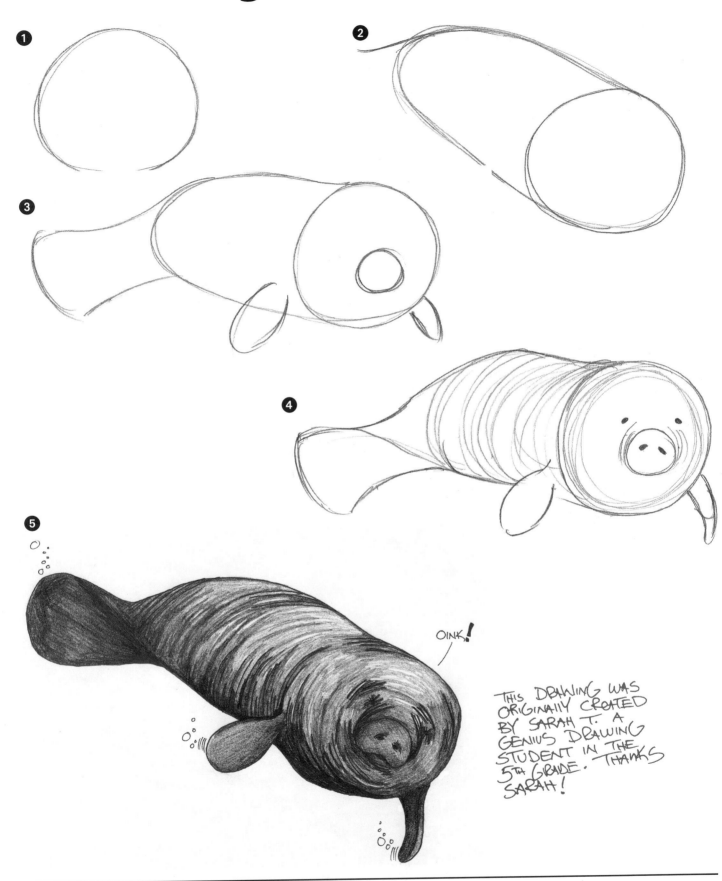

1

2

3

4

5

OINK!

THIS DRAWING WAS
ORIGINALLY CREATED
BY SARAH T. A
GENIUS DRAWING
STUDENT IN THE
5TH GRADE. THANKS
SARAH!

Migrating Martian

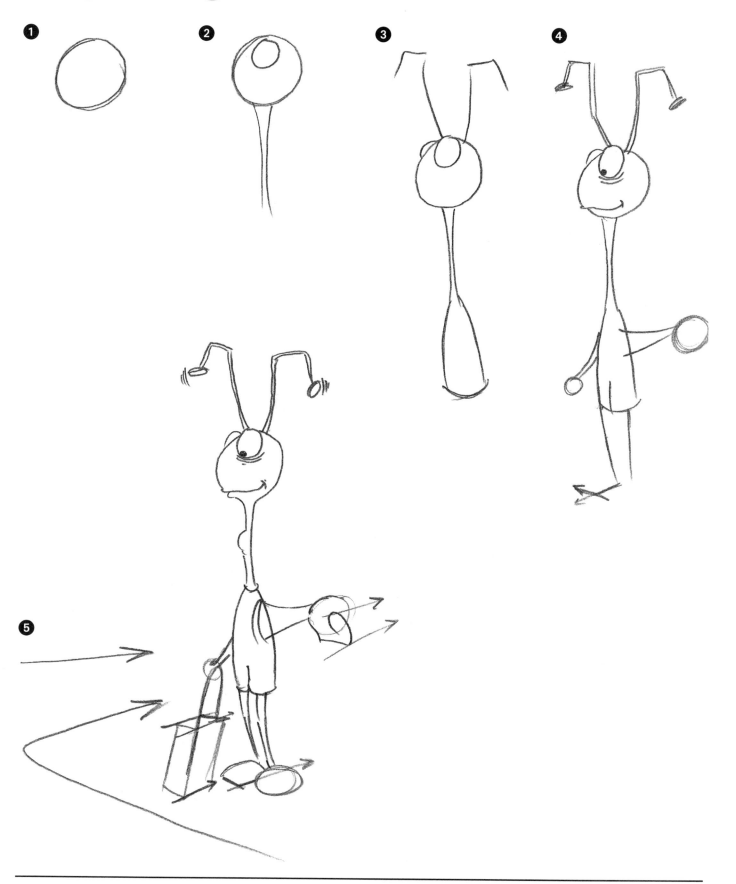

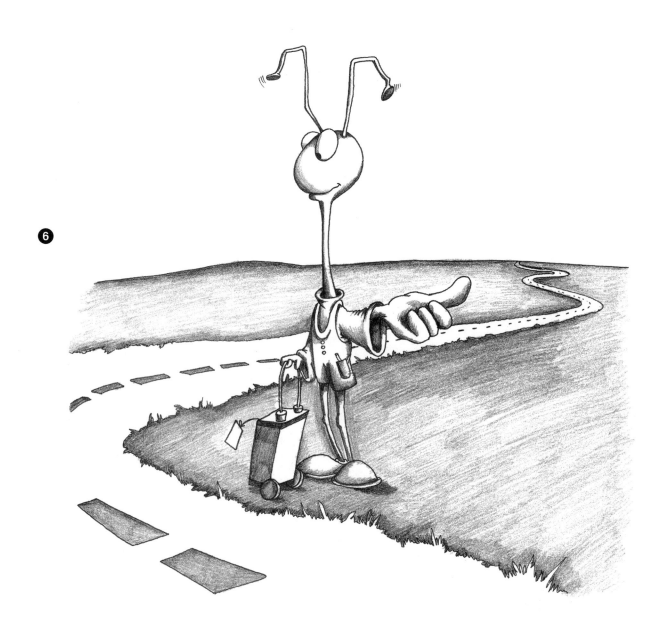

6

Moon Mobile

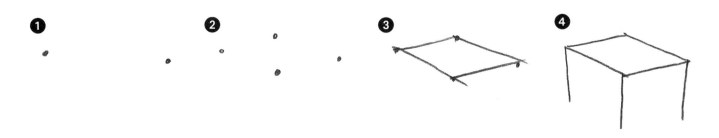

1 **2** **3** **4**

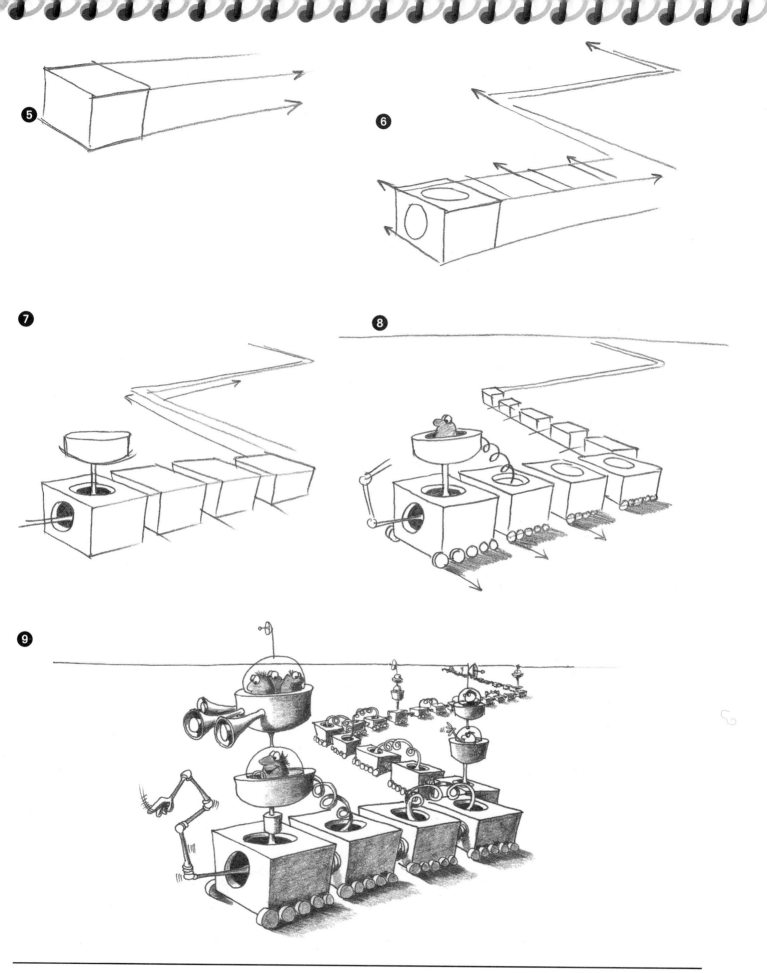

"N" Puff Cloud

"N" Peeling Shadow

"N" Chiseled Stone

"N" Super 3-D

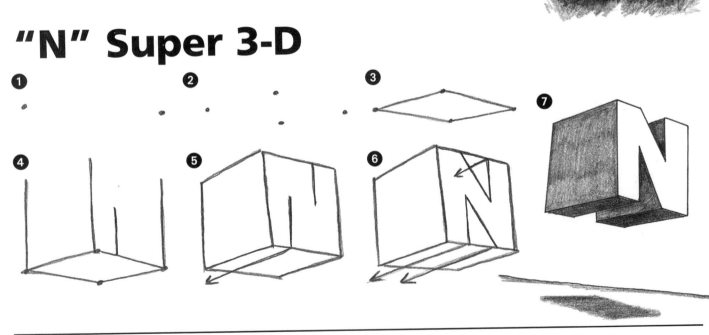

"N" Block 3-D

Near NASA

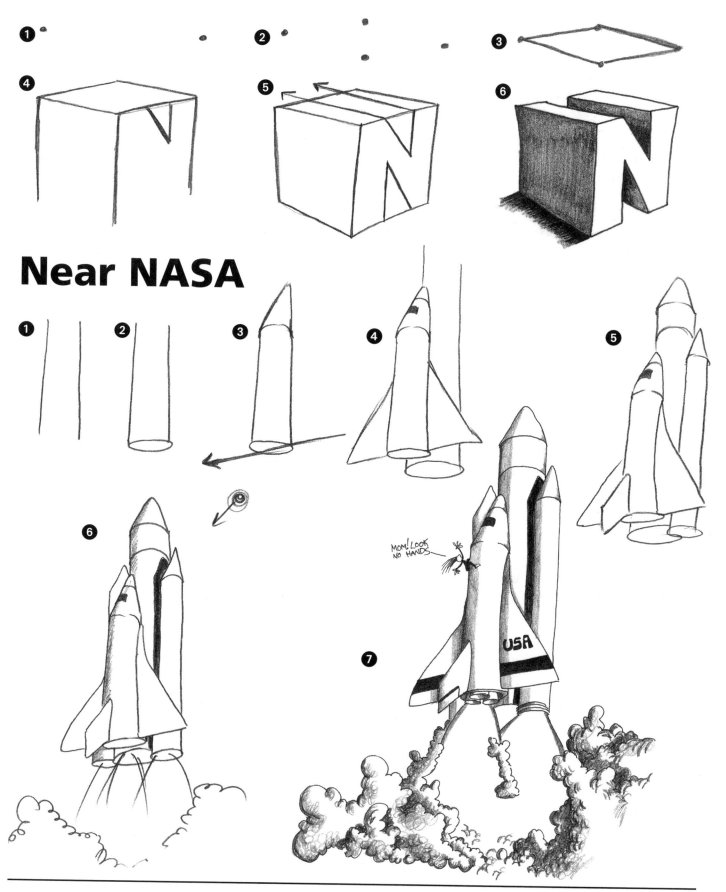

MOM! LOOK NO HANDS

USA

Neptune Ned

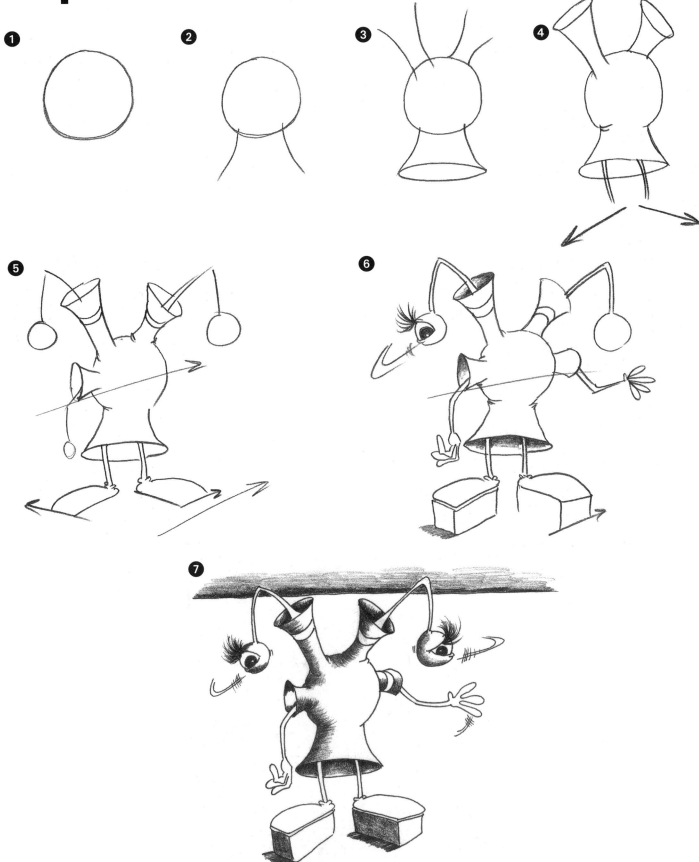

Nice Neanderthal

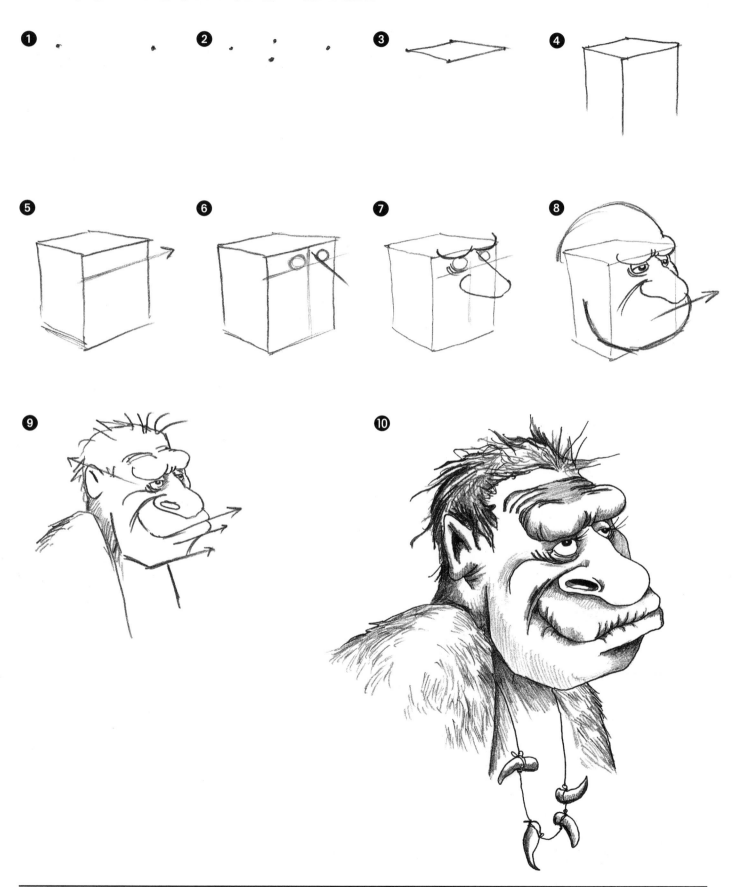

Nine Nostrils

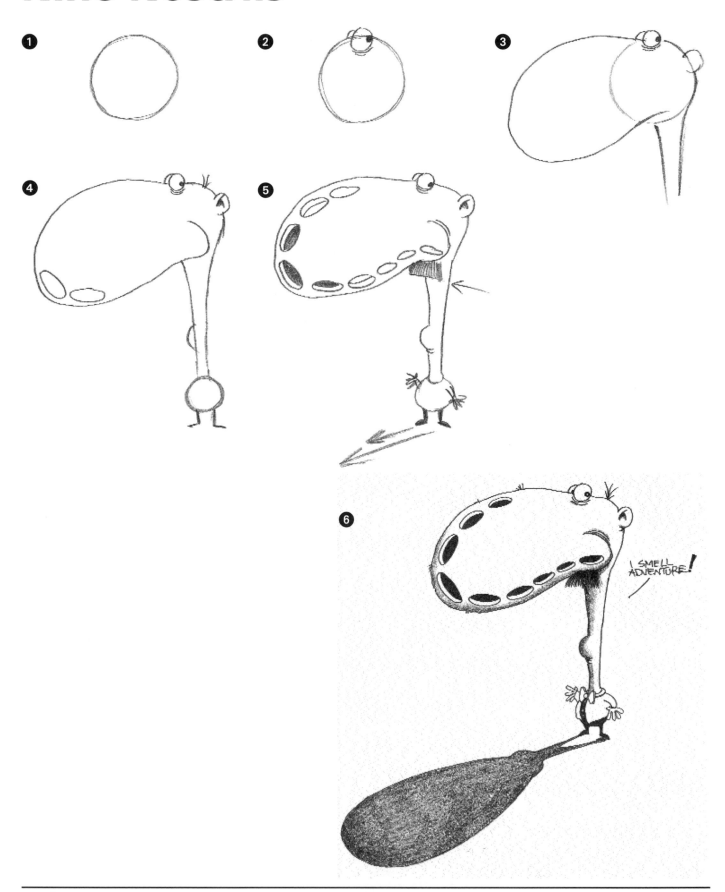

❶

❷

❸

❹

❺

❻

I SMELL ADVENTURE!

Noisy Nest

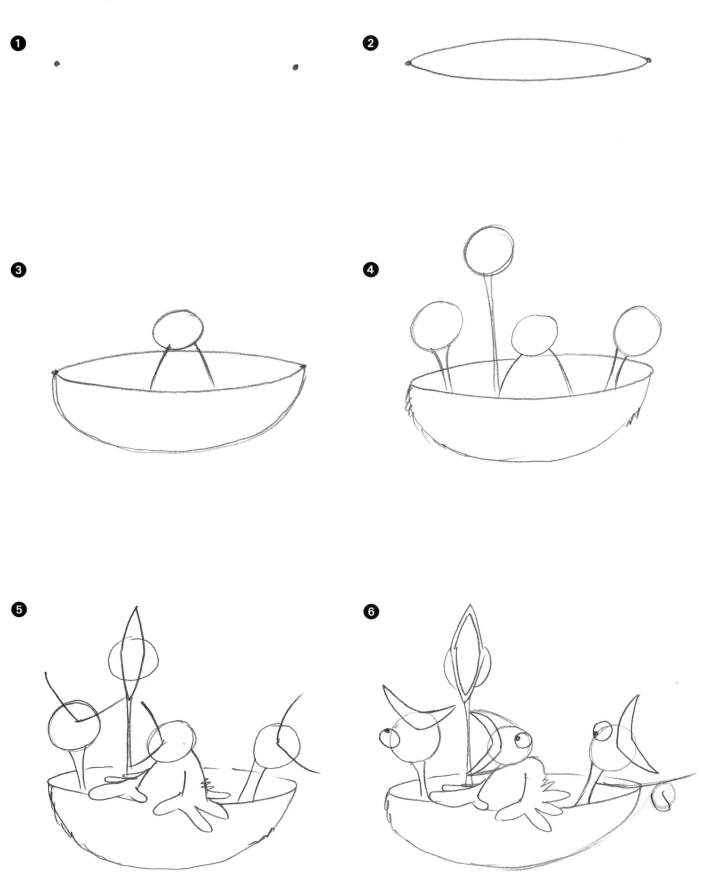

❶

❷

❸

❹

❺

❻

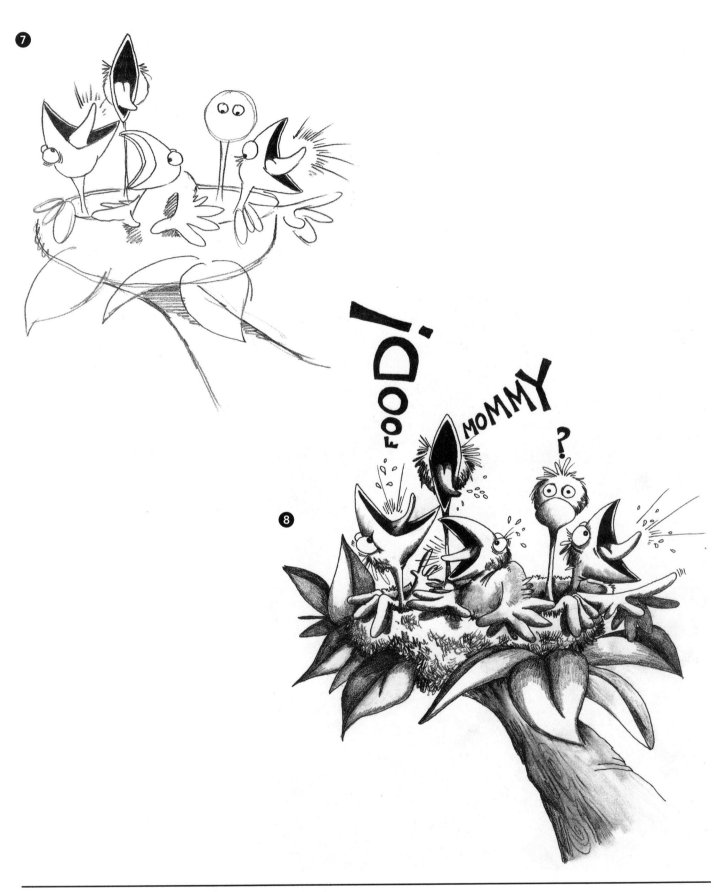

"O" Puff Cloud

"O" Peeling Shadow

"O" Chiseled Stone

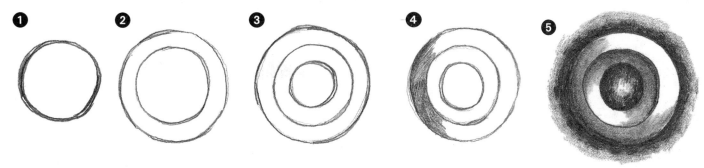

"O" Super 3-D

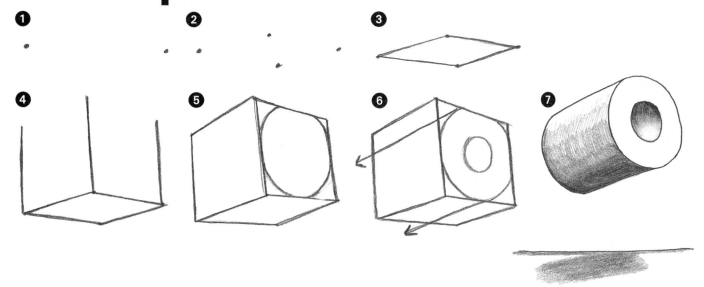

"O" Block 3-D

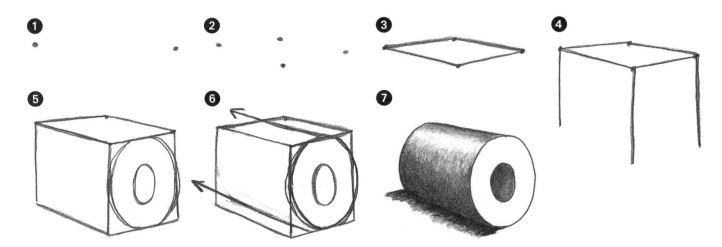

Okey Dokey

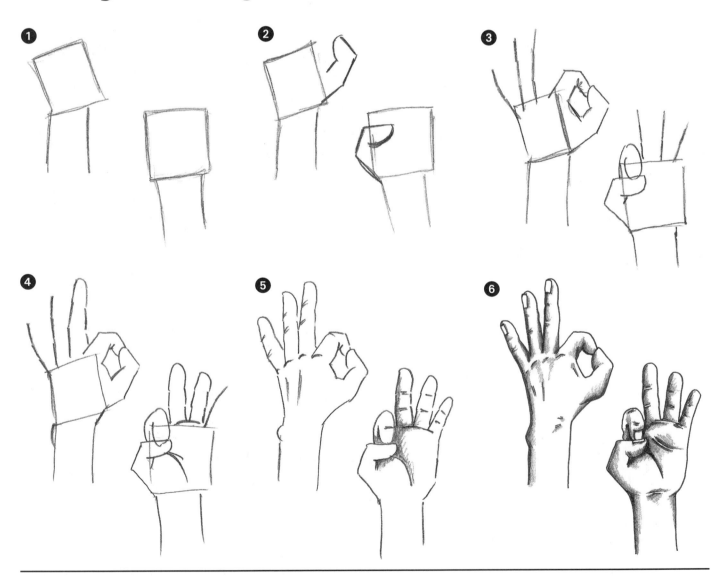

Oooops!

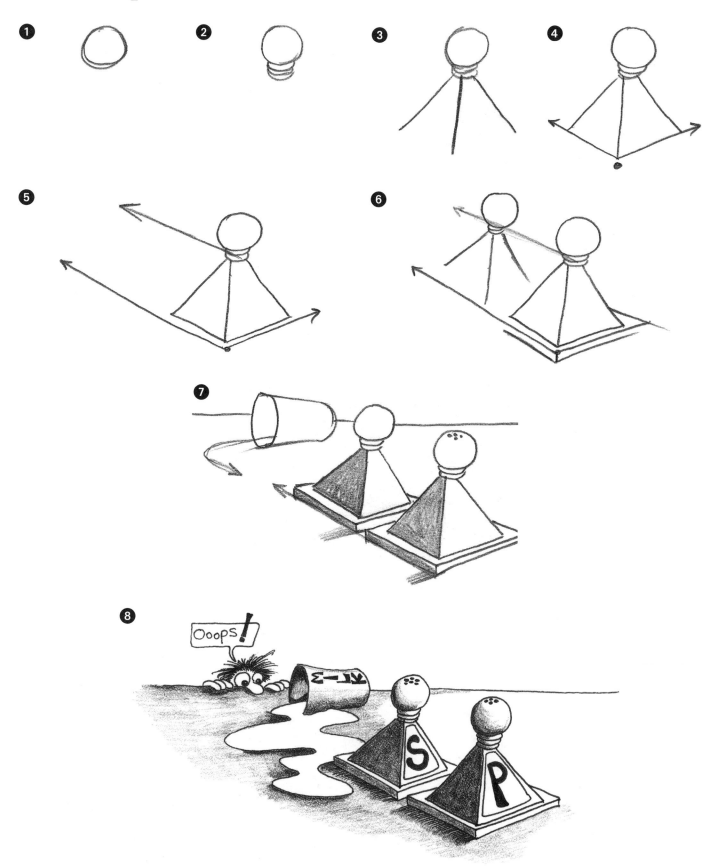

Oriental Othello

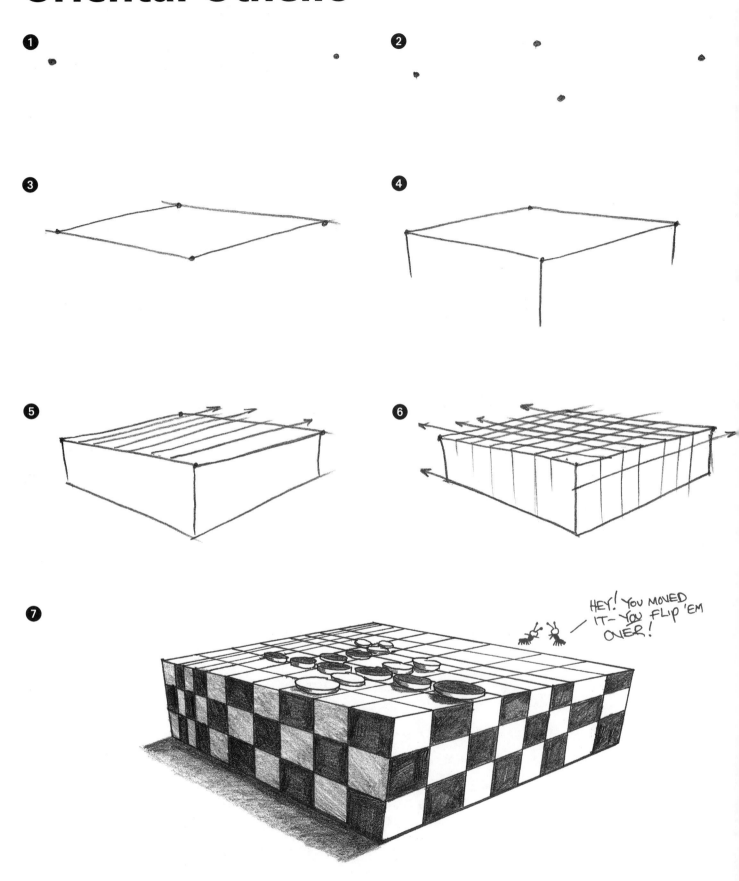

HEY! YOU MOVED
IT - YOU FLIP 'EM
OVER!

Ouch!

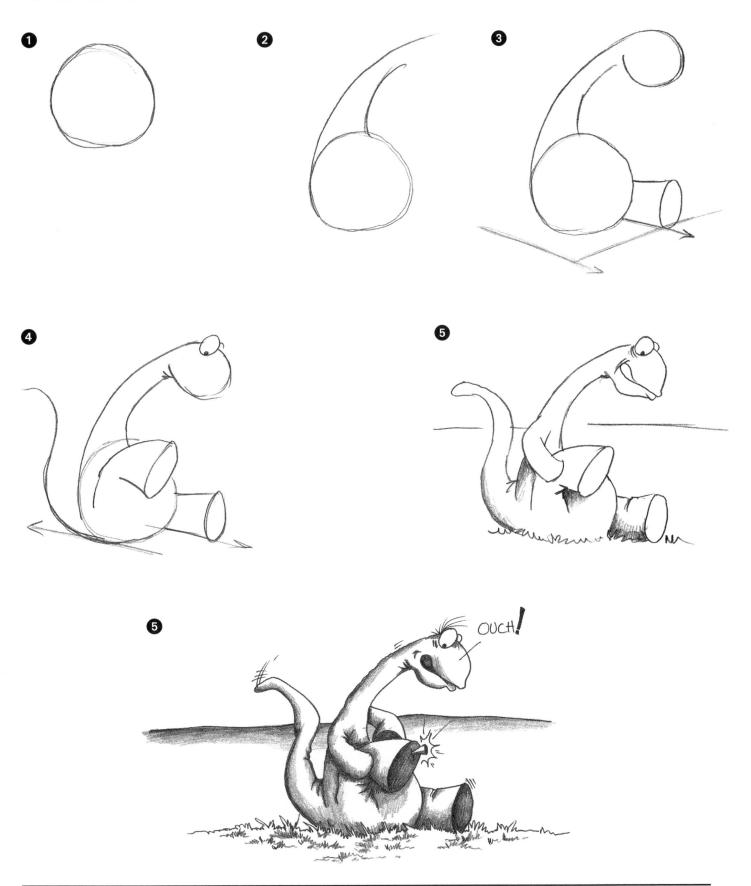

OUCH!

Overflowing Operation

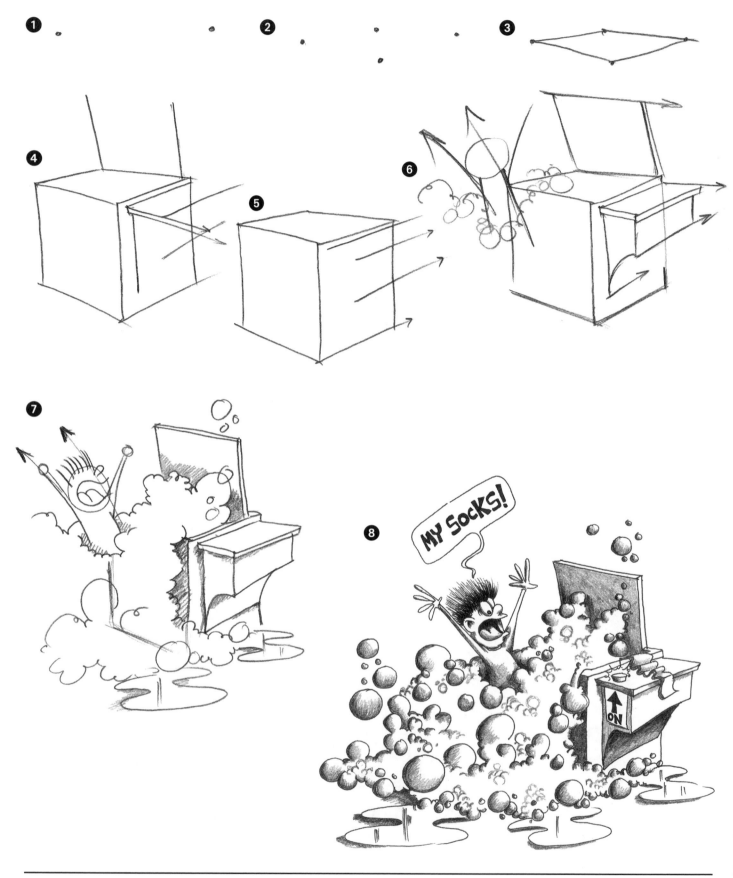

"P" Puff Cloud

① ② ③ ④ ⑤

"P" Peeling Shadow

① ② ③ ④ ⑤

"P" Chiseled Stone

① ② ③ ④ ⑤ ⑥

"P" Super 3-D

① ② ③

④ ⑤ ⑥ ⑦

"P" Block 3-D

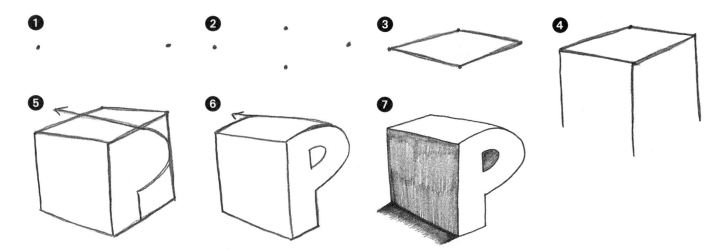

Peaceful Pelican

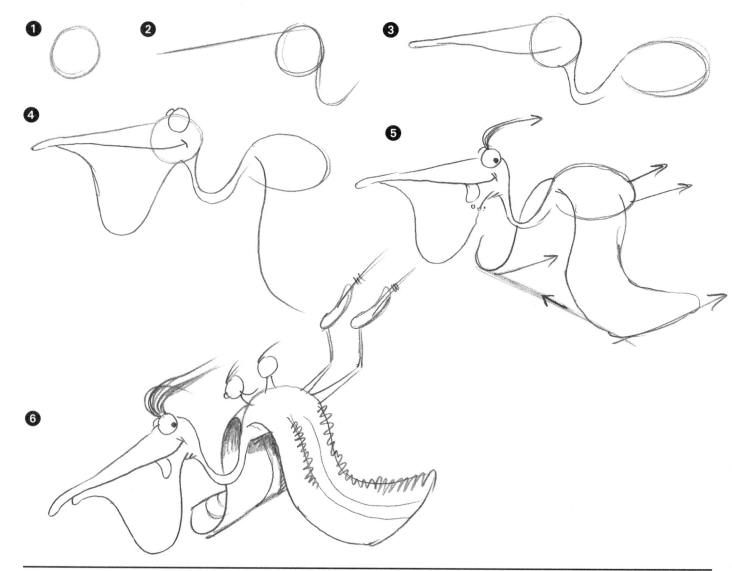

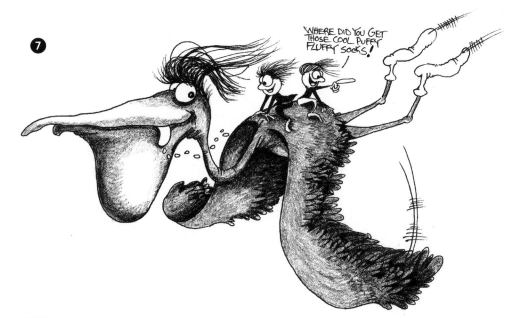

Pencil Power

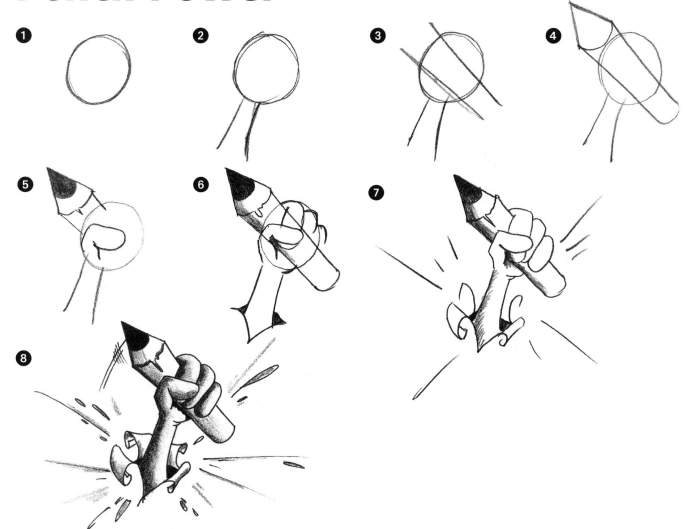

Pirouetting Pandas

1

2

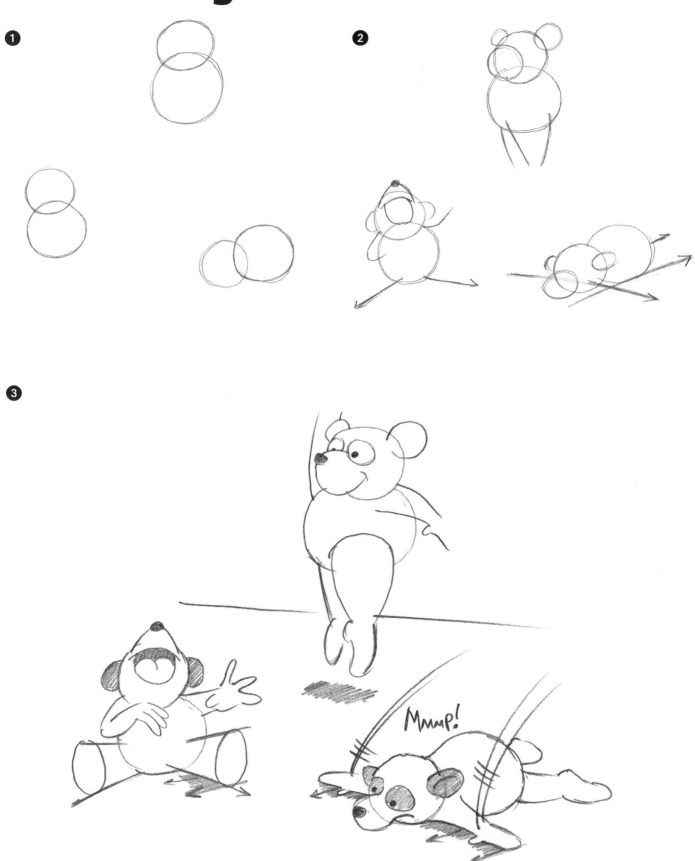

3

MMMP!

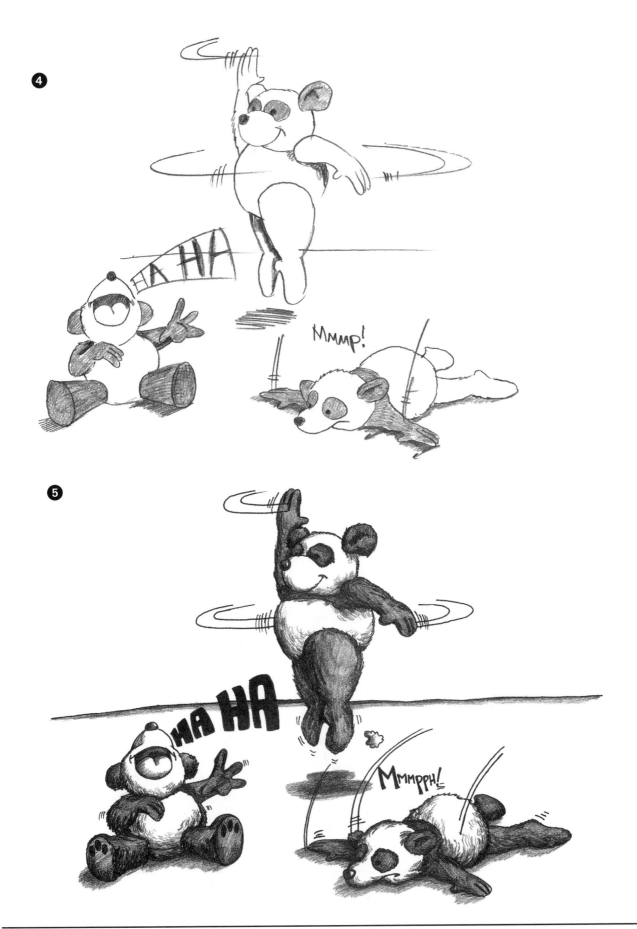

Positive Poetry

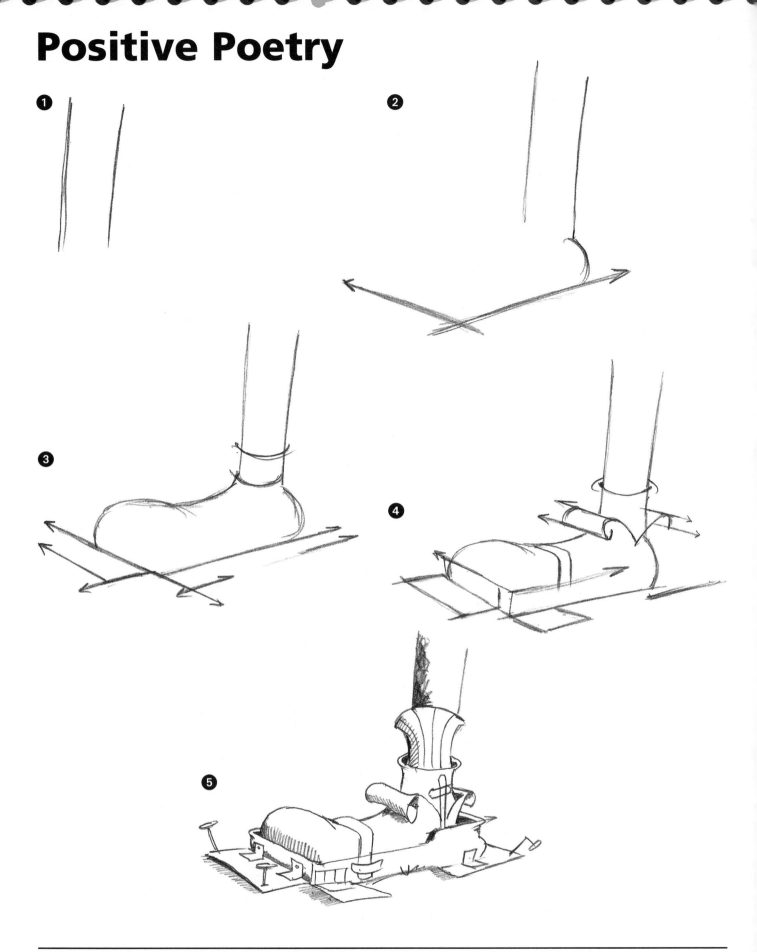

⑥

Don't pin yourself down with negative thoughts.

Pudding Plant

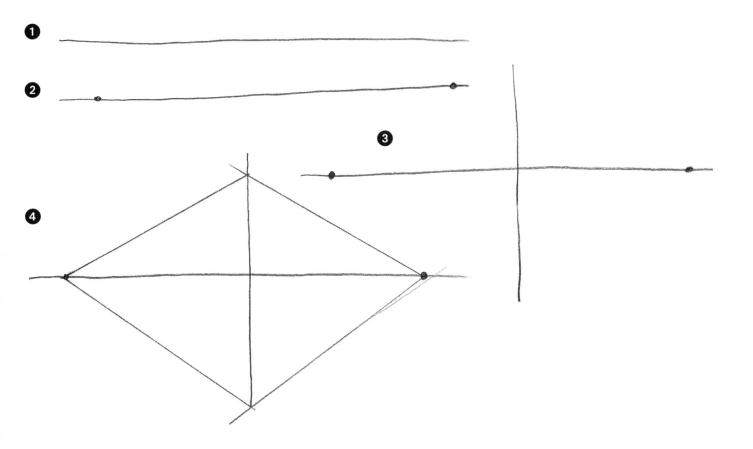

❶

❷

❸

❹

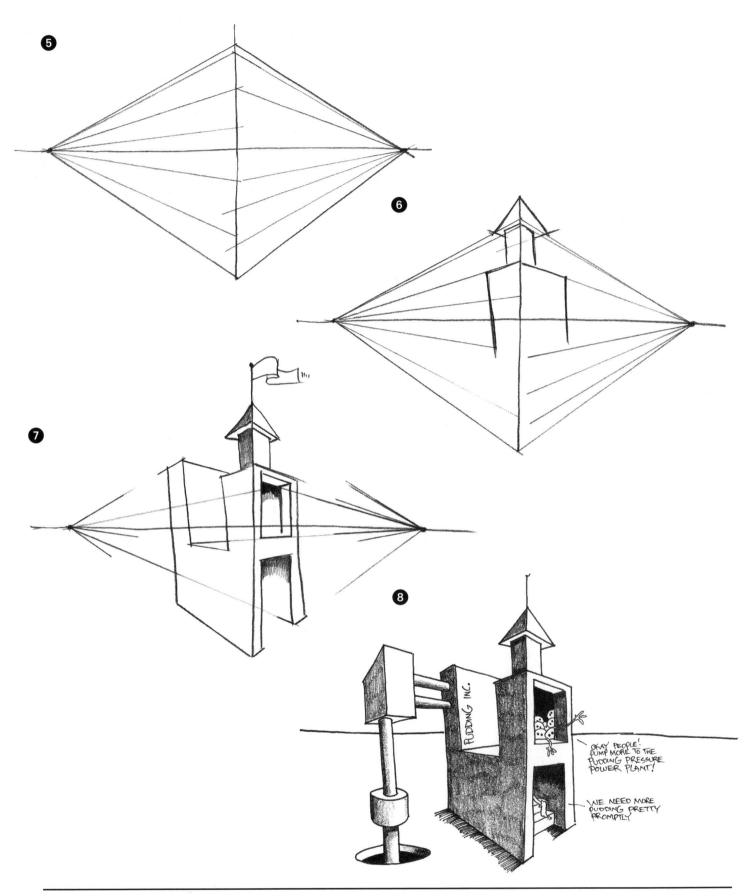

"Q" Puff Cloud

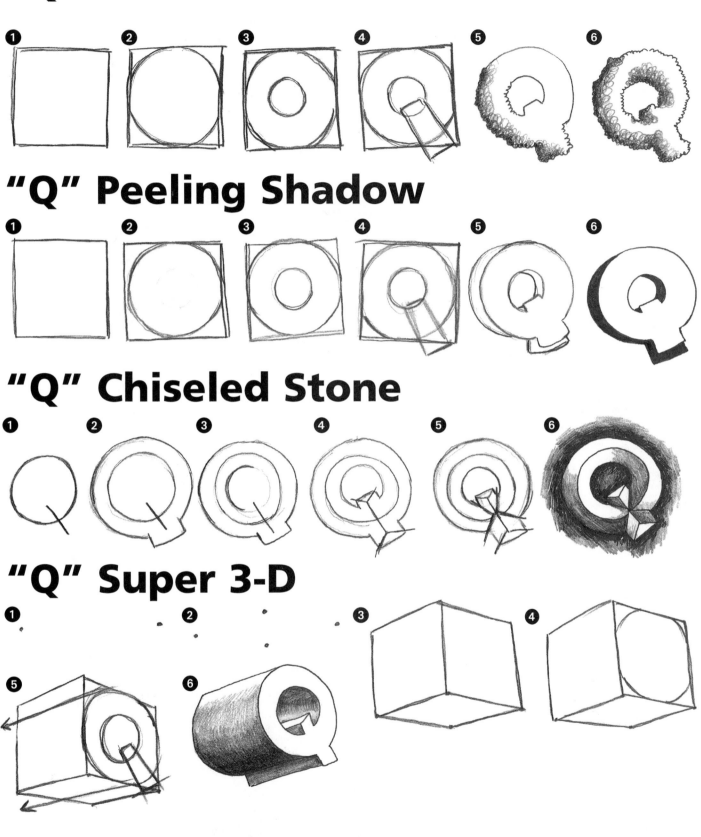

"Q" Peeling Shadow

"Q" Chiseled Stone

"Q" Super 3-D

"Q" Block 3-D

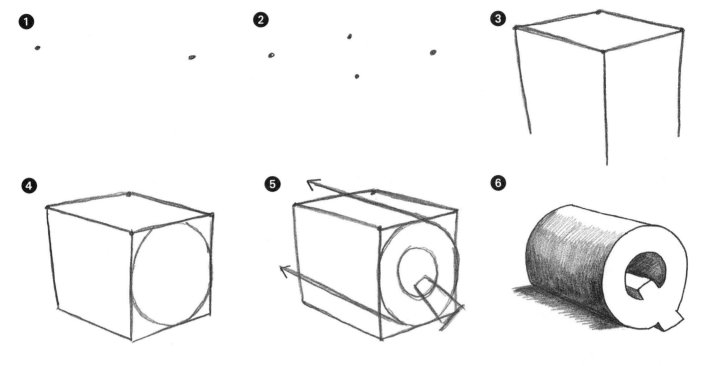

Quack! Quack!

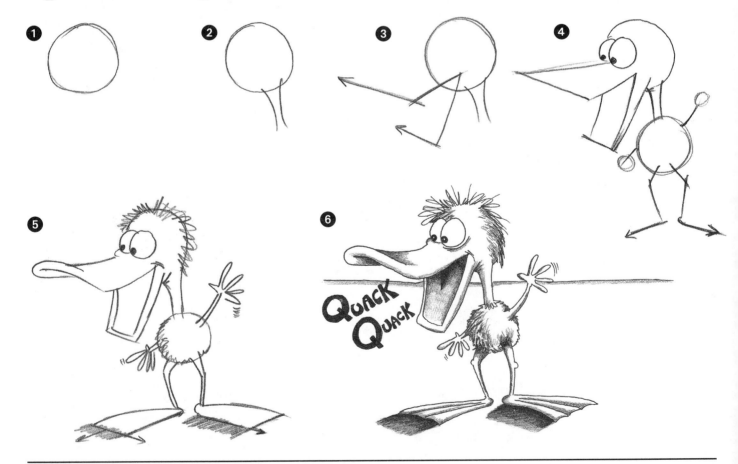

Queasy Quagmire

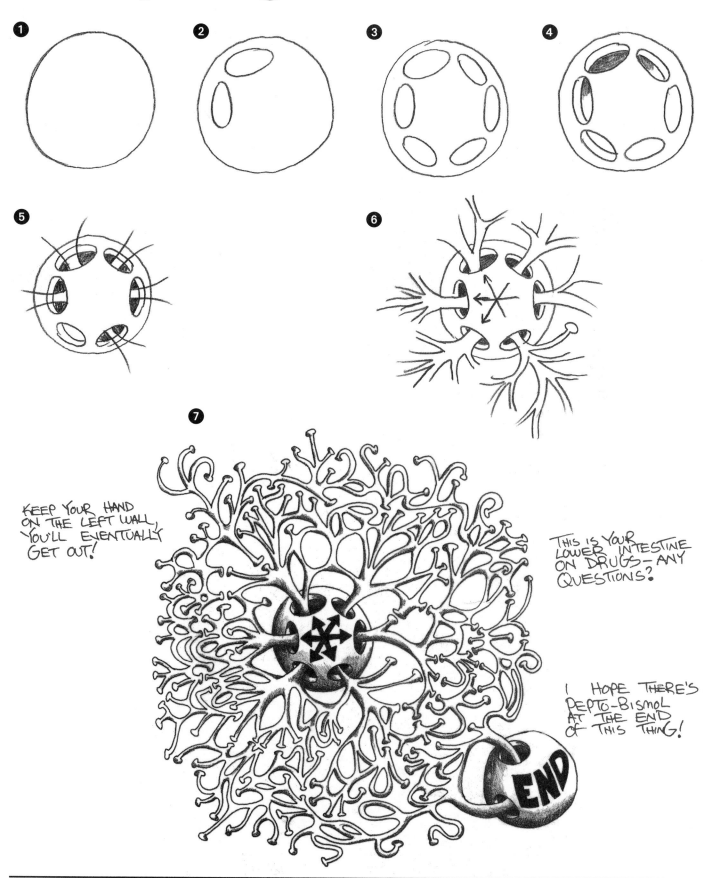

① ② ③ ④

⑤ ⑥

⑦

KEEP YOUR HAND
ON THE LEFT WALL,
YOU'LL EVENTUALLY
GET OUT!

THIS IS YOUR
LOWER INTESTINE
ON DRUGS—ANY
QUESTIONS?

I HOPE THERE'S
PEPTO-BISMOL
AT THE END
OF THIS THING!

END

Queen Bean

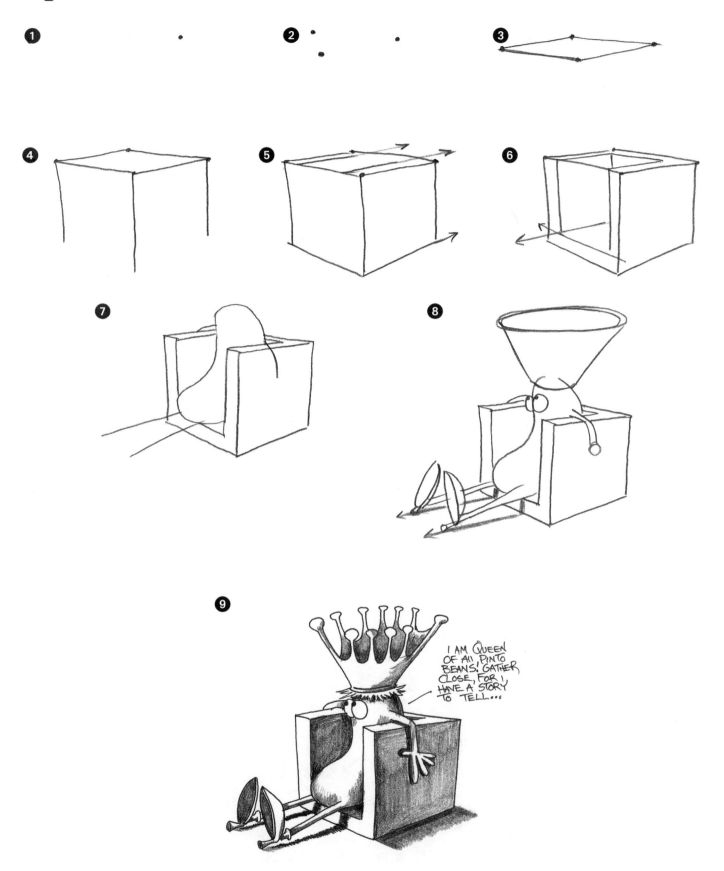

I AM QUEEN OF ALL PINTO BEANS! GATHER CLOSE, FOR I HAVE A STORY TO TELL...

Question Queue

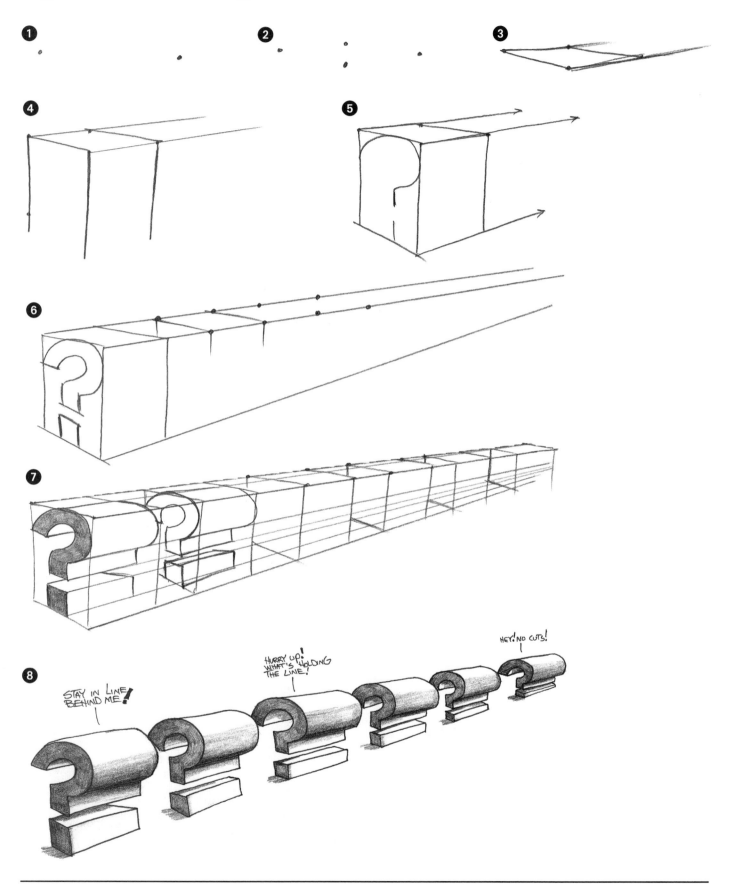

Stay in line behind me!

Hurry up! What's holding the line!

Hey! No cuts!

Quilt Quest

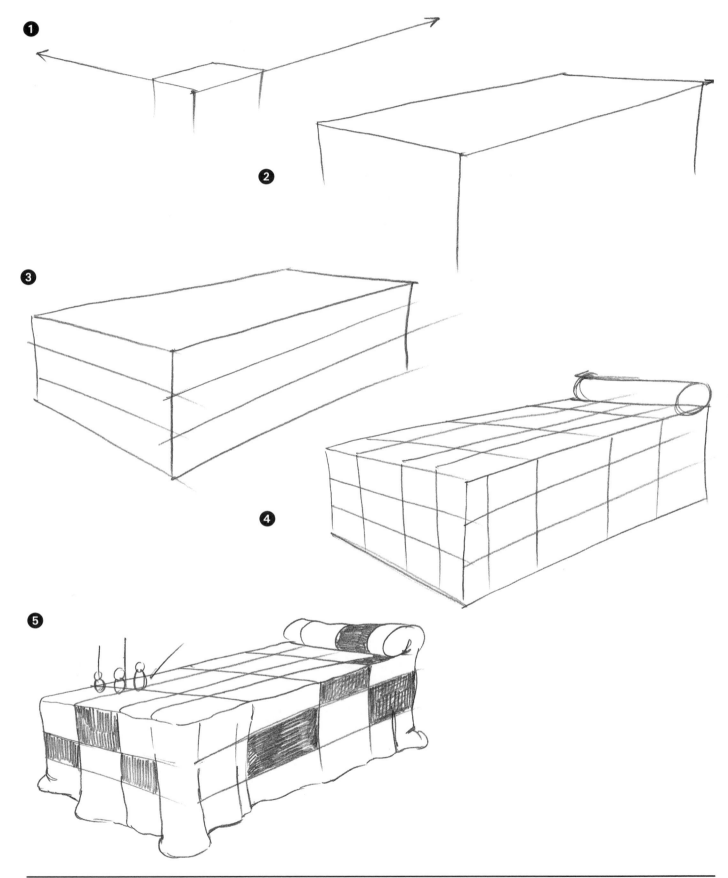

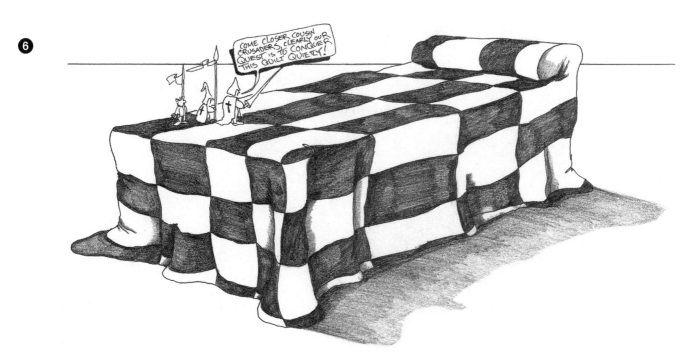

Quirky Choir

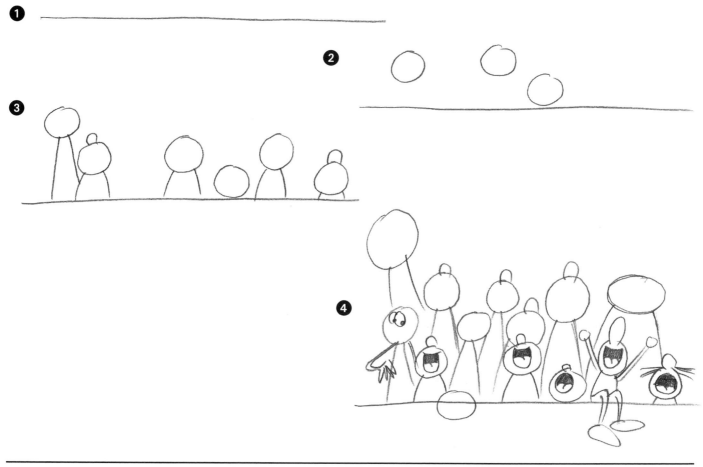

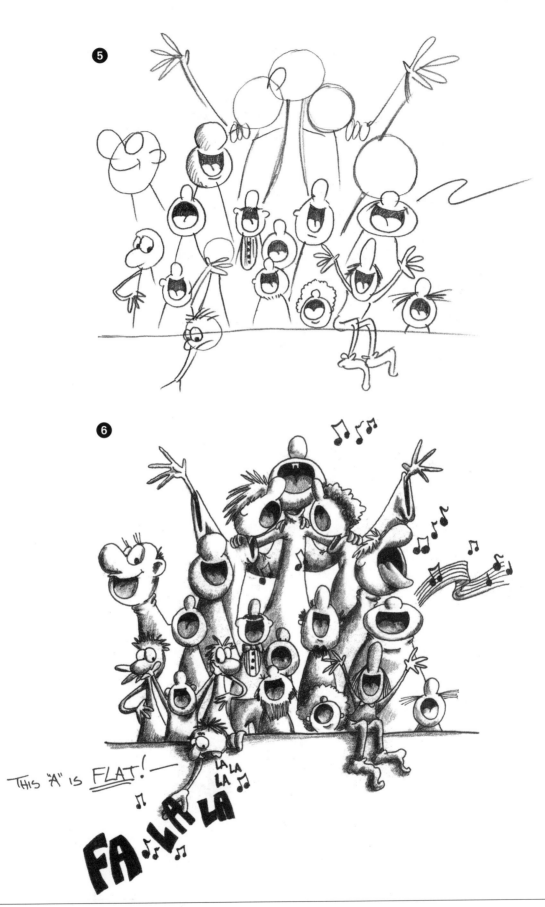

"R" Puff Cloud

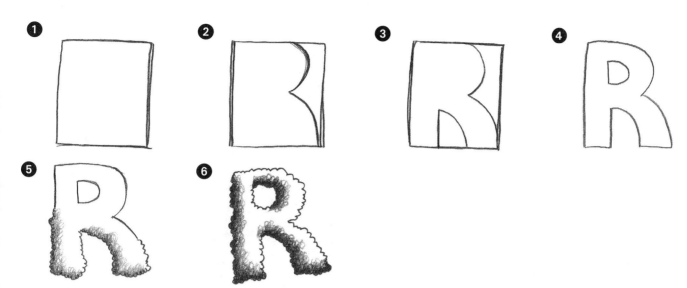

"R" Peeling Shadow

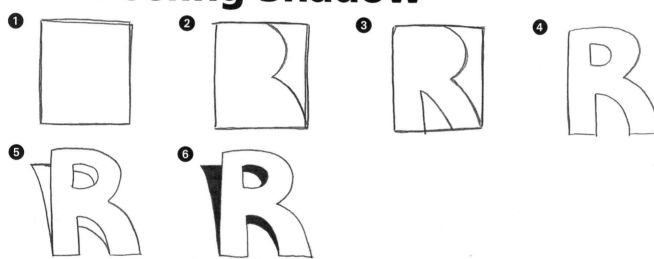

"R" Chiseled Stone

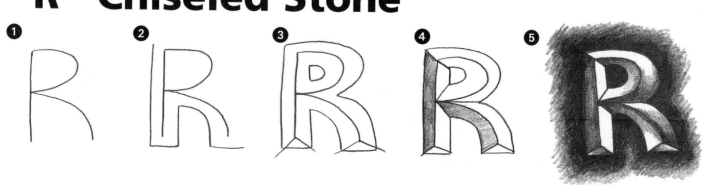

"R" Super 3-D

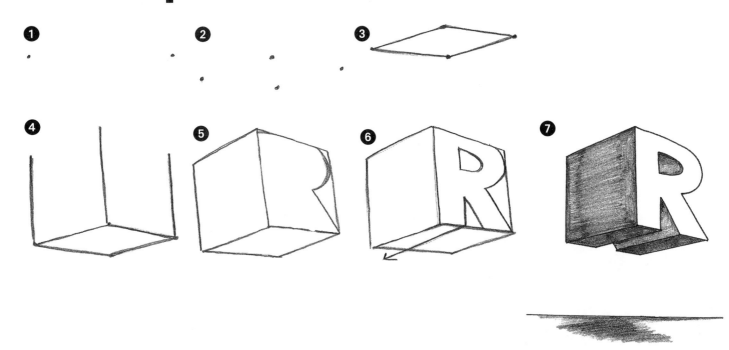

"R" Block 3-D

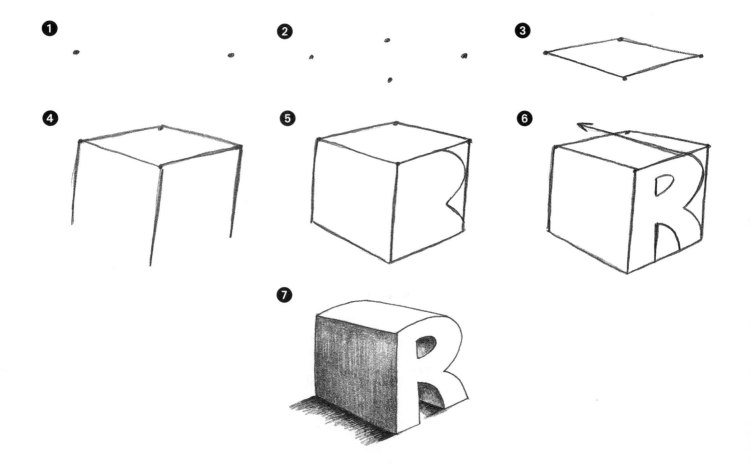

Radical Road

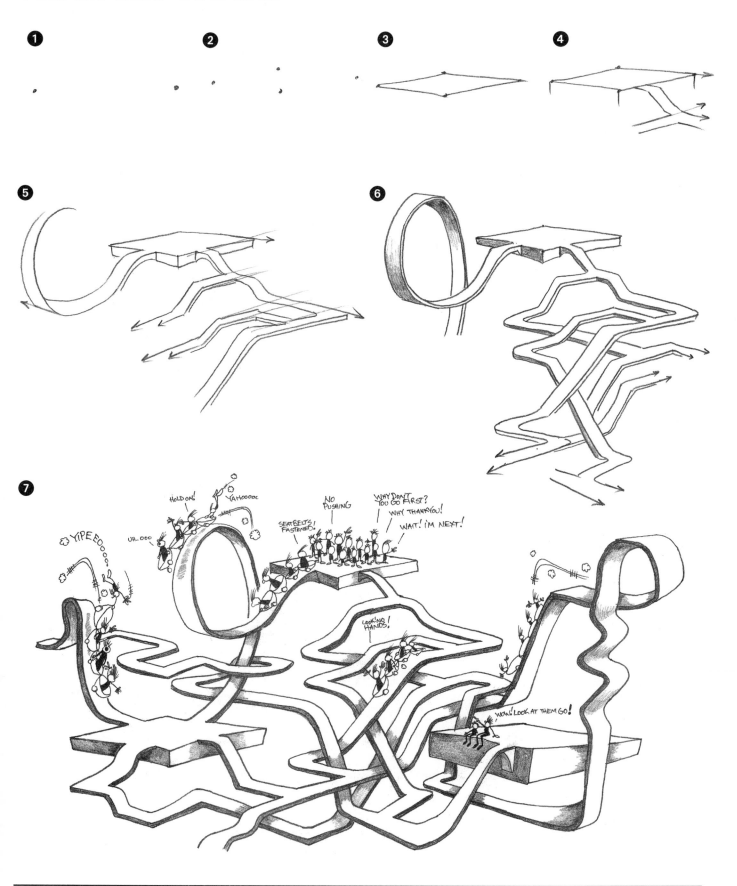

Romantic Rose

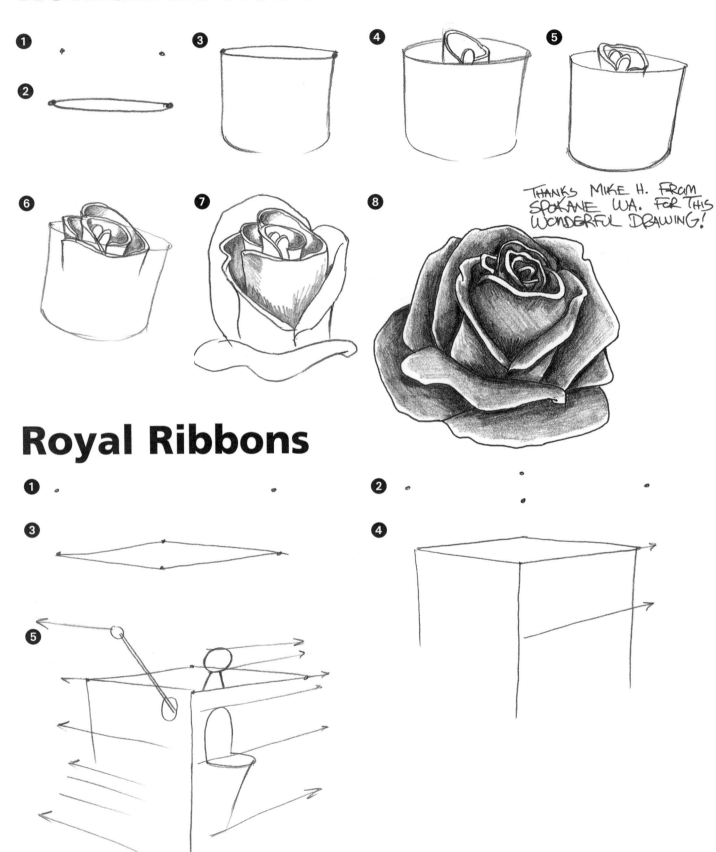

THANKS MIKE H. FROM SPOKANE WA. FOR THIS WONDERFUL DRAWING!

Royal Ribbons

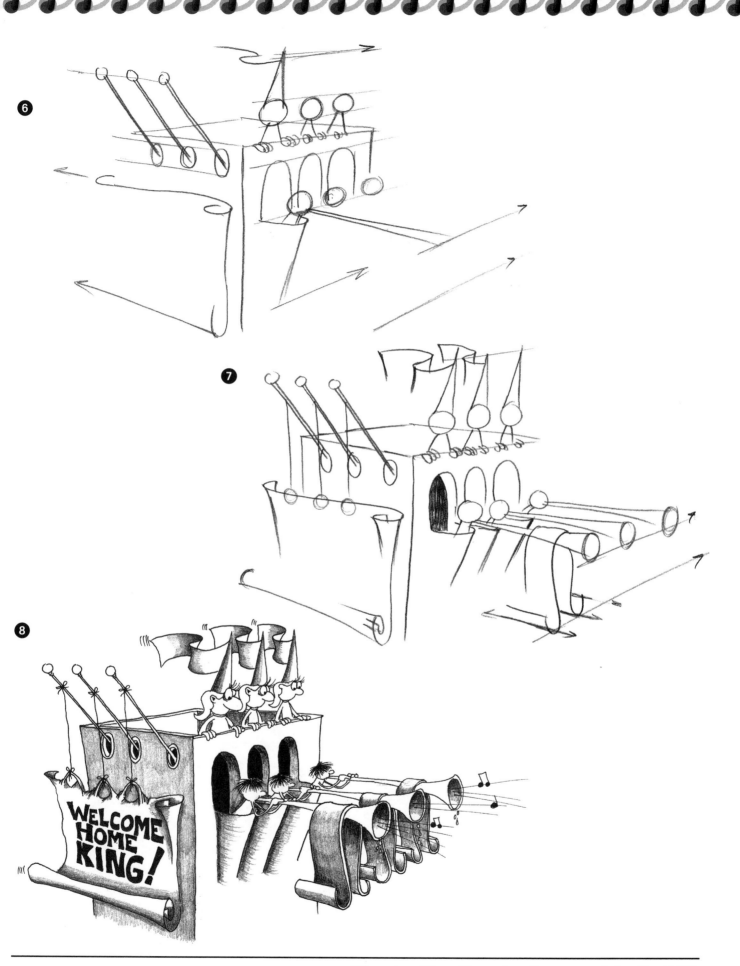

Rubbish Reconnaissance

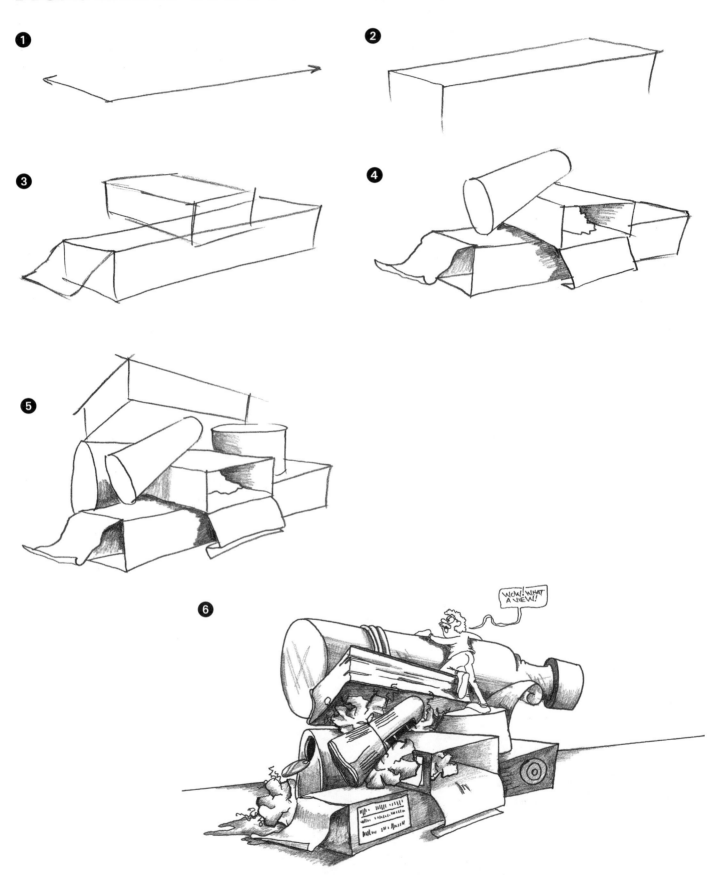

Ruminating Rhino

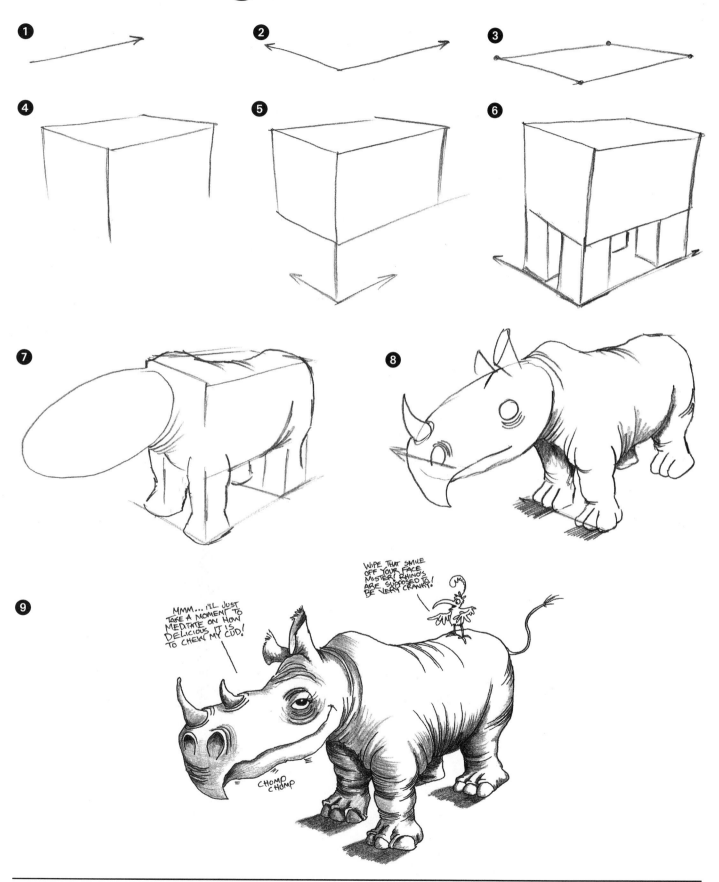

"S" Puff Cloud

"S" Peeling Shadow

"S" Chiseled Stone

 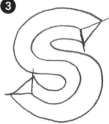 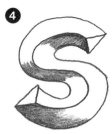

"S" Super Block 3-D

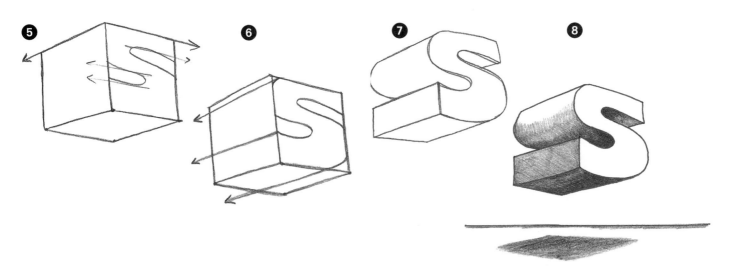

"S" Block 3-D

1 **2** **3** **4**

5 **6** **7** **8**

Sailing Sloop

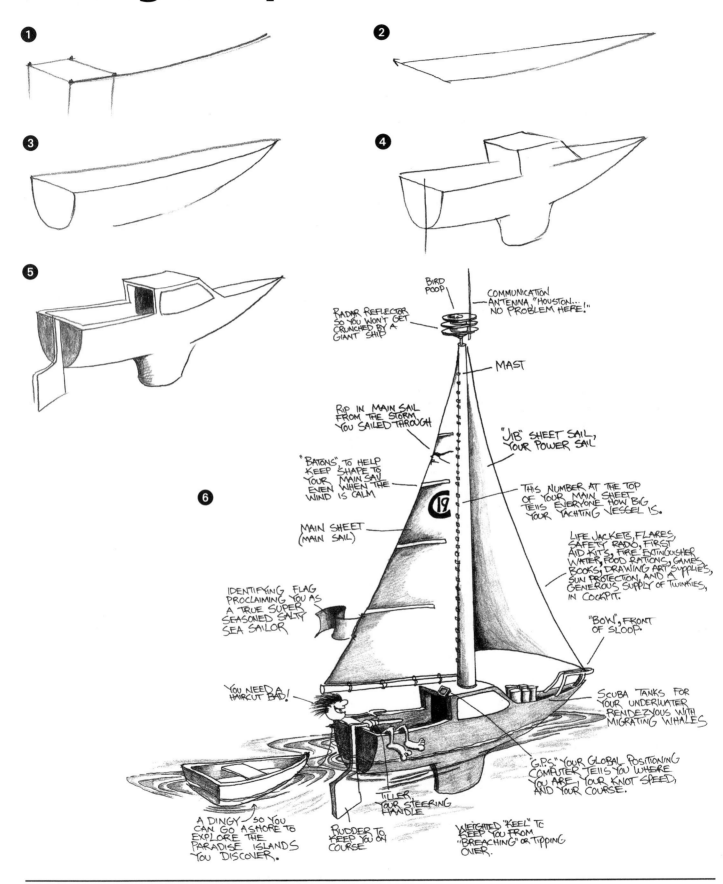

① ② ③ ④ ⑤ ⑥

BIRD POOP

COMMUNICATION ANTENNA "HOUSTON... NO PROBLEM HERE!"

RADAR REFLECTOR SO YOU WON'T GET CRUNCHED BY A GIANT SHIP

MAST

RIP IN MAIN SAIL FROM THE STORM YOU SAILED THROUGH

"JIB" SHEET SAIL, YOUR POWER SAIL

"BATONS" TO HELP KEEP SHAPE TO YOUR MAIN SAIL EVEN WHEN THE WIND IS CALM

THIS NUMBER AT THE TOP OF YOUR MAIN SHEET TELLS EVERYONE HOW BIG YOUR YACHTING VESSEL IS.

MAIN SHEET (MAIN SAIL)

LIFE JACKETS, FLARES, SAFETY RADIO, FIRST AID KITS, FIRE EXTINGUISHER WATER, FOOD RATIONS, GAMES, BOOKS, DRAWING ART SUPPLIES, SUN PROTECTION, AND A GENEROUS SUPPLY OF TWINKIES, IN COCKPIT.

IDENTIFYING FLAG PROCLAIMING YOU AS A TRUE SUPER SEASONED SALTY SEA SAILOR

"BOW", FRONT OF SLOOP.

YOU NEED A HAIRCUT BAD!

SCUBA TANKS FOR YOUR UNDERWATER RENDEZVOUS WITH MIGRATING WHALES

"G.P.S." YOUR GLOBAL POSITIONING COMPUTER TELLS YOU WHERE YOU ARE, YOUR KNOT SPEED, AND YOUR COURSE.

A DINGY SO YOU CAN GO ASHORE TO EXPLORE THE PARADISE ISLANDS YOU DISCOVER.

TILLER, YOUR STEERING HANDLE

RUDDER TO KEEP YOU ON COURSE

WEIGHTED "KEEL" TO KEEP YOU FROM "BREACHING" OR TIPPING OVER.

Scary Snarl

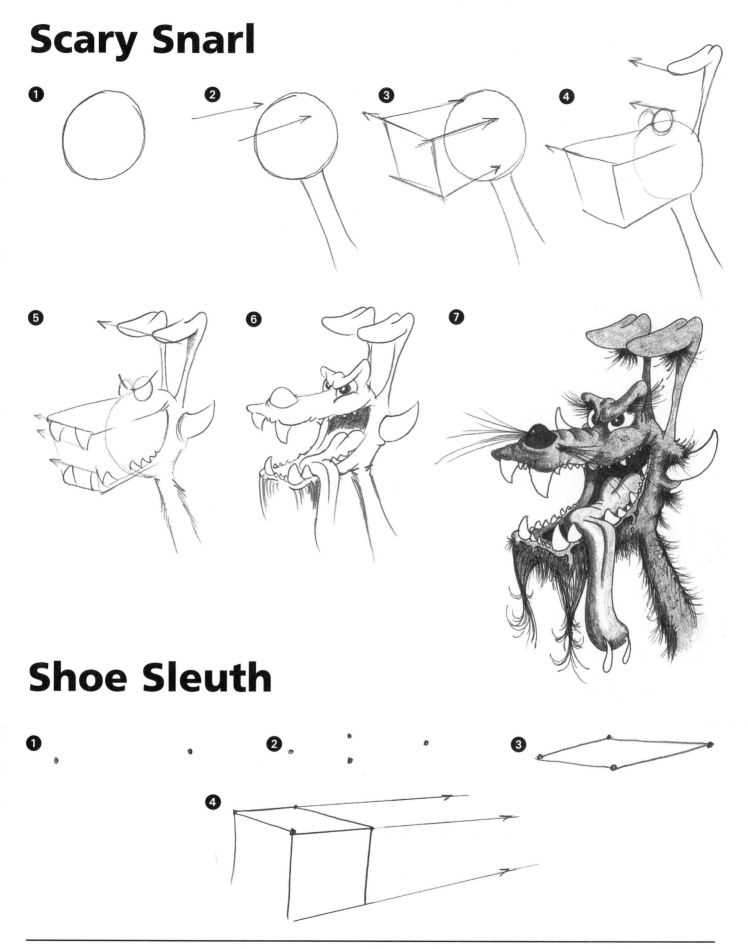

Shoe Sleuth

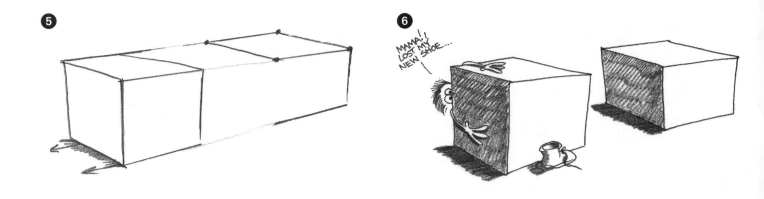

Spectacular Spider

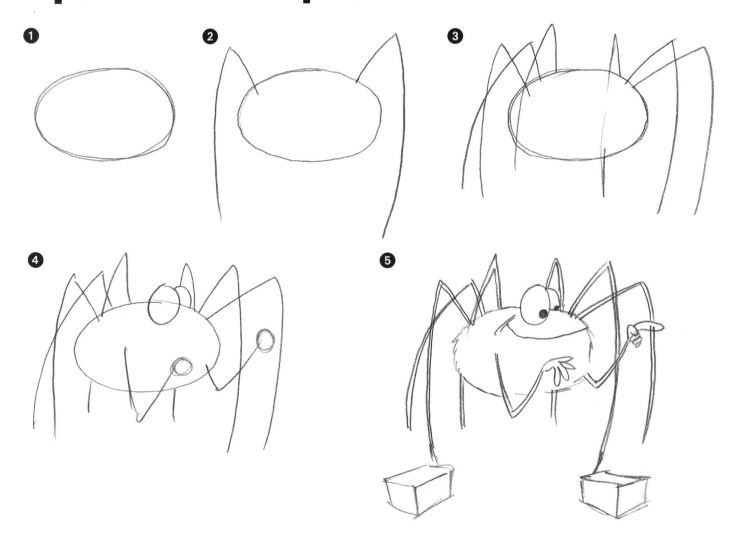

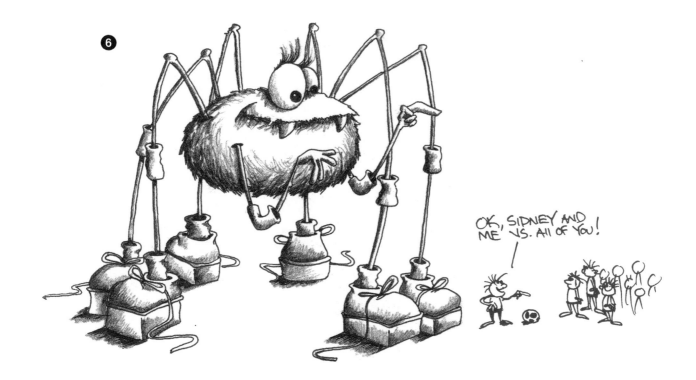

Surfing Steve

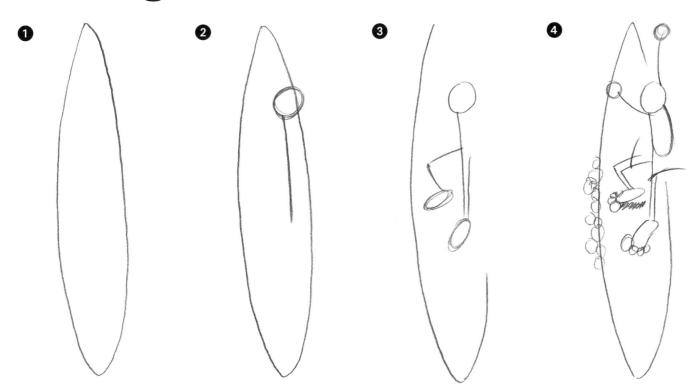

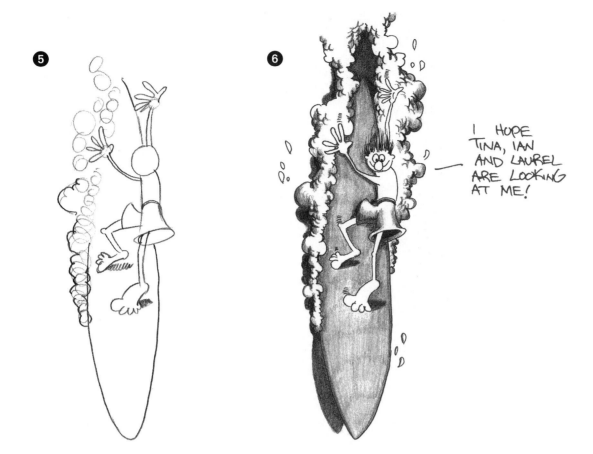

⑤

⑥ I HOPE TINA, IAN AND LAUREL ARE LOOKING AT ME!

"T" Puff Cloud

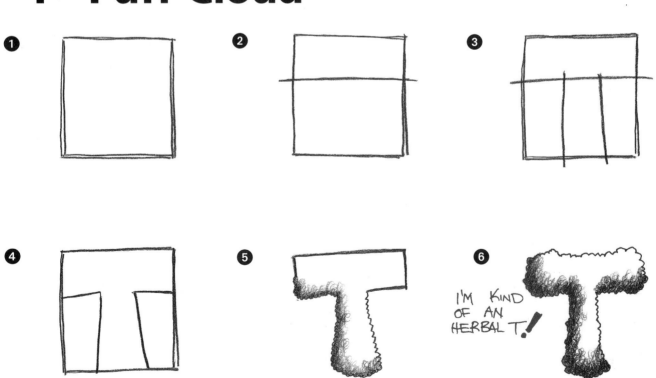

①

②

③

④

⑤

⑥ I'M KIND OF AN HERBAL T!

"T" Peeling Shadow

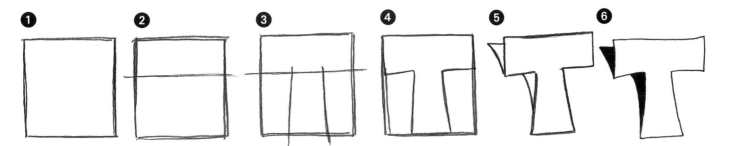

"T" Chiseled Stone

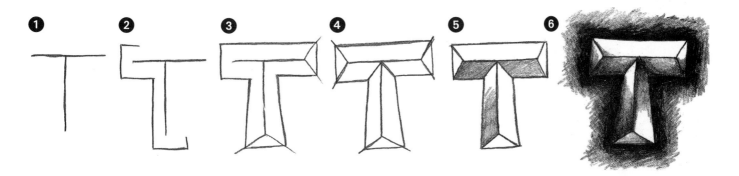

"T" Super 3-D

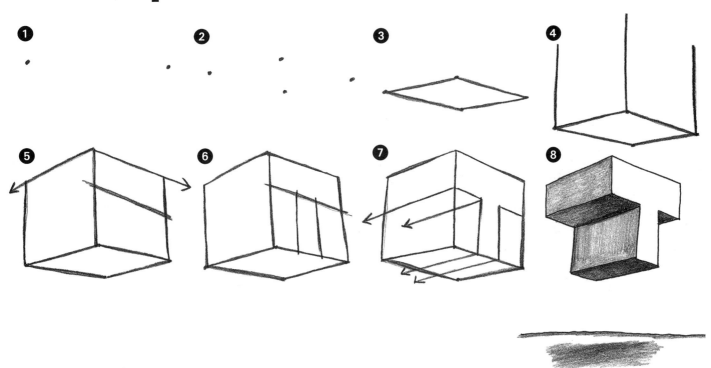

"T" Block 3-D

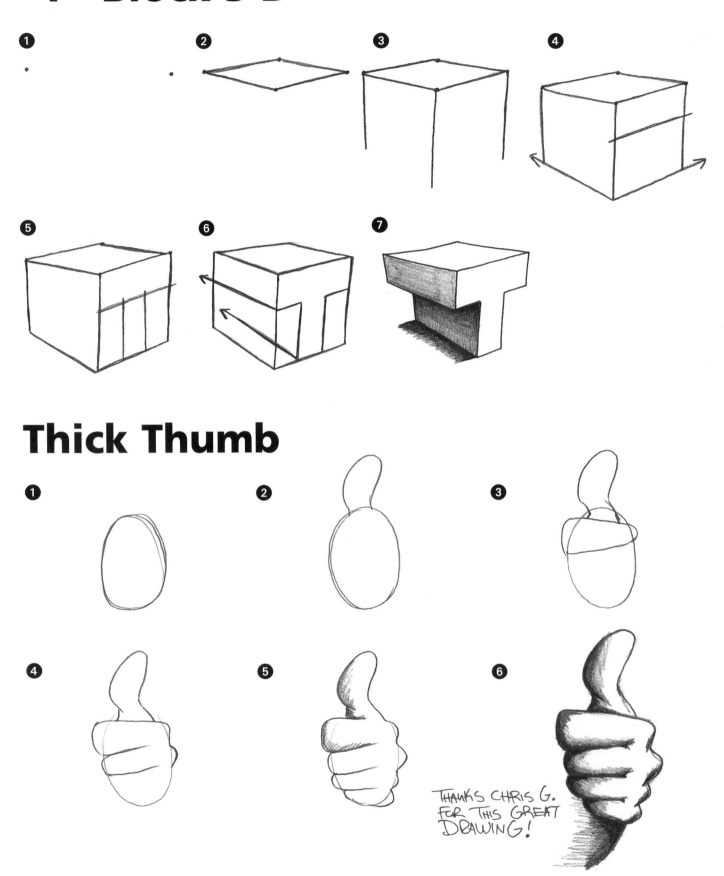

Thick Thumb

THANKS CHRIS G.
FOR THIS GREAT
DRAWING!

Throg's Throne

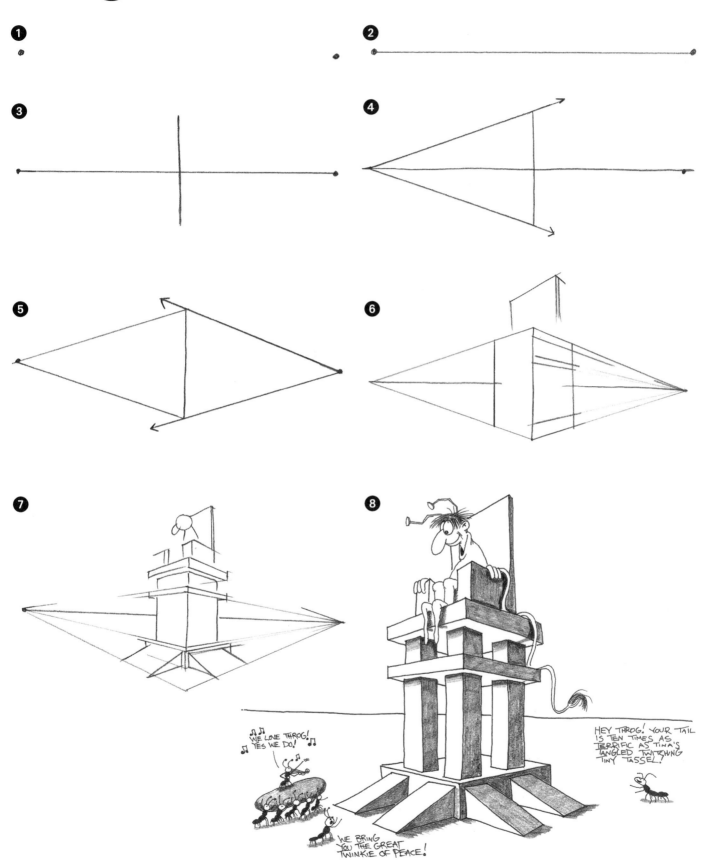

Tongue Twister

Tremendous Toad

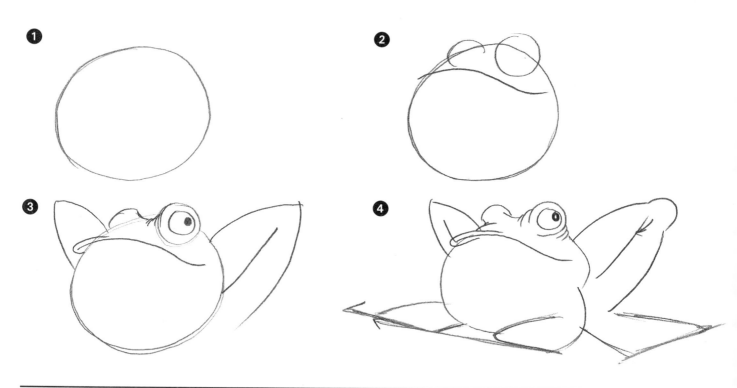

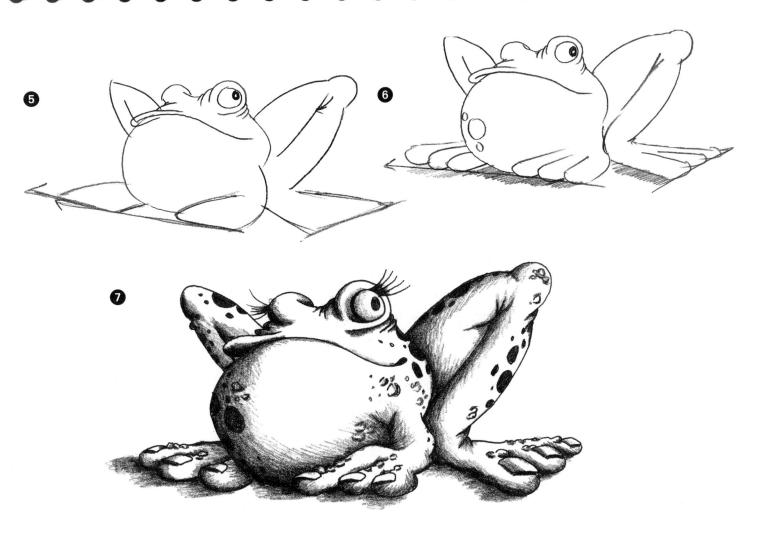

Tube Tag

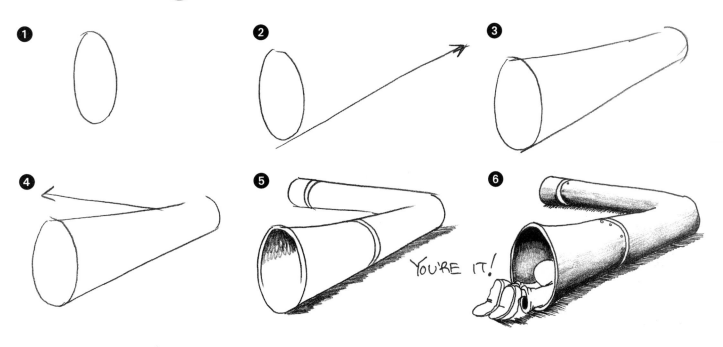

YOU'RE IT!

"U" Puff Cloud

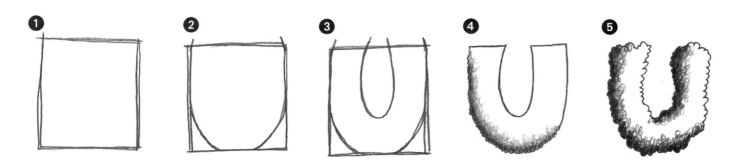

"U" Peeling Shadow

I FIND YOU A- PEELING TOO!

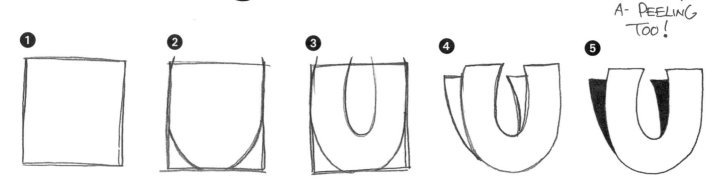

"U" Chiseled Stone

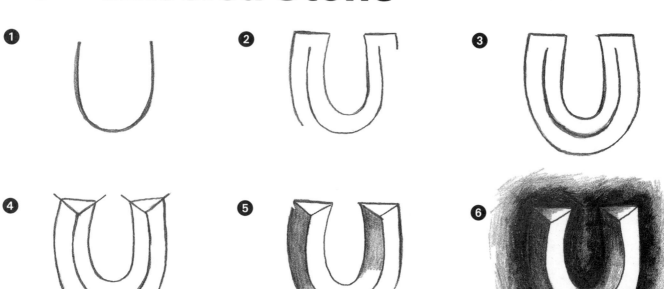

"U" Super 3-D

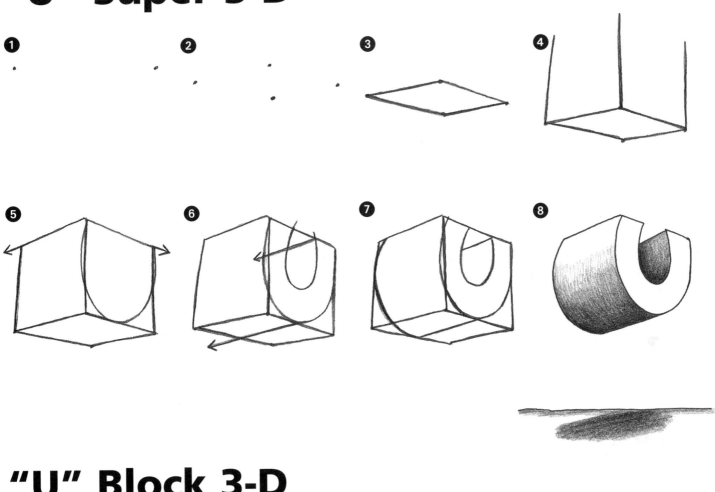

"U" Block 3-D

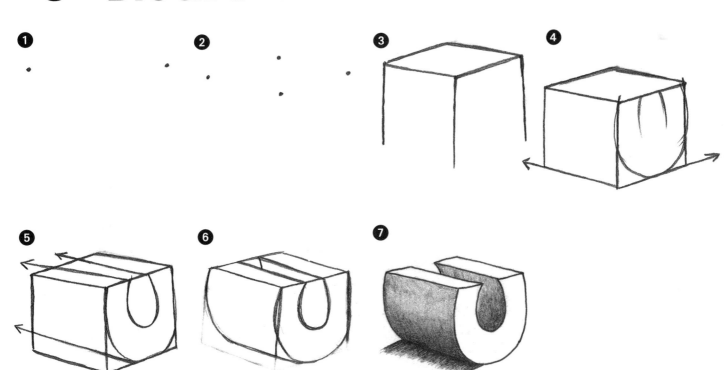

Uncle Ugly

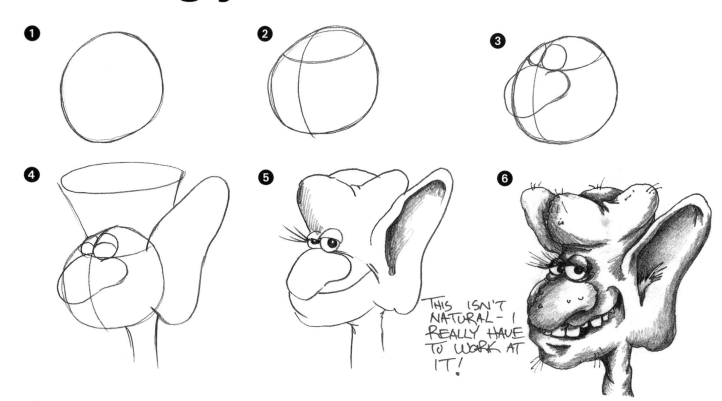

THIS ISN'T NATURAL – I REALLY HAVE TO WORK AT IT!

Unicycling Unibear

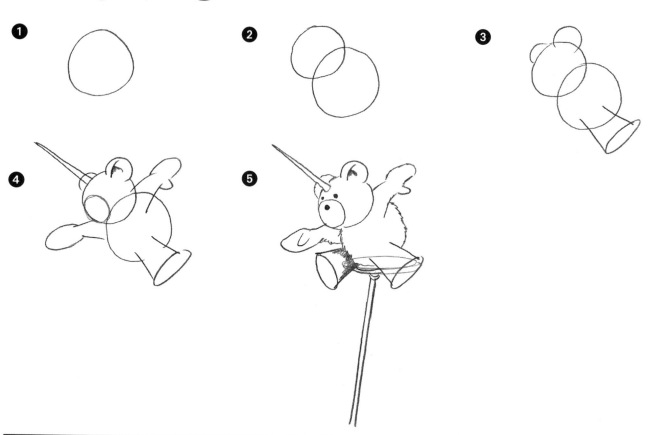

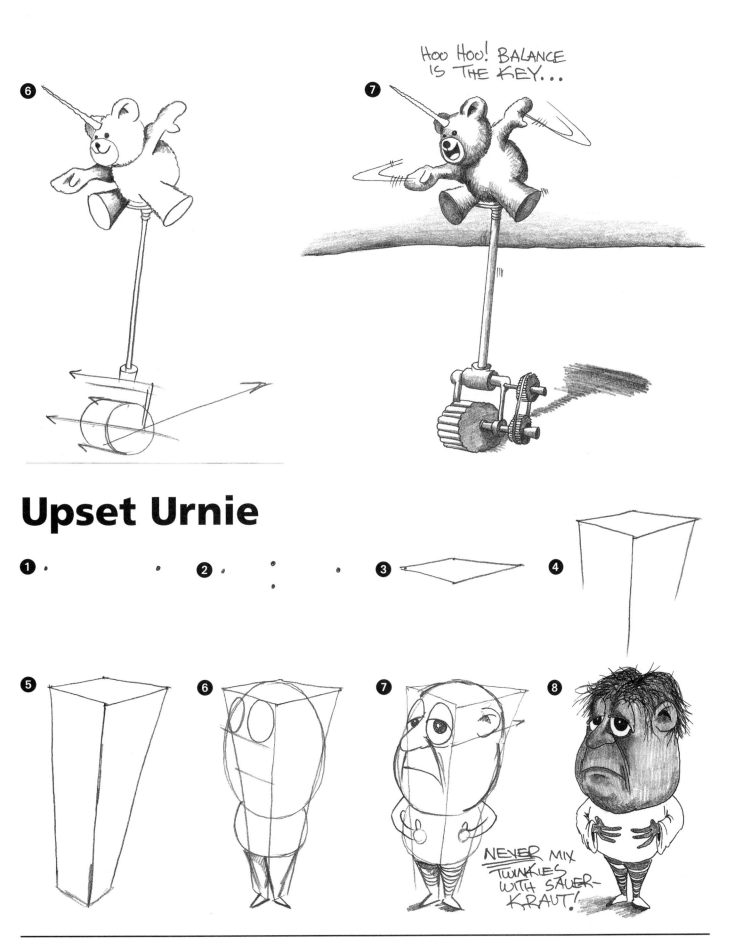

Upset Urnie

Uranus University

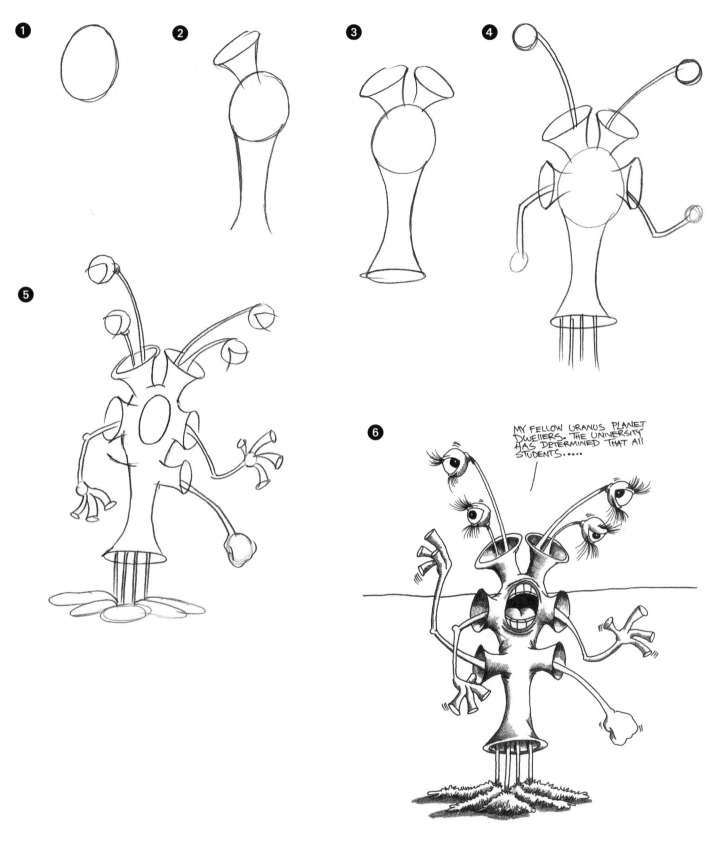

MY FELLOW URANUS PLANET DWELLERS. THE UNIVERSITY HAS DETERMINED THAT ALL STUDENTS.....

Urban Utopia

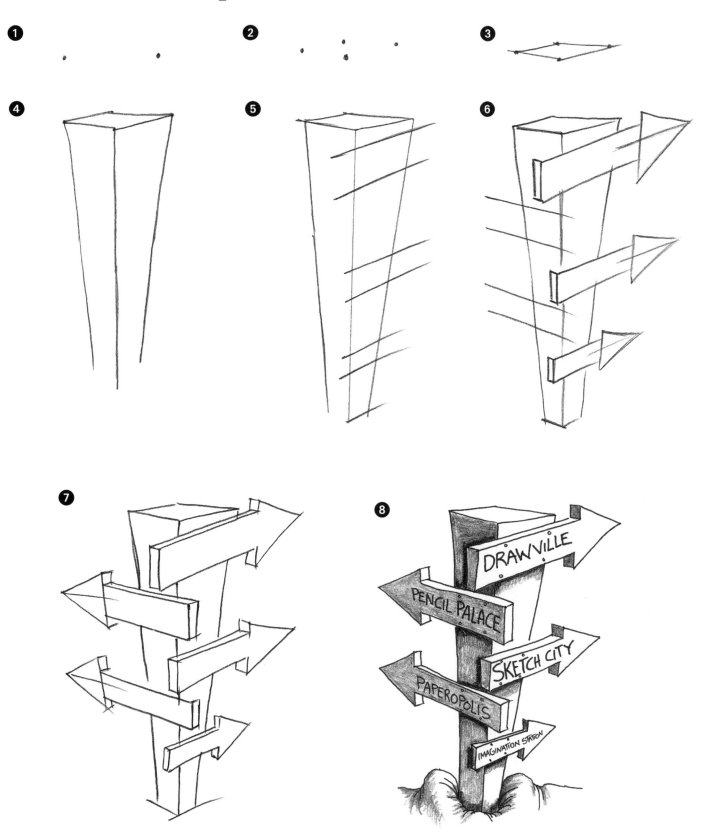

❶ ❷ ❸

❹ ❺ ❻

❼ ❽

DRAWVILLE

PENCIL PALACE

SKETCH CITY

PAPEROPOLIS

IMAGINATION STATION

"V" Puff Cloud

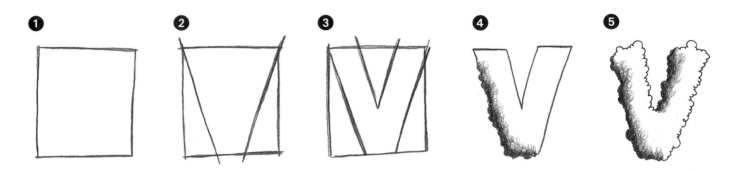

"V" Peeling Shadow

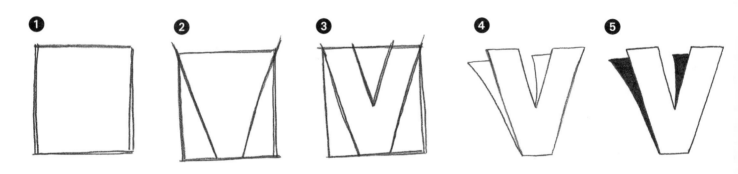

"V" Chisled Stone

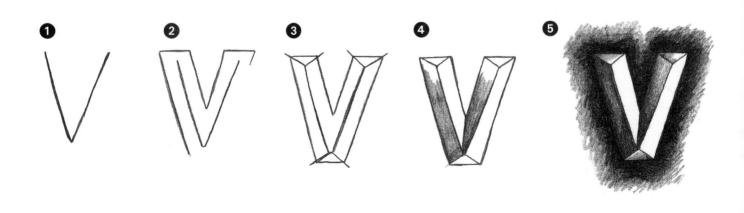

"V" Super 3-D

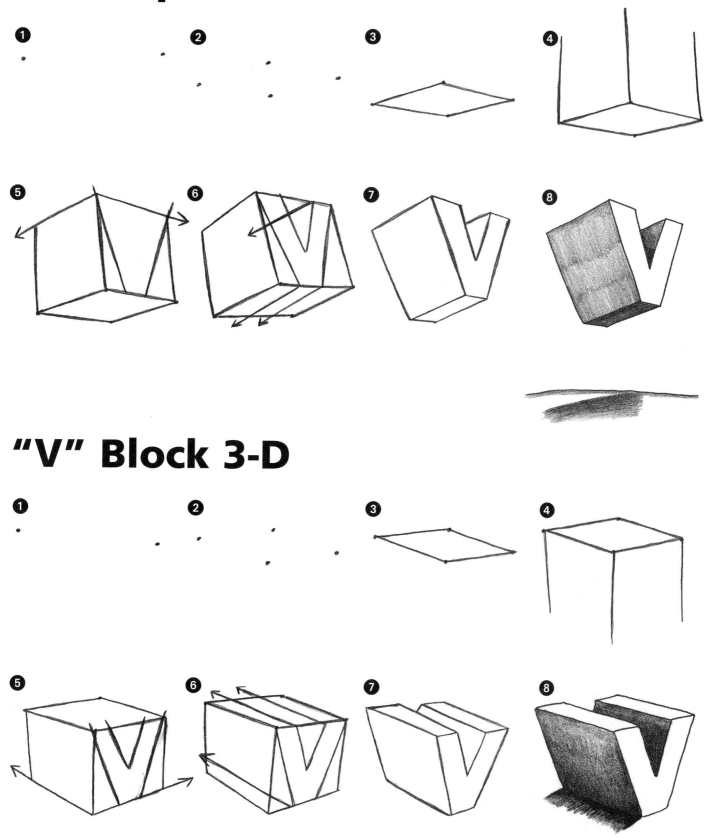

"V" Block 3-D

Vacuuming Vortex

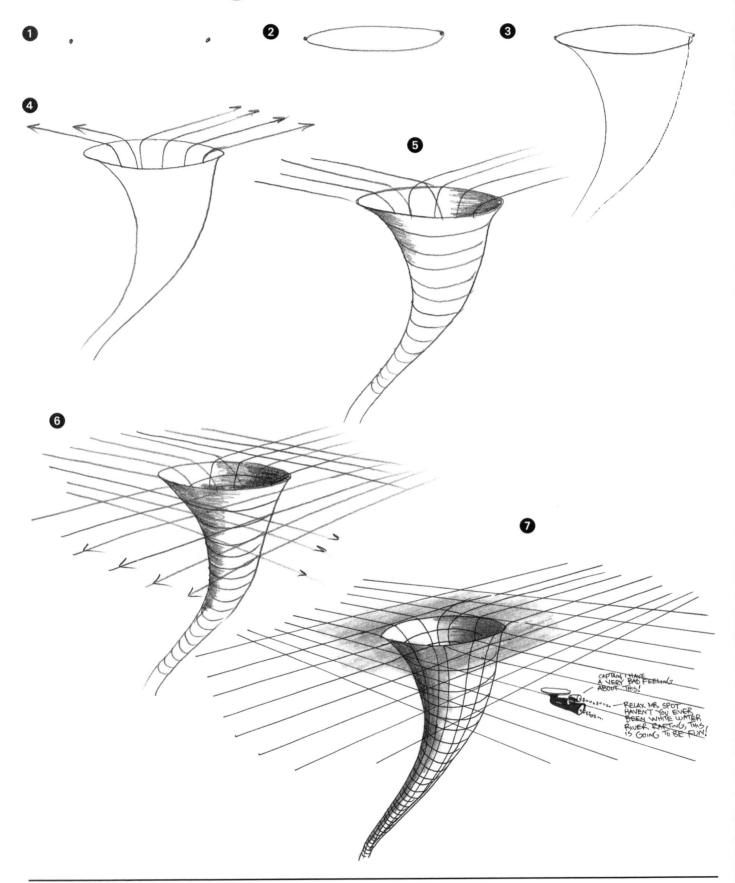

Vegetable Virtuoso

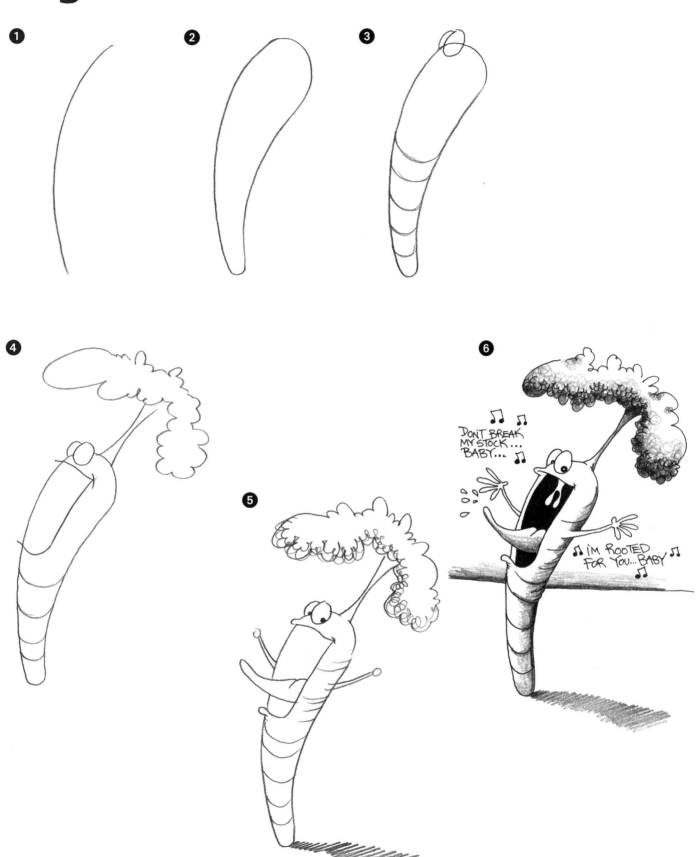

Vertical Vine

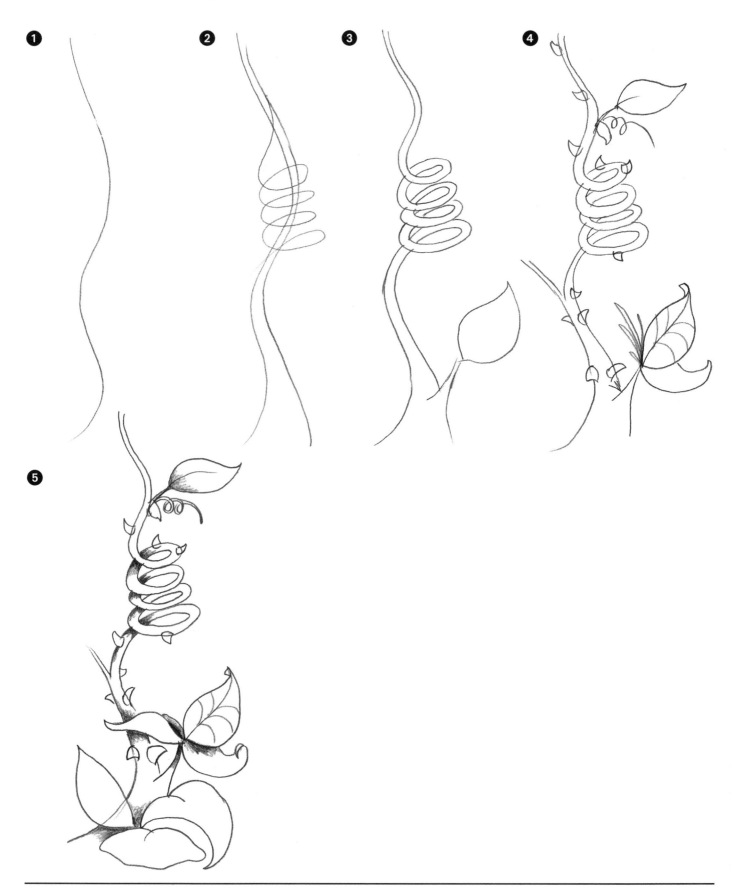

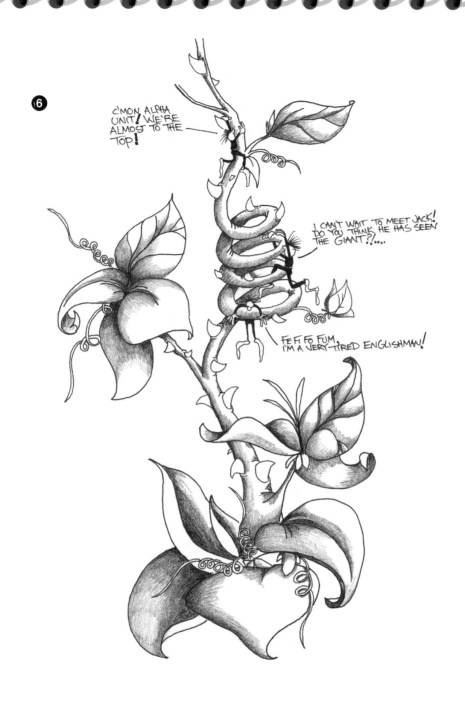

Viking Voyage

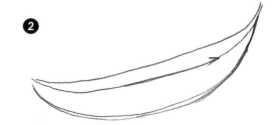

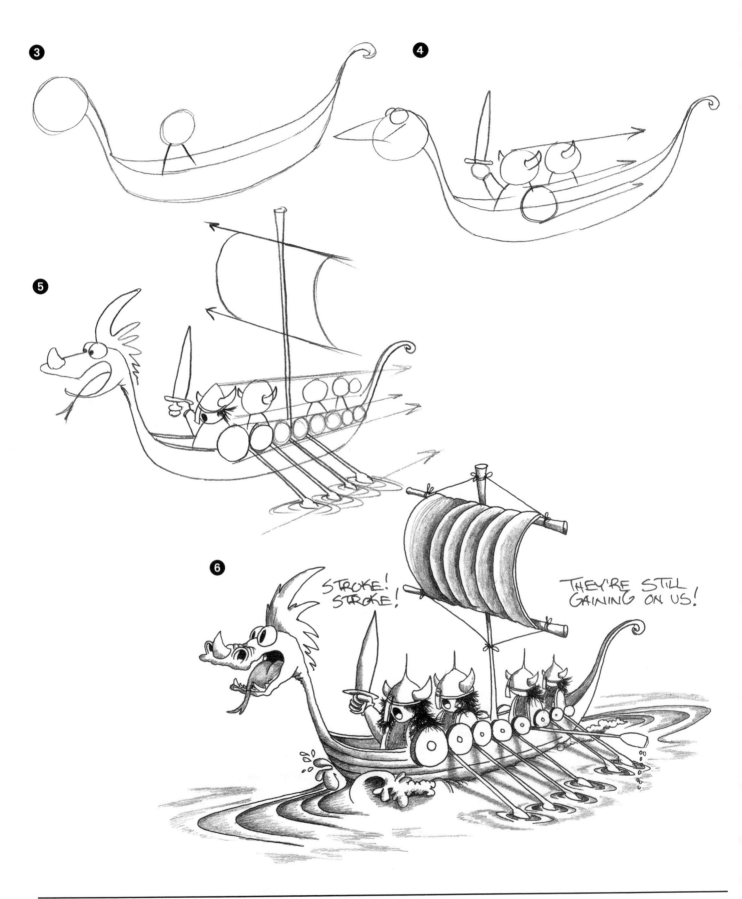

Vrooom

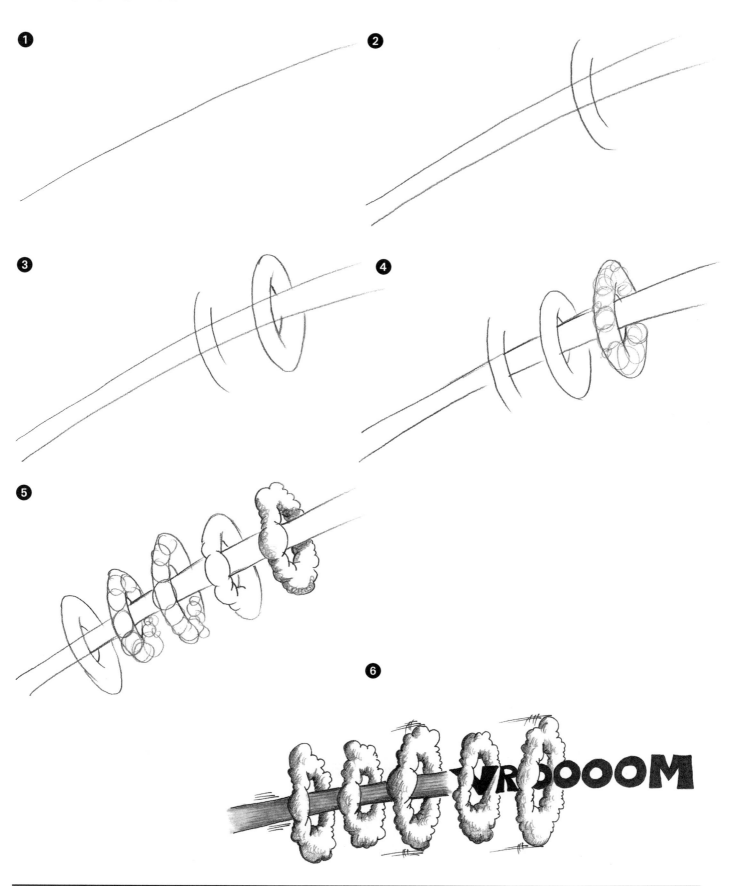

"W" Puff Cloud

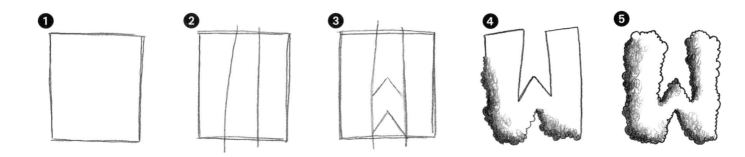

"W" Peeling Shadow

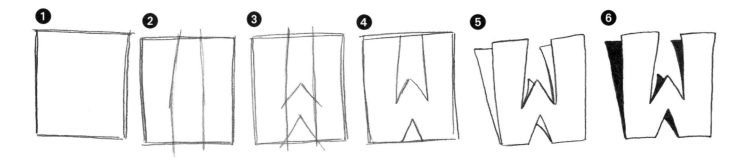

"W" Chisled Stone

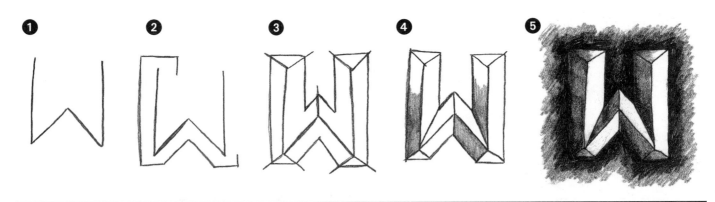

"W" Super 3-D

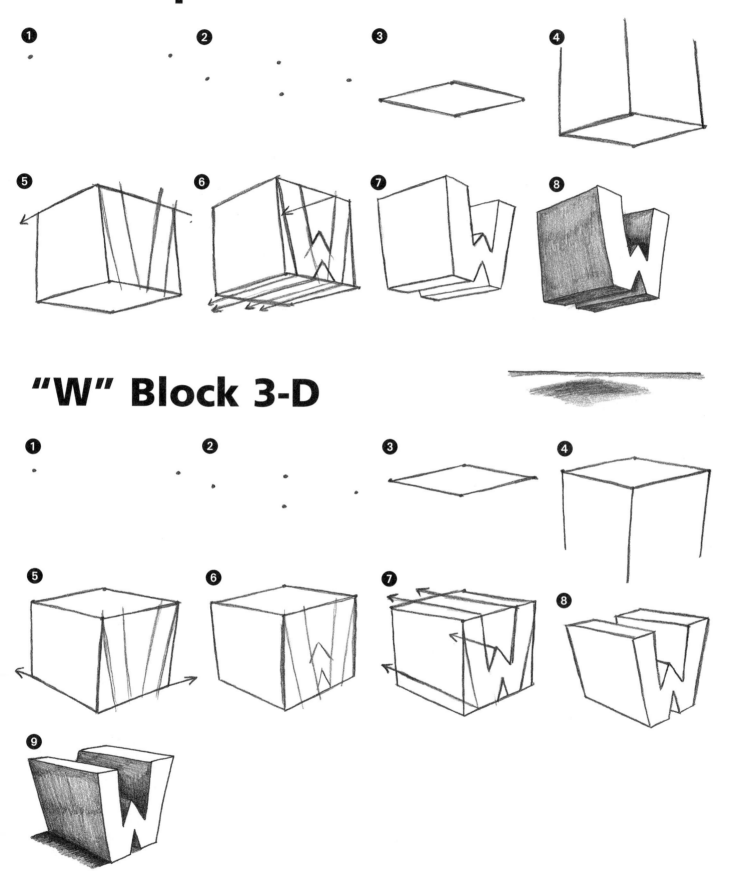

"W" Block 3-D

Walter's Wig

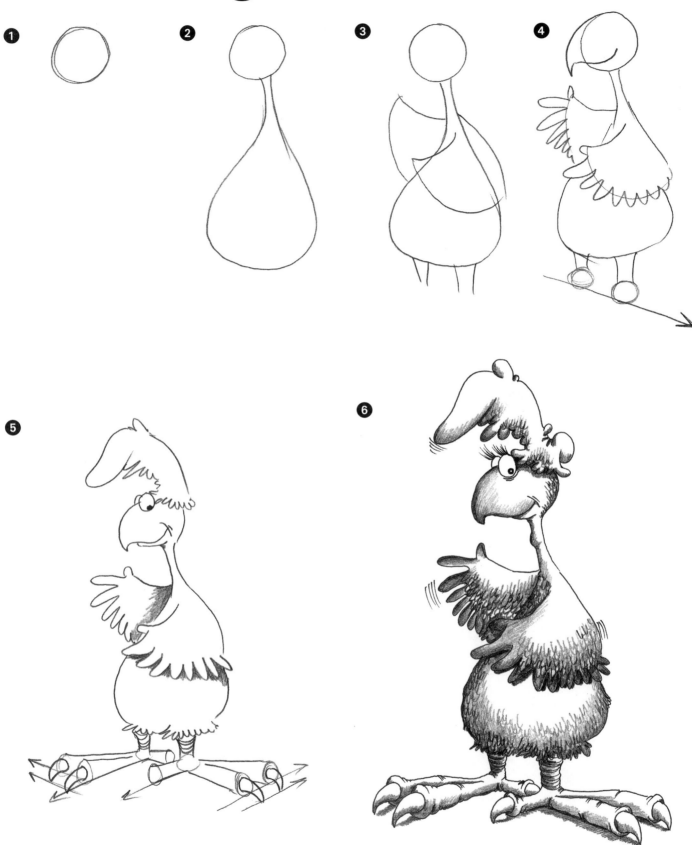

Web Wizard

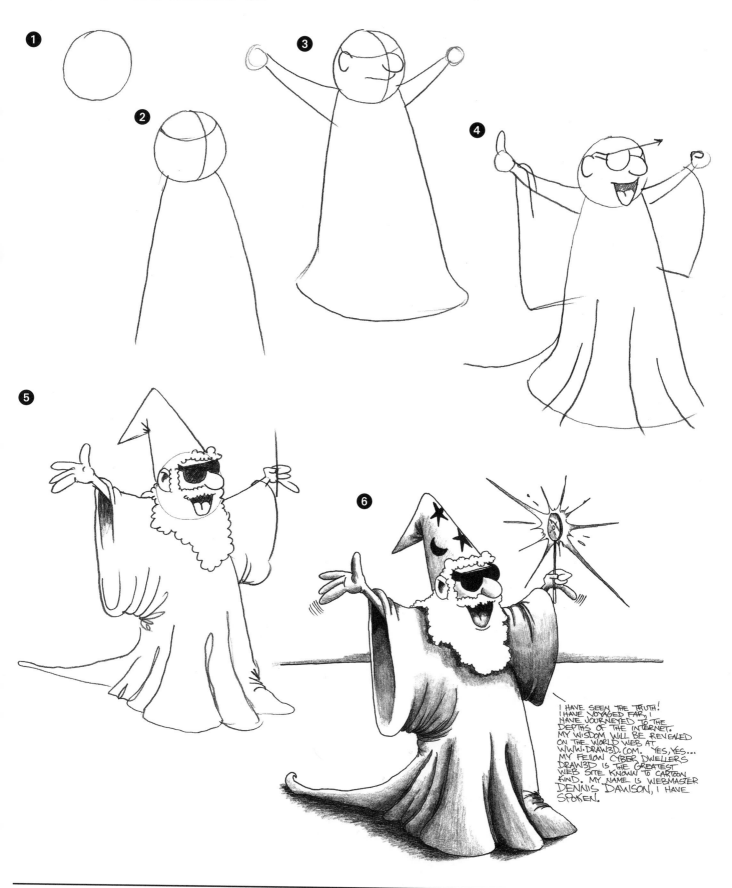

I HAVE SEEN THE TRUTH!
I HAVE VOYAGED FAR, I
HAVE JOURNEYED TO THE
DEPTHS OF THE INTERNET.
MY WISDOM WILL BE REVEALED
ON THE WORLD WEB AT
WWW.DRAW3D.COM. YES, YES...
MY FELLOW CYBER DWELLERS
DRAW3D IS THE GREATEST
WEB SITE KNOWN TO CARTOON
KIND. MY NAME IS WEBMASTER
DENNIS DAWSON, I HAVE
SPOKEN.

Wild Wave

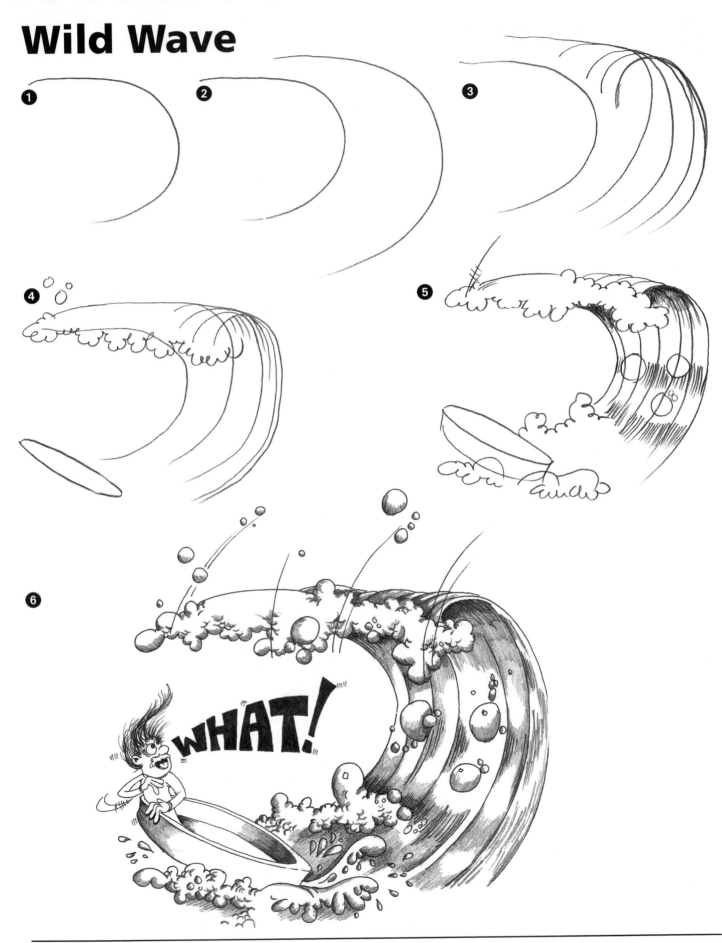

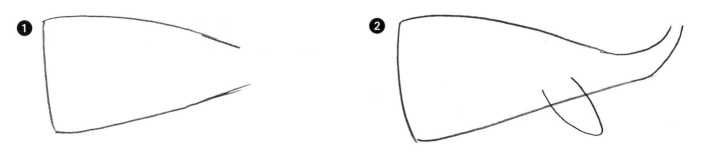

Wonderful Whale

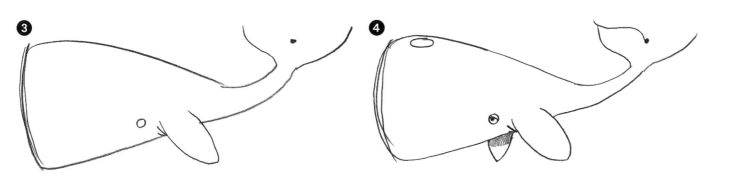

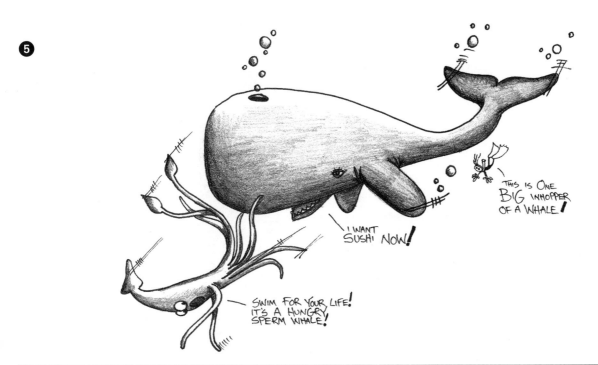

Woooo!

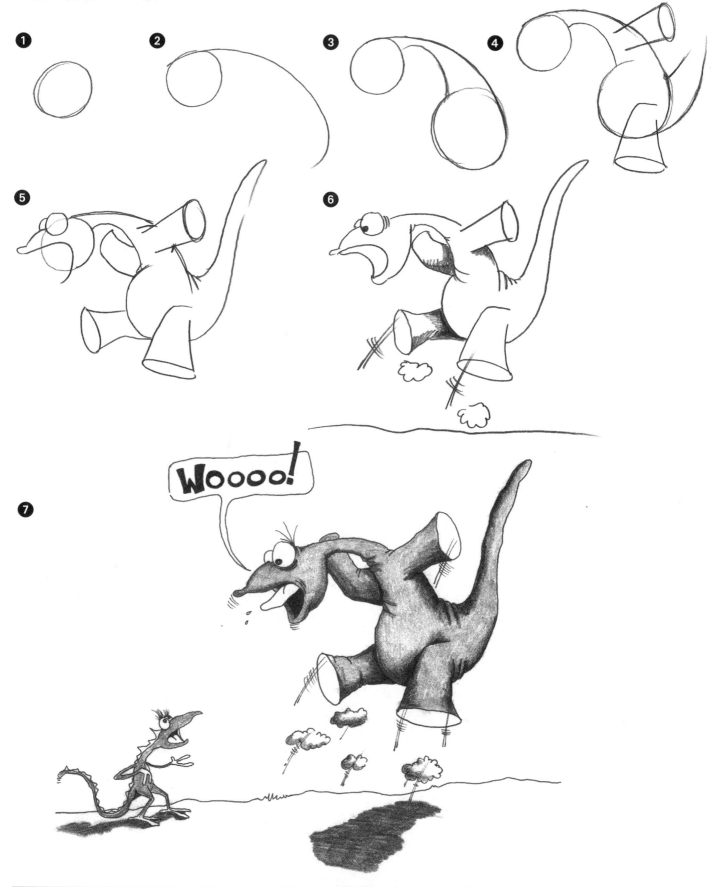

"X" Puff Cloud

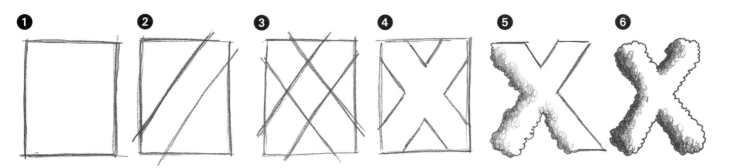

"X" Peeling Shadow

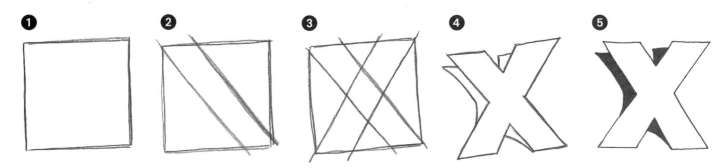

"X" Chiseled Stone

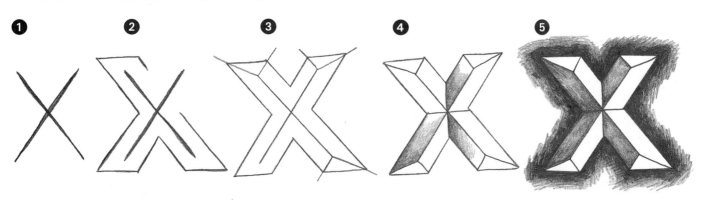

"X" Super Block 3-D

"X" Block 3-D

Xeroxing Xylophone

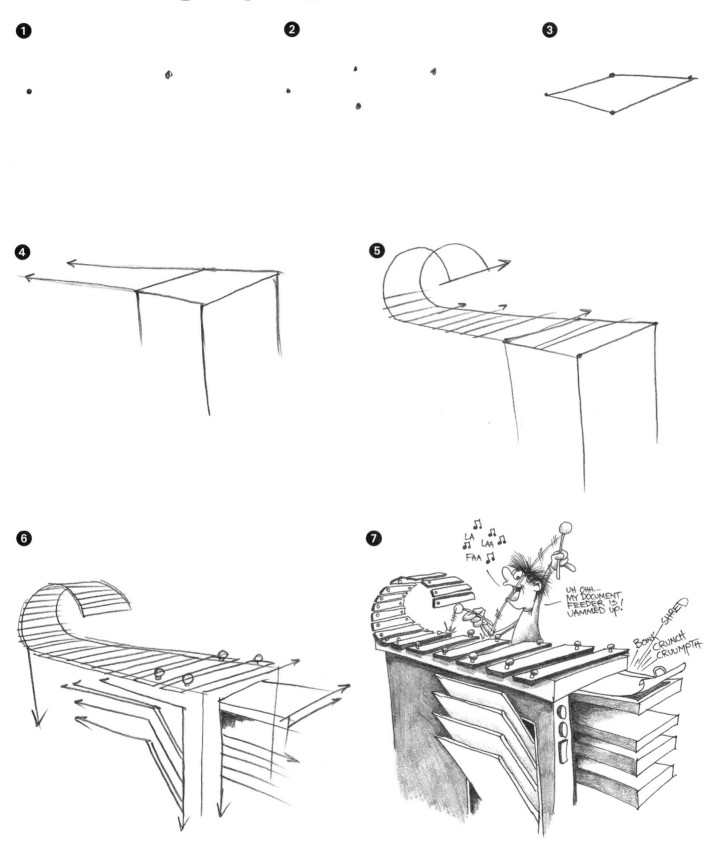

"X"ing

1

2

3

4

5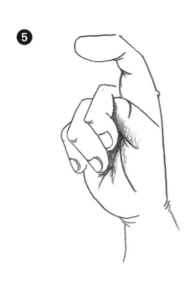

6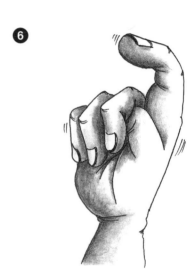

eXpensive Xmas

1

2

3

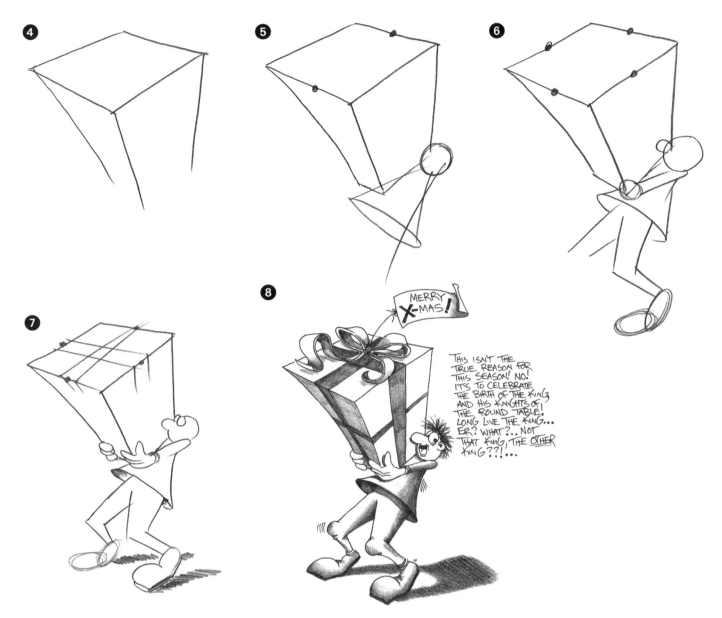

eXploding eXpression

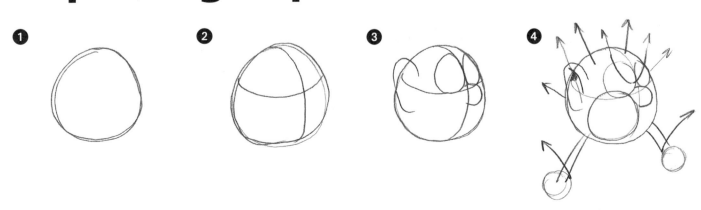

⑤

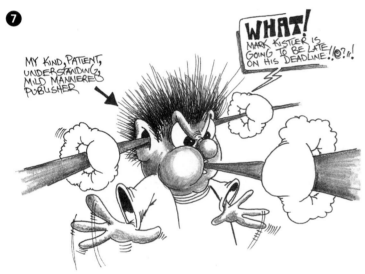

⑥

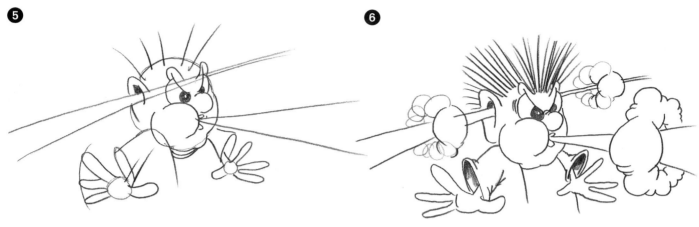

⑦

MY KIND, PATIENT, UNDERSTANDING, MILD MANNERED PUBLISHER

WHAT! MARK KISTLER IS GOING TO BE LATE ON HIS DEADLINE!©?!!

X-ray eXpert

❶

❷

❸

❹

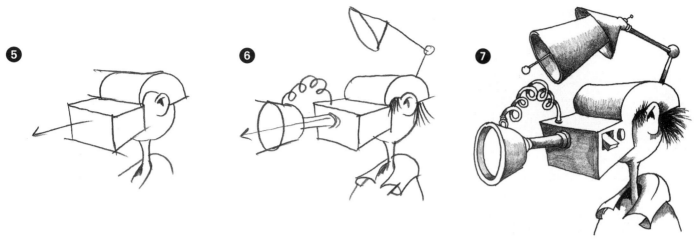

"Y" Puff Cloud

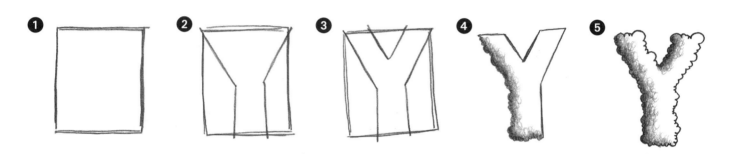

"Y" Peeling Shadow

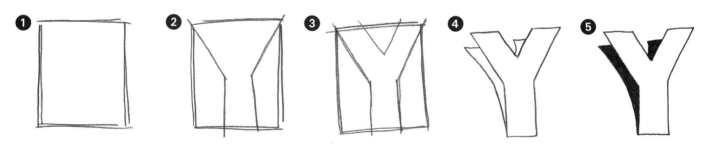

"Y" Chiseled Stone

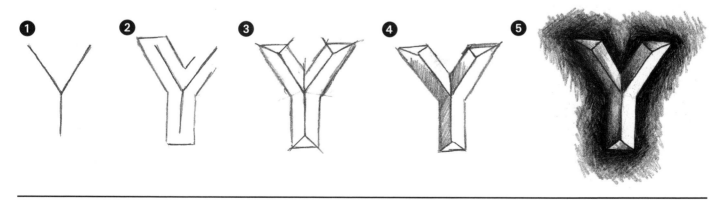

"Y" Super 3-D

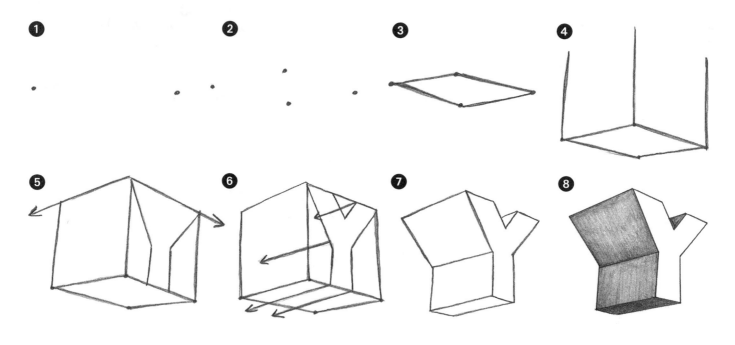

"Y" Block 3-D

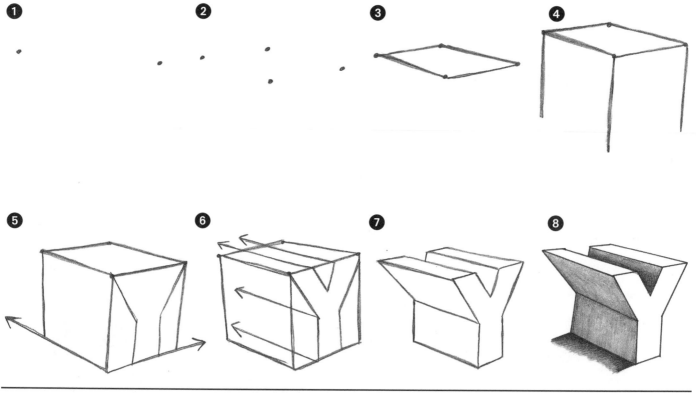

Yeehaw!

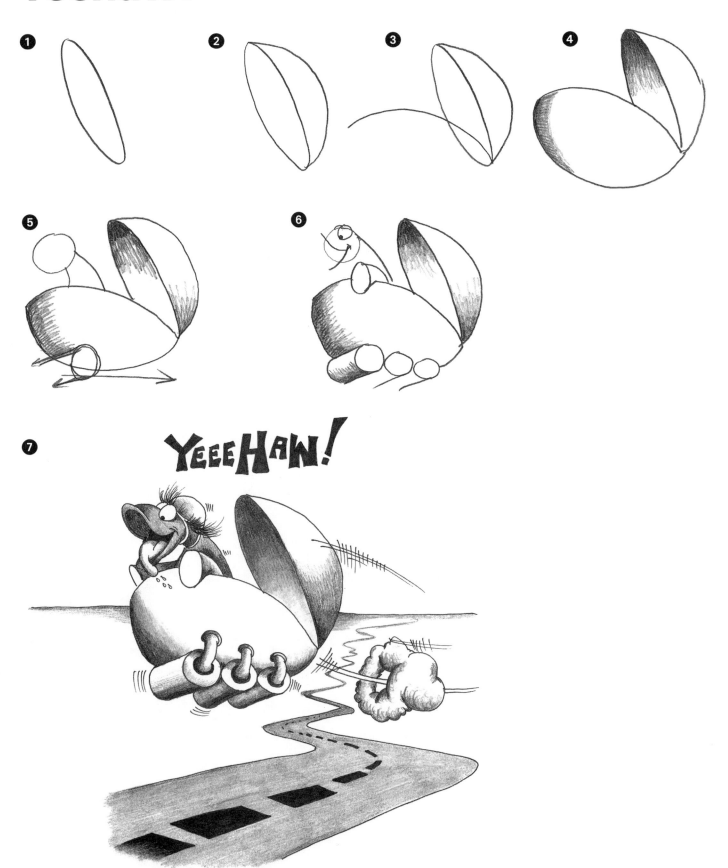

Yelling Yahtzee!

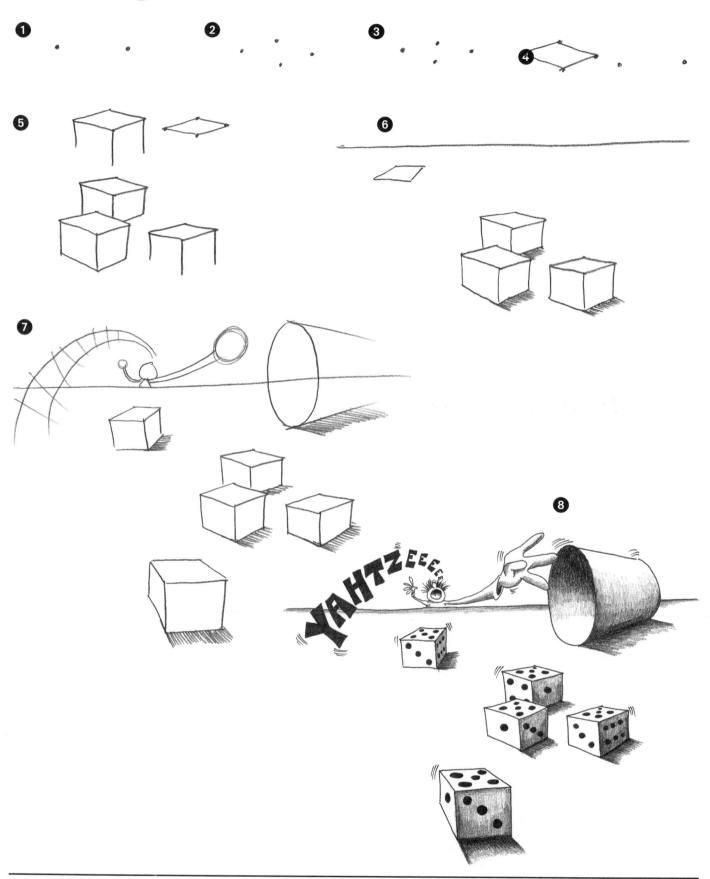

Yellow Yolk

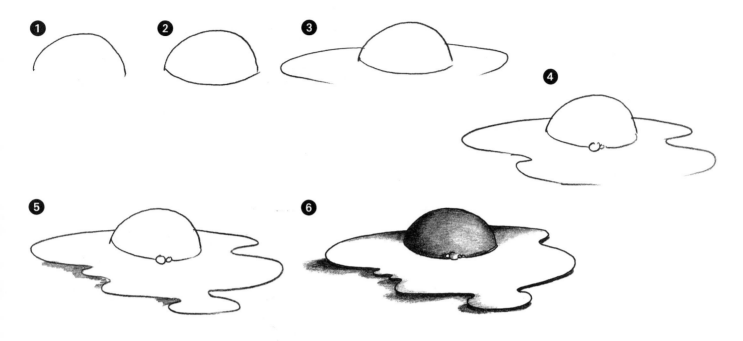

Yodeling Yop

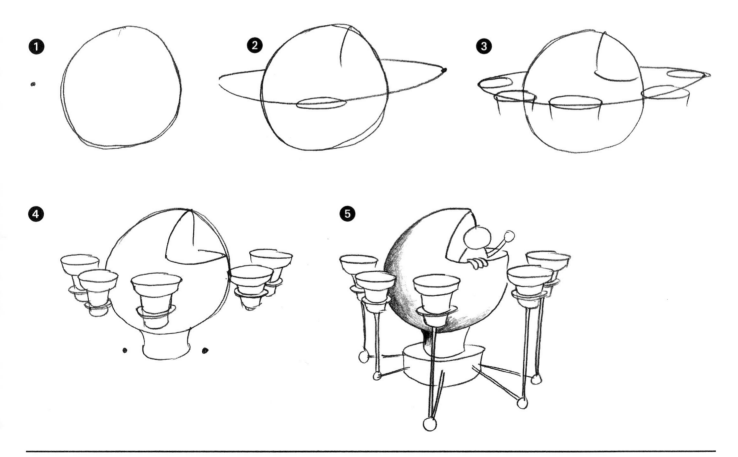

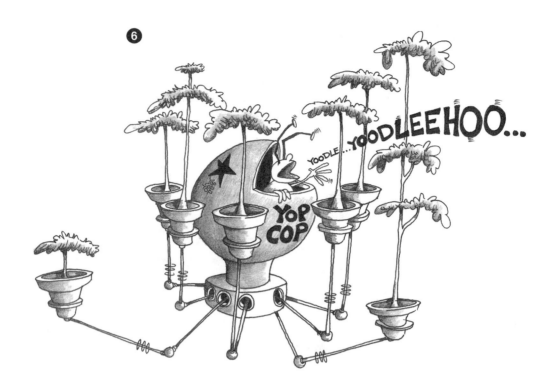

Yummmm

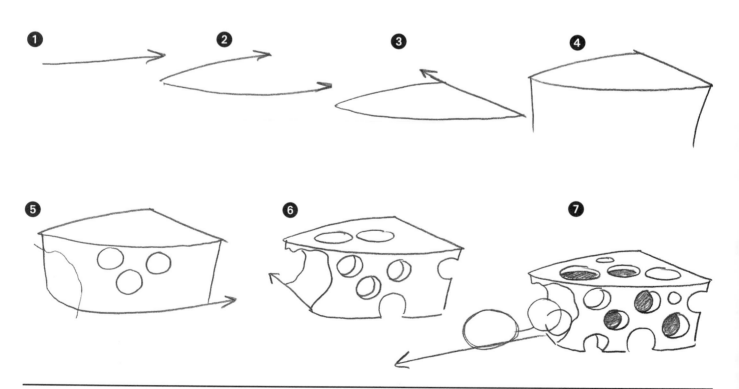

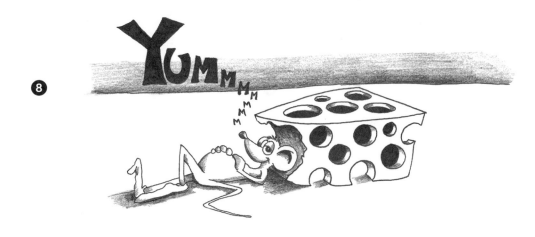

"Z" Puff Cloud

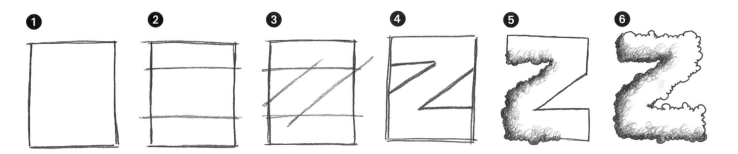

"Z" Peeling Shadow

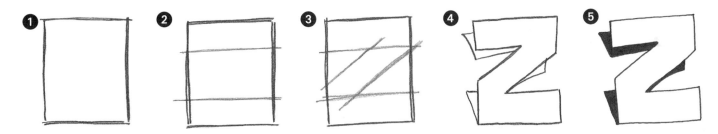

"Z" Chiseled Stone

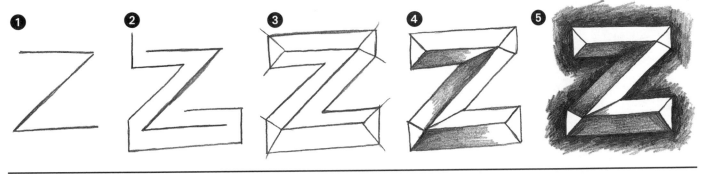

"Z" Super 3-D

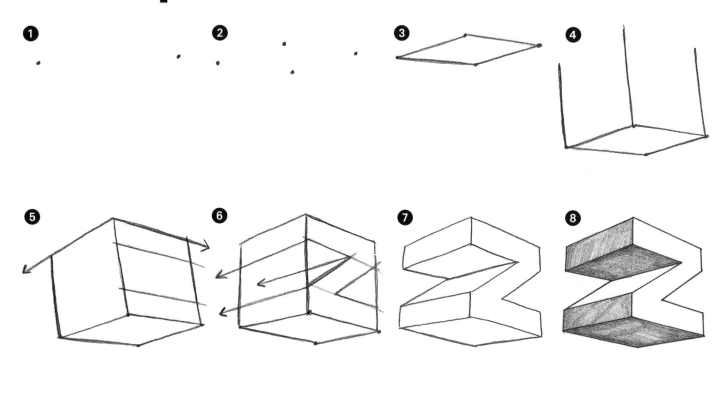

"Z" Block 3-D

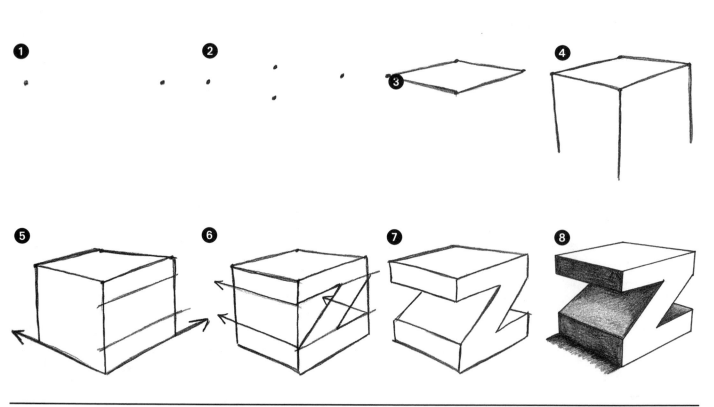

Zachary Zot

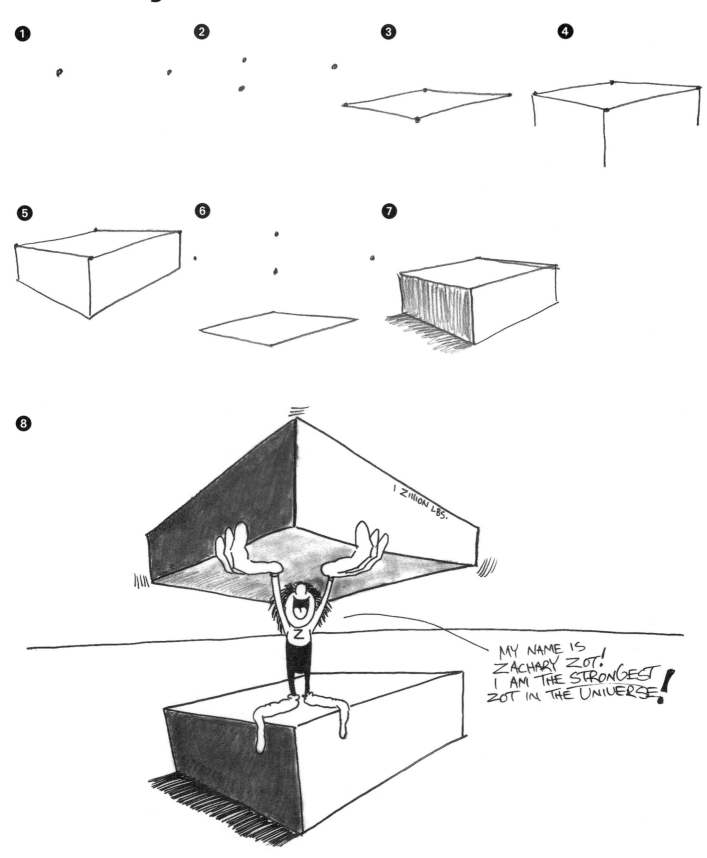

Zapping Zombies

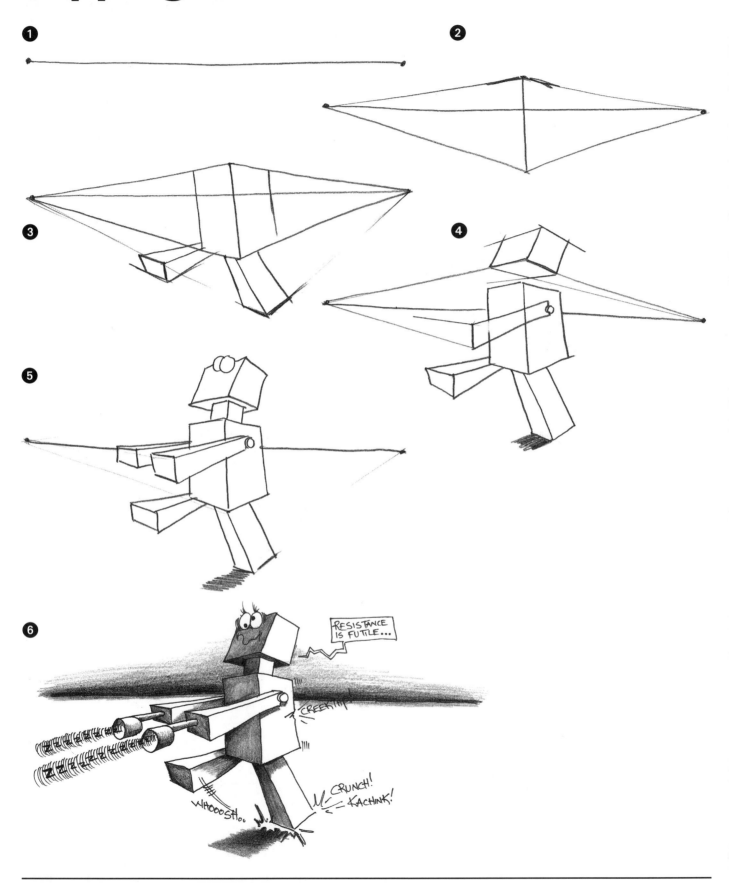

Zesty Zephyr

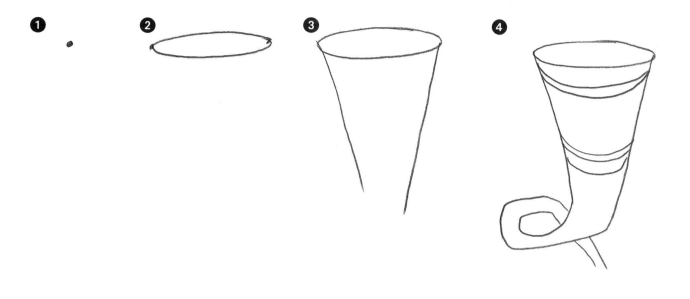

Zippered Zeros

STOP ZIG ZAGGING!

"ZIPITYEEEEE

Zzzzzzzz

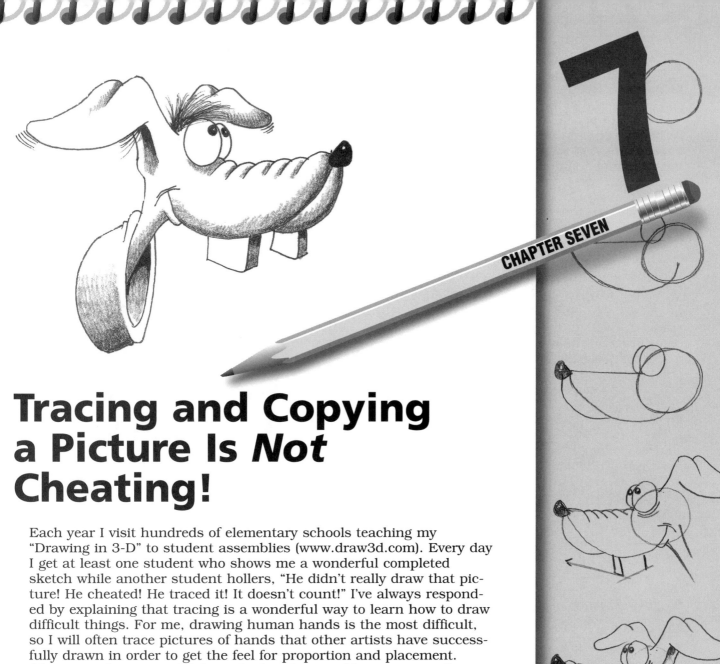

Tracing and Copying a Picture Is *Not* Cheating!

Each year I visit hundreds of elementary schools teaching my "Drawing in 3-D" to student assemblies (www.draw3d.com). Every day I get at least one student who shows me a wonderful completed sketch while another student hollers, "He didn't really draw that picture! He cheated! He traced it! It doesn't count!" I've always responded by explaining that tracing is a wonderful way to learn how to draw difficult things. For me, drawing human hands is the most difficult, so I will often trace pictures of hands that other artists have successfully drawn in order to get the feel for proportion and placement. After several tracings, I'll draw the hand ten or fifteen times without tracing while looking at the picture. Then I'll draw that same hand from memory another ten or fifteen times to really program my mental bank of visual images. Now when I'm sketching a scene and need a character's hand in a particular position, I can make a mental bank withdrawal from the hundreds of hands I've copied, traced, and drawn.

Here's another example: I had a tremendously tough time drawing the gorilla, the giraffe, and the panda bears in this book. For starters, I sketched and sketched all day long for hours, and I just could not seem to get this gorilla to come to life on the paper. One day I was scheduled to fly out of my lovely little town of Santa Barbara, California, to visit elementary schools in Seattle, Washington, for a two-week tour. I really had to get this gorilla drawn. So, along with my clean socks, shirts, and toothbrush I packed my favorite resource books. During the flight to Seattle, and during the tour, I practiced gorillas like a madman. I settled into this nice Seattle gourmet coffee shop, with classical music enchanting the atmosphere and original local paintings hanging on the gallery walls, and drew for hours. I

had chairs pulled up on either side of me. In the chair to my right was stacked my "official" gorilla reference manuals. In the chair to my left was a stack of sketchpads, and on the table I had a huge pile of torn paper, pens, erasers, and pencils. The coffee shop staff was very nice and didn't mind that I took over that table for the entire eight-hour shift. After tracing the gorilla, panda, and giraffe twenty times each, I copied my tracings twenty times each. Finally, I sketched my gorilla, panda, and giraffe ten times on my own, changing the positions, expressions, and details—the fur, the spots, and the action. Tracing is an extremely valuable tool when you are learning how to draw.

My good friend Tim Decker is a chief animator at a very prestigious major animation studio in Los Angeles. He is also a graduate of CalArts. During a recent conversation, we discussed the fantastic effect pencil tracing great artists' work had had on our own drawing and cartooning development. He shared a story about how he was having difficulty in his life drawing class at CalArts. He went to the bookstore and bought a copy of *Bridgman's Life Drawing* by George B. Bridgman. Tim disciplined himself to squeeze in one hour of tracing George Bridgman's drawings each day. He started from page one and worked his way through to the end of the book. Now, art school is very demanding, so for Tim to find one hour a day to study Bridgman on his own took much discipline. Over the course of a few weeks, Tim's life drawing instructor pulled him aside and asked him how he had improved his life drawing skill so dramatically in such a short time. Tim answered him in a whisper, not wanting anyone to overhear, "I traced the entire book of Bridgman." Tim was still under the false assumption that tracing was bad and was cheating. To his surprise, the instructor congratulated him on discovering a centuries-old technique of training art apprentices. During the Renaissance, the great masters like Raphael and Michelangelo would have apprentices trace their work for years before they could begin helping on the masters' actual paintings. I loved his story and told him about my trace/copy/draw strategy in drawing the gorilla, pandas, and the giraffe for this book. I asked him if he would share some great art/animation school leads and some of his favorite resource books with you. A few hours later I received the following fax information. Thanks Tim!

Schools Suggested by Professional Animator Tim Decker

California Institute of the Arts (CalArts)
24700 McBean Pkwy.
Valencia, CA 91355
805-255-1050
http://www.calarts.edu

Sheridan School of the Arts
1430 Trafalgar Rd.
Oakville Ontario, Canada L6H 2L1
www.sheridanc.on.ca/

American Animation Institute
4729 Lankershim Blvd.
North Hollywood, CA 91602
(affiliated with the Motion Picture Screen Cartoonist Union 839)
818-766-0521
http://www.mpsc839.org/mpsc839

Art Center College of Design
1700 Lida St.
Pasadena, CA 91103
626-396-2200

University of California Los Angeles
(UCLA School of Theatre, Film and Television)
405 Hilgard Ave.
Los Angeles, CA 90095-1622
310-825-5761
Fax: 310-825-3383

Reference Books Recommended by Tim Decker

The Illusion of Life: Disney Animation, by Frank Thomas and Ollie Johnston, Hyperion

Too Funny for Words: Disney's Greatest Sight Gags, by Frank Thomas and Ollie Johnston, Abbeville (out of print)

Any Disney book by Frank Thomas and Ollie Johnston

Cartoon Animation, by Preston Blair, Grove Press

Animals in Motion, by Eadweard Muybridge, Dover Publishing

The Human Figure in Motion, by Eadweard Muybridge, Dover Publishing

Drawing the Head and Figure, by Jack Hamm, Penguin Putnam Inc.

Bridgman's Life Drawing, by George B. Bridgman, Dover Publishing

Mark Kistler's Imagination Station, by Mark Kistler (Tim didn't write this one in, but I'm sure it just slipped his mind; so I tossed it here on his list, thoughtful fellow that I am.)

Tim Decker on Building a Portfolio

"Your portfolio should include ten to fifteen pieces of your best work. This work should consist of:

Gesture drawings
Figure drawings
Animal drawings
Some character design of your own
Flip books of animation you have created

"Your gesture drawings are drawings made quickly—one-to three-minute sketches. Your animal sketches should be three- to five-minute sketches. The reason for such quick sketching is that you are trying to capture the shape/volume and movement of the person/animal you are sketching. By sketching quickly you are training your eye to see movement without getting caught up in the details."

Tim always has good information to share about preparing for the animation profession. When I was in third grade I remember tracing pictures out of the Lee J. Ames *Draw 50* book series. I recently had the honor of meeting Lee Ames. He was a special guest artist on a few episodes of my public television series *Mark Kistler's Imagination Station*. During a production break, we had time to talk about learning to draw. We talked about the "cheating" attitude that most students and parents have about tracing. He responded with a wonderful quote: "Mimicry is prerequisite for developing creativity," which means tracing is okay.

You might want to begin each lesson in this book by copying the steps first. Try it several times, then if you need to, go ahead and trace it. Trace it a few times. Then while looking at your tracings, sketch the object on your own ten times. Now draw it on your own from memory. After you have successfully mastered the object, start changing it to reflect your own style. Add your own ideas. Stretch the nose out, make the legs shorter, add Vulcan ears, create your own unique 3-D masterpiece from the traced beginning. Consider each object you are drawing as a big chunk of clay. Using your imagination, harness your pencil to sculpt and mold that chunk of clay into a magnificent three-dimensional rendering created on your own! This is what learning how to draw is all about. Michelangelo, Escher, and even my favorite children's book illustrator Chris Van Allsburg have learned by copying and tracing from their art teachers.

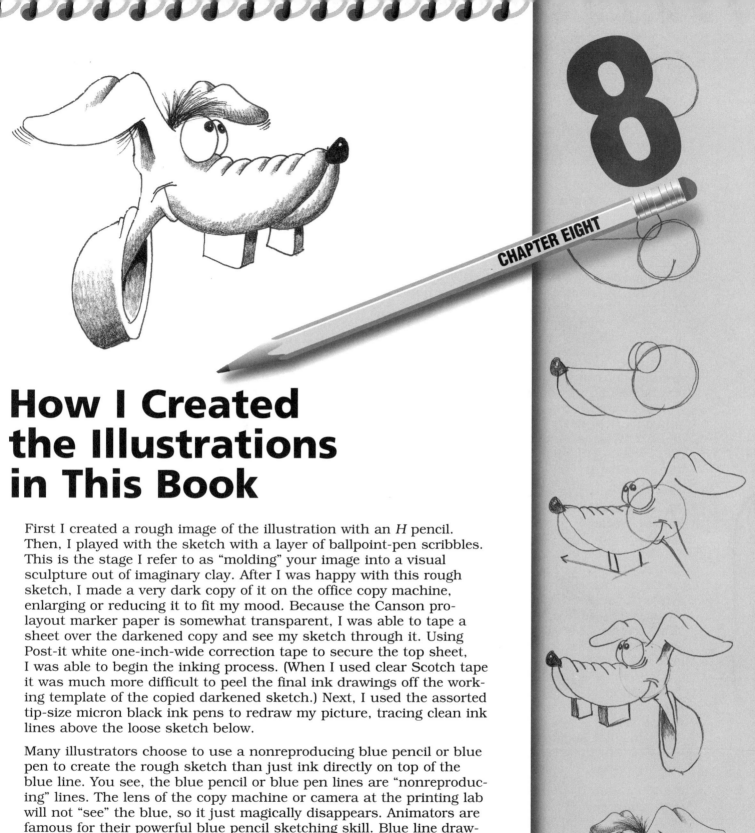

How I Created the Illustrations in This Book

First I created a rough image of the illustration with an *H* pencil. Then, I played with the sketch with a layer of ballpoint-pen scribbles. This is the stage I refer to as "molding" your image into a visual sculpture out of imaginary clay. After I was happy with this rough sketch, I made a very dark copy of it on the office copy machine, enlarging or reducing it to fit my mood. Because the Canson pro-layout marker paper is somewhat transparent, I was able to tape a sheet over the darkened copy and see my sketch through it. Using Post-it white one-inch-wide correction tape to secure the top sheet, I was able to begin the inking process. (When I used clear Scotch tape it was much more difficult to peel the final ink drawings off the working template of the copied darkened sketch.) Next, I used the assorted tip-size micron black ink pens to redraw my picture, tracing clean ink lines above the loose sketch below.

Many illustrators choose to use a nonreproducing blue pencil or blue pen to create the rough sketch than just ink directly on top of the blue line. You see, the blue pencil or blue pen lines are "nonreproducing" lines. The lens of the copy machine or camera at the printing lab will not "see" the blue, so it just magically disappears. Animators are famous for their powerful blue pencil sketching skill. Blue line drawing is easier than my time-consuming process of sketching with pencil, darkening with ballpoint, adjusting the size on the copier, then finally inking the panel. Then why do I do it? I like my final drawings better using this process. This is my special system that works for me. You will find your special system by experimenting and practice. After I finish the inked final panel, I take my faithful mechanical pencils with *HB*, *B*, and *2B* tips to layer on the shading. Depending on the drawing, this is when I'll pull out my array of paper stumps.

Paper stumps come in so many point thicknesses, it's fun to choose just the perfect one to blend the shading on each drawing component. Sometimes I'll use several paper-stump sizes to shade a hairy alien arm versus a tree branch. Each paper-stump size, pencil-tip softness, and paper weight will create a wild variety of textures on your picture. The key is to experiment like crazy and explore all of these wonderful product options available to you as you develop your own unique globally acclaimed style!

Once I finish the inking of the illustration panel, I go back to the rough sketch and add the lettering with a pencil to give the character a voice. Placing the ink panel back on top of the sketch, I move the voice letters around under the final drawing until I'm satisfied with the positioning. After I ink the lettering, it's time to brush it off with our very spiffy drafting brush. My, oh, my, how cool we look brushing off our splendid sketches! Using the gummy and kneadable erasers, I clean up any smudges and cover the drawing panel with a clean sheet of light eleven-pound tracing paper. I secure the tracing paper with the always handy one-inch-wide white Post-it correction tape. The panel is now ready to be shipped to the publisher in New York for computer scanning.

On this book project I was very fortunate to have hundreds of hours of inking and pencil shading assistance from the very talented Tami Brady. Tami is a freelance graphic artist who does amazing portrait paintings of famous celebrities in the sports and music industry. If you want, check out her Web pages on my Internet site (http://www.draw3d.com), click to the student gallery, and find her name. Her work will inspire you to draw nineteen hours every day! (You can eat, sleep, and do homework the other five hours!)

Many people have asked me what type of pens I use during my elementary school assembly presentations, as well as my public television station personal appearances. I have found that by using nontoxic Vis-à-Vis overhead markers on clear transparencies, I can project my drawing on a large screen. This giant projected lesson allows hundreds of students to draw along with me. I love drawing with enormous groups of students. If you want to try drawing using Vis-à-Vis overhead pens, use a sheet of clear plastic transparency film. You might be able to finagle a few sheets from your classroom teacher, or you can purchase a box of fifty at an office supply store. By using nonpermanent Vis-à-Vis pens, you can reuse a single sheet of film several times just by wiping it clean with a damp paper towel. These drawings turn out to look like cool animation-style "cels" and can be framed for display. With your teacher's help, you can also put these on the overhead projector in your classroom for your classmates to enjoy.

Another great use for these clear film cel drawings is for drawing portraits and landscapes. Pick a window in your house with a nice view. With your parents' help, tape a transparency film cel to the window. Looking through the transparency, close one eye and draw what you see with a Vis-à-Vis pen. When you are finished, peel it off the window, place it over a white sheet of paper, and admire your rendering. Tracing from life and nature is a great way to learn how to draw something on your own just by looking at it. Try this drawing exercise with a friend or family member sitting on the other side of a sliding glass door. A very nifty portrait artist you have become! Using different pen colors can create some wonderful shading effects.

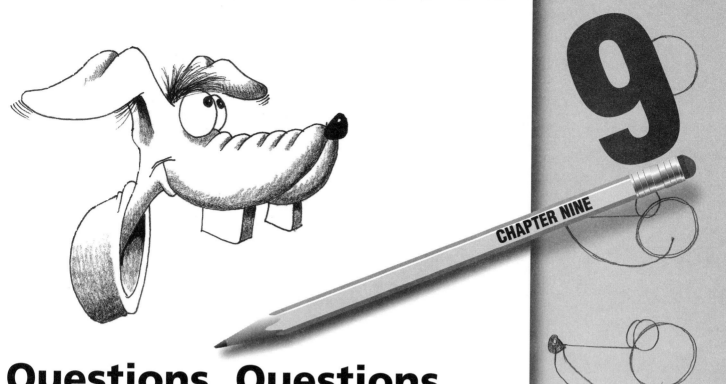

Questions, Questions, Questions

I love hearing from you! Last month I received my 1,014,000th letter. Over a million letters declaring that drawing in 3-D is cool! I enjoy each letter but often cannot respond personally to everyone. I would love to see your drawings, read your stories, and enjoy your alliteration poetry. Mail me your renderings, I love mail. My address is listed below. If you want my office to mail you back a newsletter drawing lesson you must include a self-addressed stamped envelope. Perhaps I will use one of your drawings on a TV episode of *Mark Kistler's Imagination Station* or in my next book! Below I've answered some frequently asked questions for your ever so inquisitive mind. I trust you will find my answers enlightening.

Q: How can I contact you?

 A: Call me.

Q: Do you have an Internet Web site?

 A: Yes.

Q: Is *Mark Kistler's Imagination Station* broadcasting on my PBS station?

 A: Probably.

Q: How many other books have you written?

 A: Four.

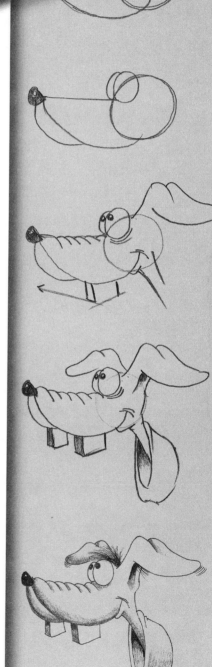

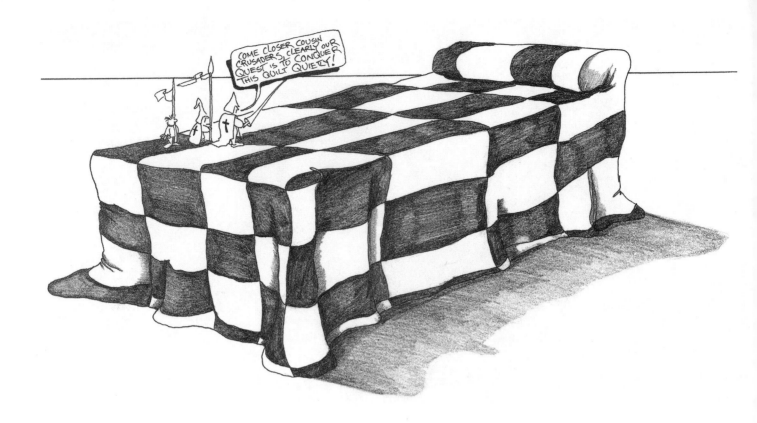

Q: **How can I arrange to have you visit my child's elementary school?**

A: Call me.

Q: **How many other Mark Kistler drawing products are available?**

A: Lots.

Q: **Why are your answers so short?**

A: I just had my brothers Stephen and Karl proofread this manuscript, and they said I talk too much. The big meanies.

Q: **Where are the real answers to these questions?**

A: Good question.

Q: **Seriously.**

A: Really?

Q: **Yes.**

A: Okay, start over.

Q: How can I contact you?

A: My mailing address is Drawing in 3-D with Mark Kistler, P.O. Box 41031, Santa Barbara, California 93140. Be sure to include a self-addressed stamped envelope if you would like a response.

Q: Do you have an Internet Web site?

A: My World Wide Web site address is http://www.draw3d.com. To directly access the interactive 3-D drawing lessons you can type http://www.drawwithmark.com. Nearly 600,000 people have hit this Web site, making it the most popular learn-to-draw in 3-D site on the planet! Webmaster Dennis Dawson has created an exciting interactive-imagination cyber playground for drawing students. You can learn the twelve Renaissance words, and the twenty-two augmenting art accents and choose from dozens of drawing adventures to sketch. Dennis has created an extensive student gallery with awesome student artwork displayed for the entire world to enjoy. You can also link to many professional cartoonists, illustrators, and animators. If you want to get your daily dose of visual cultural cuisine from the great painting masters, you can link to many major museums around the world. Dennis has added links to my good friends and fellow art educators Kim Solga of KidsArt (www.kidsart.com); Mona Brookes of Monart art schools (www.monart.com); and Mike Schmid of FAME, the Foundation for Music and Art in Elementary (www.fameart.com). You may E-mail me directly from the front home page. If you have designed your own supercool home page Web site and would like us to link to you, send Webmaster Dennis Dawson an E-mail with your information. He is the greatest dude on the planet, which also makes him one of the busiest humans I know. It might take him a little

while to review your home page and get back to you with the link information. Since you are such a kind, tolerant, patient artist you won't be bothered by any delays. I love checking out new exciting Web sites that you have discovered and enjoy. Pass on your favorite links to Dennis and me and perhaps we will make the link available to all the artists visiting www.draw3d.com. I look forward to drawing with you in cyberspace!

Q: Is *Mark Kistler's Imagination Station* broadcasting on my PBS station?

A: The best way to find out if the show is being aired in your local PBS area is to call your public television station and speak with the programming director. They will tell you if it is currently being broadcast and what time of day it is on. If it is not on in your city, your phone call encouraging them to begin broadcasting it will make a big impact. This children's television series now consists of ninety-five half-hour episodes. Each year I donate these programs to all participating PBS stations across America. The tremedous PBS broadcast success of *Mark Kistler's Imagination Station* is due primarily to the quiet grassroots parent/teacher support campaign of phone calls and letters to the appropriate programming directors. I want to thank you in advance for calling and supporting my mission of broadcasting a quality art education program across America. If you are interested in volunteering your time to help coordinate viewer support in your state, give my office a call. We would love to have you onboard!

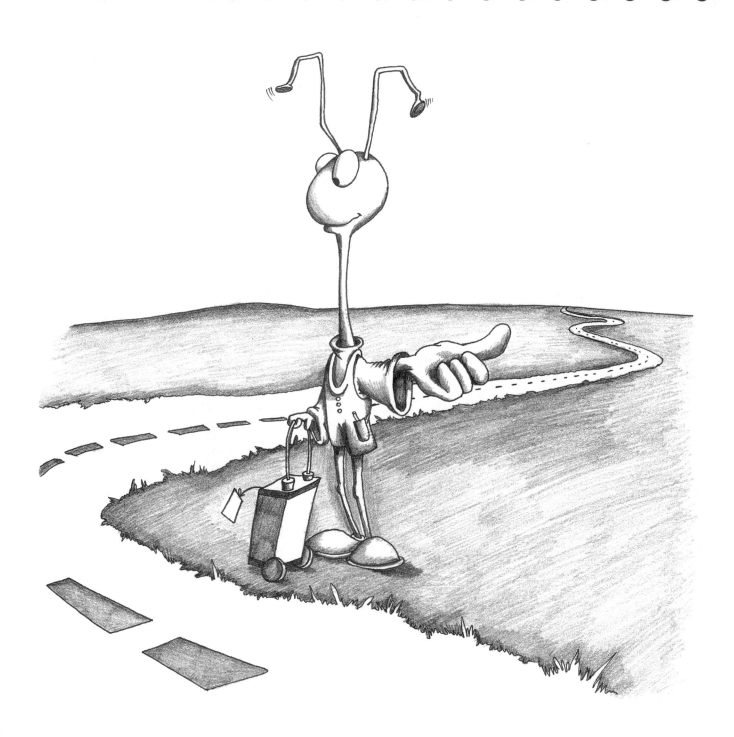

Drawing in 3-D builds dynamic self-esteem, nourishes powerful creative-thinking tools, and helps blossom expressive socializing skills. Children who actively draw in 3-D will read more literature to generate ideas for drawing, write more stories narrating their grandly illustrated three-dimensional renderings, and will certainly interact more with peers describing their exquisite artistic masterpieces. My goal with the PBS children's drawing series is to make drawing education universal for all children to enjoy. In the broadcast markets that have proved difficult to gain broadcast support I have made the series available to school districts for interschool broadcast and multiple set duplication for each elementary school site.

Q: **How many other books have you written? What new books do you have coming out?**

A: Five. Four are still in print and available in bookstores around the country. *Learn-to-Draw with Commander Mark*, 1985 (out of print); *Mark Kistler's Draw Squad*, 1990; *Mark Kistler's Imagination Station*, 1995; *Drawing in 3-D with Mark Kistler*, 1998, and *Mark Kistler's Drawing in 3-D Wacky Workbook*, 1998.

My new book projects due out soon are *World Wide Web Wizards!*, cowritten with Dennis Dawson; *The Bobby Chronicles*, cowritten with Stephen Kistler; *Drawing in the Elementary School Classroom*, cowritten with Margaret Hansen; *Antman's Amazing Art Adventures through Time!*, cowritten with Kim Solga; and *Animating in 3-D* cowritten with Tim Decker.

Q: **How can I arrange to have you visit my child's elementary school?**

A: I have several different elementary school assembly programs available. The "Drawing in 3-D Imagination Station" is a series of assemblies designed for consecutive annual visits, from first year through the tenth year. I also present special programs, the "Young Authors/Illustrators" workshop, "Our Diversity University" multicultural program, "World Wide Web Wizards!," and my "Dream Dominators Dump Drugs!," a lifelong goal clarification workshop. You can read more about these special programs on page 280. You can write for an information brochure at the above address. Our administration phone number is 888-UDRAW3D. For additional information look at the "Kistler Katalog" icon on my front home page at www.draw3d.com.

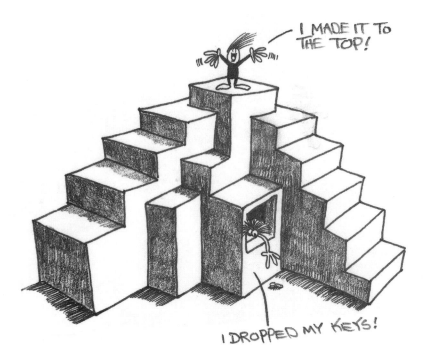

Q: What other Mark Kistler drawing products are available?

A: Lots of spiffy stuff. Turn to page 277.

I've answered many more questions on the draw3d.com Web site.
Drop me a note or E-mail. I would enjoy hearing from you.

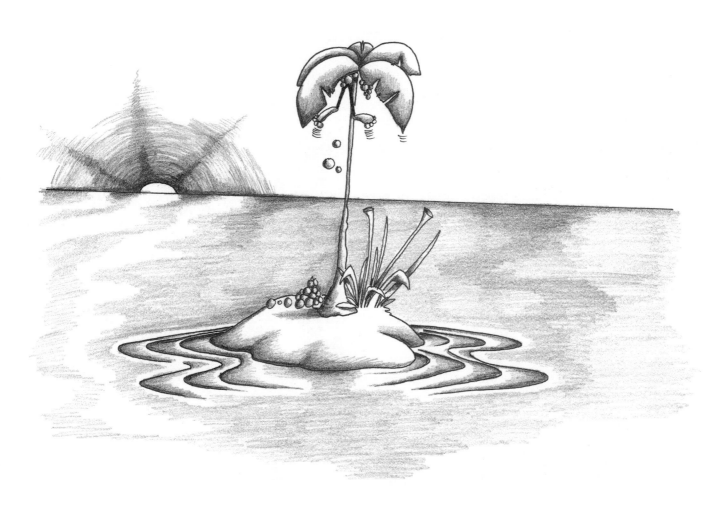

Appendix A

Books, Books, Books!

Now that you have determined you are going to be a lifelong dynamic 3-D drawing genius, it's time for you to start building your idea reference library.

People often ask me why I would recommend other drawing books, videos, and TV shows. Why would I promote my competitors' products? I figure there are over 50 million children in the United States, totaling around 2 billion kids on planet Earth. My mission goal is to see that each one of these children explores his own awesome individual creative potential by learning how to draw. Learning to draw builds self-esteem, expands creative problem-solving skills, and promotes imaginative communication skills through pictures, words, and music. When billions of kids are drawing they are growing up into more creative, resourceful, tolerant, patient adults, becoming honorable members of our human societies. To teach drawing skills to 2 billion children, we are going to need a vast resource of instructional materials. Variety is the key to successfully reaching kids in every nation, economy, race, religion, and value structure on the planet. Some books will have tremendous success with one group of children in Seattle, while other ones seem to work better in Bangor, Maine, or yet another in Munich, Germany. I believe we've barely witnessed the beginning of the massive growth in the how-to-draw (art lessons) book publishing industry. Currently you will find one small section of these books in your local bookstore. Soon you'll notice two sections, then eventually there will be such a wonderful selection that they will outnumber even the "making money in business" books.

Fifteen years ago when I started producing my first public television series, *The Secret City with Commander Mark* at Maryland public television, we were the only how-to-draw television series broadcasting. Not since the *John Gnagy Drawing Show* in 1967 had there been such a fun interactive show. Fifteen years later there are three wonderful and different drawing shows on public television: my series, *Mark Kistler's Imagination Station*, the delightful *Bruce Blitz on Cartooning*, and the charming

Pappyland. This same explosion of interest has happened in the drawing book industry. When my first book, *Mark Kistler's Draw Squad* was published by Simon & Schuster in 1988, there were only a few how-to-draw titles available. And most of these were decades old. Fellow authors Mona Brookes, Lee J. Ames, Betty Edwards, and I really gave the industry a wake-up call when huge book sales caught the attention of dozens of publishers. Now, thirteen years later, you can find hundreds of fantastic drawing books on the Internet, in bookstores, and in your local library. I feel like a proud uncle of the how-to-draw industry.

For fifteen years I've campaigned for corporate support of my public television shows and drawing books. I campaigned on the platform that there is a tremendous need for drawing education in the television and book publishing industries. After personally writing hundreds of letters and attending cross-country meetings with corporate representatives, the response was consistently, "no, we don't think there is any market here." I feel pleasantly vindicated with this exploding industry producing a spectacular variety of how-to-draw products for billions of people eagerly wanting to learn.

I believe the industry has room for hundreds more authors, each one publishing his own unique approaches to teaching drawing skills. With 2 billion kids around the globe all loving to draw, all clamoring for a variety of instruction books, there continues to be an enormous demand for fresh new books. Use the reference books listed below often. Perhaps someday you'll want to publish your own best-selling artist's how-to book.

This was a very fun resource list to compile. I love these books and resource materials. Each has proven indispensable to me in developing drawing lessons for the ninety-five episodes of my television series and the six hundred drawing lessons in my three books, *Imagination Station*, *Draw Squad*, and *Drawing in 3-D.* I encourage you to look at the hundreds of art education-related hot-links available from the World Wide Arts Resources Internet Web site. You can locate their Web icon directly from my www.draw3d.com Internet site.

These great books are listed in alphabetical order. If you cannot find any of the listed titles in your bookstore, ask the front desk to special order it for you. All the books listed below contain intricate illustrations ideal for dynamic copy/trace/draw practice sessions. You can access more information about each of these amazing authors via sizzling hot-links from my Internet Web site at http://www.draw3d.com.

Alphabetical Soup, Suzy Spafford, published by Suzy's Zoo. Suzy was a delightful guest artist on several episodes of my public television series. A phenomenally successful cartoonist, she has distributed her line of greeting cards, stationery, calendars, posters, stuffed animals, toys, games, clothing, and coffee cups (she gave me two, how cool!). This book and all of her cards and calendars are excellent for copy/trace/draw practice sessions. To order her book or obtain a catalog of her cool cartoon products call 619-452-9401. More information is available via link from www.draw3d.com or E-mail her company at Duckport@suzyszoo.com.

Animalia, Graeme Base (several of his titles available in book-stores), Abrams. These books make fantastic copy/trace/draw practice sessions. I referred to Graeme's illustrations daily while drawing this book. More information about this author is available via a link from www.draw3d.com.

Aster Aardvark's Alphabet Adventures, Steven Kellogg (many titles available), William Morrow & Company, Inc. These books make fantastic copy/trace/draw practice sessions. I referred to Steven's illustrations daily while drawing this book. More information about this author is available via a link from www.draw3d.com.

Cartoon Animation, Preston Blair (available in bookstores and art supply stores nationwide), Grove Press. Considered the animation bible for most professional animators. These books make fantastic copy/trace/draw practice sessions. More information about this author is available via a link from www.draw3d.com.

Castles and *Cathedrals*, David Macaulay (several titles available), Houghton Mifflin Company. Hundreds of brilliant, intricate illustrations that allow for months of copy/trace/draw practice sessions. More information about this author available via link from www.draw3d.com.

Draw 50 Animals, Lee J. Ames (over twenty-five titles in series), Doubleday. Lee was a great guest artist on several episodes of my television series. All of his books are fantastic copy/trace/draw practice workbooks. I've used his books since I was in third grade. This book helped me learn how to draw a rhino to look like a rhino, and not a rat with horns and armor. You can E-mail Lee from my Web site, www.draw3d.com.

Drawing with Children, Mona Brookes (two titles available in bookstores), G. P. Putnam's Sons. Mona was a fascinating guest artist on several episodes of my television series. Mona also has dozens of Monart Drawing Schools around the world, teaching zillions of kids how to draw and color amazing masterpieces. She also conducts educator workshops and lectures around the world. She is a very inspiring dedicated lady. For more information about Mona, link to Monart via www.draw3d.com or contact www.monart.com.

Fairies, Michael Hague, Henry Holt and Company, Inc. Hundreds of extraordinary drawings of magical fairies, trolls, gnomes, and other mythological creatures. Copy/trace/draw every drawing in this book and your drawing skill will be unstoppable.

HELP STOP WORLD VIOLENCE, TAKE A NAP EVERYDAY!

Harley Hahn's Internet and Web Yellow Pages, Harley Hahn (updated editions available annually in bookstores around the globe), Osborne/McGraw-Hill. Over 1 million copies of this indispensable Internet reference directory have been sold. A fully hot-linked CD-ROM version of the book with free AT&T Worldnet Service to access the Net is included in the book. Harley Hahn and I have been great friends and started writing books about the same time nearly fifteen years ago. He edited my first published book, *Draw Squad*. These yellow pages reflect his gentle brilliance spiced with his hilarious comic per-

sonality. Buy this book—it's over nine hundred pages of fun. For more information about this author, connect to www.harley.com or link to him via www.draw3d.com.

KidsArt art teaching booklets, Kim Solga (sixty titles), KidsArt. Kim has written sixty great multicultural art books, with information about artists from just about any time period, any country, or any cultural group. She has created accompanying art lessons in each booklet. Kim has also written eight children's hardcover how-to art books about painting, drawing, sculpting, making crafts, printmaking, clothing designing, and making gifts and cards. These books are published by Northlight and are available in art supply stores around the world. She just finished coauthoring a new book titled *Great Artists* with MaryAnn Kohl by Bright Ring Publishing, Inc. *Great Artists* is available in bookstores everywhere. When I spoke with Kim about including her books in this reference list I asked her what kind of deal she would extend to my faithful readers if they sent her $15. Being an enthusiastic generous person she rattled off the following package, all substantially discounted for you. Kim Solga will put together a package of five of the greatest artists KidsArt booklets. You can request the collection in the All-Time Favorites Sampler Package, or Kim encourages you to challenge her with a list of your five favorite art topics, greatest artists, or time period. She will meet your challenge and ship you the suitable KidsArt booklets. Good luck loyal reader! Send $15 to: Kim Solga, KidsArt, P.O. Box 274, Mount Shasta, CA 96067, Kidsart@macshasta.com, www.kidsart.com, or link from www.draw3d.com. You can call her at 530-926-5076.

Oh, the Places You'll Go!, Theodor S. Geisel (over fifty Dr. Seuss titles available), Random House. All Dr. Seuss books are great copy/trace/draw practice books. More information about Theodor Geisel is available via a link from www.draw3d.com.

The Far Side Gallery, Gary Larson (dozens of other titles), Andrews and McMeel. All Larson books are wonderful for copy/trace/draw practice sessions. More information about this author via a link from www.draw3d.com.

The Imagination Station, Douglas Love, HarperCollins. A year or so after my *Imagination Station* book was released by Simon & Schuster I discovered something strange. Another book had just been published with an identical title as my book and television series. I was appearing at an elementary school book signing. A few hundred kids thought they had purchased my *Imagination Station* book and wanted me to fly in for a drawing assembly/book signing. I was a wee bit surprised when the bookstore arrived with a dozen cases of my books for the kids. The students had preordered over two hundred copies of my *Imagination Station* book. However, when the bookstore opened the boxes to distribute the book, surprise! The children were bewildered, standing there with Douglas Love's *Imagination Station* book in their hands. I was furious, how could someone blatantly copy my company name, TV series, and book title? How could a bookstore make such a monumental blunder? I grabbed one of these imposter books totally prepared to dislike it immediately. I slammed open the book and started to read it. By page three I was so charmed with the book, I ended up buying several copies for my daugh-

ter, niece, and nephew. The two hundred kids were fairly disappointed because they wanted drawing books, but I flew home with three very cool new books.

Evidently, Douglas Love is a very successful children's theater director in New York City. At the time he wrote his book my show was not broadcasting in the Manhattan area. He didn't copy my title; he had a great idea for a free-standing easel-type of book with flip pages of creative movement exercises for children. This easel forms a station of creative discovery, hence *Imagination Station*. It's still strange when I see our identical titles displayed in bookstores, but I totally endorse his book. Perhaps I'll meet Douglas Love one day and cowrite a children's play about drawing pictures. Sounds like heavy drama doesn't it? Picture it: Stage curtains open to reveal several kids vigorously drawing on sketchpads spread out across the stage. Silence. Scribble, sketch, sigh, sketch. The audience watches mystified. More sketching and sighing. Ninety minutes later the curtain closes. It will be an action-packed production, eh?

The Indispensable Calvin & Hobbes, Bill Watterson (dozens of other titles), Andrews and McMeel. All Watterson books are delightful copy/trace/draw practice sessions. More information about this author via a link from www.draw3d.com.

The Z Was Zapped, Chris Van Allsburg (dozens of his titles available in bookstores). All Van Allsburg books are delightful copy/trace/draw practice sessions. More information about this author via a link from www.draw3d.com.

Through the Cracks, written by Carolyn Sollman and illustrated by Barbara Emmons, Davis Publications. Special order it directly from the publisher as I did at 800-533-2847 or call your local bookstore. Currently the price is $19.95 + $5.00 shipping to your house. This price is subject to change in the future. This was a seven-year labor of love for these women. A wonderful story about how integrating art into all areas of a school's curriculum saved children from "falling through the cracks" of society. Brilliantly written and exquisitely illustrated.

"Where's Waldo?", Martin Hanford (several titles available), Little, Brown and Company. All Hanford books are cool copy/trace/draw practice sessions. More information about this author via a link from www.draw3d.com.

Wildlife Fact File, Written by many researchers with lots of breathtaking photography, published by International Masters Publishing, 4 Gateway Center, 444 Liberty Ave., Pittsburgh, PA 15222, 1-800-599-9694. This is a membership-type deal. You sign up and receive a packet of Wildlife Fact Files every month or so. You store all of your file packets in a slick-looking three-ring binder. The individual files focus on facts of specific animal, species, geographical region, flower, plant, tree, etc. My older brother Steve has built up quite a collection for his seven-year-old son Ian, who

at times will share them with his little sister Laurel. I enrolled for a while but found it to be a bit pricey and opted to buy the *ZOOBOOKS* listed below. However, for classrooms and family libraries it's a perfect information directory. Your students will love the photographs.

ZOOBOOKS, written by many zoologists, research scientists, and amazing animal illustrators (sixty titles available for around $4 each); published by Wildlife Education, Ltd.; contact Julaine Chattaway at 800-477-5034. An encyclopedia of animals from alligators to zebras. This collection is a superb copy/trace/draw practice tool. I was introduced to these books by an art teacher in Duluth, Minnesota. I was visiting her Duluth school district when she shared these books with me. The books are terrific so I decided to order a set. To my surprise, the publishers are located only a few miles from where I live in California. I bought the entire set and use these almost daily.

Art Clubs and Organizations

National Cartoonist Society: A very cool organization supplying thousands of cartoonists, illustrators, animators, and artists with important information pertaining to the industry. You can also obtain information about how to become an active member of your local or state cartoonist group through the NCS. Contact the NCS from my Web site. I've been a member of my local Southern California Cartoonist Society (SCCS), organized by the famous cartoonist Jim Whiting, for years. I even have the cool SCCS coffee mug! Become a member of the NCS today and begin networking with other successful cartoonists to build your own career.

National Art Education Association (for teachers and parents): This is a fantastic organization for all art teachers of all grade levels. It is also very helpful for regular classroom teachers who are forced to teach art because art teachers have been cut from the district budget. I've been a member for over ten years. The newsletter and national conventions are wonderful. The NAEA relentlessly pushes the inclusion of quality art education in our national curriculum guidelines. It's highly recommended to have a membership in your state art education association simultaneously because the state and national support each other. Contact NAEA and your state AEA through the Internet via www.draw3d.com or mail inquires to: NAEA, 1916 Association Dr., Reston, VA 22091.

National Catholic Education Association (for teachers and parents): Catholic educators combining efforts to provide quality education in Catholic schools across America. Contact NCEA at 1077 30th St. NW, Suite 100, Washington, DC 20007.

National Education Association (for teachers and parents): Millions of educators join efforts pushing quality education to a top priority in the agendas of local, state, and national policymakers. Contact NEA at 1201 16th St. NW, Washington, DC 20036.

Local museum foundations: Support your local art, history, and science museums. You'll get great discounts for exhibits and help support your local museums.

The Mark Kistler Fund for Creative Children's Television: Corporate and personal underwriters are invited to join our efforts for the expensive production and satellite feeds of the donated public television series *Mark Kistler's Imagination Station*. For information on how you or your company can help with our mission of producing quality creative children's programming, contact 888-UDRAW3D or on the Internet at www.draw3d.com.

Tremendously Tantalizing Teaching Tips!

A Special Note for Parents, Home School Teachers, and Classroom Educators

In my previous drawing books, *Mark Kistler's Draw Squad* and *Mark Kistler's Imagination Station*, I included special instruction chapters for parents and classroom educators. I also included appendix chapters outlining creative teaching ideas from an array of talented educators across America. In this book, *Drawing in 3-D with Mark Kistler*, I have some of my favorite drawing-lesson classroom ideas for encouraging students. These are fresh ideas to add to the lists in my previous books. You may read a more extensive "Teacher Tips" chapter on the Internet at www.draw3d.com. It is permissible to make copies of this chapter for fellow parents, home schooling families, or other staff members at your elementary school.

Here is a sampling of my favorite classroom ideas. Remember to bookmark the www.draw3d.com Web site for the more complete list.

One Drawing a Day Is All I Ask

I have a very simple one-week challenge for each elementary classroom teacher in America. This challenge is to pick a seven- to ten-minute block of time out of each classroom day for one week, preferably the same time each day. For this daily seven to ten minutes use your overhead projector to draw one lesson at random from this book (refer to the drawing directory on page 27). Draw one lesson each day for one school week. Should you decide to accept this challenge I must warn you of the classroom uprising that will erupt if you forget to teach the daily daring drawing. You are going to be so pleased with your students' imaginative results and with the quiet time that follows your drawing time as students work independently, embellishing their artwork. Prepare yourself for a quantum jump in the level of creativity your students will exhibit. There is not a subject in classroom curriculum that will not be enhanced by a daily dose of drawing in 3-D.

Integrating 3-D Drawing into Your Classroom

Integrating 3-D drawing lessons into the elementary school curriculum has been a passion of mine for years. I am currently working on a book titled *Drawing in the Elementary Classroom* with Margaret Hansen. Margaret has been a mentor teacher in the San Ramon, California, school district for thirty-one years. Over the past fifteen years that I've known Margaret, I have witnessed her phenomenal classroom teaching success with amazement. She is clearly one of the most magical elementary classroom teachers I have ever met. Margaret attributes the astounding classroom test results, student eagerness, and parent participation to one common

denominator—drawing. She has tied several daily drawing components into each curriculum area, including science, math, history, language, geography, and computer technology. Our joint effort in creating *Drawing in the Elementary Classroom* will result in an extraordinary teacher resource book. For excerpts of the book check out my Web site (www.draw3d.com). You may contact Margaret Hansen via my Web site for specific questions about integrating 3-D drawing into your classroom curriculum. Her surface mail address is Margaret Hansen, Montevideo Elementary School, 13000 Broadmoor Dr., San Ramon, California 94583. You will enjoy contacting Margaret and perhaps her magic will enhance your teaching; it certainly has mine.

Overhead Transparencies

The ideal way to use this book in your classroom is to draw the lesson slowly on the overhead projector while the class follows along. After you finish the lesson, you can award the completed transparency to any student and have her stand up and recite a few of the twelve Renaissance words of 3-D drawing. These transparencies get expensive so you may prefer wiping them off for reuse. The transparency wiping process can also be offered as a reward to a student who has really made a wonderful effort in today's drawing lesson. For the occasions that you need to be working with a smaller group of students on a focused task, you can make transparency copies of the lessons in this book. This terrific idea was shared with me by a good friend and fellow art educator, James Clarke, from Houston, Texas.

Using Multiple Overhead Projectors

As you are teaching the daily drawing lesson on one overhead projector, have two students draw on transparencies on two other projectors. Your projector is in front of the class; the other two face opposite walls and are set up to your right and left back toward the middle of the room about four feet away from the walls. Any blank wall space works as a screen, or a poster turned around, or some white butcher paper taped up. I use the Vis-à-Vis nontoxic fine-tip (not ultrafine) overhead transparency markers. Have a selection of colors available to each student at the projector. Sometimes I will draw a line down the middle of the transparency so two students can be at the same machine. This enables you to have four kids be the featured famous projector artists of the day.

Chalkboard Artists

During your drawing lesson choose students to draw on the chalkboard or dry-erase boards. Encourage these students to sketch very large so the entire class can enjoy their artistic rendering. During my elementary school assemblies I set up two large boards or easels on either side of the audience. During one children's summer drawing in 3-D workshop, Hillary Mosher of the Shast Arts Council in Redding, California, set up six easels. We had twelve different students rotating with each separate drawing lesson. This became so popular that the kids would write their names on a piece of masking tape on the easel legs, securing their place in line.

Famous Artists Guest Teach for a Day

This great idea was inspired by West Virginia public television's Karen Achers. For the last few years, Karen has coordinated my week-long children's summer drawing workshops at the Beckley PBS studios. She is such a special dynamic supporter of the *Mark Kistler's Imagination Station* television series that we are even talking about producing my next season of thirty-five episodes with her station. Why not have students "audition" for the honor of teaching for the day? Have students submit five completed

drawings of their favorite lesson from the book. The reason for this is to strengthen their confidence before drawing the lesson in front of the entire class. With the quieter kids I'll softly play some background music such as instrumental piano by Jim Brickman, Enya, or a selection from my classical collection. The music creates a nice drawing environment. Before the lesson, I introduce these "guest teachers" as famous visiting artists from distant enchanted lands. I introduce them as Pablo Picasso or as Monet, Seurat, Degas, Renoir, Escher, Davis, Hanford, Base, Kellogg, Van Allsburg, Matisse, da Vinci, Raphael. I have to keep an index card with the names in order to rotate them among the students. You can assign each student a famous artist's name at the beginning of the year. Write the famous artist's name on both sides of a folded, giant, colored index card, creating a paper "puptent" similar to restaurant table advertisements. Have the students pull these puptent name cards out and place them on their desks to start each daily drawing lesson.

Assigning a one-page report about the famous artist helps the student learn about and develop an affinity for that particular master. Information about artists is readily available on the Internet. Use any search engine by typing in the artist's name in quotes as the key word. Students can also conduct research for their reports from my Web site at www.draw3d.com. I've linked to dozens of my favorite artists through museums around the world. Students may create a drawing based on this famous artist's work.

Having a video drawing lesson running in front with student guest teachers drawing along on two overhead projectors placed on both sides of the room really inspires the class to draw. Occasionally I will allow the students to draw directly on the overhead projector glass top. The nonpermanent ink will wipe off easily with a damp towel. Keep a separate dry towel handy for a quick dry before another student takes their place. Drawing directly on the glass will stain the plastic edges framing the glass top. If you need to avoid this stain use transparencies. Some students have a problem if the transparency slides around on the glass while they draw. I often tape the transparency in place to avoid this. The only problem with taping the transparency is that it freezes a picture in one position. I need to constantly remind the students following along at their desks to twist and turn their papers while drawing to capture smooth confident lines. For example, when I draw a bowl shape I will turn my paper upside down to confidently curve the bottom line. It's more comfortable for most people to push a curve, rather than pull one across the paper. Keep several pairs of cheap very dark sunglasses on hand. Should the overheads you are using project an extremely bright light, you will need to insist the kids put on the sunglasses. The sunglasses are a precaution to protect their eyes. Sunglasses make the kids appear even cooler as the famous guest artists of the day. Instead of sunglasses you can purchase colored or smoky gray transparencies that will reduce the glare more than 50 percent.

Pencil Power Portfolios

Cindy Brocklesby, my summer drawing in 3-D workshop coordinator and marketing director for the Fort Wayne Little Professor Book Company, had this brainstorm. The "pencil-power portfolio" is a simple plain-white double-pocketed folder. Each child in the class receives this folder on the first day of our drawing in 3-D adventures. Each folder is stuffed with several blank sheets of practice paper, a simple small practice scratchpad, copies of "The Twelve Renaissance Words" chart and "The Twenty-two Augmenting Art Accents" chart. These handy portfolios help the students keep all their drawings organized and their drawing supplies neatly stored in the inside pockets. You may want to include some extra elements that can be added over a period of weeks. This helps keep the portfolio an important priority for the student.

Portfolio Pages You May Want to Include for Each Student

Warm-up Sheet

You may duplicate page 3 of *Drawing in 3-D Wacky Workbook*. Have your student complete this pretest warm-up sheet in about ten to fifteen minutes. Have everyone write his name, age, and the correct date in one of the corners on the front of the drawing. This can be used as an effective monitor to your students' drawing skill development. You might even want to create a "Super Successful Student Sketches" bulletin board in your classroom, in the hallway, or even in the front office. Hang each student's warm-up drawings next to corresponding examples of his work after a few months of lessons. I suggest you assign the warm-up pretest before you do anything else in this drawing program. After all of your students finish this task, have them file it neatly in their Pencil Power Portfolio or collect them if you want to make sure you'll have a complete set in a few weeks. Once a month have your students look at their drawings in 3-D skill progress since the first day warm-up. These before/after drawings are fantastic for parent/teacher conferences.

The "Less Television, More Drawing" Legally Binding Contract

You may duplicate page vi of this book. The average child in America watches four to six hours of television every day. That's several years of accumulated television watching before the eighteenth birthday. This is a frightening statistic and an appalling waste of valuable time. Imagine if a child spent just twenty minutes a day of that four hours of television time drawing. That twenty minutes of daily drawing would accumulate to create the largest admissions portfolio any art school has ever seen. You would need several cargo U-Haul trucks just to ship the portfolio to the school! This "Less Television, More Drawing" Legally Binding Contract addresses this important issue with the children. This is a good page to include in every student's portfolio folder.

Dynamic Drawing Directory

You might include a copy of the "Dynamic Drawing Directory" from pages 27 to 44 in this book. This directory will give your students a handy guide for anticipating future drawing lessons. The directory can also be used for a class vote to choose the drawing lesson for the day.

Create an "Amazing A++ Art Attack Animal" ID Card

Make up a little identification card declaring the bearer to be a brilliant 3-D drawing Super Genius. Leave a space for her to write her name and a space for you to sign and date it. This card can be taped inside the portfolio or can be laminated and carried around in a pocket for handy quick access when a student needs to verify that he is indeed the coolest artist ever to walk the face of the planet. You may print up my template for this card on the Web site at www.draw3d.com.

Pencil Holders

Have your students make several taped pencil-holding loops inside the portfolio covers.

3-D Names

Encourage your students to draw their names in 3-D on the outside of the folder and create a 3-D picture dominating the portfolio cover.

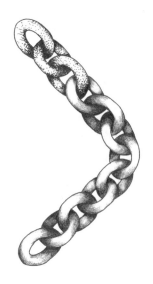

Daily Drawing Dispenser

Cut favorite drawing lessons out of this book. Laminate the pages and file in a large three-ring binder or an accordion file separated alphabetically or by themes (animals, insects, under the sea, moon mission, space exploration, aliens, buildings, etc.). Students may remove these lessons for quiet independent drawing time, replacing the lesson carefully after completion. I've met several art teachers who have made a dozen copies of selected lessons and file these nonlaminated duplicates in accordion files or shoe boxes. This allows multiple students access to the same drawing at once. Students are required to refile these copies when they complete the lesson, and reusing these copies for the entire year encourages the students to carefully conserve paper, saving more trees, which will produce more oxygen we can breathe to pump up our creative brain-powered drawing in 3-D dendrites!

Alphabetized Art-Attack Adventures

On large poster board create a checkoff chart. List the 333 drawing lessons sideways across the top. Write your students' names down the left-hand side. As the students complete each lesson, an assigned drawing buddy will check off the lesson below their names. Students must keep the completed lessons in their portfolio for your spot checking. The drawings must be neat. Often I will have kids rework a difficult drawing several times to validate the lesson checkoff. I enjoy a bit of classroom competition and think it is a very healthy social skill developer. Who has drawn the most drawings this week? Who has drawn the drawing with the most color? The most detail? The coolest bonus ideas? Who has the most organized portfolio this week? Who has kept their drawing pencils together for an entire week? Who has said the most encouraging words to a neighbor artist during class drawing time? Students can win strips of practice paper, mini-sketchpads, pencils, gummy and kneadable erasers, paper stumps, or even a class applause while they take a bow, standing on top of a table (yes, I spot them so they won't fall). You can use this lesson poster to keep track of who has won what, when. This allows you to rotate the rewards to every student by tailoring the category question accordingly.

If competition is philosophically not going to work with you, this chart is a great student reference guide to see what they have accomplished and what they have to look forward to. If a student is having a difficult time with the gorilla, they can refer to the chart, find a classmate who has completed the gorilla, and get help. You can take this even a step further by making a smaller chart to copy for each student to monitor independently. If the 333 drawing challenges in this book seem too excessive for a wall chart, you can pick one hundred or fewer. Perhaps you prefer to go crazy and combine all the lessons from my three drawing books to create a chart with nearly six hundred columns. Go for it. This will certainly keep those little tornadoes busy for the entire school year!

Awesome Artist Rewards

I enjoy giving my students rewards for doing great work. I've listed a few of them below. Perhaps you can use them in your class.

The Mighty Magic Marker

I have a spiffy neon-colored marker that I call my personal "Mark's mighty magic marker." I explain to my students that for a long time, this has been my very special pen, my favorite drawing pen in all the world. "Today, since Stephanie is so eager to draw I'm going to let her use my mighty marker. And since Jeffrey looks so happy with his pencil poised in his hand ready to draw, he gets to keep the *Drawing in 3-D* book on his desk for the hour. And since Melissa has said so many positive encouraging words to her fellow art students, she gets an extra two sheets of drawing paper for her portfolio." These little gestures really work wonders with the first, second, and third graders. For the upper grades you need to mature the verbiage a bit. Rotate the student compliments each day.

Lucky Lesson Lottery

For variety sneak into your classroom during recess, write the alphabet in big, bold print, one letter per page, on a small pad of yellow Post-its. Take any letter from the pad and stick it at random to the bottom of any student's chair. When it's time for the drawing in 3-D part of the day, have your students look under their seats for the yellow Post-it. The lucky winner gets to pick the drawing lesson from the letter you have identified on the Post-it. Do this a few times a month to keep the surprise effect fresh each time.

Wonderful Wheel of Wisdom

As a variation on *A* to *Z*, you can create a "Wheel of Wisdom." This is a cardboard wheel with a nailed or bolted pencil as a spinner. Draw the letters of the alphabet around the outside of the wheel with dartboard-type pie separations confining each letter. As a special reward, have a student spin the Wheel of Wisdom to see which letter you will be drawing from that day. Once the letter is chosen, you can quickly select the drawing, or you can give the class two drawing lesson options within that letter to vote on.

Variations of the wheel can be letters on crumpled pieces of paper in a bowl, or an old deck of cards with a different letter written boldly over the face of the card. Shuffle the deck and pick any letter. It is perfectly

acceptable and even recommended to have the same lesson chosen several times during the year. Repetition builds familiarity and confidence with the twelve Renaissance words and the twenty-two augmenting art accents.

Cherished Check Marks

Use check marks, dashes, A+++s, and colored dots to validate students' artwork. While students are quietly drawing, take a stroll through the class. At random, you place brightly colored Art Animal check marks, dashes, or A+++ on their genius lesson papers. Happy faces will work, but if you draw a happy face you need to add shading, contour, and foreshortening to the image. A simple orange check mark from you while you declare "what an amazing drawing" will send each student's attitude soaring.

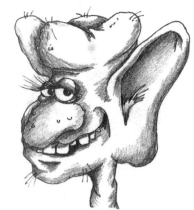

Incredible Inked Icons

Draw a favorite animal from a lesson in this book. Above the drawing write "Mrs. Smith's (your name) Genius Award!" Below the drawing write "A+ Awesome Art Attack." Take it to a local copy store, and for around $20 make it into a nifty ink stamp. When your students are drawing, stamp a few students' papers at random. Be sure to rotate to different students each day. It is very special to see the exploding smile on a student's face when he discovers you have stamped his paper.

Radical Recess Reward

My big brother Stephen Kistler taught fourth grade for several years at a Christian school in Santa Barbara, California. Steve would sometimes reward students for reading and math skills by allowing them to enjoy a "bonus" thirty-seven seconds at recess, with the class cheering them on while waiting in line at the door. I tried this during my drawing classes, and it works wonders for keeping kids focused on tasks, anticipating that blissful "bonus" thirty-seven seconds at recess.

Spectacular Sketching Strips

Purchase a large economy package of twenty-four rolls of calculator paper. Once a week choose a roll of paper and put a pencil through the middle. Have a student you want to reward take the loose end and walk to the back of the class holding the ribbon of paper above the other students' heads. You can make this quite the noble majestic march while you hum the national anthem. Tear off the strip from the roll and declare the student the "pencil power practice person" of the day. Instruct the student to draw fifty giraffes, ants, or whatever the lesson was that day on the strip of paper. Once a month you can give everyone a six-foot section for take-home practice. These practice ribbons look great hanging on the bulletin board. Debbie McGangus, alias "Duchess Debbie," has facilitated my drawing workshops in Houston, Texas, for ten years. She enjoys these "royal Renaissance ribbons" so much that each day after class she stands at the door with a roll of paper on a pencil in her hand. As each student leaves, they may take as much of the roll as they can fill up that evening. She didn't want to promote waste, so before kids could get more the next day, they had to show the previous strip completely filled in. Duchess Debbie has moved to Louisiana, so I haven't taught the summer workshops at Northland Christian School in Houston for a few years. Duchess Debbie, I miss your bubbly enthusiasm!

The number of high-caliber professional educators I meet each day during my national school tours is really exhilarating. Don't let the nagging, nasty naysayers paint the picture of doom and gloom for our nation's elementary schools. Inspiring professionals like Debbie can be found in every single elementary school across America. The United States has 98,150 public, private, and parochial elementary schools. Most schools have over two dozen dedicated, enthusiastic classroom teaching professionals. That's over 2 million teachers committed to the focused quality education of our nation's kids. I salute you teachers for your noble work.

Energetic Evening Etchings

At the end of the day, challenge your students to create an entire scene based on the theme from the drawing lesson. This "home-fun" assignment will motivate the kids to practice, inspiring them to draw, rather than waste time in front of the television. To maintain enthusiasm for completing these evening etchings, have the children form a circle the next day when they bring in their completed drawings. This "genius roundup" allows the group to spend about four minutes enjoying everyone's artwork. I will walk around the circle and tap each child on the shoulder in turn. This signals them to take the "stroll," walking around the inside of the circle, holding their drawings proudly with great dignity at eye level for everyone to see. As the "stroller" moves around the circle, walking a special, bobbing, cool-artist's walk, the class is encouraged to quietly murmur, "ooooooo, ahhhhhh, eeeeeee . . ." I tap the shoulders at a ten-second interval, allowing each child to feel validated for the home-fun effort, yet not eating up a lot of class time. If your classroom does not have available space for a roundup, form the circle outside or in the hallway. A large group oval works just as well. Select a few pictures from different students each day to display on the board. The students who had their drawings selected previously retrieve their work and file it in their portfolio.

Dramatic Drawing Display

Keep a dynamic drawing display building year round on your campus. The folks at Milwaukee public television went wild with the display during my week there. They covered just about every blank space on the walls throughout their entire studio complex. Another fantastic display idea was inspired by Mike Schmid. Mike is an art teacher at Haverhill Elementary School and a founding sponsor of FAME, the Fort Wayne Foundation for Art and Music in Elementary Schools. Each year for the last ten years, forty elementary schools send thousands of student paintings, drawings, and sculptures to be displayed over a two-day festival of creativity. Cofounder Dorothy Kittaka (one of my favorite people on the planet) supervises as each participating school sends choir groups to perform. The groups sing on multiple stages scattered around the hall for parents and the community to enjoy. Choir groups rotate every fifteen minutes, allowing nonstop musical performances for ten hours straight. To solve the logis-

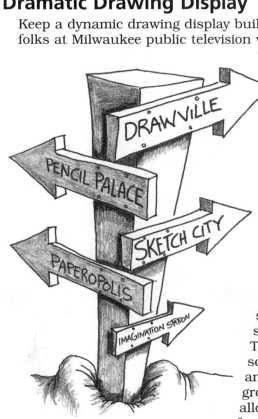

tical problem of hanging thousands of art pieces and to comply with the fire marshal's code in the Grand Wayne Hilton Ballroom, Mike built very clever *Z*-folding cardboard display walls. Each wall had three sections of large 4 X 8-foot cardboard flats connected three deep lengthwise with brown packing. These taped cardboard pieces created a *Z* freestanding zigzag display measuring eight feet high and twelve feet long, creating over 180 square feet of display space per wall. Each school was assigned one cardboard *Z*-wall. The representing art teacher from each school hung the art pieces with clear thumbtacks, adding professional title tags, descriptions, and background mats. This tremendous effort results in a delightful 3-D labyrinth of zigzagging art display walls that all twenty thousand visitors to the foundation walk through to get to the choir stages.

Mike, Dorothy, and a dozen other dedicated volunteer board members of FAME have even expanded the festival to include a week-long fine arts camp each summer in Fort Wayne. Over 150 kids get to eat, sleep, play, learn, and participate in fine art activities for an entire week. Last summer I joined the teaching staff and was impressed with the wide variety of activities taught by so many established art professionals. They had classes in symphony composing, dance, choreography, photography, sculpture, orchestra, singing, drama, and of course 3-D drawing with me! I encourage you to consider establishing a FAME organization in your city, and perhaps even a summer fine arts camp at a local college campus or outdoor YMCA camp facility. For information about the FAME organization, contact Dorothy or Mike at Fameart@aol.com. The volunteer staff will answer your questions about how to establish a satellite FAME festival. I encourage you to get involved with this remarkable organization.

Recycle Refrigerator Wrappers

Another Indiana art teacher, Pam Kieser, recycled old refrigerator packing boxes into giant freestanding art display pillars throughout all the hallways in her elementary school. Pam loves anything related to giraffes, so I dedicate the Giant Giraffe lesson on page 104 to you, Pam.

Massive Magnificent Mural

Several years ago, Becky Laabs, an art teacher and active member in the Ohio Art Education Association, invited me to tour elementary schools throughout her state during the March Youth Art Month. She shared so many cool art education classroom ideas that I could write another entire chapter, and this was nearly ten years ago. Becky has written several teacher guides with her ideas. The Ohio Art Education Association also has stacks of teacher resource materials for classroom ideas. You can contact the association through the NAEA (see page 260 for recommended organizations). One of Becky's ideas was to create an environment of creative exploration for students working together drawing a never-ending mural. One way she accomplished this was to tape several long sheets of white butcher paper together, stacking the sheets vertically to create a blank wall surface at least 4 X 10 feet. Creating areas or worlds based on daily drawing lessons, she encouraged students to draw in themes of ocean odysseys (whales, dolphin, fish), moon mountains (craters, Moon Mobile, aliens), jolly jungles (gorilla, giraffe, pandas), Australian adventures (koala, wonderful waves, Big Bugeyed Birds), fancy forests (trees, insects, clouds), etc.

Sidewalk Drawing

Use your playground as a giant canvas. Assign a different drawing lesson and a few pieces of sidewalk chalk to each of your students. Create several small squads of artists to team up and paint the planet. Louis Allard shared this idea with me. Louis is an extraordinary elementary art teacher in Spokane, Washington, and coordinator of my week-long summer drawing camp in his city.

Amazing Artistic Animal Autograph Day

Pick a day every two weeks or so to spotlight four student drawings. Choose a drawing from four students; reduce the drawings on a copy machine so they all fit on one sheet. Run off enough copies for each student in your class. At a special time, distribute the copies to your class. The four spotlighted artists are given different colored markers to walk around the class autographing their published drawings. Encourage all students to keep these completed autograph sheets in their portfolios. At the end of the year, this packet will make a great booklet of dynamic drawings officially autographed by the artists! Display the autographed sheet on your class door, motivating the class to submit drawings for inclusion on the next sheet. These can also make great calendar illustrations.

Charming Chain Challenge

Several years ago, I designed a series of children's greeting cards for Blue Mountain Press. I've posted a few of my favorite children's card designs on my Web site for examples to encourage students to design and reproduce their own unique greeting card line. One of my favorite card designs was the never-ending "Chain Game." Take this idea and have your students run with it. The card was designed to have one child start a picture, then send it to a friend, preferably out of state or out of the country. The recipient would add to the drawing, taping on additional paper if necessary, then mail the incomplete drawing to another friend. Each person signed the card under their added bit of art, with their name, state, and age. Addresses are not necessary, except for the originator. I'd prefer to keep this as safe as possible, so I suggest the originator put the address of their school, care of the principal. The rule was if you were the tenth person to receive the card, you would complete the drawing. Now comes the fun part: Since the tenth person had the task of completing the drawing, she now had the responsibility to go back to panel one and begin a story, alliteration, or poem about the picture. Person number ten continues the chain by mailing it to a new person. The twentieth person finishes the story and mails it back to the originator. What an amazing illustrated story number one will have to cherish for years to come. Twenty different creative ideas representing people from all over the world bundled together in one little art project. How very cool indeed. I would love to be part of your students' chain game. Ask them to write as part of the rules in the introduction to their chain-game letter that participant number thirteen mail the chain to me at Mark Kistler, attn: Urgent Chain-Game Link Needed, P.O. Box 41031, Santa Barbara, CA 93140.

Children who grow up with established art pals in different countries might be more likely to be tolerant

adults wanting to seek out peaceful solutions to global conflicts. I figure the process of getting all twenty creative additions to complete a single chain-challenge card will take six months if each participant is speedy, to several years if the letter gets sidetracked for a bit in Germany or China. As these chain games start trickling back to your classroom, mail me a copy of the finished work. I'd like to post these on the Web site for other children to enjoy. In fact, I've decided to ask my noble Webmaster Dennis Dawson to post a "Chain Challenge" starter template on the www.draw3d.com Web site.

THIS IS ONE BIG WHOPPER OF A WHALE!

I WANT SUSHI NOW!

SWIM FOR YOUR LIFE! IT'S A HUNGRY SPERM WHALE!

A variation of the chain challenge is to have each student begin a drawing on a sheet of paper. After a few minutes, signal the class to switch papers. They continue drawing until you signal once again for everyone to switch with the third link in the chain. Continue this for five or six links. Experiment—this game can produce some very clever results. Another variation can be a creative E-mail story chain, or perhaps a verbal alliteration word relay around your classroom.

Savvy Cyber Spot

Build a special Internet home page for your classroom. Give your students the thrilling experience of having a personal presence in cyberspace on the Internet (see page 275). Use this home page as a global bulletin board to post a drawing, story, and a poem from each of your students. I don't suggest posting school portrait photographs, last names, or even your city name. I am suggesting that you create a safe, really fun cyber gallery of pictures and writings representing the boundless creative talents of your students. As soon as you connect your classroom home page to the Internet, E-mail my Webmaster Dennis Dawson the linking address, so we can make your site available to the hundreds of thousands of kids hitting my www.draw3d.com site each year. If you have technical questions about building your home page you can review Webmaster Dennis Dawson's posting of tips on how to build home pages in the Web Wizard Q&A link from the www.draw3d.com page. You can also E-mail Dennis directly from the site. However, since he is one of the coolest Internet gurus on planet Earth he is a tad bit busy eighteen hours each day. It may take some time, but he will respond to your inquiries.

LA LAA FAA

UH OHH... MY DOCUMENT FEEDER IS JAMMED UP!

BONK SHRED CRUNCH CRUUMPTH

Pretty Peculiar Posters

This is a wonderful project that can be stretched over an entire week. Separate your class into teams of five students each. A team member lies down on a large piece of white butcher paper. The other team members carefully trace the body outline, including puffy hair and untied shoelaces spread out on the

paper. Now give the teams a time limit to draw in clothes, eyes, nose, messy hair, fingernails, and maybe alien antennae to the poster. Encourage them to use the twelve Renaissance words, and the twenty-two augmenting art accents to give this life-size portrait a solid feeling of three-dimensional depth.

Flag Tag

I call this relay game "Flag Tag the Masters." Get a giant laminated poster reproduction of a master's painting. Split your class up into teams of three students each. Give each student in the room one blank sheet of a tiny yellow Post-it pad. Call one team at a time while shouting one of the twelve Renaissance words or one of the twenty-two augmenting art accents. The team needs to quickly scramble to the board and tag the poster with three tiny yellow Post-it notes. They tag where the master artist has used the shouted Renaissance word in the painting. Teamwork is encouraged; they help each other find the three appropriate spots to flag tag the poster. When the poster is covered the game is over. Each time you play this game, pick a different master from a different country, and a different time period throughout history. Now you can weave a little art history and appreciation into your daily drawing lessons. For help in locating masters' art posters contact Kim Solga at kidsArt.com.

Fabulous Flapping Flags

Each year the National Youth Art Month Council holds a contest for the flag design that will fly in our nation's capitol during the month of March. I am delighted to be an honorary board member of this important organization. Have your students draw and color their March Youth Art Month flag designs and submit them to the national council. Finalists from each state are often invited to a reception in Washington, DC. Your students can have the opportunity to rub elbows with many senators and congresspersons attending. Obtain submission guidelines and other important information about March Youth Art Month by writing 100 Boylston, Suite 1050, Boston, MA 02116.

Creative Classroom Drawing Games

These games are based on my school assembly programs (page 280). Your kids will love them!

The "Diversity University" Classroom Game

Last year I received a call from Debra Hannu, an educator in the Duluth, Minnesota, school district. She wanted to schedule an elementary school tour with me but needed a multicultural theme. The week I was to visit coincided with the school district's week-long cultural diversity celebration. Nearly all the student body had roots in four cultural backgrounds: African American, Native American, Asian American, and Mexican American. I decided to develop four different student assembly drawing lessons based on each of these groups. I wanted to talk and draw about each culture's specific contributions to the world in science, math, astronomy, medicine, literature, music, and art. I picked a famous person from each cultural group and developed a 3-D drawing lesson teaching the students about that special person's historical contribution. In each school assembly program I teach four

drawings in an hour. Using these historical people as a lesson guide I picked an object to draw that would symbolize their achievements. These programs turned out to be so much fun that I've decided to include them in my national elementary school assemblies program selections.

Last summer, using the same themes above, I experimented with a game version of this for my students. On a large world map poster I had the students carefully stick name-flag pins in the country their ancestors came from. Seventeen countries on three continents were represented in this single class in Milwaukee. From China to Scotland, we had the world covered. The students placed a second name-flag tag in an empty box. At random, a designated student mixes up the box and chooses a flag tag. I read the name on the tag and the ancestral country. I would assign the class to bring me pictures and information about a famous artist and a famous scientist from that country. They could get the information from the public library, school library, or over the Internet. The next day I'd go through the information turned in by the students, pick a famous person, and decide on an appropriate object for the

drawing lesson. Each time you do this, file all the collected research material in an accordion file with the country labeled. Over the year, you can build up quite an impressive "Diversity University" file. When I was creating this series of assembly programs for the Duluth elementary schools, I was doing frantic researching in the library and on the Internet. Fate smiled on me that day when I received a call from Kim Solga. Kim is a successful writer of children's art books specializing in multicultural art lessons. Her company KidsArt has over sixty booklets covering just about any artist, from any time period, from any culture. She generously sent me a dozen different titles and hundreds of sample booklets to give to the teachers in Duluth. Her booklets will greatly enhance your "Diversity University" game. I listed her books and contact phone numbers in my suggested books list on page 255. For more information about my "Diversity University" and other elementary school assembly programs call 888-UDRAW3D or fax 760-431-9114 or check out the Internet site at www.draw3d.com.

The "Young Authors" Super Story Starting Adventure Game

This is another exciting game that evolved from one of my elementary school assemblies. Last year, an elementary art teacher friend of mine, Mike Schmid from Fort Wayne, Indiana, called me. Apparently he was coordinating the visiting author workshops at area elementary schools for Young Authors Week. At the last minute he had a cancellation from a key author. He called me to see if I was interested in pinch-hitting for him. The collaborative effort resulted in a fantastic new assembly program that I now offer to elementary schools around the country. During the assembly, the audience helps me write and illustrate a

story. We create a character living in a special place, during a specific time period, performing a defined action while trying to solve a certain problem or mission. I love these programs because the five hundred kids mold the story and drawing lesson, and every program is spontaneous creativity within a defined format. This young authors writers' workshop keeps me on my toes.

The "Pondering Poets" Classroom Tag Relay

Rhyming sentences or long alliteration sentences inspired by your classroom daily drawing lesson is the basis for this game. After the drawing lesson, pick one student to start the poem or alliteration. For a poem the student will offer you one sentence to write above the drawing on the overhead projector. For example: "Killer whales will sometimes kiss." You choose another student to continue the next line, maybe something like "Look at their smiles of happy bliss." This can continue for as long as you want. My students love this game.

For a "Pondering Poet" game using alliterations, choose a student to start the alliteration. After you complete the drawing lesson, have the starting student say a word relating to the drawing. Write that word above the completed drawing lesson on the overhead projector. Example: giraffe. The next student in line offers an alliterated word to place before or after the first word. Example: giraffes generally. The next student offers an alliterated word that can be placed before, after, or in between the started sentence. Example: gentle giraffes generally. The sentence builds until a complete thought is formed. Example: Gentle giant German giraffes generally generate geometric gestures gingerly. Display the successful alliteration on your door to inspire constant poetic thinking. You might want to cut up a blank transparency into sixteen small pieces. This allows you to move the words around as students insert new words into the middle of the sentence.

A variation of this is to switch from an alliteration line to a rhyming poem line. Example:

> Gentle giant German giraffes generally generate geometric gestures gingerly,
>
> The long graceful necks swaying together in a magical synergy.

Continue this over several days, alternating an alliteration with a rhyming line. You can also really challenge your students by creating continuous alliterations that begin forming a poem, one word at a time. Example:

> Gentle giant German giraffes generally generate geometric gestures gingerly.
>
> Swaying sugary sweet smiles swiftly swelling symbolic symphonic synergy.

This gets really difficult very quickly. Remember lines three and four will use a new rhyming alliteration or poem from a new drawing lesson theme. A variation is to experiment and see just how many lines of poetry your

kids can create based on a single theme. Perhaps your little literature buffs will be able to create thirty-five rhyming alliteration lines in less than an hour. Students can be encouraged to have their dictionaries out while playing all the variations of this game. I've been developing this into a board game for over three years now. If you have any ideas you think would give "Pondering Poets" an extra boost, or ideas about scoring, board maneuvering, or rule format, I'd love to hear them. I'm also selecting a few teachers to test out this educational game in their classrooms. Contact me via my wild, weaving, wacky, Web wonderland at www.draw3d.com.

Create a Classroom Video Drawing Lesson Library

I encourage elementary classroom teachers to record my public television series on videocassette. I've produced ninety-five episodes of *Mark Kistler's Imagination Station*. Recording each one would build a very in-depth drawing lesson library, from Atomic Android to Zesty Zephyr, and lots of cool stuff in between. If the PBS series is not being broadcast in your area, there are three options available to you.

1. You can call the programming director of your local PBS station and voice your support for broadcast of this series.

2. You can contact the programming director for your local PBS station's ITV (instructional television) department. ITV programming departments may purchase licensing rights to the series for educational broadcast to schools.

3. Your school may purchase video copies of the episodes (see page 278 in the back of this book). Your school may duplicate these tapes for a neighbor school. These duplicates can also be used for student library checkout copies or as reward prizes for students to keep. Students can make copies of their copies to send to a friend in Greenland who can make a copy of the copied copy to mail to a friend in Moscow. At this point the video quality will resemble interesting colored static snow. I encourage this extensive video cloning, because it's a fun way to spread interactive art education. You can download video clips of the series from my Internet site www.draw3d.com.

Radical Resource Review

On page 255, I listed my absolute favorite resource books, magazines, and membership organizations for teachers, parents, and kids. These books are all amazing idea generators and fantastic drawing starters for your students. Build this library in your classroom; you'll love the resulting impact on your class. Your kids will metamorphize into little researching rug rats. The additional professional educator resource materials listed will prove to be indispensable for you.

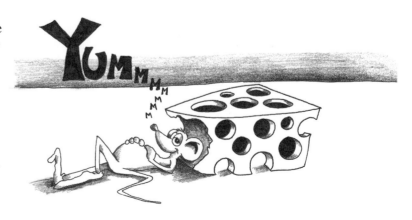

Appendix C

World Wide Web Wizards!

Webmaster Dennis Dawson (creator of www.draw3d.com) and I have joined forces to produce an exciting new children's book about exploring cyberspace on the Internet. *World Wide Web Wizards* guides children on a whistle-stop tour of our favorite top fifty interactive children's Web sites. That's just the beginning! *Web Wizards* explains how kids can create their own amazing Internet home page very simply with our clearly illustrated step-by-step instructions.

Our goal with this book is to link 1 million children's Internet home pages from around the planet through our www.draw3d.com kids home page-linking art gallery. By designing their own independent home pages, children can create a virtual billboard of their creative talent for millions of other cyber kids from around the world to enjoy. From Moscow to Manhattan, our dream is to see children sharing drawings, poetry, paintings, stories, writings, world opinions, global ideas on conquering world hunger, and even tips on how to sort recyclable trash at home. We want kids to build their own E-mail buddy pen-pal lists with new global cyber friends. *Web Wizards* shows children how to build an Internet home page that can be constantly updated and expanded with new drawings, writings, and even postings of favorite library books for other kids to read. Independent home pages allow children to directly link favorite Internet Web locations for cyber visitors to enjoy. As you have surmised, Dennis Dawson and I are very excited about this project. We will be posting sample portions of the book on our Web site (www.draw3d.com). We will also be posting publishing dates and distribution information as it becomes available. *Web Wizards* should be available in bookstores across America in summer 1998.

I HAVE SEEN THE TRUTH! I HAVE VOYAGED FAR, I HAVE JOURNEYED TO THE DEPTHS OF THE INTERNET. MY WISDOM WILL BE REVEALED ON THE WORLD WEB AT WWW.DRAW3D.COM. YES, YES... MY FELLOW CYBER DWELLERS DRAW3D IS THE GREATEST WEB SITE KNOWN TO CARTOON KIND. MY NAME IS WEBMASTER DENNIS DAWSON, I HAVE SPOKEN.

Mark Kistler's Drawing Products and Classroom Video Series

About Mark Kistler

For the past 18 years, Mark Kistler has been teaching millions of children how to draw in 3-D at over 7,000 elementary school assemblies around the world, including teaching tours through Australia, Germany, England, Scotland, Mexico, and the United States.

He has starred in three hit children's public television "Learn-to-Draw in 3-D" series. These dynamic shows have been broadcast around the world in seventeen countries. His television programs include *The Secret City*, *The Draw Squad*, and *Mark Kistler's Imagination Station*. Over 40 million children globally have experienced the joy of 3-D drawing from these broadcasts. *Mark Kistler's Imagination Station* is broadcast on public television stations across the United States. For your local broadcast schedule, check your local listings or visit Mark's Internet Web site at www.draw3d.com.

Mark has authored and illustrated many popular children's *How to Draw in 3-D* books, published and distributed around the world, including *Mark Kistler's Draw Squad* and *Learn to Draw with Commander Mark*. His book *Mark Kistler's Imagination Station* is published by Simon & Schuster and is available in bookstores nationwide. His third book, published by Simon & Schuster, is titled *Drawing in 3-D with Mark Kistler* and is available in bookstores everywhere.

600,000 visitors have hit his Internet Web site at www.draw3d.com. This cyber art academy teaches kids around the world how to draw. Visit museums, chat with famous authors and illustrators, safely explore the imaginative world of the World Wide Web!

Mark Kistler's Imagination Station

A Fun Way to Learn How to Draw in 3-D!

This book is included with your school's assembly. A release from Simon & Schuster, it has 256 pages of action-packed, step-by-step drawing adventures, including thirty drawing lessons for a total of seventy 3-D pictures to learn! Mark teaches readers the twelve Renaissance words of three-dimensional drawing with his world-famous follow along technique. Drawing lessons include an adventure to Dinosaur Land, the Under Ocean Odyssey, A Space Visit to Moonville, and of course Genius Pickle in 3-D! This book is available in bookstores everywhere!

Mark Kistler's Draw Squad

Drawing in 3-D Is Easy!

This book is included with the Teachers' Training Workshop and the Family Evening Program. Includes 356 pages, with OVER 300 drawing adventures. Over 150,000 copies of this book have been sold, an all-time favorite for budding 3-D genius artists. Both of Mark's books

end with special teacher-parent chapters. These pages help parents harness the enthusiasm that drawing generates into powerful self-esteem-building experiences.

Mark Kistler's CD-ROM for Windows™
Learn to Draw with Your Computer!

This computer software is an interactive draw-along adventure. Take your favorite pencil, pick up a piece of paper, turn on your computer, slip in the disk, and take control of the IMAGINATION STATION! Based on his public television series and his best-selling children's book, this computer game will teach anyone how to draw in 3-D! Includes over twenty drawing lessons from Dinosaur Land to the Undersea Odyssey.

Mark Kistler's Imagination Station...Classroom Video Series

Sixty-five half-hour "Learn to Draw in 3-D" lessons reedited from the national public television series for teacher resource sets and student library checkout sets. This sixty-five-lesson video series will guide your class through an enchanting voyage of creative discovery. Millions of students have learned how to draw in 3-D with Mark Kistler videos...yours will, too!

Drawing in 3-D Lessons 1–16:

Eight hours of instruction, sixteen thirty-minute lessons, four VHS cassettes, introduction to the twelve Renaissance words. Lesson titles include: **1.** Dinosaurs, Dinosaurs; **2.** Dinosaurs in the Sky; **3.** Knights of the Drawing Table; **4.** The King's Breakfast; **5.** The Cool Cloud Colony; **6.** Pondering Pencil Power; **7.** The Magnificent Moon Base; **8.** The Great Undersea Adventure; **9.** An Ocean Odyssey; **10.** Terrific Tree Town; **11.** The Voyage of Ideas; **12.** Delightful Diving Dolphins; **13.** Return to Dino Town **14.** Fabulous Flapping Flags; **15.** The Great Adventure Down Under; and **16.** Awesome Australian Animals.

Drawing in 3-D Lessons 17–32:

Eight hours of instruction, sixteen thirty-minute lessons continuing from beginning set, four VHS cassettes, covers intermediate and advanced skill levels and application of the twelve Renaissance words. Lesson titles include: **17.** Earth Patrol HQ; **18.** Mammoth Moon Metropolis; **19.** The Cool Clam Family; **20.** Professional Pollution Patrollers; **21.** The Adventures of Genius Pickle; **22.** Expressions of Drawing; **23.** More Expressions of Drawing; **24.** Dino-Lizards; **25.** Polar Party; **26.** Flying High with Your Imagination; **27.** Knights of the Drawing Table Return; **28.** Super Solar System; **29.** Thumbs Up for Thinkers; **30.** Cool Creative Creatures; **31.** Melf Magic; and **32.** Plumbing Puzzler.

Drawing in 3-D Lessons 33–48:

Moving to more advanced 3-D lessons. Beginning use of blocking, blending, shading with paper stumps; special guest professional artists, illustrators, CD-ROM designers, Webmaster artists, and NASA space station engineers. Lesson titles include: **33.** The Forest of Ideas; **34.** Stalactite City; **35.** Sprinting Spinach Superstars; **36.** Be a

Dream Beam; **37.** Aerodynamic Asteroids!; **38.** Atomic Android; **39.** Amazing Ants!; **40.** A+ Awesome Attitude; **41.** Arriving Aliens; **42.** Big Bugeyed Birds; **43.** Biosphere Buildings; **44.** Buzzing Beehives; **45.** Billions of Blocks; **46.** Books, Books Books!; **47.** Crawling Cobras; and **48.** Colossal Castles!

Drawing in 3-D Lessons 49–65:

Advanced use of the twelve Renaissance words, blocking, theme building, balance, the twenty-two art accents. Special guest artists include professional cartoonists, authors, and car designers! Lesson titles include: **49.** Crane Contraptions; **50.** Colorful Coral; **51.** Cool Canyons; **52.** Drooling Dragons; **53.** Dirk's Declaration!; **54.** Deep Space Droids; **55.** Daring Driving Dogs; **56.** Drawing Determines Destiny!; **57.** Eccentric Elephants; **58.** Early Egyptians; **59.** Enthusiastic Environmentalist; **60.** Elevated Earth Equalizer; **61.** Eek Squeaks!; **62.** Fearless Floating Frogs; **63.** Furry De Franco from Florence; **64.** Funky Flying Faucets; and **65.** Forest of Freedom!

TO RECEIVE A PRODUCT ORDER FORM, FAX YOUR PURCHASE ORDER TO 805-965-6723.

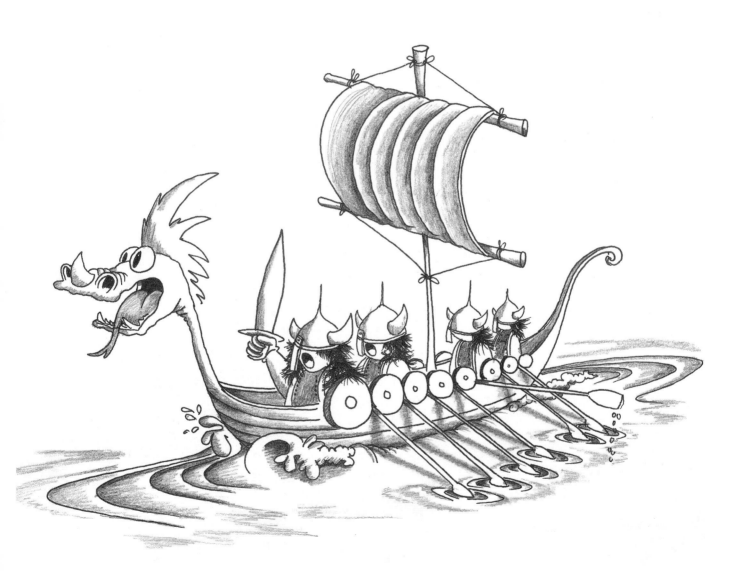

Appendix E

Mark Kistler's Elementary School Assembly Programs

1. **Draw in 3-D with Me!**
2. **Diversity University**
3. **World Web Wizards**
4. **Young Authors/Illustrators**
5. **Dream Dominators Dump Drugs!**
6. **Family Evening Drawing Lesson!**

"Mark Kistler's Imagination Station"

Learn to Draw in 3-D with Me

Get your students prepared to blast off into the land of imagination with pencil power! For seventeen years, Mark Kistler has been teaching kids how to draw in 3-D with this world-famous assembly program. An unforgettable hands-on assembly that encourages students, teachers, and parents to participate. Mark has taught 30 million children around the world how to draw...he can teach your students, too!

Mark deeply believes that learning how to draw in three-dimensions builds a child's critical thinking skills while nourishing self-esteem. His positive messages on self-esteem, goal setting, dream conquering, environmental awareness, and the power of reading have sparked millions of children around the world to discover their awesome individual potential.

"I wish I had Mark Kistler's Draw Squad when I was 10!"

—Ray Bradbury

Here's What You're in For

Two enchanting live performances with Mark Kistler.

One assembly for grades K–2, and another for grades 3–6.

Fresh new lessons each year!

Students arrive at the assembly equipped with paper, pencil, and a book to use as a lap desk.

Mark Kistler has the group (up to 5,000 at a time!) sit on the floor poised ready for drawing action.

Students complete four 3-D drawing lessons, get introduced to the Internet cyber art academy, and get inspired to illustrate their own great American novel!

At the conclusion of the drawing lesson, Mark encourages the children to explore specific fun children's Web sites on the Internet. Children can now mail, fax, scan, and modem their drawings into student art gallery Web sites. Their drawings will be displayed in international cyberspace for all the world to see and applaud! Students and teachers are invited to visit Mark's Web site at http://www.draw3d.com.

Your school will also receive four of Mark's drawing in 3-D video lessons for two hours of classroom follow-up instruction. Schools are encouraged to duplicate this video for additional library checkout copies.

Using an overhead projector, television/VCR, chalkboard, and microphone, Mark Kistler guides your children through an extraordinary imagination adventure. Your students learn how to draw in 3-D while Mark tells stories of great galactic adventures, journeys to the bottom of the sea, time-traveling odysseys back to the land of the dinosaurs and forward into time with pencil power! This "how-to-draw" assembly is an experience your children will never forget!

Cool!

In our very first 3-D drawing adventure, we've used four of the twelve Renaissance words. These words have helped artists draw and paint in 3-D for over 500 years. Learn these twelve words and you'll be drawing brilliant masterpieces!

Other Mark Kistler Programs Available

Inspiring Student Achievement through the Power of Art

Family Evening Drawing Program

Schools scheduling Mark's Daytime Assembly Programs now have the option of scheduling Mark's extremely successful Evening Family Program. During the student assemblies, Mark invites all the children to return that evening for another fun-filled drawing in 3-D adventure with their entire family! The result of this exciting invitation is record-breaking parent attendance in fourteen states! Normally scheduled from 6:30 to 7:30 P.M., this magical evening family program motivates children to draw on their boundless imagination rather than spending the average 26,880 hours (before the age of eighteen) watching mindless television. Even adults who constantly say "I can't even draw a straight line" will be confidently sketching cool 3-D illustrations. This delightful evening of creative magic is fun for the entire family.

Our Diversity University

This unique multicultural art program celebrates the power of ethnic diversity in our nation's elementary schools, from extraordinary breakthroughs in science, technology, and medicine to our vast array of artistic expressions in music, literature, and art. Mark surveys the assembly crowd to illustrate how wonderfully diverse the group's cultural heritages are. Your school's student body makeup is a "Mini-United Nations." Mark chooses four cultures represented out of a hat and launches into a global journey of drawing 3-D. This is a drawing lesson your students will treasure!

Internet Web Wizards

The World Wide Web is one of our planet's most exciting technological evolutions of the century. Children now have at their fingertips the ability to explore information on virtually any special interest area, from career options, historical data, and science breakthroughs to millions of pages of research topics. The Internet is like having all the world libraries, museums, and research facilities at your fingertips. In this exhilarating "Cyber Journey," Mark teaches your students: 1. how to explore the Internet safely with "Cyber-Kid" rules; 2. oh! what you can do on the Net!; 3. creating and linking home pages; 4. becoming a worldwide "Cyber-Kid Author/Illustrator!"

Young Authors/Illustrators

This program explores the exhilarating process of writing and illustrating storybooks. Your students learn:

- how to generate ideas with the "Theme Game"

- how to create characters, locations, motivation, purpose, etc.

- how to illustrate the story in 3-D

- ideas for self-publishing and submitting to national publishers. Drawing the illustrations for a book first before writing the story is an unusual yet highly effective story-building technique Mark teaches. Drawing in 3-D sparks a flood of story ideas. This assembly program is the writer's workshop your students will reuse, review, reflect, and remember!

Dream Dominators Dump Drugs!

This drawing lesson harnesses the power of art to help students illustrate in 3-D their lifelong goals. Students learn how to evolve from "Dream Beams" to "Dream Dominators" by: 1. clearly identifying dream goals; 2. aggressively avoiding drugs and violence; 3. reading about your dreams (ten books); 4. exploring your dreams on the Internet (ten Web sites); 5. understanding that drugs dilute dreams and "Drawing Daily Dynamic Dreams Are Do-Able!" Along with the 3-D drawing dreams lesson, Mark teaches the kids American Sign Language to mentally capture important visual metaphors. He uses visual snapshots such as a ship with a strong (goal) steering tiller, hot air balloons rising with (dream) power, and a star shuttle with solid (self-esteem) targeting launch tower. These are mental images that will strengthen your student's resolve to dominate dreams through creativity rather than diluting them with drugs.

Call 888-UDRAW3D to Schedule a MARK KISTLER PROGRAM!